HENRY MOORE

From the Inside Out

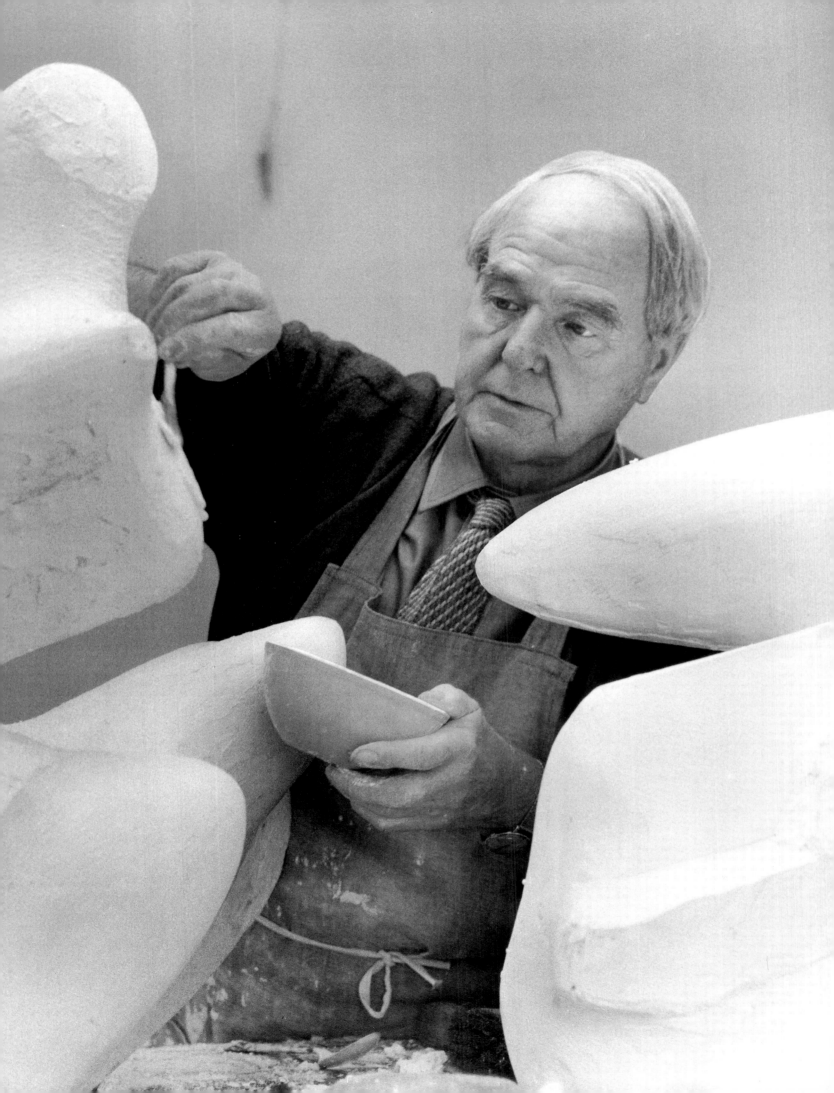

HENRY MOORE

From the Inside Out
Plasters, Carvings and Drawings

Edited by Claude Allemand-Cosneau, Manfred Fath
and David Mitchinson

Prestel

Munich · New York

Published in conjunction with an exhibition shown at the Musée des Beaux-Arts,
Nantes (3 May – 2 September 1996), and the Städtische Kunsthalle, Mannheim
(29 September 1996 – 12 January 1997)
© 1996 by the Henry Moore Foundation, Much Hadham;
the Réunion des Musées Nationaux, Paris; the Musée des Beaux-Arts, Nantes;
Prestel-Verlag, Munich and New York; and the authors
© 1996 of the English edition by Prestel-Verlag, Munich and New York
© of all works by Henry Moore by The Henry Moore Foundation, Much Hadham
© of all other works by the artists, their heirs and assigns, except Pablo Picasso:
by VG Bild-Kunst, Bonn
Photographic Acknowledgements: p. 200

'Henry Moore: The Path to Maturity' and 'Chronology' translated
from the German and the French respectively by Elizabeth Clegg
'Form: The Seeing Eye; Henry Moore – London to Paris and Back'
translated from the French by Maev de la Guardia
'Moore, Moore's Children: "Being There"' translated from the French
by Brian Holmes

Cover illustration: *Warrior with Shield* (plate 64) in Moore's studio at Perry Green
Frontispiece: Moore at work on *Working Model for Two Piece Reclining Figure:
Points*, 1969–70 (LH 605)

Prestel books are available worldwide. Please contact your nearest
bookseller or write to either of the following addresses for information
concerning your local distributor:
Prestel-Verlag, Mandlstrasse 26, D-80802 Munich, Germany
Tel. (+49-89) 381 7090, Fax (+49-89) 381 709 35
and 16 West 22nd Street, New York, NY 10010, USA
Tel. (212) 627-8199, Fax (212) 627-9866

Designed by BuchHaus Robert Gigler GmbH and Heinz Ross, Munich
Lithography by Design Typo Print, Ismaning
Printed by Aumüller Druck KG, Regensburg
Bound by Graphische Betriebe Oldenbourg, Heimstetten

Printed in Germany

ISBN 3-7913-1664-4 (English edition)
ISBN 3-7913-1662-1 (German edition)

Contents

Committee of Honour

M.Jean-Marc Ayrault, *Député-Maire de Nantes*
Herr Gerhard Widder, *Oberbürgermeister, Mannheim*
Mr David Ricks OBE, *Director, The British Council, France*
Sir Rex Richards FRS, *Chairman, The Henry Moore Foundation*

Organizing Committee

Claude Allemand-Cosneau, *Curator, Musée des Beaux-Arts, Nantes*
Manfred Fath, *Director, Kunsthalle, Mannheim*
Catherine Ferbos-Nakov, *Visual Arts Officer, The British Council, France*
David Mitchinson, *Curator, The Henry Moore Foundation*
Julie Summers, *Deputy Curator, The Henry Moore Foundation*

The Organizing Committee would like to thank the following, who contributed
in so many different ways to the organization of the exhibition and the preparation
of the accompanying publication:

Jean-Louis Bonnin
Jacky Bordier
Nathalie Brunet-Hazan
Hans-Jürgen Buderer
Yvette Burgaudeau
Kenneth Burgen
Christoph Cesbron
Elizabeth Clegg
Jill Constantine
Henry-Claude Cousseau
Dominique David
Martin Davis
Gordon Dawson
Angela Dyer
Diana Eccles
John Farnham
Sebastian Fath
Michael Foster
Pat Gibberd
Tim Hardacre
Inge Herold
Clare Hillman

Ann Hindry
Célia Houdart
Janet Iliffe
Jochen Kronjäger
Michael Maegraith
Anne de Margerie
Jim Moyes
Michel Muller
Octavia Nicholson
Sherry Phillips
Marie Rouhète
Geoff Robinson
Andrea Rose
Heinz Ross
Vincent Rousseau
Reinhard Rudolph
Monika Schulte
Emma Stower
Jean-Yves Tougeron
Lynn Warren
Mike Winter
Malcolm Woodward

Foreword

The exhibition that this publication accompanied in its French and German editions was the result of an exceptionally fruitful collaboration between the Musée des Beaux-Arts, Nantes, the Städtische Kunsthalle, Mannheim, the British Council, France, and the Henry Moore Foundation, Much Hadham. The subject of the exhibition provided an opportunity to present Henry Moore's work in a way never seen before. Although Moore is well known internationally for his monumental sculptures sited out of doors in many major cities, the plasters are less well known than the casts that were made from them, representing as they do a stage in the working process towards the final bronze editions. They have been infrequently exhibited and appear only occasionally in monographs on the artist and in catalogues of his work. The exhibition therefore offered a unique chance to see a great number of these plasters and to view them beside a selection of Moore's drawings and carvings made over the sixty years of his working life.

Henry Moore's connections with France and Germany go back a very long way. He first visited France in 1922 as a student and made his first sale of a sculpture abroad to the Museum für Kunst und Gewerbe, Hamburg, in 1931. From the 1950s he worked with the Valsuani and Susse foundries in Paris and later with the Noack foundry in Berlin, which continued to cast his work for a quarter of a century. There have been a great number of Moore exhibitions in both countries, many supported by the British Council. The artist's work is familiar across Europe in both private and public collections. His largest marble carving of the 1950s, *Unesco Reclining Figure*, is sited in Paris, while *Large Two Forms* (1966–69) stands in front of the Bun-deskanzleramt in Bonn. Moore was honoured by both countries, receiving the German Order of Merit in 1980 and the French Légion d'Honneur in 1984.

The Musée des Beaux-Arts in Nantes, in collaboration with the British Council, has sought over several years to make contemporary British art known in France, in particular through displays of work by Howard Hodgkin, Tony Cragg and Barry Flanagan and through the exhibition 'Matter of Facts'. The Kunsthalle in Mannheim has pursued a policy of collecting work by twentieth-century British artists, including the acquisition in September 1955 of Moore's *Warrior with Shield* following a British Council touring exhibition in Germany during 1953–54.

The exhibition was curated by David Mitchinson, the works coming principally from the Henry Moore Foundation's own collection, supplemented by loans from the British Council, the Arts Council of Great Britain, the Art Gallery of Ontario in Toronto and the Harlow Arts Trust. These additional works greatly enhance the art historical value and the visual appeal of both the exhibition and the present volume, and we are very grateful to the lenders for their generosity. Our thanks extend to the members of the Organizing Committee who, by following the development of the artist's thoughts and by understanding the evolution of his exploration of form, worked hard to make possible an exhibition and a publication involving three institutions.

Tim Llewellyn, Director, The Henry Moore Foundation, Much Hadham
Jean Aubert, Directeur, Musée des Beaux-Arts, Nantes
Lothar Mark, Kulturdezernent, Mannheim

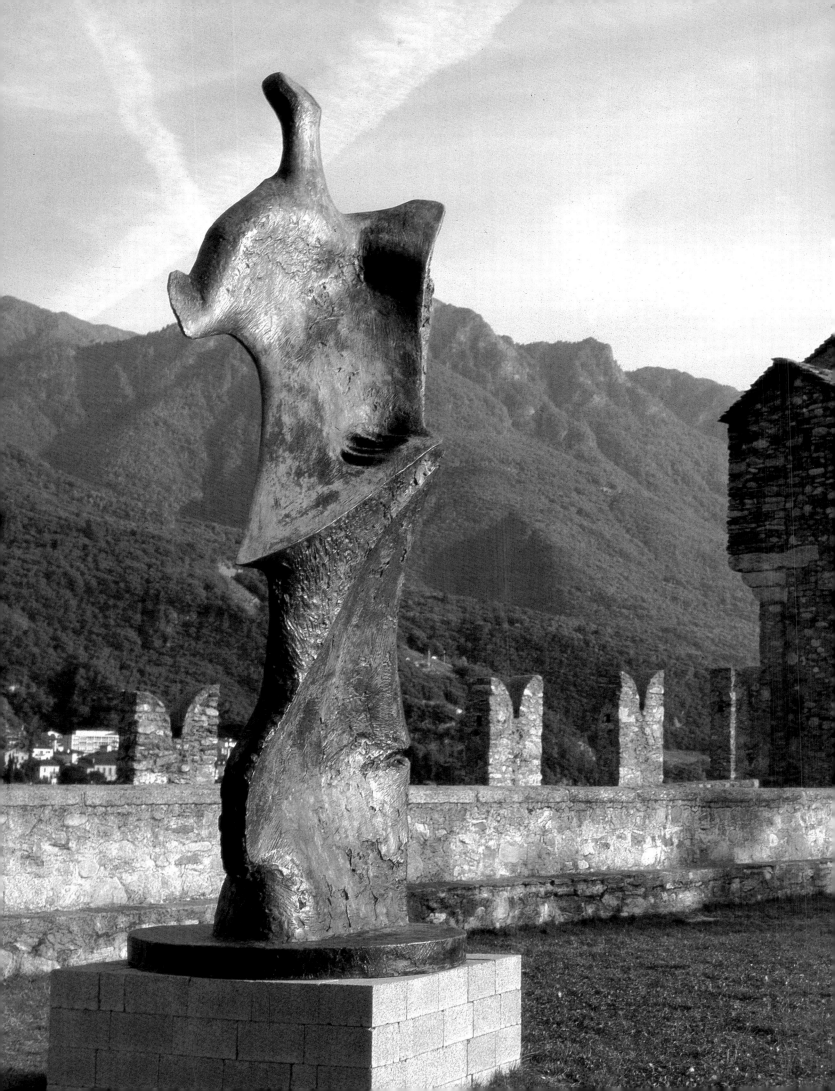

Henry Moore: The Path to Maturity

Manfred Fath

*My work is a mixture of influences and appreciation
of art and my excitement and observation of nature.
I think this is what all art has been.*[1]

Introduction

Henry Moore now ranks unchallenged as the most
important British sculptor of the twentieth century, a
status reflected both in the many international exhibi-
tions of his work and in the large number of his sculp-
tures to have been installed in museums or open-air
sites. Such celebrity was, however, attained only after
the Second World War, more specifically after 1948,
when the artist won the Prize for Sculpture at the first
post-war Venice Biennale. Without doubt, Moore is
also among the few outstanding sculptors of this cen-
tury to have exerted a fundamental influence on the art
of the age. In adopting and further developing Jacob
Epstein's engagement with 'primitive' art and with the
forms of sculptural expression favoured by avant-garde
artists in Paris, Moore significantly hastened the freeing
of British sculpture from Classical tradition. Respond-
ing from the start to the most varied influences and
stimuli, in the 1930s he developed from these a distinc-
tive and independent formal language, characterized by
the critic Herbert Read as 'vitalist'. Alongside Barbara
Hepworth, Moore was the first British sculptor to
attain a high international reputation. For a long time,
however, his work proved controversial. Initially it was
rejected because it was seen as an attack on the tradi-
tional forms of representing the human figure, as too
abstract or too deformed. Later, Moore's critics found
his adherence to the figure too conservative and too
indebted to a specifically English Romantic tradition
(a tradition of which Moore is now often seen as the
most important twentieth-century representative).[2] This
tradition endures above all in Moore's endeavour to
conceive and convey the human figure as a form of

Large Standing Figure: Knife Edge, 1961 (LH 482a); bronze, h. 358 cm

'landscape', a process through which he strives for the
sort of 'poetic penetration of the world'[3] characteristic
of the art of Romanticism.

Using elemental forms, Moore evolved a universal
visual language, by means of which he revealed new
dimensions for the representation of the human figure
in terms of both form and content. Through his works
he bound British sculpture into developments on the
Continent and, at the same time, created the precondi-
tions for the important position it currently occupies
within international art. As Ann Hindry wrote in 1988,
it now appears that sculpture is the dominant medium
in contemporary art in England; and Catherine Ferbos
has written that, over the last fifty years, there has
evolved an 'English School' of sculpture that began with
Moore and Hepworth and continues with such artists
as Anthony Caro and Richard Long. She sees the most
important shared characteristic of English sculptors of
this century as the fundamental significance of land-
scape to their work.[4]

Though it did not introduce any aesthetic or formal
innovations, Moore's early work has often been identi-
fied with the beginnings of modern sculpture in Eng-
land. The stylistic and formal basis of his contribution
had been established in Paris during the first two
decades of the century, by artists such as Pablo Picasso,
Alexander Archipenko and Constantin Brancusi:
'Moore was not himself responsible for a single sub-
stantial technical advance which could be seen as such
in the context of modern sculpture as a whole.'[5] Moore
was no pioneer of modern sculpture in the sense intend-
ed by Naum Gabo when he demanded that works of art
should reflect the technologically and scientifically
informed spirit of our age and its rationalism.[6] In fact,
as many of Moore's own statements show, he had very
little interest in the preoccupations of the avant-garde.
He was, rather, imbued with a deep humanism, and it is

to this that his works give expression. He used abstract forms because he believed that he would thus be able to realize the human and spiritual content of his ideas with greater directness and intensity.[7]

Moore's oeuvre can be divided into two periods, distinguished above all by changes in his preferences regarding materials and sculptural techniques, but also by changes in his approach to form. For the works made from the mid-1920s to 1939, Moore used almost exclusively stones and pieces of wood that had been carefully selected in accordance with his eagerly repeated maxim of the time – that the sculptor's work should be guided by the spirit of the material. After the break in his work as a sculptor occasioned by the Second World War (during which, as an Official War Artist, he created his Shelter drawings),[8] he principally produced modelled, rather than carved, sculptures for eventual casting in bronze. Of the first two hundred sculptures listed in the *catalogue raisonné* of Moore's oeuvre, only sixteen are intended for casting in bronze – a clear indication of where the artist's interests initially lay. In the works in stone and wood made between 1922 and 1939 Moore evolved both the characteristic sculptural style and the thematic repertoire to which he was to remain faithful throughout his career, however varied the forms and dimensions of his later work.

Moore's central subject was the human figure. 'There are three recurring themes in my work', he said, 'the "Mother and child" idea, the "Reclining figure" and the "Inner/Exterior forms". Some sculptures may combine two or all of these.'[9] He introduced an astounding degree of variety into these archetypal subjects. In the mother and child groups the emotional tenor ranges from the most intimate tenderness, through majestic dignity, to an alienating sense of aggression.[10] Moore regarded his reclining figures as an aesthetic 'framework' that offered the greatest freedom in terms of both composition and space. They allowed him to create new forms: from the 1930s he identified the human figure with landscape elements or literally derived it from nature in the guise of found objects. Moore himself often referred to the importance of landscape for the creative process from which his works emerged: 'Landscape has always been for me one of the sources of my energy.'[11] Furthermore, he always paid great attention to the installation of his sculptures in open-air sites in order to ensure their balanced integration into the architectural environment or the landscape setting.

At the start of his career as a sculptor, Moore took his bearings from various models. Some of these he refers to in his writings; others he does not mention, although

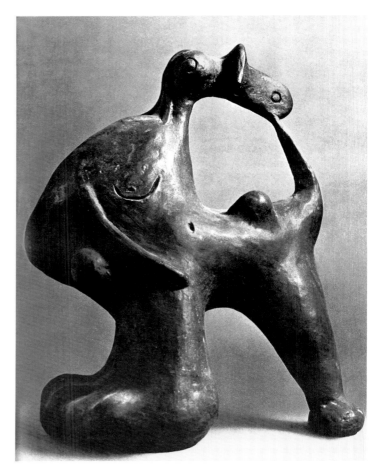

Fig. 1 Pablo Picasso, *Metamorphosis I*, 1928; bronze, h. 22.6 cm

they clearly influenced his ideas on art and his approach to form.

The International Situation

The work of Auguste Rodin is generally identified with the dawn of modern sculpture. By dissolving solid forms, firm outlines and self-contained surfaces, Rodin created figures that were made up of a continuous sequence of swellings and hollows. He was thus able to represent 'inner form' and so to reveal the essence of each piece. This aspect of Rodin's achievement influenced many sculptors in the first decades of the century. Moore stated that he had rated Rodin extremely highly, no doubt especially on account of the latter's intensive engagement with the human figure. Like Rodin, Moore evolved ever new forms of expression for the figure. It is also possible that Moore was attracted to the work of Rodin because of its formal proximity to that of Michelangelo, whom Moore had considered his most important model even before he visited Italy.[12] In Moore's reclining figures, in particular, there is evidence of his preoccupation with Michelangelo's own works of

this type.[13] Looking back over his career, Moore later reported that at the start of his studies in Leeds he had produced sculptures in which he had taken his lead from Rodin.[14] The artistic antithesis of Rodin, Aristide Maillol (a sculptor entirely committed to the Classical ideal of form), held only a passing interest for Moore. Maillol's work, with its Classically self-contained figures, never served as a model for Moore, even though, in 1922, during his first stay in Paris, he had planned to visit him.[15]

Of much greater significance for Moore were the Cubist and abstract tendencies to be found, from the early years of the century onwards, in the work of artists belonging to the Paris avant-garde. Picasso was the first of these to apply to sculpture the Cubist formal canon he had evolved together with Georges Braque in the context of two-dimensional work. While the sculptures Picasso produced between 1899 and 1906 were still modelled in the 'Impressionist' technique of the followers of Rodin or Medardo Rosso, from 1907 he produced sculptures in which a clear attempt was made to transfer to this medium the formal principles developed in painting. At around the same time,

André Derain produced his first expressively distorted stone sculptures, carved directly from the block. Their formal qualities reflect the artist's interest in African sculpture, a model also apparent in the sculpture made in and after 1909 by Amedeo Modigliani. Of greater importance for Moore, however, were to be the sculptures made by Picasso in the 1920s, with their distorted figures, their open volumes and their conscious incorporation of empty space as an integral compositional component. These were to prove a more lasting influence on Moore than Picasso's early Cubist works, which are reflected only in a few of Moore's early sculptures. Moore's interest in Picasso became clearer during the 1930s, a period when the latter was keenly involved in sculptural projects. A key work in this context is Picasso's *Metamorphosis I* of 1928, which has a direct bearing on Moore's *Composition* of 1931 (figs. 1, 2).

Moore was crucially impressed by the 'three-dimensionality' of Picasso's sculptures: in this he saw one of the principal concerns in any sculptor's work. In 'Notes on Sculpture' (1937) Moore added that the sculptor had to grasp form in every aspect of its spatial existence: 'He must strive continually to think of, and use, form in its full spatial completeness.... He mentally visualizes a complex form *from all round itself*; he knows while he looks at one side what the other side is like; he identifies himself with its centre of gravity, its mass, its weight; he realizes its volume, as the space that the shape displaces in the air.'[16] Moore believed these principles to have attained their optimum realization in Picasso's work of the late 1920s.

Moore also repeatedly alluded to the importance of Brancusi for the development of contemporary sculpture. Brancusi's approach was based on two principles: the notion of overall harmony, and truth to materials. For him, 'overall harmony' meant that the definitive shape and character of a work had to be attained through the creative engagement of the artist with his material.[17] Moore saw Brancusi's particular contribution in the fact that he reduced every individual entity, through a radical process of concentration, to a definitive 'primal form', thus re-awakening a 'consciousness of form' among contemporary sculptors. Moore stated that Brancusi's championing of 'form for its own sake... was a great help for me, a sculptor twenty years his junior'. Brancusi was also important to Moore on account of his advocacy of direct carving of a stone or wood block. For very many years Moore regarded this as the only truly 'sculptural' way of working. He was fascinated by the fact that 'you begin with the block and have to find the sculpture that's inside it'.[18]

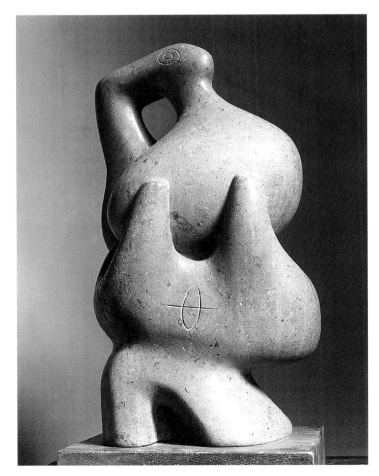

Fig. 2 *Composition*, 1931 (LH 99); green Hornton stone, h. 48.3 cm; Moore Danowski Trust

At the end of the 1920s and in the early 1930s Hans Arp started from the same idealistic conceptions of organic form as Brancusi when he began producing his first emphatically rounded stone and wood sculptures. In his own works Moore sought, like Brancusi, 'to show the secret ways of nature'. Arp called his own sculptures *concrétions* and defined them as emerging from 'the natural process of condensation, hardening, coagulating, thickening, growing together....Concretion is something that has grown. I wanted my work to find its humble, anonymous place in the woods, the mountains, in nature.'[19]

Moore, too, repeatedly alluded to the close connection between his works and natural forms. In its almost mythical bond with nature, his work reveals a close inner relationship with that of Brancusi and Arp. Herbert Read saw two determining forces at work in the sculptures of all three artists: one mythical and one vital. Of Moore he wrote: 'From the vital source comes everything represented by Arp's word "concretion" – formal coherence, dynamic rhythm, the realization of an integral mass in actual space. From the mythical source comes the mysterious life of his figures and compositions, in one word, their *magic*.'[20]

The work of Brancusi and Arp accorded with Moore's notions of vitality and the power of expression as he defined them in his essay of 1934 for *Unit 1*:

> For me a work must first have a vitality of its own. I do not mean a reflection of the vitality of life, of movement, physical action, frisking, dancing figures and so on, but that a work can have in it a pent-up energy, an intense life of its own, independent of the object it may represent. When a work has this powerful vitality we do not connect the word Beauty with it....Between beauty of expression and power of expression there is a difference of function. The first aims at pleasing the senses, the second has a spiritual vitality which for me is more moving and goes deeper than the senses. Because a work does not aim at reproducing natural appearances it is not, therefore, an escape from life – but may be a penetration into reality...an expression of the significance of life, a stimulation to greater effort in living.[21]

Another important contribution to the development of modern sculpture was made by Archipenko, though Moore himself never mentions him in his comments on sculpture. Archipenko was probably the sculptor who embraced Cubist and Futurist art most whole-heartedly and who freed sculptural form from its naturalistic ties. His early figural works are distinguished by smooth, taut volumes and by elegant forms that exude a refined sensuality. Around 1909–10 his figural style changed, under the influence of Cubism and Futurism, from realistic illustration to Cubist construction using both concave and convex forms. A significant innovation in Archipenko's work of this period was the incorporation of negative volumes: a penetration of the principal mass was achieved by openings that were used as a constitutive element of his rendering of the figure. After 1913, and above all in 1915, in the various versions of *Woman Combing her Hair*, Archipenko produced highly innovative works in which – as a further development of Cubist formal principles – both closed and open volumes were employed as equally important formal elements. This was a stylistic principle that Moore was to adopt in his work of the early 1930s, and which was to become a fundamental feature of his approach to sculpture. In his own words: 'The first hole made through a piece of stone is a revelation. The hole connects one side to the other, making it immediately more three-dimensional. A hole can itself have as much shape-meaning as a solid mass. Sculpture in air is possible, where the stone contains only the hole, which is the intended and considered form.'[22]

Moore and British Sculpture

During the course of the twentieth century, British art has produced a series of notable sculptors who have gone on to win acclaim throughout Europe. This development was initiated in the late nineteenth century with the New Sculpture movement. The founding of the Society of British Sculptors in 1904 bears witness to the new significance attached to sculpture in England at the start of the century. Sculptors were inspired by a new conception of their work and their role, which led, among other things, to a redefinition both of the importance of sculpture in relation to architecture and of the design of public monuments.[23] Although British sculpture in the early years of the century was still firmly embedded in Classical tradition – as demonstrated, above all, by many of the monuments erected around the turn of the century – the beginnings of a response to modern tendencies, particularly those emerging in Paris, could be detected in the work of certain artists.

Gradually, the representation of emotion assumed greater significance than the production of empty allegories that had been characteristic of Victorian art. In 1910 Roger Fry described the situation in England as characterized by two opposing trends: on the one hand, that of the commonplace, expressionless, representa-

tional style and, on the other, that of an expressive style emerging under the influence of Rodin.[24]

For a number of British artists, the 1910s were marked by a search for an alternative figural language. Like Picasso and his circle in Paris, artists in England – above all Jacob Epstein and Henri Gaudier-Brzeska – sought new inspiration in the formal vocabulary of 'primitive', non-European and medieval art. The expressivity and originality of the resulting works were regarded as sensational and often provoked scandal.

Epstein, Gaudier-Brzeska and Eric Gill were the first sculptors in England to engage seriously with the new forms for the representation of the human figure that were being evolved in Paris. In turn, these artists, who were responsible for 'the emergence of British sculpture from a provincial academic tradition into the mainstream of modern European art',[25] decisively influenced the young Henry Moore as he embarked on an artistic career in the early 1920s. It is interesting in this connection to note that two of the most important sculptors to have initiated the renewal of sculpture in England were not themselves English.

Probably the most significant innovator in British sculpture before the First World War was Jacob Epstein. The son of Russian Jewish emigrants to America, he was born in New York on 10 November 1880 and in 1902 went to Paris, where he studied at the Ecole des Beaux-Arts and the Académie Julian. The work he produced up to around 1911 shows very clearly an approach to sculpture akin to that of the Classically imbued tradition of the Ecole des Beaux-Arts, although it was not altogether uninfluenced by Rodin and by the sculpture of the Renaissance. In 1905 Epstein moved to London; he remained there for the rest of his life, in 1907 becoming a naturalized British subject. However, he always retained a critical distance towards the culture of his adopted country, in particular towards its traditionalist sculpture. His strongly expressive and idiosyncratic works, imbued with a truly modern spirit, offered a compelling alternative.

From the time of his arrival in London, Epstein was a constant visitor to the British Museum. Yet the influence of 'primitive' art exhibited there did not begin to appear in his work until around 1912. It then became quite obvious in the sculpture he produced between 1912 and 1915. This short period was one of the most creative and innovative phases of Epstein's career. Like many other forward-looking artists at that time, Epstein drew inspiration from a passionate engagement with the magical and formal qualities of 'primitive' art, which interested him most for the rhythm of its forms, its arrangement of masses and its marked frontality.

In 1907 Epstein received a commission to provide eighteen large sculptures for the façade of the headquarters of the British Medical Association in London. In the resulting figures Epstein achieved a union of the Classical tradition and the work of Rodin[26] so as to convey a combination of calm and dignity, intimacy and forceful expressivity. The emphatic nudity of the figures and the explicit treatment of erotic motifs caused a storm of protest, the first evidence of that public resistance to Epstein's work which was to endure until well into the 1930s, even though esteemed artists, critics and art historians repeatedly voiced their support for him.[27] 'In the years before and just after the first world war, while he was perhaps the sculptor most admired by the perceptive, he was undoubtedly the most loathed by the philistines.'[28] In 1912 Epstein was described in the press as a 'Sculptor in Revolt, who is in deadly conflict with the ideas of current sculpture'.[29]

From 1911 to 1913 Epstein worked in Paris on a monumental tombstone for Oscar Wilde's grave in the cemetery of Père Lachaise. His representation of the poet as a naked 'winged daemonic angel', derived from one of the colossal, human-headed winged beasts in the British Museum, provoked an outcry. A similar, particularly vehement dispute arose regarding the artist's *Rima*, a figure intended for the memorial to the writer W. H. Hudson that was to be erected in Kensington Gardens, London, in 1925.[30] This unconventionally passionate and mystical rendering of sexuality prompted widespread shock.

During Epstein's 1911–13 stay in Paris, he came into close contact with Brancusi and Modigliani, and the work of both was to have a strong influence on his own in the following years. At this time Modigliani was working on his elongated sculptures and drawings influenced by Baule masks, and Epstein, who saw Modigliani almost every day, became deeply interested in the Italian's work. To Brancusi, on the other hand, Epstein owed his conviction, held firmly until well into the 1920s, of the importance of direct stone carving, of 'retaining manual responsibility for every blow of the chisel and allowing the intrinsic character of the stone to affect the fundamental individuality of the sculpture'.[31] Epstein's contact with Brancusi and Modigliani thus brought about a reorientation in his own work. This, in turn, initiated the phase during which he was strongly influenced by 'primitive' art. Commenting on the latter, Epstein said that 'the chief features of negro art are, its simplification and directness, the union of naturalism and design, and its striking architectural qualities'.[32] Epstein's preoccupation with 'primitive' art led him to practise a radical simplification and reduc-

tion of form, with the aim of achieving a heightened power of expression. This was the quality that impressed Henry Moore so deeply at the outset of his own career as a sculptor.

Epstein was, in fact, the first British sculptor to take an especially deep interest in non-European 'primitive' art, an interest reflected in the large and impressive collection of such work that he amassed over the years.[33] The qualities in Epstein's wood and stone sculptures that provoked fierce public debate – their stark expressivity and their uncompromising depiction of sexuality – were precisely those that the artist derived from his engagement with 'primitive' art. In 1913 and 1914 Epstein's sculptures and drawings focused almost exclusively on the representation of sexuality: copulation, pregnancy and birth. Nothing at all comparable is to be found in the work of other artists at this time.[34]

In 1913 and 1914 Epstein was in contact with the Vorticist group, founded by Percy Wyndham Lewis. Building on the ideas of the Futurists, the Vorticists strove for a renewal of English art; they wished to give expression in their work to the changes in society that were creating the 'Machine Age'. They published their ideas in their own avant-garde journal, *Blast*. It was characteristic of the Vorticists that, while in theory committed to a thorough rejection of the representational, they did not altogether exclude visible reality from their works.[35]

Epstein's short-lived interest in conveying the spirit of 'mechanization' is probably explained by his sympathy for the Vorticists' ideas. The foremost expression of this interest was found in what is probably his best known work, *Rock Drill* of 1913–15, of which only the torso survives (fig. 3).[36] In this work Epstein combined the mechanized figure of a worker with an industrially produced drill. The figure was prepared in a long series of studies and sketches. These draw on various 'primitive' models, which Epstein combined into a synthesis.[37]

An increasing simplification of form characterizes the work Epstein produced after *Rock Drill*, but the direct influence of 'primitive' art lessened. With regard to subject-matter, Epstein showed particular interest in figural depictions and in portrait busts of members of his family and his contemporaries. These are distinguished by great sensitivity and psychological insight. In the lively treatment of the surfaces, heightening the effect of light and shade, Epstein here works in the tradition of Rodin, just as he was later to do in his large-scale, expressive bronze groups of religious subjects.

Henry Moore first visited Epstein in 1921, bearing a letter of introduction from Charles Rutherston,[38] one of the first collectors of Epstein's work. Despite the

difference in age, a close friendship developed between the two artists. Epstein frequently invited Moore to his house, where, alongside Epstein's own work, Moore was able to study the choice collection of 'primitive' and Egyptian art. Epstein soon became aware of the decisive importance that Moore would have for the future development of English sculpture. Epstein visited Moore when the latter was teaching at the Royal College of Art and began to acquire Moore's work for his own collection. In 1928 Epstein arranged for Moore to receive his first public commission – for the large relief *West Wind* (LH 58) for the London Underground headquarters at St James's Park station – and in 1931 he wrote a text for the catalogue of Moore's second one-man show. For his part, Moore spoke up for Epstein, in 1924 arguing (albeit without success) that he

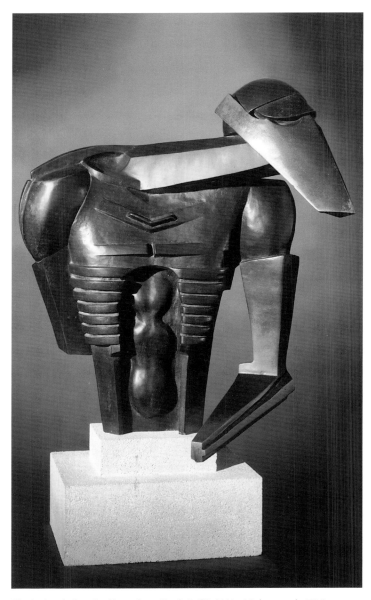

Fig. 3 Jacob Epstein, *Torso from 'Rock Drill'*, 1913–15; bronze, h. 70.5 cm; Tate Gallery, London

be appointed to the vacant Chair of Sculpture at the Royal College.[39]

The influence of Epstein's work is detectable in a number of early drawings and sculptures by Moore,[40] though Herbert Read is undoubtedly right in asserting that Epstein should be regarded here as a 'creative stimulus rather than as a model that was imitated'.[41] Both artists shared a great interest in the theme of mother and child,[42] but for Moore, Epstein was above all of significance as the first British sculptor to make a concious effort to follow developments in France and introduce them to England.

Before his untimely death Henri Gaudier-Brzeska grappled with much the same problems as those addressed by Epstein. Despite the smallness of his oeuvre, Gaudier-Brzeska made an important contribution to the sculpture of the twentieth century.[43] Ezra Pound mourned the early death of an artist whom he regarded as the most talented sculptor of his age. The young Henry Moore, too, admired Gaudier-Brzeska: 'Gaudier has given us the reassuring feeling that figurative and non-figurative art could co-exist without serious danger. To myself he gave the certainty that by seeking to create along other paths than those of traditional sculpture it was possible to achieve beauty.'[44] Moore was often to refer to the importance of Gaudier-Brzeska's work for his own artistic development: 'In this man I found a fellow spirit, a man that had won his spirit through direct work on the stone.'[45]

Gaudier-Brzeska, a self-taught sculptor, was born in St Jean de Braye, near Orléans, in 1891 and was killed in action on 5 June 1915. He arrived in London in 1911. Here he initially produced prints and portraits, but also modelled sculptures that, in their expressivity and their treatment of surfaces, were at first close to the work of Rodin and then, for a time, to that of Maillol, Picasso, Archipenko and Henri Matisse.[46] It was not until 1913 that Gaudier-Brzeska devoted himself entirely to sculpture.

As soon as he settled in London, the 19-year-old Gaudier-Brzeska had attempted to contact Epstein, whose work, in particular the tomb for Oscar Wilde in Paris, clearly impressed him. It was in all probability this admiration for Epstein that moved Gaudier-Brzeska to open himself to new, contemporary developments. Under Epstein's influence, he embarked on direct stone carving. This awakened his interest in 'primitive' art and this in turn drew him to the collections of the British Museum. During 1913 Gaudier-Brzeska produced his first works that reflect formal aspects of that art. From this point on, he saw his work as 'continuing the tradition of the barbaric peoples of the earth'.[47]

Now committed to direct stone carving, in 1914 he wrote:

> The sculpture I admire is the work of master craftsmen. Every inch of the surface is won at the point of the chisel – every stroke of the hammer is a physical and a mental effort. No more arbitrary translations of a design in any material. They are fully aware of the different qualities and possibilities of woods, stones, and metals. Epstein, whom I consider the foremost in the small number of good sculptors in Europe, lays particular stress on this. Brancusi's greatest pride is his consciousness of being an accomplished workman.[48]

In 1913 Gaudier-Brzeska allied himself with the Vorticists. In June 1914 he published the prescriptive text 'Gaudier-Brzeska Vortex' in *Blast*. It opens with the words: 'Sculptural energy is a mountain. Sculptural feeling is the appreciation of masses in relation. Sculptural ability is the defining of these masses by planes.'[49] Henry Moore frequently alluded to this text when speaking, in connection with his reclining figures, of the integration of landscape and figure.

Early in 1914 Gaudier-Brzeska produced what is universally judged his most important work, the *Hieratic Head of Ezra Pound* (private collection). In this piece, 91 cm in height and carved from a block of marble, he consciously refrained from providing a naturalistic record of the subject. In his biography of the artist, published in 1916, Pound wrote of it: 'He [Gaudier-Brzeska] had intended doing the bust in plaster, a most detestable medium, to which I had naturally objected. I therefore purchased the stone beforehand, not having any idea of the amount of hard work I was letting him in for. There were two solid months of sheer cutting, or perhaps that counts spare days for reforging the worn-out chisels.'[50] This monumental head is the only work by Gaudier-Brzeska that can be securely connected with specific 'primitive' models: the heads on Easter Island. Particularly striking is the 'phallic' form of the head. This was quite deliberate, as Horace Brodzky reported: '[the work's] purpose and beginnings were entirely pornographic. Both the sculptor and the sitter had decided on that. Brzeska informed me of the fact that it was to be a phallus.'[51] Brodzky also quoted Pound as saying: 'Brzeska is immortalising me in a phallic column!'[52]

When Moore moved to London in 1921, he was evidently not unaware of the work of Gaudier-Brzeska (though he appears not to have read Pound's biography until 1922) and an interest in Gaudier-Brzeska was not without impact on his early work. Gaudier-Brzeska's

allusion to truth to materials, and to the importance of the direct, and strenuously physical, 'hewing' of a sculpture out of the block, exerted a great influence on Moore's thinking until well into the 1930s. In conversation with Richard Cork, he said: 'Gaudier's writings and sculpture meant an enormous amount as well – they, and *Blast*, were a confirmation to me as a young person that everything was possible, that there were men in England full of vitality and life'.[53]

A number of Moore's sculptures provide clear evidence that he paid very close attention to some of Gaudier-Brzeska's works. A comparison of Moore's *Torso* of 1925–26 (LH 29) with Gaudier's *Torso* of 1913, or of Moore's *Standing Woman* of 1923 with Gaudier's *Red Stone Dancer* of about 1913, reveals unmistakable similarities. The pose of *Standing Woman*, with the right arm over the head, surely re-iterates that of Gaudier's dancer (figs. 4, 5).

Alongside Epstein and Gaudier-Brzeska, Eric Gill and Frank Dobson were among the more advanced English sculptors of the first half of this century and thus among those whose work served to prepare the way for younger artists. Although Moore respected them both, their works did not have a lasting influence on him. Only a few of Moore's reclining figures can be compared to one in marble made by Dobson in 1924–25.

Moore always gave the impression that he received no inspiration or influence at all from the professors working at the Royal College of Art when he was a student and, later, a teacher there. However, among them were sculptors who held artistic convictions comparable to his own. Neither academic nor modernist, Leon Underwood, G. F. Watts and Gilbert Ledward, for example, shared with Moore some ideas derived from the English Romantic tradition, in particular the writings of John Ruskin.[54]

Highly disparate influences were at work on British sculpture in the 1920s. Of greatest importance was the return to Classicism, originating in France, which helps to explain the vehement reaction to the works of Epstein. Alongside this development, however, there was a move towards greater expressiveness, reflected in the distortions by means of which sculptors sought to heighten the expressive power of their works. At the same time, the work of younger sculptors, and in particular that of Moore, displayed a growing interest in the most varied forms and traditions of art. These could be exploited without any sense of constraint deriving from awareness of the conventions governing them, in the interests of attaining 'significant' forms. Carving directly from the block of stone or wood – 'truth to materials' – became established as a key criterion of

truly modern sculptural art, in combination with the notion that a sculpture need have no significance or content beyond that implicit in its formal qualities. At the end of the 1920s Moore produced sculptures in which he increasingly dispensed with the exact rendering of human anatomy in favour of anthropomorphic or biomorphic forms and fragments of form. None the less, in both appearance and spatial arrangement, these still evoked the human figure.

By the mid-1920s Moore had absorbed and digested the most important influences that were to determine his later work. His sculptural output up to this time shows in what varied ways he made use of these impulses, evolving from them a distinct style of his own, in which, in the late 1920s, his earliest masterpieces were created.

'Primitive' Art and Greek Art

To an extent unequalled by almost any other artist of this century, Moore took an intense interest in the history of both European and non-European art. This is evident from his writings and from the studies he pursued, one of their principal aims being that of 'measuring' his own work against that of the past. It was within the general historical context that he found justification for, and the basis of, his own artistic activity.

For a long time, a significant part was played by examples of so-called 'primitive' art, Moore feeling himself closely connected with these on account of the directness and intensity of their emotionally expressive content, but also on account of the identity in them of form and material. In 'primitive' art he detected a 'common world language of form...apparent in them all'[55] and said of it: 'apart from its own enduring value, a knowledge of it conditions a fuller and truer appreciation of the later developments of the so-called great periods, and shows art to be a universal continuous activity with no separation between past and present.'[56] He also observed:

> through the workings of instinctive sculptural sensibility, the same shapes and form relationships are used to express similar ideas at widely different places and periods in history, so that the same form-vision may be seen in a Negro and a Viking carving, a Cycladic stone figure and a Nukuoro wooden statuette. And on further familiarity with the British Museum's whole collection it eventually became clear that the realistic ideal of physical beauty in art which sprang from fifth-century

Greece was only a digression from the main world tradition of sculpture, whilst, for instance, equally European Romanesque and Early Gothic, are in the main line.[57]

Although Moore here appears to issue a decisive rejection of the entire Classical Western art tradition, from Ancient Greece to the Renaissance, from Neo-Classicism to the art of the twentieth century, he nevertheless repeatedly engaged with Greek art throughout his career, making full use of the stimuli he derived from it in the context of his own visual language. For an artist of Moore's creative and intellectual capacity, even the briefest phase of close dependence on a specific model would be unthinkable. His artistic understanding and his diverse interests moved him, rather, to find a place for the most varied sources of inspiration within his conception of sculpture. In 1937 he wrote of this in his essay 'The Nature of Sculpture': 'in my opinion, everything, every shape, every bit of natural form...anything you like are all things that can help you to make a sculpture.'[58]

When Moore embarked on his studies at Leeds School of Art in 1919 he had already completed training as a teacher and had taught at Temple Street School in his native Castleford. His interests, including

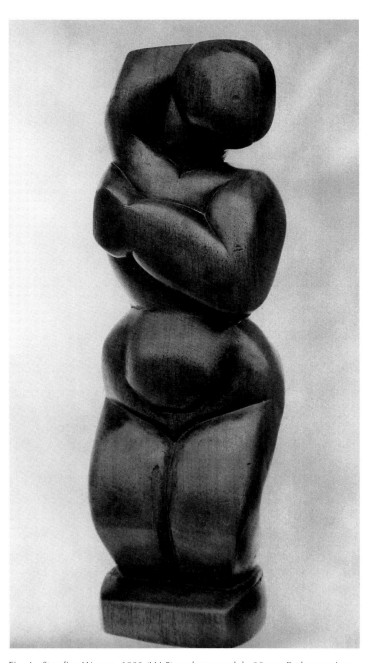

Fig. 4 *Standing Woman*, 1923 (LH 5); walnut wood, h. 30 cm; Rutherston Loan Collection, City Art Gallery, Manchester

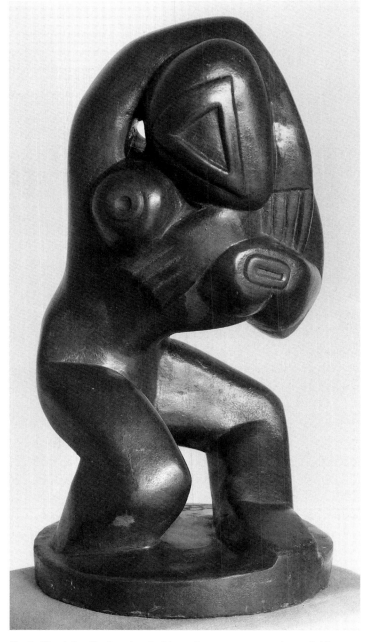

Fig. 5 Henri Gaudier-Brzeska, *Red Stone Dancer*, c. 1913; red Mansfield stone, h. 43.2 cm; Tate Gallery, London

a passion for literature, were broad and he was fired with a longing for 'universal' knowledge. This is evident in his activity as a book and art critic[59] and as a writer of plays[60] and possibly poems (though the latter have not survived). Moore's training at Leeds School of Art was largely conventional, with a strict timetable and a prescribed curriculum, which Moore completed more speedily than was intended.[61] Alongside his practical education, which, in sculpture, involved only modelling in clay, Moore made a keen study of the art of the past, in order to familiarize himself with the history and preconditions of sculpture. In the ninety-six pages of his *History of Sculpture Notebook* (1920; HMF 20[3] – 20[48]) he compiled a history of sculpture that, in its texts and drawings, ranged from Babylonian, Assyrian, Greek and Roman sculpture to that of Michelangelo. In 1976, in the introduction to the facsimile publication of a 1926 sketchbook, Moore explained that he viewed learning as much as possible of the history of sculpture as an important task, just as a scholar finds it useful to know about the evolution of his or her particular subject or just as a writer ought to have knowledge of the history and use of language.[62]

It was in Leeds that Moore first came into direct contact with works of modern art. Professor Michael Sadler, for many years Vice-Chancellor of the University of Leeds, was one of the most enthusiastic champions and collectors of modern art in England. It was thanks to him that Vasily Kandinsky's *Über das Geistige in der Kunst* was translated into English, as *On the Spiritual in Art*. Among the artists represented in Sadler's collection were Cézanne, Gauguin, Daumier, Courbet, Matisse and Kandinsky; and he also owned examples of African art. Sadler used to invite especially gifted students of the School of Art, including Moore, to his house. On these visits Moore was particularly impressed by Gauguin.[63]

One day in the Leeds reference library Moore chanced upon a copy of *Vision and Design*, the volume of essays published by Roger Fry in 1920. Moore's reading of this book, which he later called 'the luckiest discovery',[64] was to exercise a decisive influence on the development of his work and on the formation of his conception of art. In discussion with the American journalist Donald Hall in 1960, he was to comment on this.[65] Spurred by his reading of Fry, Moore started to take a keen interest in 'primitive' art, that is, in art objects that, at this time, were regarded from an almost exclusively ethnological or archaeological point of view.

As a result of these new interests, Moore abandoned the Classical ideal of beauty as it was still being transmitted by the traditional teaching at art schools. He had

been especially impressed by Fry's essays 'Ancient American Art' and 'Negro Sculpture'. The latter opens with a rejection of the Classical tradition: 'What a right little, tight little, round little world it was when Greece was the only source of culture, when Greek art, even in Roman copies, was the only indisputable art, except for some Renaissance repetitions!'[66] Fry's essay gave Moore an awareness of the freedom in the treatment of three-dimensionality, and of the 'truth to materials', characteristic of 'primitive sculpture', concepts that were to prove of the greatest significance to him. Together with the work of Brancusi, this was a source of Moore's long-held conviction that direct carving of stone or wood was the only valid sculptural technique.[67] Fry's comments also strengthened Moore in his rejection of the art of Classical Greece: 'There was a period when I tried to avoid looking at Greek sculpture of any kind. And Renaissance. When I thought that the Greek and Renaisance were the enemy, and that one had to throw all that over and start again from the beginning of primitive art.'[68] Elsewhere he said: 'The world has been producing sculpture for at least thirty thousand years. Through modern development of communication much of this we now know and the few sculptors of Greece of a hundred years or so no longer blot our eyes to the sculptural achievements of the rest of mankind.'[69] In rejecting the figural ideal derived from the art of Classical Greece, Moore became part of a widespread movement, initiated by Gauguin, who, around 1890, wrote: 'The great error is the Greek, however beautiful it may be.'[70]

Gauguin was the first European artist to draw the logical consequences from the rejection of the academicism inherent in the Classical tradition, and to seek out new points of departure in an attempt to heighten the expressive capacity of his art and to open up new possibilities for it. A precursor of the twentieth-century avant-garde, he was the first artist to recognize that the art of 'primitive' peoples gave expression to an original creative power that was free of convention and had a quite distinct approach to form. In this art he saw a model for the renewal of the image of humanity.[71] This conviction was later to be shared by Matisse, Derain, Vlaminck, Modigliani, Lipchitz and Picasso in France, by Epstein, Gill and Gaudier-Brzeska in England and by the artists of the *Brücke* group in Germany. While it was initially African and Oceanic art that inspired such artists to new formal solutions, their interests soon extended to the Pre-Columbian art of Central and South America and to that of the North American peoples, including the Eskimos.[72] In contrast to the purely mimetic images produced by the academic tradi-

tion, 'primitive' art provided these artists with concrete examples of the emotional force that, in a form appropriate to the age, they were striving to express in their own work. In 'primitive' art they discerned astonishing freedom, wide-ranging formal inventiveness, and intensity and directness of expression. From all these they drew inspiration.

In the autumn of 1921 Moore moved to the Royal College of Art in London, where, spurred by his reading of Fry's essays, he began to study the collections of the British Museum in a remarkably systematic way. In his essay 'Primitive Art' he describes how, step by step, he studied works of Egyptian, Assyrian, Sumerian, Cycladic, African, Oceanic, North and South American and Eskimo art.[73] He pursued these studies while on his travels too. Tracing Moore's engagement with 'primitive' art as recorded in his sketchbooks and as reflected in many of his sculptures of the 1920s, we note that the works of the various cultures exerted different sorts and degrees of influence. With instinctive certainty, Moore understood how to get the most out of the formal discoveries gained through his studies. He saw how these discoveries related to a timeless concept of the original, the archetypal and the unfalsified.

The evidence of the numerous sketchbooks surviving from the 1920s, and of Moore's writings, allows us to understand how he went about his studies of 'primitive' art and to determine which works impressed him. In addition to the collections of the British Museum, an important source was literature on 'primitive' sculpture. Moore himself possessed such books as Carl Einstein's *Negerplastik* and Ernst Fuhrmann's *Afrika* and *Reich der Inka*. Moore's sketchbooks of these years constitute the most complete survey of 'primitive' art to have been provided by an artist in this century. Drawings after African sculptures far outnumber those after works from other cultures. Surprisingly, Moore copied examples of Pre-Columbian art relatively rarely; it is known that he admired these greatly during the 1920s and that they played an important role in his own sculpture.

Many of these drawings clearly reveal that they were not made simply for the general purposes of study; their function, rather, was to record formal motifs that might be used to advantage in Moore's own work. For many years, drawing played a crucial role in the evolution of his sculptural ideas. As a rule, he made careful preparatory drawings and sketches for every piece on which he embarked, fixing its formal aspects before he moved on to its execution.

The most thorough examination of Moore's engagement with 'primitive' art has been undertaken by Alan G. Wilkinson. This scholar has succeeded in identifying the models from which many of the artist's sketches and studies were made; he has also pointed to objects in the British Museum or illustrated in publications accessible to Moore that appear to relate to a number of the artist's sculptures of the 1920s.[74] These investigations have shown that the formal influence of African or Oceanic sculpture was at first not especially marked. Among the few instances are *Head of a Girl* of 1922 (LH 4), which shows a clear connection with African art both in its proportions and in the shaping of the eyes and the mouth, and the small wood figure *Standing Woman* of 1923, whose self-contained solidity and characteristic pose with bent knees and curved legs appear to derive from a wooden 'mumuye' figure in the British Museum – an item recorded by Moore in *Page One from Notebook No. 3* (1922–24; HMF 123).[75] However, as mentioned above, *Standing Woman* surely also draws on Gaudier-Brzeska's *Red Stone Dancer* of 1913.

From about 1924 onwards there is clearer evidence of the influence of Pre-Columbian stone sculpture in Moore's work. In 'Primitive Art' Moore says of this:

> Mexican sculpture, as soon as I found it, seemed to me true and right, perhaps because I at once hit on similarities in it with some eleventh-century carvings I had seen as a boy on Yorkshire churches. Its 'stoniness', by which I mean its truth to material, its tremendous power without loss of sensitiveness, its astonishing variety and fertility of form-invention and its approach to a full three-dimensional conception of form, make it unsurpassed in my opinion by any other period of stone sculpture.[76]

Moore focuses here on those formal qualities of Mexican art that were of particular concern to him in the realization of his own conception of art: truth to materials, the fully three-dimensional conception of form, variety and formal richness, and power without the loss of sensitivity.

The influence of Pre-Columbian art is apparent in, for example, the marble *Snake* of 1924 (fig. 6) or the masks made in concrete in 1929 (LH 62–4). It is especially marked in *Reclining Figure* of 1929, made in brown Hornton stone (fig. 8, p. 187), and in *Reclining Woman* made the following year in green Hornton stone (LH 84). Wilkinson regards these two pieces as occupying a key place in Moore's oeuvre.[77] While they do not mark the beginning of his great series of reclining figures, they embody for the first time in his work that metaphorical connection between the human figure and

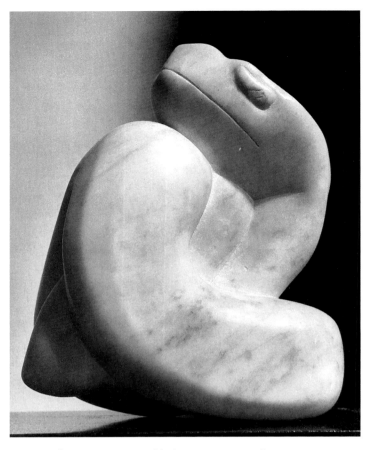

Fig. 6 *Snake,* 1924 (LH 20); marble, h. 17 cm; private collection, UK

a genuinely and deeply expressive image that might be captured in a form true to the materials stone and wood.[80] He was especially impressed by the instinctive assurance of African work in wood, but he was also struck by the way African artists freed the figures' arms from their bodies and left space between the legs, producing an emphatic three-dimensionality.[81] 'To discover, as a young student, that the African carvers could interpret the human figure to this degree but still keep and intensify the expression, encouraged me to be more adventurous and experimental.'[82]

Non-European sculpture was not Moore's only interest in the 1920s. The sketchbooks of 1922 to 1924 include drawings after prehistoric idols from the Cyclades, examples of the so-called Aegean culture. In 1981 he described what attracted him to Cycladic sculpture: 'Simplicity, purity, "unity of form", intellectual conclusiveness of form, the conception and its transformation into marble in a manner true to this material.'[83] As already mentioned, these were qualities that Moore also found in works of non-European art and that decisively influenced his approach to sculpture. According to the artist himself, he drew inspiration for the alabaster

an expression of landscape which was to acquire such fundamental significance in Moore's approach to form. At the same time, these sculptures represent the high point of the artist's engagement with Mayan art. The model for both was the figure of Chac-Mool (the Rain Spirit) found at Chichén Itzá (fig. 7, p. 187), which Moore knew from a published reproduction and from a plaster cast. The artist himself said that this sculpture had been the strongest of all influences on his early work.[78] Comparison of *Reclining Figure* and *Reclining Woman* with their model reveals, however, that Moore evolved something entirely new: not only had he transformed a male into a female figure; he had also succeeded in treating the figure as a 'landscape'. It is instructive to note that Moore had already altered the hieratically rigid form of the Mayan figure in his preparatory drawings; in fact, he derived only the upright upper body from his model, while the execution of the legs recalls his *West Wind* relief of 1928.[79] It was in Moore's early mother and child groups that the rigidity and formal solidity of Pre-Columbian sculpture found a reflection (see fig. 7).

African sculpture had a marked impact on Moore's approach to the representation of the human figure; in particular, it strengthened him in his efforts to seek out

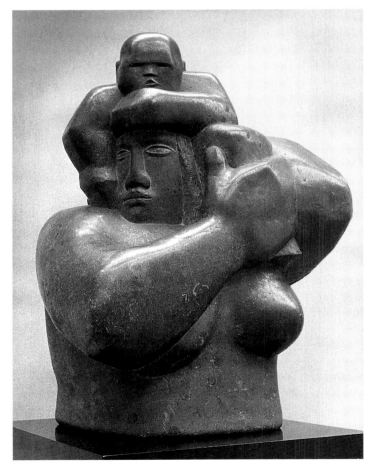

Fig. 7 *Mother and Child,* 1924 (LH 26); Hornton stone, h. 63.5 cm; City Art Gallery, Manchester

Seated Figure of 1930 (LH 92) from photographs of a Cycladic lyre player in the National Museum in Athens. As he told Wilkinson, what especially fascinated him about this figure was the way the sculptor had opened up and hollowed out the marble so that both the figure and its support stood entirely free from the original block.[84] These qualities prompted Moore to evolve a form of sculpture 'that dares to incorporate space, without thereby forfeiting its distinctive character as stone'.[85]

Moore's interest in Etruscan art, reflected in sketches he made after bronzes in the British Museum in 1922 and in 1925–26, increased in the mid-1930s. As Christa Lichtenstern has shown, he concerned himself not only with the reclining figures on sarcophagi, with their fully three-dimensional, portrait-like representation of the dead and their flattened legs, but also with the sarcophagi themselves. Lichtenstern points to striking parallels between Moore's drawings of these sarcophagi, notable for their bold grooves and openings, and the 'Square Forms' that the artist made in 1936 (see plate 36).[86] Reliefs from Tiahuanaco in Peru have also been cited as a model for the use of relief in these sculptures.[87]

In the 1930s Moore's interest in 'primitive' art was concentrated more strongly on Oceanic and, occasionally, Eskimo art. There are relatively few drawings of the latter, and Moore's boxwood sculpture of 1932, *Girl* (LH 112), with its softly flowing, abstracted forms, is one of the few pieces of this period to reveal a direct engagement with Eskimo works.[88] Not until the 1950s, in a sculpture such as *Upright Motif: Maquette No. 11* (LH 391), does the link between organic forms and elements that recall Eskimo ivory drum handles reappear in Moore's work.[89]

After the early 1930s the influence of 'primitive' art on Moore's work declined, though it is still to be found in individual cases. During the 1930s Surrealism acquired more and more importance for him. Nevertheless, both the drawings and the sculptures made by Moore during this decade still reveal the influence of Oceanic art, the artist's attention to its often bizarre qualities perhaps encouraged by the Surrealists' own keen interest in these.

Moore once remarked: 'The many islands of the Oceanic groups all produced their schools of sculpture with big differences in form-vision.'[90] The sculpture of New Ireland, for example the 'Malanggan' in the British Museum (fig. 8), clearly had the greatest influence on his work: 'New Ireland carvings like this [the 'Malanggan'] made a tremendous impression on me through their use of forms within a form. I realised what a sense

Fig. 8 'Malanggan' figure, Northern New Ireland, *c.* 1900; painted wood, h. 106.7 cm; British Museum, London

of mystery could be achieved by having the inside partly hidden so that you have to move round the sculpture to understand it. I was also staggered by the craftsmanship needed to make these interior carvings.'[91] In 1935 Moore produced his first drawings after the 'Malanggan', marking the beginning of his long preoccupation with the problem of 'inner/external form', which, particularly in the 1950s, was to find highly varied expression in his work as a sculptor. *Working Model for Upright Inner/External Form* of 1951 (plate 59), which was preceded by preparatory drawings made between 1948 and 1950, undoubtedly derives from Moore's interest in sculpture from New Ireland. A key work in the artist's treatment of inner/external form, *The Helmet* of 1939–40 (fig. 9), may, however, have also derived inspiration from prehistoric Greek tools.[92] According to Moore himself: 'the idea [of this work] is a sort of embryo being protected by an outer form, a mother and child idea, or the stamen of a flower, that is, something young and growing being protected by an outer shell'.[93] *Bird Basket* of 1939 (fig. 12, p. 189), too, testifies to the artist's enduring interest in Oceanic art. The forms of this work clearly recall those of New Ireland friction blocks – drums played by rubbing. In *Bird Basket* Moore uses string (a common feature of his sculpture at this time) to define planes and spaces. There are also certainly formal connections here with the work of Antoine Pevsner and, as Wilkinson points out, Naum Gabo.[94]

After 1942 Moore made a few more works in which the influence of 'primitive' art is detectable. In *King and Queen* of 1952–53 (fig. 20, p. 126), the poses of which are derived from Egyptian seated figures in the British Museum, he evidently turned to African models – for example, works of the Igbo or Yoruba peoples – for the treatment of the heads. In the king's head Moore saw 'a combination of a crown, beard and face' that he intended to represent 'a mixture of primitive kingship and a kind of animal, Pan-like quality',[95] a form that the artist presumably also chose in order to bestow greater monumentality on the group. This type of head, seen for the first time in *King and Queen*, recurs frequently in Moore's work of the 1950s, and is particularly striking in *Warrior with Shield* (plate 64). One of the last of Moore's sculptures to reveal the influence of 'primitive' art is the bronze *Moon Head* of 1964 (LH 521), its symmetry deriving from a Mama buffalo mask from Nigeria.

It is notable that Greek art began to assume greater significance for Moore in proportion to the decrease in his interest in 'primitive' art. During the war years, in particular in 1941–42, Moore acquired a new under-

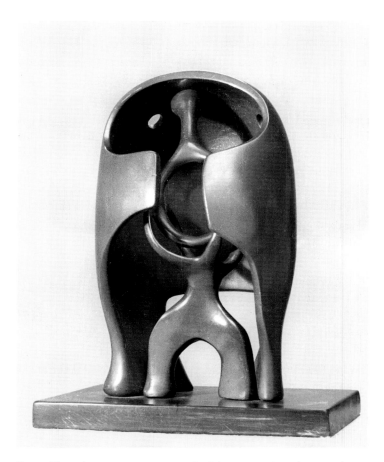

Fig. 9 *The Helmet,* 1939–40 (LH 212); lead, h. 29.2 cm; Scottish National Gallery of Modern Art, Edinburgh

standing of works of the Archaic Greek period, partly in response to his interest in the Homeric epics. The influence of the draped figures of Greek art is evident in the drawings he made in 1943 and in his illustrations to the published text of Edward Sackville-West's radio play *The Rescue*, first produced that year, which re-tells Homer's account of Odysseus' return to Ithaca. These 'archaizing', large-scale drawings were made at a time when Moore was planning his *Madonna and Child* for the church of St Matthew in Northampton (fig. 12, p. 109). Lichtenstern sees a connection between the rigid frontality of the Northampton Madonna and the Archaic seated figures from Didyma near Miletus in the British Museum.[96] Similarities with these Greek figures are to be found, too, in the treatment of the drapery folds, which Moore used to heighten further the austere, monumental corporeality of his figures.

Moore's deep interest in the art of Archaic Greece is also reflected in *Three Standing Figures* of 1947–48 (fig. 18, p. 117), in which he adopts the motif of the Three Graces. Since 1942 the artist had explored this motif repeatedly in his drawings, and he made the first small-scale model for this sculpture in 1945. In its austerely statuesque quality and in the treatment of its drapery

folds this group is very close to the figures from Didyma. Lichtenstern links this orientation to the Antique with the search for a new humanism triggered by the horror of the Second World War, many artists in the immediate post-war years striving for a new beginning based on the creative legacy of Antiquity.[97]

One of Moore's most important works in which this new humanism is still very much in evidence is *Nuclear Energy*, made from 1963 to 1965 for the University of Chicago (fig. 27, p. 147). It is intended to recall the first self-sustaining nuclear chain reaction, achieved here on 2 December 1942. Moore chose a form that, by combining closed and open volumes, polished and rough surfaces, simultaneously evokes a skull and a mushroom cloud, thus serving as a compelling *memento mori*. One source for this form was the helmeted head of a bronze horseman made in southern Italy in about 550 BC that had impressed Moore in the British Museum.[98] This head obviously interested the artist on account of the sense of opposition between the self-contained curvature of the helmet and the implied face hidden behind the cheek flaps and nose guard. Moore succeeded in transforming the characteristic appearance of these features into an abstraction.

Reminiscences of Antique art are also apparent in *Warrior with Shield* and *Goslar Warrior* (1973–74; fig. 31, p. 158).[99] In connection with both these, Lichtenstern has pointed to a number of Greek works that Moore knew from the British Museum. Of more significance, however, is her reference to the artist's own admission that, during his first journey to Greece, in 1951, he had acquired a new understanding of Greek art, one that allowed him to grasp its essence as identical with that of Greek tragedy. These warrior figures, from which everything heroic has departed, do indeed partake of the substance of Greek tragedy.

Having finally overcome his academic traumas, and with increasing confidence in his own artistic capacity, Moore attained a new view of the art of Classical Greece. In his 1960 interview with Donald Hall, he said: 'It's only perhaps in the last ten or fifteen years that I began to know how wonderful the Elgin Marbles are.'[100] Moore's recognition of, and reconciliation with, the historical significance of the art of Classical Greece – that of Phidias and his idealizing representation of the human figure – was a protracted process. His new attitude is especially clear in the treatment of drapery. In the artist's sculpture, body and drapery are first seen as a new unit of expression in *Draped Reclining Figure* of 1952–53 (LH 336). As Moore himself observed,[101] the modelling of the drapery folds served him as a means both of heightening the expressivity of the body and of elucidating the sculptural idea of the figure. In addition, it helped emphasize the identity between figural and landscape forms. Moore's own comments reveal that, for him, drapery was ultimately not a calligraphic or decorative element, but rather a formal tool for addressing his central sculptural task.

Draped Reclining Figure led directly to *Draped Torso* of 1953 (LH 338). While observing the individual parts during casting of the former work, Moore recognized the upper body as a torso with its own formal integrity: 'when I saw the torso cast, separate from the rest, even I, who had done it, was very struck by its completeness and impressiveness just as a thing on its own.' He therefore worked up this fragment into an autonomous sculpture. Surprised at 'how Greek' it now appeared, he commented: 'my visit to Greece … must have had a bigger influence than I had been aware of'.[102] In *Henry Moore at the British Museum*, published in 1981, he illustrated this sculpture alongside the torso of a Nereid from the tomb in Xanthos and compared drapery of this Antique figure with that of his own *Draped Torso*. This relationship between his work and Greek art was to be developed further in *Draped Seated Woman* of 1957–58 (fig. 10).[103] However, the high point of Moore's engagement with Greek models is probably *Large Standing Figure: Knife Edge* of 1961 (p. 8). Its form was inspired by the breast bone of a bird, but both in its dynamic and expressive movement and in the form of the torso there are unmistakable parallels with the Winged Victory of Samothrace.[104]

These examples show that Moore's relationship to Greek art was not one of eclectic appropriation; rather, it was determined by a process of assimilation that reflected the evolution of that art. During this process,

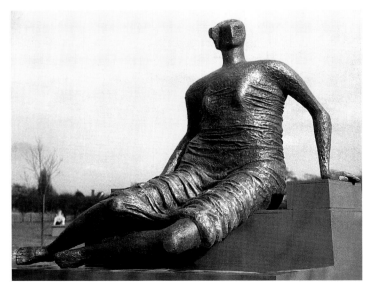

Fig. 10 *Draped Seated Woman,* 1957–58 (LH 428); bronze, h. 185.5 cm

both the formal and the intellectual stimuli gained in significance for Moore, as is evident in *Falling Warrior* of 1956–57 (fig. 11). This work is an achievement of Moore's artistic mastery, but it is also a testament to his great human maturity – a quality that enabled him to think and to work in terms of large spiritual interconnections.

Moore's preoccupation with the history of both European and non-European art enabled him to place his own work, and that of the twentieth century as a whole, in relation to world history, and to see in his own endeavours an attempt to reaffirm a connection with world traditions. In his view, these traditions had reached their strongest and purest form of expression in African work in wood and in Pre-Columbian work in stone. Indeed, Moore may be said to have been influenced by 'primitive' art to a more significant and meaningful degree than any other artist of this century.

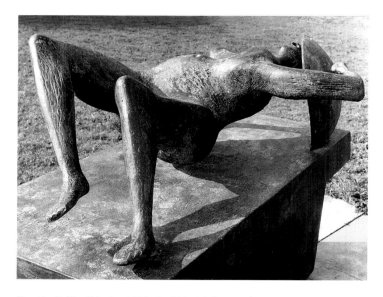

Fig. 11 *Falling Warrior,* 1956–57 (LH 405); bronze, l. 150 cm

The 1930s: Moore between Abstraction and Surrealism

During the 1930s Moore evolved, to a certain degree as a form of synthesis, the characteristic figural style that was to distinguish the sculpture he produced after the imposed pause of the war years. His work of this decade is determined by two opposed developments: on the one hand, a tendency towards abstraction, influenced by the international avant-garde, and, on the other, an attraction towards Surrealism. Accordingly, as well as contributing to the anthology *Circle: International Survey of Constructive Art* of 1937 and taking part in the exhibition 'Constructive Art' at the London Gallery that year, he participated in Surrealist exhibitions and other activities. In his writings of this period Moore repeatedly indicated that he did not view abstraction and Surrealism as opposites.[105] It therefore comes as no surprise to find that many of his works from this period may be understood as syntheses of these two tendencies. In 1935 Geoffrey Grigson wrote of Moore that he was 'a constructor of images between the conscious and the unconscious...the one English sculptor of large, imaginative power'. Grigson was also the first to term Moore a 'biomorphist'.[106]

The formal reorientation in Moore's work began with *Composition* (fig. 2), made in green Hornton stone, probably early in 1931. That year saw the culmination of his difficulties at the Royal College of Art (following vehement attacks in the press on his one-man show at the Leicester Galleries) and his move to Chelsea School of Art. It was at this time that Moore became close to Paul Nash, Ben Nicholson and Barbara Hepworth, an association reflected, among other things, in the great similarity between the works of Moore and of Hepworth during this period.

Moore had met Nash in 1927. In 1931–32 the latter planned to establish an 'English Contemporary Group', in which forward-looking artists, architects and designers were to join forces to create a unified movement. Shortly afterwards the name Unit One was chosen for this association.[107] Especially important was the participation of the critic Herbert Read, on whose initiative *Unit 1: The Modern Movement in English Architecture, Painting and Sculpture* was published in 1934 to accompany the group's only exhibition, an event that attracted considerable attention. All members of the group contributed to this publication. As Read stated in his own text, the name of the group was intended to evoke the ideas of unity and individuality. Nash invited Nicholson, Hepworth and Moore to contribute. Following his exhibition at the Leicester Galleries, Moore had come to be regarded as one of the most important, if also most controversial, modern artists in England. His connection with Unit One helps to explain his interest in abstraction.

Nash's efforts to unite the progressive artists of England in a single group ended in 1936 with the opening of the International Surrealist Exhibition in London. While Nicholson and Hepworth joined international artists' associations devoted to abstract art, others took part in the activities of the Surrealists. Moore was the only artist to have a foot in both camps.

Nicholson and Hepworth were at this time preoccupied with the problems of Constructivism and non-

representational art – the legitimacy of which had repeatedly been questioned in England during the 1920s – and published a number of theoretical texts on these subjects.[108] They shared the idealistic conviction of many Continental Constructivists that art can alter society, yet in contrast to the technologically orientated Russian Constructivists, they saw their work as representing 'an idealist attempt of abstract art to rival the structures of natural forms'[109] – an approach that was very much in keeping with Moore's.

In his text for the Unit One publication Moore alluded to Gaudier-Brzeska's comments of two decades earlier, demanding not only truth to materials but also the fully three-dimensional execution of a sculpture: 'Sculpture fully in the round has no two points of view alike. The desire for form completely realised is connected with asymmetry' – a concept that could be applied to most of his own works. Moore also emphasized how crucial the observation of nature was to the creation of a work of art; it enlarged artists' knowledge of form, fed their inspiration and kept them free of the temptation to fall back on empty formulas. At the same time he recognized the importance of pebbles, rocks, bones, trees and shells as objects that might help sculptors to expand their 'form-knowledge' and hence enrich both conception and expression. Trees, he explained, illustrated the 'principles of growth and strength of joints, with easy passing of one section into the next', a feature that he repeatedly explored in drawings. Stones, on the other hand, 'show nature's way of working' them: 'Smooth sea-worn pebbles show the wearing away of the sea, the rubbed treatment of stone and principles of asymmetry. Rocks show the hacked, hewn treatment of stone, and have a jagged nervous block rhythm.' These qualities were to characterize Moore's work of the next years. Above all, however, he required a work of art to possess a 'vitality and power of expression…independent of the object it may represent'.[110] In the works Moore made in the 1930s all the demands expressed in this statement appear to be fulfilled.

One of the most important changes to occur in Moore's work of the early 1930s is the dissolution and piercing of self-contained, solid forms. The first steps in this direction had been taken in 1929, in a concrete *Half Figure* (LH 67) in which Moore worked with both positive and negative forms in a continuation of the principles of Analytical Cubism. In the following years he repeatedly produced works in which he began to hollow out the solid corporeal form. Eventually, he opened it entirely. In 1937 he wrote, for the first time, of the hole as a means of linking one side of a sculpture with the other, in order to make the depth of a form visible and allow the spectator to experience consciously the three-dimensionality of a sculpture.[111] He was not, of course, the first artist to have pierced the self-contained volumes of sculptures. Archipenko had done so in his Cubist works of 1912 and, until the early 1920s, continued to dissolve bodily masses by means of openings. Moore was, however, the first to develop this approach into a formal system and an independent means of expression that is undoubtedly one of his most important contributions to twentieth-century sculpture. Moore's liking for holes was related to his desire to achieve a real sense of space and three-dimensional form in his sculptures: 'For me, the hole is not just a round hole. It is the penetration through from the front of the block to the back. This was for me a revelation, a great mental effort. It was having the idea to do it that was difficult, and not the physical effort.'[112]

Despite eager engagement with abstraction during the 1930s, Moore never committed himself to it totally: 'Purely abstract sculpture seems to me to be an activity that would be better fulfilled in another art, such as architecture. That is why I have never been tempted to remain a purely abstract sculptor….A sculpture must have its own life…be alive and expansive….It should always give the impression of…having grown organically, created by pressure from within.'[113]

Moore's relation to Surrealism is complex. He first encountered it in Paris in 1931–32, in the form of works by Picasso, Arp, Giacometti and Miró. Yet it was the linear Cubism and the biomorphic constructions of Picasso that drew Moore most decisively towards Surrealism.[114] Moore's 1931 *Composition* was, without doubt, influenced by Picasso's sculpture *Metamorphosis I* of 1928. As a further source for the formal innovations apparent in *Composition*, Herbert Read cites works of art from the Cyclades. A particularly important role seems to have been played by the Cycladic *Idol with a Lyre* that had served Picasso as the model for *Metamophosis I* and that Moore knew through a reproduction in a 1929 issue of *Cahiers d'Art*.[115] With *Composition* Moore completed his move towards the 'biomorphic abstraction' that was henceforth to characterize his work. This was subsequently to occupy a position half-way between a more or less anatomically exact rendering of the human figure and forms that were to be understood as 'metaphors' of organic entities that had no equivalent in nature. With this reorientation, carving decreased in significance for Moore; he now became more interested in modelling.

Composition may be regarded as a testament to Moore's closeness to Surrealism. Although he could at no point be unambiguously associated with the Surreal-

ist movement in Breton's strict, revolutionary sense, Moore's interest in the movement was of fundamental significance. He first began taking part in the Surrealists' activities in 1933.[116] Three years later he was a founding member of the working party of Surrealist artists in London and a member of the committee organizing the International Surrealist Exhibition, which was shown in London in June and July. With nearly four hundred works by over sixty artists from fourteen countries, this provided the first extensive survey of Surrealism to be offered to the British public (fig. 6, p. 40). At the exhibition Moore showed seven works (the same number as Arp) – three drawings and four sculptures. The materials of the latter, all dating from 1931 to 1934, were lead, concrete and marble. Moore evidently saw the lively biomorphic forms of his exhibits as the best testimony to his Surrealist experiments. By means of a rhythmic arrangement of both compact and extended shapes, Moore modulated the space between the figures and presented this as an autonomous three-dimensional element. He was reacting here to the contemporary efforts of Picasso, Arp, Giacometti and Lipchitz to create biomorphic sculptures. At the same time, Moore appears to have been seeking a sculptural solution for the Surrealist notion of 'continual movement'. In *Composition* he gave form to this idea for the first time, the outline of the work conveying the impression of potential mobility – a characteristic of many of his sculptures in the following years.

As Lichtenstern has argued, Moore's contribution to the International Surrealist Exhibition was a demonstration of his understanding, and adaptation, of biomorphic forms (above all as developed by Picasso and Arp) and, at the same time, an exposition of his own concept of an 'emotional space' emerging from the material itself and taking on the imaginary density of a 'form'. This ambivalence between form and space found its first valid articulation in *Composition*, of which the artist said: 'Eventually, I found that form and space are one and the same thing. One can't understand space without understanding form. For example, in order to understand form in its complete three-dimensional reality you must understand the space that it would displace if it were taken.'[117]

For English artists, the Surrealist movement brought greater freedom, not least in the new creative possibilities offered by the use of found objects from nature. Starting in 1930, Moore, too, used such objects, although he usually did not integrate them into finished sculptures, viewing them, rather, as starting points in the process of sculptural composition. He began collect-

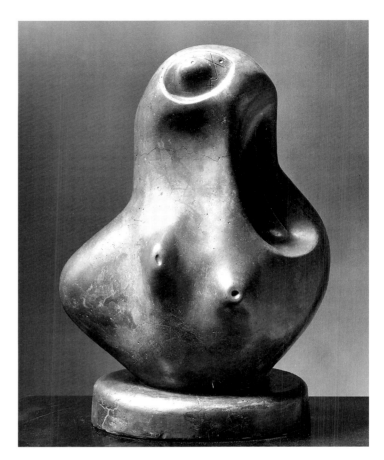

Fig. 12 *Composition*, 1933 (LH 133); concrete, h. 58.4 cm; The British Council

ing stones, shells, bones and the like (see fig. 13). In an interview with Lichtenstern in 1977 he said:

> I see the human figure everywhere. Although it is the human figure which interests me deeply, I have always paid great attention to natural forms such as bones, shells, and pebbles, etc. Sometimes for several years running I have been to the same part of the sea-shore – but each year a new shape of pebble has caught my eye, which the year before, though it was there in hundreds, I never saw. Out of the millions of pebbles passed in walking along the shore, I choose out to see with excitement only those which fit in with my existing form-interest at the time.... There are universal shapes to which everybody is sub-consciously conditioned, and to which they can respond if their conscious control does not shut them off.[118]

This interest in the sculptural qualities of found objects went hand in hand with an increased awareness of such qualities in landscape formations and of the possibilities of integrating these in figural sculpture.

Found objects were often the basis of Moore's 'transformation' drawings, the first of which was made in

1930 (see plates 19–22).[119] In these, Moore took bones, pebbles, shells, trees and plants as starting points from which to evolve ideas for sculptures through the metamorphosis implicit within the drawing process. Lichtenstern relates this associative way of working to the *objets trouvés interpretés* of the Surrealists.[120] An example of a work produced by this method is *Sculpture to Hold* (LH 173), shown in the 'Constructed Objects' section of the 1937 exhibition at the London Gallery, 'Surrealist Objects and Poems'. In this piece the artist sought to reconcile tactile sensations with sculptural form. Neither here nor elsewhere in his oeuvre can Moore be said to have created Surrealist objects in the strict sense; his working procedure was, rather, comparable to that adopted by Max Ernst for his Maloja stones.

From his 'transformation' drawings Moore evolved biomorphic figures that represent his closest approximation to Surrealism and are yet marked by a high degree of abstraction. Forms attained in this way were to characterize all his future work. The found objects from which they evolved served Moore as indications of morphogenetic development. Throughout his career, as Lichtenstern points out, he selected found objects with regard to how far they corresponded to his conceptions of the 'humanity of form', with regard to their suitability for adaptation as human figures.[121] Lichtenstern has shown, too, that Moore frequently drew inspiration from such Surrealist publications as *Minotaure* and *Le Surréalisme au service de la révolution*.[122] The source of *Bird Basket*, for example, is to be found here.

Beginning in 1931 with a lead sculpture (fig. 14), Moore produced a long series of reclining figures during the 1930s in which he dissolved and separated forms. These works recall the contemporary Surrealist objects made by Alberto Giacometti. Moore's *Four-Piece Composition: Reclining Figure* of 1934 (fig. 7, p. 85) shows

how he was able to arrange individual biomorphic forms in space in such a way that the viewer can associate these both with human figures and with natural forms. For every apparently arbitrary element in this sculpture there is an organic equivalent. At this time Moore also made the first of his reclining figures that, with their hollowed and pierced forms, clearly evoke landscape elements, without, however, expunging all sense of the human figure. This ambivalence is especially strong in the elmwood reclining figures of 1935 to 1939 (fig. 15; fig. 2, p. 49), whose soft undulations and hollows convey a feeling of landscape forms and space. Anna Gruetzner characterizes these figures – which do not appear to allude to human anatomy – as the suggestion of a female presence that has undergone metamorphosis into the heaving forms of a landscape.[123]

The most important result of Moore's involvement with Surrealism was this discovery of 'biomorphic' forms whose turbulent, flowing masses and rhythmic interruptions give expression to organic growth. Also of significance, however, was the relation between form and outline and, in particular, the metaphorical significance of the piercing of volumes, in which Moore's experience of the deeper psychological and human content of sculpture finds expression.[124]

Alongside the biomorphic sculptures, Moore produced, from the mid-1930s, a sequence of works that are characterized by a solid 'cubification'. In these 'Square Forms' (see plate 36) indentations, swellings, hollows and holes, and above all delicately engraved lines, allow us to divine that these sculptures, too, were derived from the human figure. They are metaphors for an organic whole that is characteristic of all Moore's work. Herbert Read said of these pieces that, in spite of their far-reaching abstraction, they arouse a far more powerful impression of animal vitality than many of the artist's representational works from the same period.[125] As Franco Russoli has observed, Moore used geometrical bodies not to achieve an abstract harmony, but rather as an analogy to the relations between a body and its essential functions.

To this sequence of abstract sculptures belong the works made from 1937 to 1940 in which Moore used strings or wires as the dominant formal element. These serve not only to place two planes in relation to each other; they also create spaces by incorporating the inner space as a constitutive element of the sculpture. As noted above, these works mark the beginning of Moore's long preoccupation with inner/external form and, as the artist himself observed, they initiated his 'most abstract period'. They were principally inspired by mathematical models that he had seen in the Science

Fig. 13 Flints from the artist's collection of *objets trouvés*

Fig. 14 *Reclining Figure,* 1931 (LH 101); lead, l. 43.2 cm; private collection, Switzerland

Museum in South Kensington: 'I saw the sculptural possibilities of them and did some. I could have done hundreds.'[126] What initially fascinated Moore about the models was the fact that they had been constructed 'to illustrate the difference of the form that is half way between a square and a circle'.[127] The creative possibilities of this were explored by Gabo and Hepworth in a comparable way. Moore, however, rejected this approach at the start of the Second World War because of its experimental character and because it was not suited, in his view, to dealing with fundamental human experience.

The Period of Maturity

The Second World War enforced a pause in Moore's activity as a sculptor. In response to a commission from the War Artists' Advisory Committee he made what were to become probably his most celebrated works on paper, the Shelter drawings, incisive records of the life of Londoners in the tunnels of the Underground during the Blitz.[128] During this time Moore also produced drawings in which he noted ideas for sculptures; only a few of them, however, were intended for realization in three dimensions.

After his London studio had been bombed, Moore and his wife moved to the village of Perry Green, near Much Hadham in Hertfordshire, where he lived and worked until his death in 1986. It was here that he produced those works of his maturity that earned him world-wide fame. Although Moore and Epstein had already been regarded as the most important British sculptors before the Second World War, widespread international recognition was not accorded Moore's

work until after 1945. In the 1950s he started to receive a long series of important large-scale public commissions. Among the most prominent of these was the monumental reclining figure in travertine marble that he made in 1957–58 for the Unesco headquarters in Paris (fig. 8, p. 42).

During the later 1930s, as noted above, Moore's work was marked by an increasing preference for modelling over carving. Although he continued to make important pieces in wood and stone, even after the war, modelled pieces, intended for casting in bronze, took on ever greater significance for him. Modelling permitted Moore to realize his ideas without constraints, in a pliable material, and even his preparations for stone or wood sculptures now took the form of modelled maquettes. While, at the start of his career, the artist had evolved his ideas in relation to the given qualities of a piece of stone or wood, he now chose whichever materials appeared most suited to the work he was planning.

Starting with small maquettes, Moore selected certain forms, which he then enlarged, by means of intermediary models, to the dimensions he required. During this process the sculptures underwent repeated alteration. 'Often at the maquette stage, where I can hold the sculpture in my hands, I decide if I want it life-size, well over life-size, or under life-size – that is its actual "physical" size.'[129] Moore now relied far more on the help of assistants in the execution of his large sculptures, although he himself usually carried out the final stages of work, including the patination. This procedure enabled him to produce large-scale pieces, while also allowing him to satisfy the growing demand for works by him. According to the artist himself, he never saw any difficulty in enlarging existing works and thereby matching their dimensions to the surroundings for which they were intended.

Moore's resumption of sculptural work was marked by the commission he received in 1942 for a Madonna and Child for the church of St Matthew in Northampton. For Moore this commission represented a great challenge, for he wished to find a convincing contemporary solution for a subject that had such a long, hallowed tradition in art. Representations of the mother and child had been a central theme throughout his career, appearing very early in his oeuvre (see fig. 7). In embarking, after prolonged hesitation, on the group for Northampton, however, he consciously took his bearings from a traditional iconographical type especially common during the Renaissance and not from his own earlier mother and child groups. Eric Newton, while relating the Northampton Madonna (fig. 12, p. 109) to

images of the Virgin and Child that reached as far back as Michelangelo and Donatello, also recognized in Moore's sculpture the embodiment of a 'timeless' form of expression and a deep earnestness, qualities characteristic of the mid-twentieth century.[130] On this occasion Moore started by reflecting on the basic differences between religious and profane art. He then made a series of preparatory drawings, which he used as the basis for some small models. The definitive solution, to be executed slightly larger than life-size in stone, evolved out of these models.[131] Moore insisted that the final work should satisfy both his demands for any sculptural work and his understanding of the theme of Madonna and Child. He said that he had attempted to achieve an impression of complete balance and calm. According to Edward Lucie-Smith, the Northampton *Madonna and Child* introduced a 'classical phase' in Moore's oeuvre, because it was from this time that the artist, in an almost eclectic spirit, began to adopt forms from various preceding periods of his career. Lucie-Smith finds this most clearly realized in the biomorphic mingling of forms, originally evolved by Moore during his Surrealist phase.[132]

The Northampton Madonna no doubt had a bearing on the family, and mother and child, groups made in the subsequent years. The family groups (see plates 49–51) ultimately relate to a commission of 1934 for a sculpture to be set up at a school, a project that was not, in fact, realized until 1948–49 (fig. 15, p. 113). From 1944 to 1947 Moore created, in various materials and sizes, a number of variants on these two themes, both naturalistic and abstract in character.[133] In all probability, these works may be seen as precursors of the seminal sculpture of 1952–53, *King and Queen*.

After the war, with a sculpture made in 1950–51 for the Festival of Britain (fig. 19, p. 118), Moore returned to his reclining figures, further developing the theme, established during the 1930s, of the integration of form and space as an indivisible unity.[134] The artist also returned to another feature of his work in the 1930s (and one influenced by Arp and Giacometti): the analysis of the figure into individual fragments of form and their rhythmically enlivened arrangement in space. Here, Moore was above all interested in the problems of space and in the possibility of dynamizing and differentiating Brancusi's 'primal forms': by condensing these and simultaneously expanding and opening space, he was able to create an organic whole.[135] It is in this aspect of Moore's work that Lichtenstern sees the artist's significance in the history of twentieth-century sculpture, in his striving 'to point the multiplicity of sculptural elements towards an image that was analogous to

Fig. 15 *Reclining Figure,* 1936 (LH 175); elmwood, l. 106.7 cm; Wakefield City Art Gallery and Museum

nature, to bring everything together into an evolving, lively yet organized unity, an organic whole'.[136]

In the early 1950s, with works based on characteristic transformations of morphological natural entities, Moore returned to the subject of metamorphosis, which had occupied him in the later 1930s as a result of his interest in the associative metaphors of the Surrealists. This was a theme addressed by many artists in the early post-war period, among them Germaine Richier, César, Reg Butler and Lynn Chadwick. In Moore's case it was undoubtedly connected with his now more intense identification of human figure and landscape, for he increasingly saw the two as comparable manifestations, their union requiring an autonomous sculptural form. A great many artists were preoccupied with similar, landscape-related problems of form in the 1950s.[137] Moore's work in the post-war period is characterized by an almost incalculable number of variations on themes that he had evolved in the years before the war. These now attained full development as archetypes, made possible by the artist's absolute mastery of form and the uncompromising integrity and clarity of his humanistic concerns.

The culture of the period immediately following the Second World War was initially dominated by those who had done path-breaking work before the outbreak of hostilities. Among the sculptors, Moore became the outstanding personality, an artist who was seen to have found a valid and compelling form for the image of humanity in the post-war years. In Moore's work, Giulio Carlo Argan sees the realization of a certain classicity that 'concentrates into the representative power of form a global conception of the world and a consummate (and thus historical) experience of space and time, of both the natural and the human'.[138]

NOTES

1 Quoted in Hedgecoe, 1968, p, 121.
2 See Peter Fuller, *Theoria: Art, and the Absence of Grace*, London, 1988, pp. 190–1; idem, 'Henry Moore: An English Romantic', in *Henry Moore*, exh. cat., 1988, pp. 37–44; and Waldemar Januszak, 'What, Moore?', *Connoisseur*, December 1989, p. 29.
3 Gert Schiff, 'Die Plastik, der Mensch und die Natur: Eindrücke von einem Besuch bei Henry Moore', *Frankfurter Allgemeine Zeitung*, 9 January 1954, p. 11.
4 Ann Hindry, 'La Sculpture anglaise: La Disposition insulaire'; Catherine Ferbos, 'La Sculpture anglaise: Sculptures "in between" le paysage'; and Stephen Bann, 'La Sculpture anglaise: La Sculpture anglaise et la tradition du paysage', *Artstudio*, no. 10, autumn 1988, pp. 6, 20ff. and 26ff., respectively.
5 Charles Harrison, *English Art and Modernism 1900–1939*, New Haven and London, 1981, repr. 1994, p. 331.
6 Naum Gabo, *The Realistic Manifesto*, Moscow, 1920, trans. in *Naum Gabo: The Constructive Process*, exh. cat. (London, Tate Gallery, 1976–77), London, 1976.
7 See Moore, 1966, p. 68.
8 See Moore, 1988.
9 Quoted in Mitchinson, 1981, p. 50.
10 See Lichtenstern, 1994, p. 41.
11 Quoted in Mitchinson, 1981, p. 246.
12 See Moore, 1966, p. 175.
13 See Lichtenstern, 1994, p. 46ff.
14 Moore, 1992, p. 198.
15 See Moore, 1966, p. 211, and Berthoud, 1987, pp. 65–6.
16 Moore, 1966, pp. 62–3.
17 See Herbert Read, *A Concise History of Modern Sculpture*, London, 1964, pp. 80–2.
18 Moore, 1966, p. 135.
19 Quoted in Read (note 17), p. 83.
20 Read (note 17), p. 84.
21 Moore, 1966, p. 72.
22 Quoted in Mitchinson, 1981, p. 46.
23 See Benedict Read, 'Classical and Decorative Sculpture', in *British Sculpture in the Twentieth Century*, exh. cat., ed. Sandy Nairne and Nicholas Serota (London, Whitechapel Art Gallery, 1981–82), London, 1981, pp. 39–47.
24 Roger Fry, 'The Sculpture of Maillol', *The Burlington Magazine*, vol. 17, no. 85, April 1910, pp. 26–32.
25 Alan G. Wilkinson, 'Paris and London: Modigliani, Lipchitz, Epstein and Gaudier-Brzeska', in *'Primitivism' in 20th Century Art: Affinity of the Tribal and the Modern*, exh. cat., ed. William Rubin (New York, Museum of Modern Art; Detroit Institute of Arts; Dallas Museum of Art), New York, 1984, p. 448.
26 See Richard Cork, *Art Beyond the Gallery in Early 20th-Century England*, New Haven and London, 1985, pp. 36–40.
27 See Denis Farr, 'The Patronage and Support of Sculptors', in *British Sculpture in the Twentieth Century* (note 23), pp. 11–13.
28 Moore, 1966, p. 194.
29 G. R. H., 'Gallery and Studio: Oscar Wilde's Tomb', *Pall Mall Gazette*, no. 14,698, 6 June 1912, p. 7.
30 See Terry Friedmann, *Epstein's Rima, 'The Hyde Park Atrocity', Creation and Controversy*, Leeds, 1988.
31 Richard Cork, 'The Emancipation of Modern British Sculpture', in *British Art in the 20th Century: The Modern Movement*, exh. cat., ed. Susan Compton (London, Royal Academy of Arts, 1987), Munich, 1987, p. 32.
32 Quoted in Arnold L. Haskell, *The Sculptor Speaks: Jacob Epstein to Arnold L. Haskell*, London, 1931, p. 90.
33 See *The Epstein Collection of Tribal and Exotic Sculpture*, exh. cat. (travelling exhibition organized by the Arts Council of Great Britain), London, 1960.
34 See Wilkinson (note 25), p. 443.
35 See *Vorticism and its Allies*, exh. cat., ed. Richard Cork (London, Hayward Gallery, 1974), London, 1974, p. 5ff.
36 *Vorticism and its Allies* (note 35), p. 159ff.
37 See Wilkinson (note 25), pp. 439–40; Richard Cork, *Jacob Epstein: The Rock Drill Period*, London, 1973, p. 9; and Robert Goldwater, *Primitivism and Modern Art*, rev. edn, New York, 1967, p. 240.
38 Terry Friedmann, 'Epsteinism', in *Jacob Epstein: Sculpture and Drawings*, exh. cat., ed. Evelyn Silber and Terry Friedmann (Leeds City Art Galleries; London, Whitechapel Art Gallery, 1987), Leeds, 1987, p. 35.
39 See Berthoud, 1987, p. 75.
40 See Friedmann (note 38), pp. 35–6, and Evelyn Silber, *The Sculpture of Epstein, with a Complete Catalogue*, Oxford, 1986, pp. 49–52.
41 Read, 1965, p. 50.
42 Silber (note 40), p. 49.
43 Ulrich Weisner, 'Das Leben Henri Gaudier-Brzeskas', in *Henri Gaudier-Brzeska 1891–1915*, exh. cat. (Bielefeld, Kunsthalle, 1969), Bielefeld, 1969, p. 5.
44 Quoted, in adapted form, from Michel Seuphor, *The Sculpture of this Century: Dictionary of Modern Sculpture*, London, 1959, pp. 268–9.
45 Quoted in *Henri Gaudier-Brzeska 1891–1915*, exh. cat. (London, Mercury Gallery, 1991), London, 1991, unpaginated.
46 See Ezra Pound, *Gaudier-Brzeska: A Memoir*, London, 1916, p. 90.
47 Quoted in Pound (note 46), p. 35.
48 Quoted in Pound (note 46), p. 26.
49 Quoted in Pound (note 46), p. 9.
50 Pound (note 46), p. 50.
51 Horace Brodzky, *Henri Gaudier-Brzeska 1891–1915*, London, 1933, pp. 58–9.
52 Quoted in Brodzky (note 51), p. 62.
53 Quoted in Richard Cork, *Vorticism and Abstract Art in the First Machine Age*, vol. 2: *Synthesis and Decline*, London, 1976, p. 551.
54 See Fuller, 'Henry Moore: An English Romantic' (note 2), pp. 39–40.
55 Moore, 1966, p. 159.
56 Ibid., p. 155.
57 Ibid., pp. 159–63.
58 Ibid., p. 60.
59 See Susan Compton, 'Henry Moore's View of the Role of Art and the Artist', in *Henry Moore Retrospektywa*, exh. cat., 1995, p. 23.
60 Berthoud, 1987, pp. 52–4.
61 See Tom Steele, *Alfred Orage and the Leeds Art Club 1893–1923*, Aldershot, 1990, p. 98.
62 *Sketchbook 1926*, London, 1976, p. 6.
63 See Moore, 1966, p. 32.
64 Ibid., p. 49.
65 Donald Hall, 'An Interview with Henry Moore', *Horizon*, vol. 3, no. 2, 1960, p. 40.
66 Roger Fry, *Vision and Design*, London, 1920, p. 65.
67 See Moore's comments of 1930 quoted in J. Glaves-Smith, 'The Primitive Objectivity and Modernity: Some Issues in British Sculpture in the 1920's, in *British Sculpture in the Twentieth Century* (note 23), p. 79 and n. 18.
68 Moore, 1966, pp. 47–8.
69 Moore, 1966, p. 57.
70 Quoted in Goldwater (note 37), p. 66.
71 See Kirk Varnedoe, 'Paul Gauguin', in *'Primitivism' in 20th Century Art* (note 25), pp. 179–209.
72 See William Rubin, 'Modernist Primitivism: An Introduction', in *'Primitivism' in 20th Century Art* (note 25), pp. 1–79.
73 Moore, 1966, pp. 155–63.
74 Alan G. Wilkinson, 'Henry Moore', in *'Primitivism' in 20th Century Art* (note 25), pp. 595–613.

75 See Wilkinson (note 74), pp. 596–7.
76 Moore, 1966, p. 159.
77 *From Gauguin to Moore: Primitivism in Modern Sculpture*, exh. cat., ed. Alan G. Wilkinson (Toronto, Art Gallery of Ontario, 1981–82), Toronto, 1981, p. 277.
78 See *From Gauguin to Moore* (note 77), p. 277.
79 See *From Gauguin to Moore* (note 77), pp. 277–8.
80 See Christa Lichtenstern, 'Henry Moore und die Antike', in *Henry Moore: Ethos und Form*, exh. cat., 1994, p. 20.
81 Moore, 1966, p. 159.
82 Moore, 1981, p. 96.
83 Quoted in Lichtenstern (note 80), p. 24.
84 See *From Gauguin to Moore* (note 77), p. 280.
85 Lichtenstern (note 80), p. 28.
86 Lichtenstern (note 80), p. 30.
87 See *Henry Moore*, exh. cat., 1988, p. 183, cat. no. 26.
88 Wilkinson (note 74), pp. 603–4.
89 Wilkinson (note 74), p. 604.
90 Moore, 1966, p. 159.
91 Moore, 1981, p. 81.
92 Wilkinson (note 74), p. 605.
93 Moore, 1966, p. 247.
94 Wilkinson (note 74), p. 605.
95 Moore, 1966, p. 246.
96 Lichtenstern (note 80), p. 36.
97 Lichtenstern (note 80), p. 39ff.
98 Moore, 1981, p. 52.
99 Lichtenstern (note 80), p. 40ff.
100 Moore, 1966, p. 48.
101 Ibid., p. 231.
102 Ibid., p. 239.
103 See Lichtenstern (note 80), p. 46.
104 See Moore, 1966, p. 278, and Lichtenstern (note 80), p. 47ff.
105 Moore, 1966, p. 67.
106 Geoffrey Grigson, 'Comment on England', *Axis*, vol. 1, no. 1, January 1935, p. 10.
107 See Charles Harrison, 'Sculpture and the New "New Movement"', in *British Sculpture in the Twentieth Century* (note 23), pp. 105–6.
108 See Charles Harrison, 'Sculpture and the New "New Movement"', in *British Sculpture in the Twentieth Century* (note 23), pp. 106–11.
109 Susan Compton, '"Unit One": Towards Constructivism', in *British Art in the 20th Century* (note 31), p. 214.
110 Moore, 1966, pp. 70–2.
111 See the passage quoted on p. 12 ('The first hole...').
112 Quoted in Mitchinson, 1981, p. 65.
113 Quoted ibid., p. 59.
114 See *The Drawings of Henry Moore*, exh. cat., 1977, cat. nos. 88, 99 and 104.
115 Read, 1965, pp. 83–4.
116 See Anna Gruetzner, 'Some Early Activities of the Surrealist Group in England', *Artscribe*, no. 10, 1978, p. 22ff., and Christa Lichtenstern, 'Henry Moore and Surrealism', *The Burlington Magazine*, vol. 123, no. 944, November 1981, p. 646.
117 Quoted in Mitchinson, 1981, p. 112.
118 Moore, 1966, p. 64.
119 See Christa Lichtenstern, *Die Wirkungsgeschichte der Metamorphosenlehre Goethes von Philipp Otto Runge bis Joseph Beuys*, Weinheim, 1990, p. 120ff., and idem (note 116), p. 648ff.
120 Lichtenstern (note 119), p. 150ff.
121 Lichtenstern (note 116), p. 651.
122 Lichtenstern (note 116), pp. 652–8.
123 Anna Gruetzner, 'The Surrealist Object and Surrealist Sculpture', in *British Sculpture in the Twentieth Century* (note 23), pp. 122–3.
124 Lichtenstern (note 116), p. 658.
125 Read, 1965, p. 97.
126 Quoted in Mitchinson, 1981, p. 81.
127 Ibid.
128 See Moore, 1988.
129 Quoted in Mitchinson, 1981, p. 218.
130 Eric Newton, 'Henry Moore's Madonna and Child', *The Architectural Review*, vol. 95, no. 569, May 1944, pp. 139–40.
131 Newton (note 130), p. 139.
132 Edward Lucie-Smith, *Sculpture since 1945*, London, 1987, p. 20.
133 See Grohmann, 1960, p. 137.
134 See Lichtenstern, 1994, p. 65.
135 Ibid., p. 83.
136 Ibid., p. 84.
137 See Eduard Trier, *Figur und Raum: Die Skulptur des XX. Jahrhunderts*, Berlin, 1960, passim, esp. pp. 55–60.
138 Argan, 1973, p. 7.

Form: The Seeing Eye
Henry Moore – London to Paris and Back

Claude Allemand-Cosneau
and Catherine Ferbos-Nakov

Could it be that Henry Moore's renown masks a lack of knowledge or understanding of his work; that today, in France, little is actually known about sculpture in general? Are we really so blind to the power of form?

In his preface to the catalogue of the exhibition 'Qu'est-ce que la sculpture moderne?', held at the Centre Georges Pompidou, Paris, in 1986 – the year of Moore's death – Dominique Bozo remarked that the French were extremely wary about sculpture, and modern sculpture in particular, despite the fact that, with Picasso's *Guitar* of 1912, France had actually given birth to the latter. In the same publication Margit Rowell attempted to apply some schematically simple criteria in her assessment of the situation. According to her, the modern sculptors are those who 'have turned their backs on all conventional practices – in iconography, in technique and in materials'. Two possibilities followed on this rejection of 'the past and all idea of continuity between the past and the present': either to lean towards the 'cultural' pole, with a belief in progress, abstraction, and the use of materials and techniques with no preconceived ideas; or to gravitate towards the 'natural' pole and seek sources of inspiration outside a specific time-scale, in 'primitive, archaic and folk' – and, perhaps, organic – art forms, 'adopting traditional techniques of hand carving and modelling to communicate the spirituality that breathes life into forms'. The artists who espoused the second alternative felt 'no interest in the modernist adventure'.[1] British artists were considered to belong to this category, and Moore was represented in the exhibition by only one sculpture, *Reclining Figure* of 1929 (fig. 8, p. 187). Furthermore, this work was shown in the 'Archaic Figuration and Organic Abstraction' section, thereby locating Moore outside time, disconnected from his own era. He was thus virtually disregarded in this retrospective survey of modern sculpture.

The 1992 'Moore à Bagatelle' exhibition of twenty-seven monumental sculptures in the Parc de Bagatelle, Paris (fig. 34, p. 196), was undoubtedly the opening salvo in response to this kind of attitude, and the selection of works in the present volume and the exhibition that it originally accompanied – carvings, plasters and drawings carried out exclusively by the artist himself – should permit greater understanding of an artistic career that was informed by a considerable variety of contacts. The incomprehension of Moore, or rather the indifference towards him, that seems to prevail in France is worth investigating, but we should first analyse the sculptor's early encounters with French art, the influences that affected him and, above all, his contacts with artists working in Paris.

Moore recounted that he was introduced early on to the work of Rodin, initially by way of reproductions and then in the form of originals first exhibited in London in 1914.[2] While Moore was a student in Leeds and London, Rodin was still the authority in sculpture, and the young man was further influenced by reading the published interviews between Paul Gsell and Rodin, in which Rodin explained that if he could not achieve what he wanted with a clay figure, he would drop it on the ground so as to see it in a different way. As Moore said, this brought home to him that the creative process was not merely a 'mathematical development'. He acknowledged that Rodin's sculpture *Celle qui fut la Belle Heaulmière* (*The Helmet-Maker's Wife*, before 1885; Musée Rodin, Paris) inspired one of his earliest works, an old bearded man.

There were, however, significant differences of approach between Rodin, the modeller with a predilec-

Large Arch, 1963–69 (LH 503b); bronze, h. 610 cm

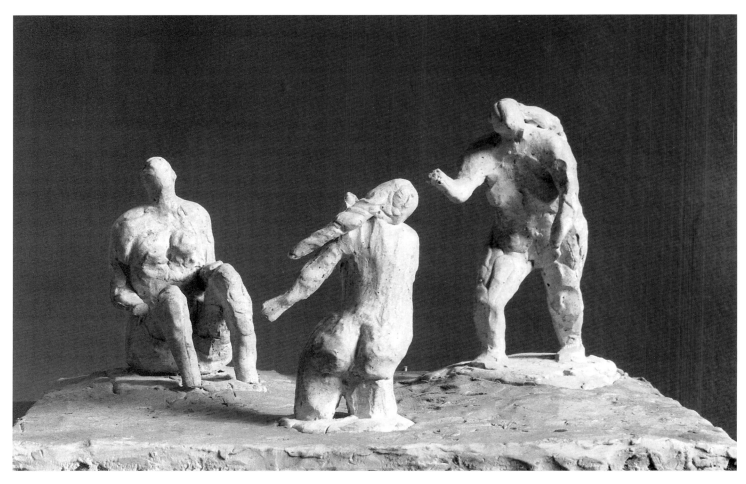

Fig. 1 *Three Bathers – After Cézanne*, 1978 (LH 741); plaster, l. 30.5 cm; The Henry Moore Foundation

tion for clay and other malleable materials, and Moore, with his natural penchant towards carving and harder substances. This conflict of attitudes was not confined to technical matters; it also informed the artists' very conception of art, with Moore criticizing Rodin's 'Victorian' sentimentality and his adherence, typical of his time, to literary explanations. Moore, nevertheless, appreciated Rodin's intimate understanding of the work of Michelangelo, his feeling for the construction of the human body, the vital energy expressed in his work and his ability to capture split-second spontaneous movement – the latter especially in his figures of dancers, which were more dynamic than those of Degas. In rendering the momentary balance of forms, Rodin applied the principles of asymmetry. This was an important lesson for Moore, who attributed to Rodin a crucial role in the history of art for having brought 'life back into sculpture'[3] and thereby preparing the way for Brancusi and Matisse. Although he was scarcely influenced directly by Rodin, Moore always showed an interest in the great French sculptor, acquiring several of his drawings and sculptures for his own collection. Notable among these was a cast of *L'Homme qui marche* (*The*

Walking Man, 1877–78), a study for the large-scale sculpture of Saint John the Baptist preaching, which fascinated Moore because it showed two attitudes at once, juxtaposing a vibrant torso inspired by Michelangelo and two legs of a walking man in an anti-naturalistic posture.

Moore's relation to Cézanne was of a totally different kind, involving the conception of art held by two artists working in different fields. This explains how Moore was able to state that Cézanne was probably the 'key figure' in his life[4] without making any artistic acts of allegiance or jeopardizing his creative abilities as a sculptor. Moore first saw paintings by Cézanne between 1919 and 1921 in the home of Michael Sadler, Vice-Chancellor of Leeds University, who also bought works by Gauguin and, as the sculptor said later, translated Kandinsky's *Über das Geistige in der Kunst* and 'really knew what was going on in modern art'.[5]

When Moore first visited Paris in 1923, he went armed with a letter of introduction to Auguste Pellerin (1852–1929), a great admirer of Cézanne who, at his death, owned ninety-two works by the painter. Moore

must have seen a number of Cézanne's paintings there, but he later recounted that he had been especially impressed by the 1906 *Large Bathers* (now in the Philadelphia Museum of Art), which held pride of place in the entrance hall of the collector's house. This unfinished painting was the largest of the 'Bathers' series and also the most highly structured in spatial terms, opening out at the back onto a vast landscape and a bright sky. The colour modulation, with ochre, blue, green and a few touches of vermilion, imparts a kind of serenity to the construction of the figures in this monumental canvas. Moore afterwards did a number of drawings inspired by the figures in the *Large Bathers*,[6] to which he always referred as 'the one with the triangular composition', as though to distinguish it from the other *Large Bathers* owned by Pellerin at the time (now in the National Gallery, London), which shows eleven bathers on virtually the same plane within a relatively shallow space. Moore's fascination with the larger composition can no doubt be attributed to the sculptural quality of the figures, which he described as 'lying on the ground as if they'd been sliced out of mountain rock'.[7] For him a major event, he often recalled his discovery of the *Large Bathers*, remarking particularly on the figures' monumentality ('which doesn't mean they're fat'),[8] the strength emanating from them, and the artist's creation of volume by means of colour.

Moore continued to regard this work as the finest by Cézanne known to him, even though he subsequently had a number of opportunities to see originals by the French painter. Also in 1923, the art dealer Alex Reid put on an exhibition of twenty masterpieces of nineteenth-century French art at Agnew's in London that included two Cézannes, *L'Etang des Soeurs, Osny* and *Still Life with Plaster Cupid*; both were bought by Samuel Courtauld, who bequeathed them to the institute in London, founded by him in 1931, that bears his name.[9] Cézanne exhibitions were held in London in 1925, 1935, 1937 and 1939,[10] and in 1929, on one of his visits to Paris, Moore was able to visit the Galerie Pigalle exhibition of the artist's work, reviewed the following year by Carl Einstein in the magazine *Documents*. Einstein emphasized Cézanne's architectural use of colour and simplified shapes and concluded that 'this exhibition shows him as the Classical painter who has rediscovered the great constructing forms'.[11] In London itself, Roger Fry, whose *Vision and Design* had such a decisive impact on Moore in 1920, had been publishing articles on Cézanne regularly since 1915[12] (his translation of Maurice Denis' article 'Conversation' having already been published in *The Burlington Magazine* in 1910). In 1927 Fry wrote *Cézanne: A Study of his Development*, which proposed the first 'modernist' interpretation of Cézanne and proved a crucial influence on subsequent understanding of the artist's work. In *Since Cézanne* (New York, 1922) Clive Bell analysed the liberating role played by Cézanne's creation of form that was 'entirely self-supporting and intrinsically significant'.[13]

Moore also owned the issue of *Cahiers d'Art* (no. 3, 1931) in which Pellerin's *Large Bathers* was reproduced, under the title *La Baignade*, along with other 'Baignades' by Manet, Daumier, Derain, Picasso, Renoir, Matisse and Seurat as illustrations to Christian Zervos's perspicacious article 'Les Problèmes de la jeune peinture: Le Retour au sujet est-il probable?' The juxtaposition of these nude female figures could only have widened the young sculptor's interests and strengthened his sense of admiration. The second part of Zervos's article, published in the following issue of the magazine, dealt entirely with Cézanne and praised the artist's consummate feeling for colour as an instrument for creating a 'representation' of nature. Finally, *Minotaure* (no. 6, 1936) published an article of several pages by Lionello Venturi on Cézanne's final works; there was also a piece on Degas, and another the following year (no. 11, 1937) dealing with drawings by Seurat, both artists in whose work Moore was particularly interested.

Sustained and deepened in this way, Moore's knowledge of Cézanne acquired such profound significance that both artists' conception of art may be said to have agreed in several important respects. Cézanne's condemnation of all those artists 'who, denying nature or copying it prejudicially, pursue style by imitating the Greeks and Romans'[14] finds an echo in Moore's initial rejection of the entire Classical tradition, as expressed in the statement (a homage to Fry's ideas in *Vision and Design*) that the 'removal of the Greek spectacles from the eyes of the modern sculptor (along with the direction given by the work of such painters as Cézanne and Seurat) has helped him to realize again the intrinsic emotional significance of shapes instead of seeing mainly a representation value'.[15] Moore found this 'intrinsic emotional significance of shapes' just as much in 'primitive' art as in Gothic art or Cézanne, and the latter's remark that 'Gothic art is essentially invigorating, it is of our race'[16] inevitably reminds one of Moore's description of the effect that the *Large Bathers* had on him: 'For me this was like seeing Chartres Cathedral.'[17]

The assertion of the necessity for observation, for the detailed study and interpretation of nature, runs like a leitmotiv through the statements made by Cézanne and

Fig. 2 Works by Roland Penrose, Paul Nash, Henry Moore, Wolfgang Paalen and Alberto Giacometti used to illustrate Tériade's 'La Peinture surréaliste', *Minotaure*, no. 8, 1936

Moore, both of whom refused to theorize about their work. In the final analysis, both were grappling with the problem of constructing forms in space, each using the means intrinsic to his art. The examination and assimilation of natural forces, the distortion and transformation of shapes, was furthered in both cases by the large number of drawings and watercolours in which the two artists worked out tentative solutions to the problem of three-dimensionality.

Cézanne's persistent fascination with this is especially clear in the works inspired by the sculptures of Barye, Michelangelo and Puget, in his studies of arranged draperies and in his watercolours of rocks near the Château Noir, with their strikingly solid, 'vaguely organic' shapes suggestive of a woman's body transformed into rock.[18] Cézanne's 'logic of organized sensations'[19] led him to construct forms by means of contrasting colour modulation.

The existence of natural objects in space was also Moore's primary concern in his drawings – swift, experimental notations of possible sculpted volumes. The

reclining figure as a metaphor for landscape, the intensity, life and inner strength of a form that is exteriorized in sculpture, were the chief elements of his approach both as a sculptor and as a draughtsman.

To Moore, then, the *Large Bathers* represented the most ambitious and successful undertaking in Cézanne's fight against tradition: the artist had overthrown conventional notions of painting by employing new pictorial means. When, in 1962, Moore acquired a small Cézanne painting – a study of three bathing women – he felt it to possess all the monumentality of the *Large Bathers*. He shared Cézanne's penchant for portraying the same type of mature, heavily built woman, and it is perhaps not too fanciful to suggest that the powerful back (as Moore describes it)[20] of the woman on the left of the canvas was somehow linked in his mind with his mother's, which he used to rub when he was a child but never drew directly. Be that as it may, he obviously saw these three figures as potential sculptures, and in 1978 he did in fact render Cézanne's three bathers in plaster for a television programme (fig. 1). Thus, half a century

later, Moore gave concrete form to his intuition as a young man that the French artist had understood, and 'realized' through his painting, the three-dimensionality of natural forms, with a deep sense of human warmth achieved by only a few great artists of the past, such as Giovanni Pisano, Masaccio and Rembrandt. More than any other modern artist, including Picasso, Cézanne furnished Moore with an example of how to express 'the tremendous power of goodness that exists somewhere in human nature'.[21] This is not a matter of 'influence', but rather of agreement on essentials: the relationship between art and life in what was necessarily a modern approach.

Moore's fruitful contacts with artists living in Paris in the 1930s found their logical conclusion in his participation in group exhibitions, in those devoted to abstract and Constructivist tendencies and in the great international shows put on by the Surrealists. Moore spent time in France almost every year from the early 1920s onwards. Indeed, when he took up his travelling scholarship to Italy in 1925, he did so very much against his will, since he really wanted to be in Paris, where living art was being created. It was during this trip that he discovered that there was more to Renaissance art than the plaster casts of academic sculpture that he had been obliged to copy when a student.[22] We know how absolutely crucial the visit to Italy was to Moore's artistic evolution, but at the time it provoked a major spiritual crisis because of his inability to come to terms with the conflict inherent in his sympathy with both Mexican and Italian art. The twofold attractions of the 'tough' and the 'tender'[23] could be satisfied only by creating actual works. This awareness of tendencies that were at once contradictory and inseparably linked was a constant part of Moore's experience in the interwar years, not only at the British Museum, where he discovered and made a highly profitable study of works from non-European civilizations,[24] but also in Paris during life-drawing sessions at the Académie de la Grande Chaumière and in personal encounters with other artists, including Brancusi, Giacometti and Picasso.

Moore was familiar with the French journals of the time, which occasionally published recent works of his during the period when he was most closely linked to the Surrealists. *Minotaure*, for example, did so in 1936, following an article by Tériade on Surrealist painting (fig. 2), and again in 1937, together with works by Surrealists (fig. 3); while in 1938 *Cahiers d'Art* included Moore among the artists chosen to illustrate Herbert Read's article 'L'Art contemporain en Angleterre'

(fig. 4). It is known that Moore's sculpture *The Helmet* of 1939–40 (fig. 9, p. 22) stemmed directly from the prehistoric Greek helmets he saw in *Cahiers d'Art* in 1934, where they illustrated an article by Zervos entitled 'L'Art en Grèce depuis les temps préhistoriques jusqu'au début du XVIIe siècle',[25] and also that in 1935–36 Moore made drawings of 'statues' that were based on photographs published in *Minotaure* in 1933 (no. 2) to accompany an account of the French ethnographic expedition in Dogon territory. Furthermore, there are similarities, as curious as they are inescapable, between the drawings of Picasso's 'Une Anatomie', published in *Minotaure* in 1933 (fig. 5), and Moore's 1937 drawing *Sculpture in a Setting* (plate 41) – and even his later sculptures, such as *Standing Figure* of 1950 (LH 290).

Such comparisons, however instructive and necessary, give only a partial idea of the role that these two French magazines, of fundamental importance in Europe as a whole, played in the development of Moore's work. For example, by publishing an article in

Fig. 3 Works by Kurt Seligmann, Henry Moore, Hans Arp and Serge Brignoni illustrated in *Minotaure*, no. 10, 1937

HENRI MOORE. ÉTUDES POUR SCULPTURES. 1937.

NORMAN DAWSON. PEINTURE. 1937.

ROLAND PENROSE. «L'ÊTRE HUMAIN», 1938.

BARBARA HEPWORTH. SCULPTURE (BOIS), 1935. MUSEUM OF MODERN ART, NEW YORK.

F.-E. MC WILLIAMS. DEUX CERCLES, 1937.

HENRY MOORE. VUE DE L'ATELIER.

35

38

Fig. 4 Works by Henry Moore, Norman Dawson, Roland Penrose, Barbara Hepworth and F. E. McWilliam used to illustrate Herbert Read's 'L'Art contemporain en Angleterre', *Cahiers d'Art*, nos. 1–2, 1938, pp. 35, 38

Cahiers d'Art (no. 10, 1928) on contemporary sculpture in which he related it freely to sculptures from Antiquity, from China, Delos and New Guinea, Zervos provided a key to the workings of visual association. The indexes of *Minotaure* and *Cahiers d'Art* are full of articles on every form of artistic expression, from 'primitive' art, the archaic periods of European art and the great artists of the past to the latest developments in all the arts, including architecture, film and literature. As with the periodical *Documents* in 1929–30 (copies of which Moore does not appear to have owned), the extraordinary juxtapositions in these two magazines of images from every conceivable source amounted to an attempt to undermine the very foundations of Classical aesthetics.[26] For Moore, on whom the texts no doubt had a less immediate impact than the illustrations, the reproductions of works by Picasso, Arp and Giacometti probably had the same liberating effect as those of African, Oceanian or Greek art. He will have regarded them more as 'evidence' than as models. It would therefore be less constricting to view the relation of Moore's work to other art from the standpoint of formal sympathies, parallel interests and (without indulging in a whole litany of occasional influences) miscellaneous encounters.

The preoccupation with enquiry characteristic of the work of numerous European artists in the 1930s gave rise to a real internationalization of the Surrealist movement. This was made possible by the new political situation in Europe and came as a welcome development after the dissension that had broken out among the Paris Surrealists. In London in 1935 there was a small colony of artists and intellectuals living in Hampstead, among them Moore, Herbert Read, Ben Nicholson, Barbara Hepworth, John Piper and Paul Nash. According to Roland Penrose, 'There was among artists at this time a sharp division between those who believed in abstract art and the surrealists, and both sides claimed Herbert [Read] as a leader who could write, make speeches and defend them in the Press'.[27] Moore chose to disregard this division, committing himself first of all

to the struggle against Fascism and participating in the constitution of the British Surrealist group, while at the same time showing his work with the abstractionists.[28]

‹So it was that Moore became a member of the committee of the 'Artists Against Fascism and War' exhibition in London in 1935. He contributed, along with Read, Nash and the other British Surrealists, as well as with Arp, Calder, Giacometti, Hélion, Miró, Mondrian and Picasso, to the magazine *Axis*, the first issue of which appeared in London in January 1935 and which continued publication until the winter of 1937. And he signed the first British Surrealist manifesto, drafted by the poet David Gascoyne, extracts from which were published in *Cahiers d'Art* (nos. 5–6, 1935, p. 107).

In 1936 work by Moore was shown in the major exhibition 'Cubism and Abstract Art' in New York and, alongside Giacometti, Hélion, Miró and others, in 'Abstract and Concrete', which opened in London before travelling to other venues in England. He was a member of the organizing committee of the International Surrealist Exhibition, held in London in June and July of that year, which brought together over sixty artists from fourteen countries and drew more than twenty thousand visitors. Moore himself was very well represented, with seven works, on equal footing with Arp, Giacometti, Brancusi and Calder. Photographs of the exhibition (see fig. 6) show the hanging, overseen by André Breton, and the presence of some African masks and other 'primitive' objects.[29] On this occasion, in company with the entire British group plus Breton, Paul Eluard and Man Ray, he signed the fourth *International Surrealist Bulletin*, published in French and English, which had been read and approved at a public meeting in Hampstead in July 1936. It included announcement of an exhibition of Moore's work, to be held in November at the Leicester Galleries, and of the publication of Read's *Surrealism*.[30] In connection with the publication of the *Bulletin*, *Minotaure* reproduced a number of Surrealist works, including some by Moore.

During August 1936 Moore took part in the exhibition held by the First British Artists' Congress for Peace, for Democracy, for Cultural Progress and again exhibited with Giacometti and Hélion, in the 'Abstract Art in Contemporary Settings' show in London. In November of the same year he signed a declaration of support for Spain, issued by the British Surrealist group with the aim of inducing the Government to take a stand in favour of the Spanish Republicans. Penrose relates that he and Moore went to a 'mass meeting at the Albert Hall, where drawings given by him [Moore], Picasso and many more were being auctioned for Spanish relief'.[31] In the summer of 1937 Moore was to see *Guernica* with Penrose in Picasso's Paris studio before the work was shown in London the following year. Nineteen thirty-seven was also the year of the publication in London of *Circle: International Survey* of *Constructive Art* by Leslie Martin, Ben Nicholson and Naum Gabo, which grouped together painters, sculptors, architects and writers, whether British, French or exiles who had taken refuge in Paris and then London. Circle was not intended as a new art manifesto, but rather as a wide-ranging collection of work by artists from different disciplines whose abstract expression evinced a concern for fundamental vital principles rather than for the outward appearance of nature. This entailed an optimistic vision of art as a universal language, which was developed by Gabo in his important text 'The Constructive Idea in Art'. Moore contributed to the sculpture section with Gabo and Hepworth, and two short paragraphs reaffirmed his allegiance to an art linked to life as 'an expression of the significance of life, a stimulation to a greater effort in living'.[32] *Circle* was issued in conjunction with the ex-

Fig. 5 Pablo Picasso, plate 5 of 'Une Anatomie', *Minotaure*, no. 1, 1933

Fig. 6 View of the International Surrealist Exhibition, New Burlington Galleries, London, 1936, with works by André Masson (1), Paul Nash (2, 13), Edward Burra (3), Roland Penrose (4), Paul Klee (5), André Breton (6), Marcel Jean (7), Henry Moore (8, 14), Pablo Picasso (9), Yves Tanguy (10), Giorgio de Chirico (11) and Max Ernst (12)

hibition 'Constructive Art' at the London Gallery, at which Moore showed work alongside Calder, Giacometti and Hélion, who came over from Paris for the occasion. The participation of a French artist such as Hélion in 'abstract' art exhibitions within the *Circle* orbit in Britain was, in a way, the logical follow-up to the inclusion of British artists in the activities of the *Abstraction-Création* group in Paris in previous years. This movement comprised all avant-garde non-figurative currents; Hepworth and Nicholson were attached to it, but not Moore, who probably felt that the group's stance was too dogmatic.

Also in 1937 Moore took part in the exhibition 'Surrealist Objects and Poems', again at the London Gallery, at which he showed his *Sculpture to Hold* (LH 173), made in 1936. At the same time the Jeu de Paume museum in Paris organized an exhibition of independent international art with the aim of showing its origins and development. The selection, which was supposed to give pride of place to foreign artists, caused an uproar in Parisian circles and, on 7 August, fifty-six artists and intellectuals signed an open letter to the President of the Council, the Minister of Education, Jean Zay, and the Director-General of the Fine Arts in protest against the omission of a number of Russians,

Germans and Italians (clearly spelling out the political problems involved) – and also of Moore and Nash. The first signature was that of Breton, followed by Brancusi, Herbin, Tzara, Kupka, Delaunay, Arp, Gleizes, Benjamin Peret, Jeanne Bucher, Vantongerloo, Tanguy and Mesens. It was a remarkable alliance of artists of all factions, Surrealist and abstractionist, in defence of a genuinely international art.[33]

It was in this spirit that the famous 'Exposition internationale du surréalisme' was shown at the Galerie des Beaux-Arts in Paris in January and February 1938, bringing together 229 works by sixty artists from fourteen countries; the *Dictionnaire abrégé du surréalisme*, published specially for the occasion, served as the catalogue. Moore was represented at the exhibition by three sculptures and a number of recent drawings, and a *Reclining Figure* done in 1934–35 (LH 155) was illustrated in the *Dictionnaire*.

On 1 May 1938 the British Surrealists, including Penrose and Moore, were taking part in anti-government demonstrations in Hyde Park in support of the Spanish people.[34] However, the 'unified front of poetry and art' that Breton was struggling to maintain fell apart later that year, when the British group refused to endorse the crucial manifesto 'Towards an Independent

Revolutionary Art', drawn up by Breton and Trotsky in Mexico on 25 July 1938 to accompany the creation of the International Federation of Independent Revolutionary Art (F.I.A.R.I.). A 'Letter to our Friends in London' was addressed to them from Paris on 21 October 1938 in an attempt to persuade them to take a stand against Stalinism,[35] but in vain: the British Surrealists continued to take part in Communist-supported demonstrations. In 1940 Moore was associated with the Third International Surrealist Exhibition, organized in Mexico (with reproductions of works in the review *Dyn*, published in Mexico in English and French and widely distributed), and he also showed at the Zwemmer Gallery in London at the last exhibition by the British Surrealists as a group, 'Surrealism Today'.

The war dispersed all the artists in different directions. Many of those who had been living in Paris found themselves obliged to leave France, first for London and then for the United States.

At a further international Surrealist exhibition, organized in Paris in 1947, Moore was conspicuous by his absence and was violently condemned by the members of the British group: 'The most surprising case is still Henry Moore, the sculptor, leaping straight from Surrealism to making religious ornaments and then plunging into the monotonous serial production of sketches done in air-raid shelters, a miserable popularization of his pre-war "reclining figures". Without making excuses for Moore, it is only fair to add that Herbert Read's eclecticism had by then reached startling proportions.'[36] The break was complete.

Closer scrutiny of this all too brief sketch of Moore's activities, particularly between 1935 and 1938, shows that, while his participation in Surrealist events had been politically motivated, his friendship with Penrose, Gascoyne, Nash and especially Read was a no less important driving force behind his enthusiastic espousal of the Surrealist venture, for the movement opened up extraordinary possibilities to all concerned. Involvement with it did not necessarily entail acceptance of all the sometimes radical proposals voiced by Breton: when the latter said 'Freeing the spirit...first requires freeing man' it was perfectly natural for him to be followed by a great many artists, who immediately took up arms alongside the Spanish Republicans in the struggle against Fascism. This was Surrealism not as a style or a new theory of art, but as a global vision of humanity and society that broadened the scope of reality and authorized the most original forms of expression of human experience. Moore was certainly convinced by these noble ideals and, even if he was never tempted to embrace the liberation of the unconscious as a source of

creation, with the Surrealists he nevertheless discovered stimulating new possibilities. His drawings, especially his 'transformation drawings' (see plates 19–22), based on such found objects as pebbles, bones and shells, on examples of 'primitive' art (seen as objects in themselves, independent of their historical context) and on reproductions in magazines, obviously had something in common with the Surrealist poets' *écriture automatique*. Spontaneous work, done without a preconceived aim until the idea or the shape surfaces and crystallizes; the clear awareness that associations of ideas and psychological factors, combined with the imagination, play an important part in sculpture; and the almost obsessive pursuit of certain themes, such as the mother and child or the reclining female figure, that were seen as part of a heritage of archetypal ideas – all these united Moore and the Surrealists.

On the other hand, Moore's insistence that the essential qualities of sculpture lay in the notion of truth to materials, in three-dimensionality, in the observation of natural objects and in abstract principles linked to the realization of an idea and the expression of inherent vitality (which the artist defined in 1933 in his text for *Unit 1*) aligned him with the abstractionists. When he

Fig. 7 *Two Piece Reclining Figure: Cut* , 1979–81 (LH 758); bronze, l. 480 cm; City of Strasbourg

Fig. 8 *Unesco Reclining Figure* 1957–58 (LH 416); travertine marble, l. 508 cm; Unesco headquarters, Paris

participated in a variety of group exhibitions in London in 1937, he himself described his detachment from a quarrel with which he could not identify: 'All good art has contained both abstract and surrealist elements, just as it has contained both classical and romantic elements – order and surprise, intellect and imagination, conscious and unconscious. Both sides of the artist's personality must play their part.'[37] He continued to adhere to this view, in 1960 virtually paraphrasing his former statement: 'I see no reason why realistic art and purely abstract art can't exist in the world side by side at the same time, even in one artist at the same time. One isn't right and the other wrong.'[38] By setting himself apart from supposedly mutually exclusive schools of thought, Moore did no more than reaffirm his personal creative power, his capacity to pursue his work as a 'constructor

of images between the conscious and the unconscious, and between what we perceive and what we project emotionally into the objects of our world...the one English sculptor of large, imaginative power, of which he is almost master; the biomorphist producing viable work with all the technique he requires'.[39]

To Moore, the war was a crucial period during which his art took an unexpected turn: he devoted himself exclusively to drawing, recording in his own particular way the hardships imposed by the war on the beleaguered population of London. This commitment on Moore's part was very different from Picasso's in *Guernica*, but it led him, none the less, to find a means of registering the visual effect of people massed in the enclosed space of the Underground stations.

For Moore, as for others of his generation who had reached artistic maturity, the post-war years brought international recognition, in his case assisted by, among others, the British Council. His first retrospective in France took place in 1949–50; people kept their fingers crossed for it, the critic René Guilly noting 'the disfavour sculpture meets with these days'.[40] In the Musée National d'Art Moderne the Paris public discovered Moore's insistence on his 'right to portray the human figure with the greatest freedom', but his huge reclining female figures really needed to be shown in a natural setting to be properly understood.[41]

As a logical consequence of this exhibition, in 1951 the French government bought a monumental bronze *Reclining Figure* (LH 293).[42] This remained the only work by Moore in the French state collections until 1981, when the City of Strasbourg also acquired a bronze (fig. 7). The commission for a large marble *Reclining Figure* for the esplanade of the new Unesco headquarters in Paris (fig. 8), opened in 1958, came at a time when the artist was already considered the world's greatest modern sculptor and, while a great event for France, was due to the initiative of an international organization. The only institution in Paris devoted entirely to sculpture was the Musée Rodin, and it seemed natural for a new one-man show to be displayed there. Held in 1961, the exhibition comprised more than one hundred works (including two prints), and Moore's friend Roland Penrose wrote the preface to the catalogue. To the artist, the confrontation with the great French sculptor doubtless represented a return to his sources as well as an act of homage. Ten years later, the director of the Musée Rodin, Cécile Goldscheider, proposed that Moore exhibit there his extraordinary series of recent etchings inspired by an elephant's skull. Fascinated by the volumes, cavities and natural complexity of this object, itself monumental, he provided evidence of his undiminished creative vitality.

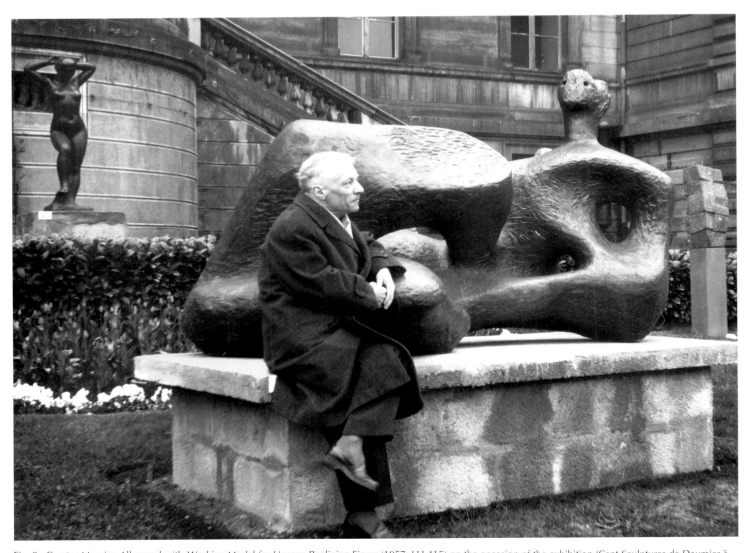

Fig. 9 Curator Maurice Allemand with *Working Model for Unesco Reclining Figure* (1957; LH 415) on the occasion of the exhibition 'Cent Sculptures de Daumier à nos jours', Musée d'Art et d'Industrie, Saint-Etienne, 1960

On an official level, Moore received the distinction of being elected a foreign associate member of the French Académie des Beaux-Arts, where he was decorated on 7 November 1973. In 1977, after twenty years of regular invitations to take part in group exhibitions in France – with the exception of Saint-Etienne in 1960 (see fig. 9), exclusively in Paris – two major shows were organized by Dominique Bozo in collaboration with the Bibliothèque Nationale (which exhibited more than two hundred engravings) and the Orangerie des Tuileries (116 sculptures and 108 drawings). The accompanying catalogue was the first large-scale monograph on the artist to be published in French. France's homage to Moore just before his eightieth birthday had a great impact, for not only did it give a retrospective view of his immense corpus of work, but the monumental sculptures, which the artist had conceived from the very beginning in relation to a landscape setting, were at last presented in an open-air context, in the gardens of the Tuileries.

Special tribute was paid to the sculptor's huge international reputation when he was awarded the highest Order of the Légion d'Honneur in 1984. François Mitterrand, President of the French Republic, presented the decoration to him personally at the artist's home in Perry Green (fig. 32, p. 195).

In general terms, the French art world during the two decades after the war may be said to have been dominated by Picasso, who, like Moore in Britain, was considered a great national artist. Each of them had built up their formal vocabulary with curiosity and energy, by daring to experiment with as many relationships between the artist and reality as possible. Their entire imagination was focused on investigating new ways of representing the female figure, all as real and as strong as the reality from which they were drawn. Moore did this by carving materials with uncompromising respect for their natural characteristics, transforming their constraints into positive, energy-producing qualities, and by casting great bronzes from maquettes made with the same feeling for the harmony of forms and the space to which they owe their existence. In doing so, he emerged as the most complete and inventive of all modern sculptors, in the same way that Picasso was the greatest 'assembler' of images in painting. It would undoubtedly be extremely rewarding to make a comparison of the works of these two great artists – in the light, too, of the rare archival documents concerning their personal relationship – so as to examine how their respective developments ran along parallel lines, converged and intersected.

Moore's international standing was recognized early on in the United States, which had come to possess the most active art scene in the world after the war. Despite Moore's confident assertion in 1970 that 'Modern art has opened people's eyes to certain pictures, textures, and things in nature – so much more than fifty years ago',[43] could it be that the blindness to new sculptural forms that seems to afflict the French will remain unchanged?

NOTES

1 *Qu'est-ce que la sculpture moderne?*, exh. cat. (Paris, Centre Georges Pompidou), Paris, 1986, pp. 10–14.
2 For this and Moore's other comments on Rodin, see Rosamund Bernier, 'Henry Moore parle de Rodin', *L'Œil*, November 1967, pp. 26–33, 63. As a result of the events surrounding the outbreak of the First World War, the works by Rodin that were shown at the Grosvenor Gallery in July 1914 remained in London. Presented to the British state by the artist in October of that year, they were displayed in the Victoria and Albert Museum until 1937, when they were transferred to the Tate Gallery. Moore is unlikely to have seen them until he entered the army on war service in 1916.
3 Quoted in *Henry Moore Intime*, exh. cat., 1992, p. 114.
4 Quoted in Moore, 1986, p. 151.
5 John and Vera Russell, 'Conversations with Henry Moore', *Sunday Times*, 17 December 1961, p. 17.
6 See *The Drawings of Henry Moore*, exh. cat., 1977, p. 67, cat. no. 62.
7 J. and V. Russell (note 5), p. 17.
8 Quoted in Moore, 1986, p. 150.
9 See *Cézanne*, exh. cat. (Paris, Galeries Nationales du Grand Palais; London, Tate Gallery; Philadelphia Museum of Art, 1995–96), London, 1995, p. 578.
10 Ibid., p. 589.
11 Carl Einstein, in *Documents*, no. 3 (1930), pp. 55–6.
12 See *Cézanne* (note 9), p. 583.
13 *Cézanne* (note 9), p. 55.
14 Quoted in *Cézanne* (note 9), p. 37.
15 Quoted in Alan G. Wilkinson, 'Henry Moore', in *'Primitivism' in 20th Century Art: Affinity of the Tribal and the Modern*, exh. cat., ed. William Rubin (New York, Museum of Modern Art; Detroit Institute of Arts; Dallas Museum of Art), New York, 1984, pp. 596–7.
16 Quoted in *Cézanne* (note 9), p. 37.
17 J. and V. Russell (note 5), p. 17.
18 See *Cézanne* (note 9), p. 368.
19 See Lawrence Gowing, 'The Logic of Organized Sensations', in *Cézanne: The Late Work*, exh. cat. (New York, Museum of Modern Art, and Houston, Museum of Fine Art, 1977–78), New York, 1977.
20 Moore, 1992, p. 208.
21 J. and V. Russell (note 5), p. 20.
22 See James Johnson Sweeney, 'Henry Moore', *The Partisan Review*, vol. 14, no. 2, March–April 1947.
23 Grohmann, 1960, p. 270.
24 See Wilkinson (note 15) and Moore, 1981.
25 Wilkinson (note 15), p. 605 and n. 39.
26 See Georges Didi-Huberman, *La Ressemblance informe ou le gai savoir visuel selon Georges Bataille*, Paris, 1995.
27 Roland Penrose, *Scrap Book 1900–1981*, London, 1981, p. 75.
28 See Christa Lichtenstern, 'Henry Moore and Surrealism', *The Burlington Magazine*, vol. 123, no. 944, November 1981, pp. 646–7, and *Circle: International Survey of Constructive Art*, London, 1937.
29 Penrose (note 27), pp. 64–7.
30 *International Surrealist Bulletin*, no. 4, September 1936, p. 7.
31 Penrose (note 27), p. 103.
32 *Circle* (note 28), p.118.
33 Reprinted in *Tracts surréalistes et déclarations collectives 1922–1969*, with introduction and commentaries by José Pierre, vol. 1, Paris, 1980, 7 August 1937 and p. 519.
34 See *La Planète affolée, Surréalisme: Dispersion et influences 1938–1947*, exh. cat. (Marseilles, La Vieille Charité), Paris, 1986, p. 162.
35 *Tracts surréalistes et déclarations collectives* (note 33), 21 October 1938.
36 Quoted in *La Planète affolée* (note 34), p. 169.
37 'Notes on Sculpture' (1937), reprinted in *Henry Moore: Complete Sculpture*, vol. 1, 1988, p. XXXV.
38 Donald Hall, 'An Interview with Henry Moore', *Horizon*, vol. 3, no. 2, 1960, p. 104.
39 Geoffrey Grigson, 'Comment on England', *Axis*, vol. 1, no. 1, January 1935, p. 10.
40 René Guilly, 'Henry Moore', *Arts*, 31 October 1947, p. 3.
41 See Philip Hendy, 'La Sculpture d'Henry Moore', *Art d'aujourd'hui*, no. 4, November 1949, p. 9.
42 Purchased by the Fonds National d'Art Contemporain and deposited on loan with the Musée National d'Art Moderne, Paris, inv. no. AM 928 S.
43 Quoted in *Henry Moore: Drawings, Gouaches, Watercolours*, exh. cat., 1970, unpaginated.

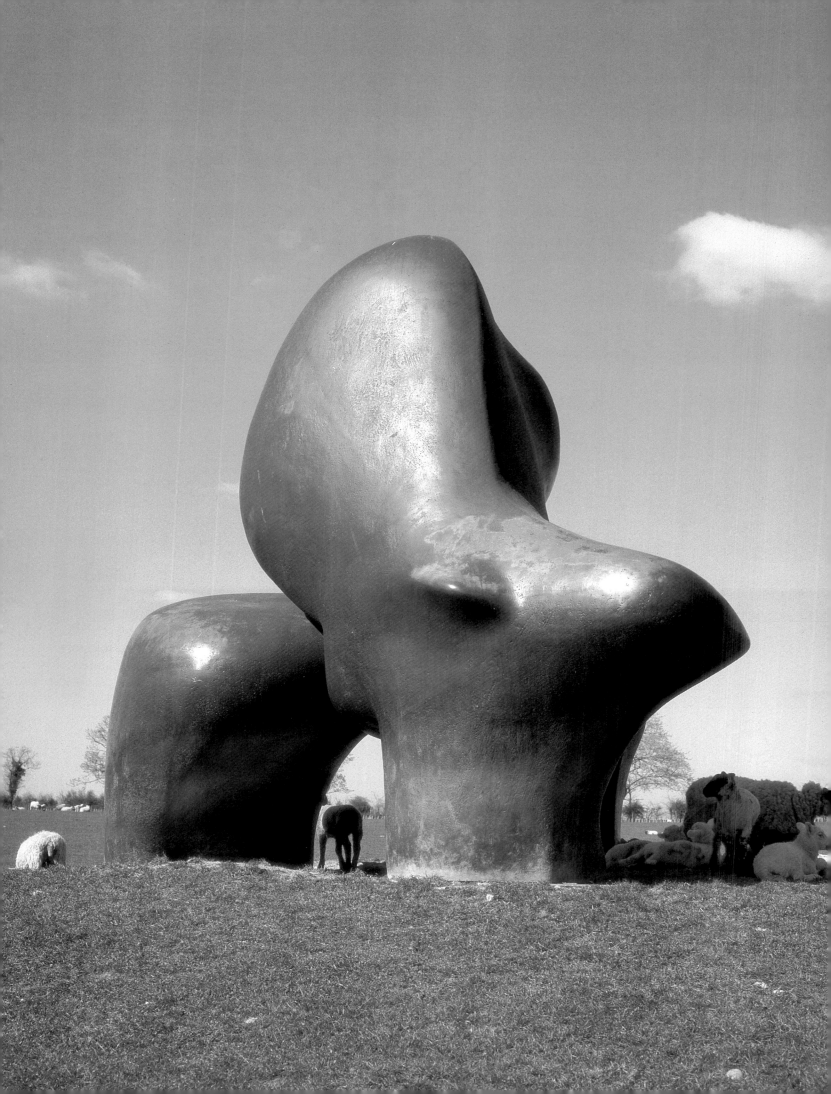

Moore, Moore's Children: 'Being There'

Ann Hindry

We are discovering little by little all over again that what a thing means is not more important than what it is.

George Kubler[1]

Though one of this century's most celebrated artists, Henry Moore is regularly denied two accomplishments of the greatest import for inclusion in the current pantheon of contemporary art: that of shaking off the yoke of a certain type of modern Classicism, and that of giving birth to a school, a following, a movement, in short, of prolonging his singularity. His art seems to have become an accepted presence; like some British Maillol, he feeds our constant desire for stable yardsticks in just the right way, at the foot of prominent city buildings or at a propitious turn in a garden path. But the century is reaching its close and its ideological walls are crumbling apace, without sparing the modernist history of art. Thus it is perhaps opportune today to look back at Moore's oeuvre through the prism of this shifting context and, in doing so, to unravel the multiple skeins of subtle or occulted threads that link him to the generation of British sculptors who 'exploded' on to the international scene in the early 1970s. Let me stress straight away that the point is not to trace affiliations at any price. Indeed, Moore exerted no direct influence on any of the major artists who came after him, nothing comparable to the inspiration that he himself had derived from Picasso, Brancusi and 'primitive' art; but many of the artists now in the limelight, such as Barry Flanagan, Richard Deacon, Tony Cragg, Antony Gormley, Anish Kapoor and even Richard Long – to limit the list to the barest needs of our discussion – have been able to develop their own untrammelled freedom on the basis of Moore's work, with its breadth of sculptural vision and its masterly exploitation of specifically national characteristics.

Sheep Piece, 1971–72 (LH 627); bronze, h . 570 cm

'Moore's children – they're on to everything!'[2]

A new reading of Henry Moore can be developed from the perspective of his 'children', thus named in a celebratory study of Barry Flanagan by Alain Borer, who stresses, however, that they are actually his *grand*children, members of the post-Anthony Caro generation (and this, too, should be taken more as a metaphor than as a genealogy).[3] But such a reading is possible only if we understand a unique attitude to personal origins, isolated but not isolating: the sense of belonging to British civilization. Beyond all superficial affinities or disparities, we shall have to consider how a dialectic of meaning and being was forged from this attitude, a dialectic that characterizes a certain kind of British sculpture, whose tutelary figure is incontestably Moore. Devoted exclusively to works carried out entirely by the artist himself, the present publication and the exhibition that it originally accompanied lend themselves marvellously well to this type of exercise. Moore is immediately divested of the trappings of Great Public Statuary. He undoubtedly always envisaged his sculpture in open-air settings, but he also mistrusted its subsequent subjection to parameters other than itself. When he preached the need to preserve 'truth to materials' throughout the first part of his career – roughly up to the Second World War – he was also thinking of the essential dilution effected by casting in bronze and by its corollaries, multiplication and enlargement. Of the works included here, the large figures carved directly in stone, marble or wood, retaining the limits of the block from which they emerged, display the full sensuous coincidence of material and form. The maquettes modelled in plaster are tiny forms, no larger than a hand's breadth; yet, infused with a tense fragility and power, they already contain their full potential for monumentality because the artist thinks in a pre- or

Fig. 1 Richard Long, *Stones and Sulven*, Scotland, 1981

post-cultural continuum in which scale is but a matter of cultivation (as is attested by the intermediary working models). Finally, the works on paper are at once autonomous drawings and evidence of the artist's sculptural studies, often rendered more plastic by the extremely 'blocky' use of plain, almost crude colour that does not 'describe' form. Herbert Read, explaining how Moore conceived all his sculptures as though he were holding them in his hand, quoted the artist's own description of the sculptor's task: 'He mentally visualizes a complex form *from all around itself*... he identifies himself with its centre of gravity, its mass, its weight; he realizes its volume as the space that the shape displaces in the air.'[4] This can be matched to Moore's dictum that all experience of space and of the world begins with physical sensation. The physical, existential feeling of occupying the centre of one's own body, experienced as an element of one's spatial bubble within a flexible continuum of things and beings, has left an indelible mark on British thought. It is as fundamental to Moore's work as it is to that of the present-day sculptors. As early as the eighteenth century, at the very time when Lessing, in Germany, made explicit the temporality

inherent in all bodies in space, Hogarth gave expression to the total integration of the natural and the human in a vast, continuous space governed by an organic principle of growth, a single evolutionary thrust moving from nature to culture. At the juncture of immobility and movement, of the momentary and the permanent, sculpture as practised by Moore effected a synthesis of, on the one hand, its own particularities as an artistic mode and, on the other, the specifics of the British character.

The latter, as Elias Canetti astutely noted in an essay on the mass symbols of nationality, is identified primarily by the fact that it situates itself in reality, rather than in allegory, metaphor or concept.[5] The tangible contiguity between the British and their environment has a share in this. Cast in the beginning on a vast base washed by waves (transformed by Shakespeare into a 'precious stone set in the silver sea'), then freed quite early on from the necessity of defending their borders (with the defeat of the Armada in 1588), the intrepid British were able to develop a singularly intimate relation, a fusional relation, so to speak, to their territory – an exceptionally hospitable territory, with no climatic

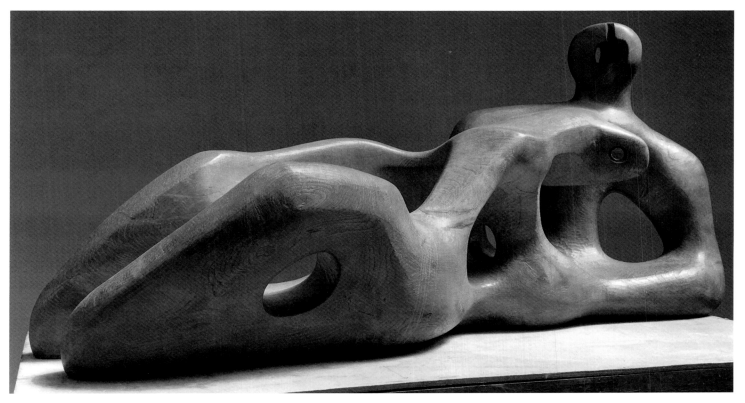

Fig. 2 *Reclining Figure*, 1939 (LH 210); elmwood, l. 205 cm; The Detroit Institute of Arts

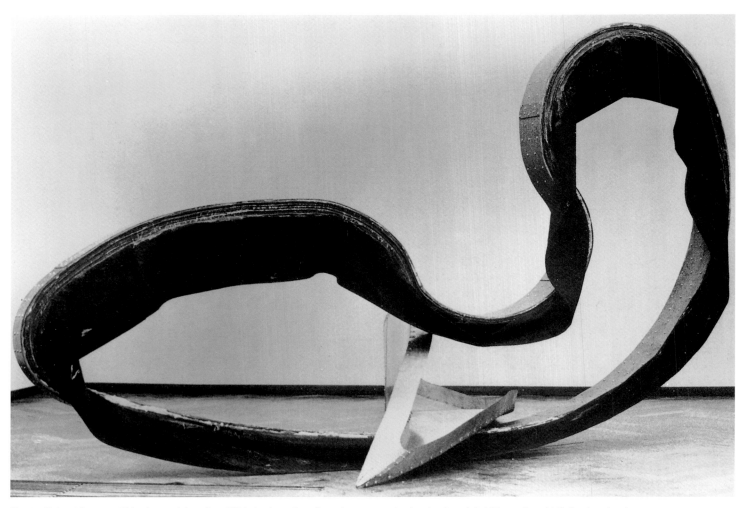

Fig. 3 Richard Deacon, *This, that and the other*, 1986; laminated cardboard, canvas and galvanized steel, l. 390 cm; Saatchi Collection, London

or topographical extremes, that its inhabitants went on to appropriate in a literal, mental and philosophical sense. The spatial organization of the British landscape contains a slightly more explicit statement of the nature of temporal experience than is found elsewhere. Nostalgia for an earlier, pre-cultural epoch in which natural history is as yet undistinguished from human history, for a continuous world with no demarcation between containing space and form contained, is evinced by constant reference to archaic sites (as a result of widespread familiarity with a relatively large number of the Neolithic remains scattered across the landscape, whether cultivated or not). One can see this as a metaphor of time, marking the relational unfolding of man and nature that leads to culture. Moore devoted an 'album' to Stonehenge; Richard Long will encircle the man of Cerne Abbas on one of his walks. In the work of both there is a singular yet comparable manner of making one *rethink time* as it is inscribed in this mental landscape. Both artists continually reformulate an equation of real time, real space and real distance. Moore said of his sculpture – whose structural force is developed as a transitory state of the natural tension inherent in any living form – that it is 'like a journey'.[6] Long makes his journeys into a sculpture that exists beyond the ephemeral form it assumes.

Anthropocentricism

One of the most striking characteristics of Moore's sculpture, and of that of the young sculptors mentioned here, is its anthropomorphism – which, in Moore's case, is a 'landscape anthropomorphism'. Without dwelling on his affinities with Arp and the vitalist current of European art in the 1930s, which reinforced Moore's desire to 'give life and vitality to the material' (in the words of Barbara Hepworth, who shared his approach),[7] one can still usefully resituate the idea of growth and transformation as a *double metaphor* within the fusional anthropocentricism of British artists, differentiating them from their Continental contemporaries. Moore's biomorphism partakes as much of landscape as of anatomy (and let us recall that, in the

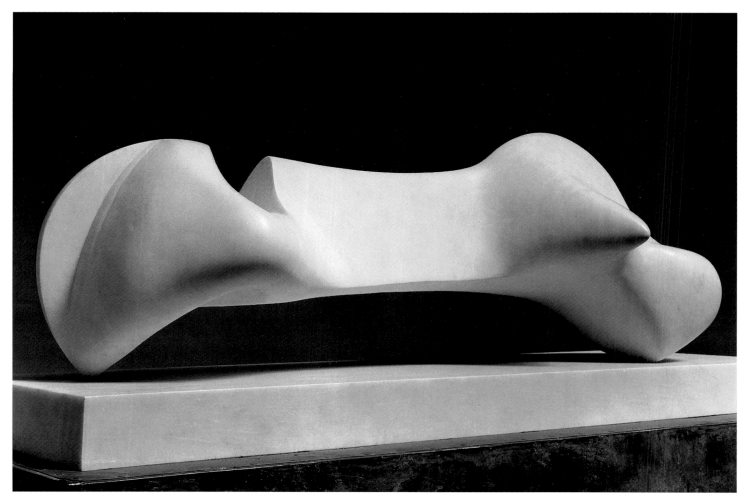

Fig. 4 *Reclining Figure*, 1966 (LH 557); white marble, l. 114 cm; Norton Simon Museum, Pasadena

1930s, referring to the first of his pierced sculptures, he spoke of the fascination of caves in the hillsides and cliffs, thus rejoining a tradition honoured by Epstein and Gaudier-Brzeska, who often referred to their desire to 'sculpt mountains'). Heavy on their bases but in a state of constant dynamic tension, Moore's sculptures give the impression, as David Sylvester has remarked, of having been modelled by nature itself, 'weathered, eroded, tunnelled into by the action of wind and water'[8] – a rendering of the cycle of nature and its effect on things that we shall rediscover in Deacon's work and, more literally, in Long's (see fig. 1). But almost all Moore's sculptures also embody perceptions of the human body, founded less on what is seen than on what is apprehended sensorially: a holistic appreciation of the capitalization of vital forces. Beyond the stylistic differences between works from the various phases of his career, in his favourite figural themes – the reclining woman and the mother and child – and in all the others as well, Moore expresses what might be called generic feelings. He shows the relations between things, sensations and sentiments, never with the aim of representing

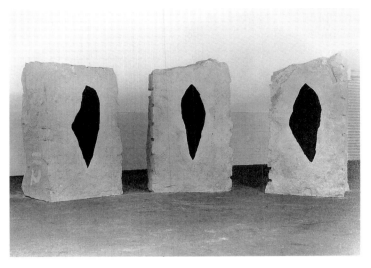

Fig. 6 Anish Kapoor, *Untitled*, 1990; painted limestone, h. 192, 202 and 204 cm; courtesy Lisson Gallery, London

a specific object, but rather with that of creating a perceptual dynamic by means of a play of visual and tactile tensions. The atrophous or hypertrophous nature of his figures, even the most realistic, finds an echo in the diverse guises of the hare humanized by Barry Flanagan or, *a contrario*, in the standard 'body units' used by Antony Gormley (and, in passing, let us note the formal affinities between the grid of Gormley's figures and the striations used to stress volume in so many of Moore's figure drawings). The contiguity of curved and straight, smooth and inscribed surfaces in the work of both Moore and Flanagan clearly defines the limits of the internal pressures of sculpture and conveys a 'vitality' parallel to that of the perceived figure. Moore's reclining figures, in their multifarious variations, are not so much imaginary representations (Surrealism, whose path the artist briefly shared, was soon left behind) as partial metamorphoses within an overriding tendency towards abstraction – an attempt to account for the similarities governing the natural world of forms (see figs. 2, 4). This approach, in which expression is based on an exploitation of the analogical principles underlying the infinity of threads in the phenomenological tapestry, can be found in the work of Tony Cragg, who reorders fragments of form into a whole, bringing into operation the dialectic of the one and the multiple (see fig. 5). The two artists meet in their manifest recognition of the metaphorical quality of all figures, of the symbolic potential of all forms and of the indispensability of the fragment as the sole sign of an order that may elude verbal articulation. Cragg's work in the late 1980s, reminiscent of Moore and, in this respect, also close to Anish Kapoor (see fig. 6), displays forms that are at once natural and cultivated, that evoke what they

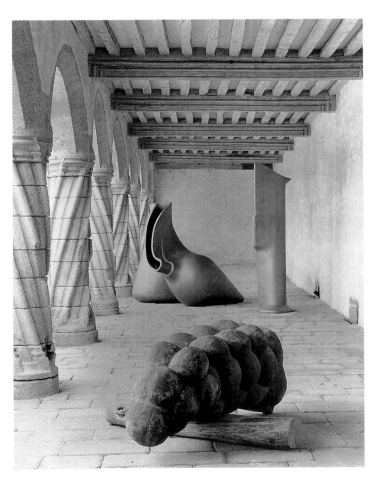

Fig. 5 Tony Cragg, installation at the Musée Departemental d'Art Contemporain de Rochechouart, 1992; foreground: *Bodicea*, 1989 (bronze, l. 180 cm, and wood, l. 170 cm), background: *Untitled*, 1990 (bronze, h. 200 and 300 cm); collection of the artist

are not and yet simultaneously prompt an experience of the indescribable that remains within the process of the interpretation of being and of things. Richard Deacon, for his part, confirms: 'Often my work uses forms by analogy with certain parts of the body. It is through the body that we form an image of the world.'[9]

Humanism

The ethic of humanism, which nourishes Moore's work and draws its vigour from a necessarily positive relation of humanity to nature, is also fundamental to the approaches of these present-day artists. In Flanagan's leaping hares and sensual, Venus-like ceramics there is a reticent lyricism that betrays deep-seated aspiration towards a state of fusion between humankind and nature. Richard Long restates the immemorial indissolubility of life and art by making his life his art. Antony Gormley, too, takes human beings as the measure of all things. His faceless figures, anchored firmly in space in various positions and deformations, are so many inescapable reminders of the fragile yet indestructible character of humanity's original relation to the world. Richard Deacon's horizontally convoluted works, though highly constructed (the masterly *This, that and the other* [fig. 3], and *Blind, Deaf and Dumb*, for example), refer back to the concept of the Earth Mother that Moore developed over the years in anonymous figures whose imposing quality of 'being there' opened up a new physical and mental space for sculpture. Deacon's frenetic riveting – or, to use his own words, the 'extreme determination of the fabrication process'[10] – is an answer to Moore's direct carving, to the distortion and atrophy of his figures – a suggestion, in fact, of human beings' arbitrariness towards objects in which, none the less, they recognize an autonomous life. Each in his own way, all the artists discussed here have shown how focusing on the moment abstracts the object, the subject and the viewer from a specific culture and resituates them in a timeless process of experimentation.

'The figure in Henry Moore's work', writes Marc Le Bot in a nice turn of phrase, 'is a body grappling body-to-body with the body of the world.'[11] The ethic of humanism that permeates Moore's oeuvre and informs the present-day approaches discussed here has not monopolized British art. Nevertheless, anthropocentricism is present almost everywhere, directly or indirectly, even when it fashions other paths, ones just as essential to the complex make-up of the national character. Thus it may be interesting at this point to come full circle, as it were, by briefly comparing the two great forerunners of present-day British art, their importance and uniqueness recognized by international consensus: Henry Moore and Francis Bacon. These men exemplify a deep ethical dualism. Iconic figures, yet relatively isolated in their own time, and without legitimate successors, both orientated their work around a multiplicity of variations and distortions of the human figure. Bacon dissolves the figure into an immaterial angst, pictorial, of course, and not volumetric, but above all *enclosed*, abstracted from any immediate relation to life. Moore, on the other hand, responds directly to external conditions and tirelessly draws an equation between humankind and nature. In the one, human beings are doomed, subject to a dark destiny, while for the other, there lies hope of redemption in the fusion of humanity and nature. Both are sons of Shakespeare: Richard III and Henry V, the man who verges on the sublime in his struggle with the unnameable and the artifex who forges a cosmos from chaos. It is clear, however, that Bacon's present-day 'children', locked in their individualist consciousness of a fruitless but signal combat, really belong more to the family of, say, Gilbert & George.

One of the great American painters of the century's second half, Ad Reinhardt, is supposed to have said: 'Sculpture is what you bump into when stepping back to look at a painting!' It might be illuminating to answer this (apocryphal?) *bon mot* with Jacques Lacan's aphorism: 'The real is what you bump into.' But there is no need to bump into a Moore, either head-on or from behind. His works, monumental or not, succeed in occupying the spectator's mental and physical space all at once, without concessions or concussions. They permeate our perception like the sensation of landscape, with an effect somewhat similar to Turner's painting. One could imagine that it is to this indefinable quality of immediacy that his recalcitrant descendants basically aspire today.

Notes

1 George Kubler, *The Shapes of Time: Remarks on the History of Things*, New Haven, 1962, p. 35.
2 Alain Borer, 'Flanagan, l'insaisissable,' *Artstudio*, no. 3, 1986, p. 74.
3 Ibid.
4 Herbert Read, *Henry Moore: The Art of Sculpture*, New York, 1956, p. 74; Moore, 'Notes on Sculpture' (1937), reprinted in Moore, 1966, pp. 62–3.
5 Elias Canetti, *Masse und Macht*, Hamburg, 1960.

6 Quoted in Marc Le Bot, 'Henry Moore: Les Sculptures-paysages', *Artstudio*, no. 10, 1988, p. 52.
7 Quoted in Rosalind Kraus, *Passages in Modern Sculpture*, New York, 1977, p. 141.
8 *Henry Moore*, exh. cat., London, 1968, p. 5.
9 Quoted in Mona Thomas, 'Deacon, le parti pris des choses', *Artstudio*, no. 3, 1987, p. 155.
10 Ibid.
11 Le Bot (note 6), p. 47.

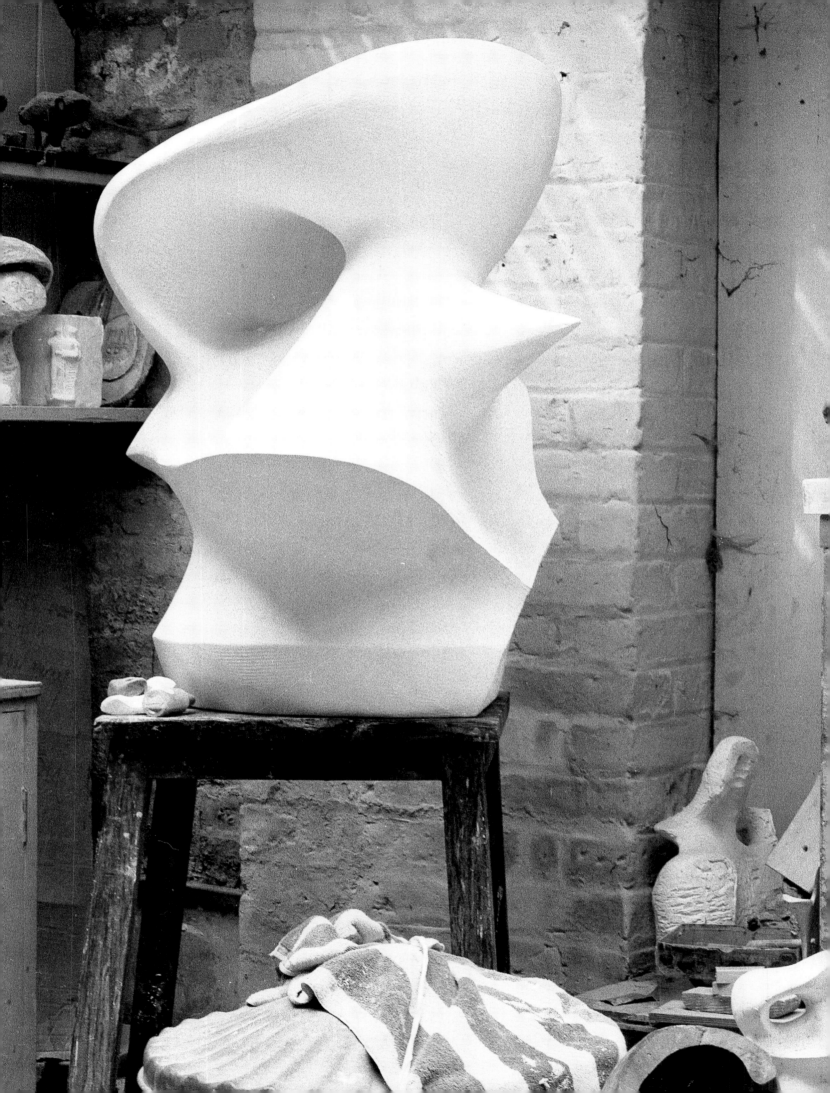

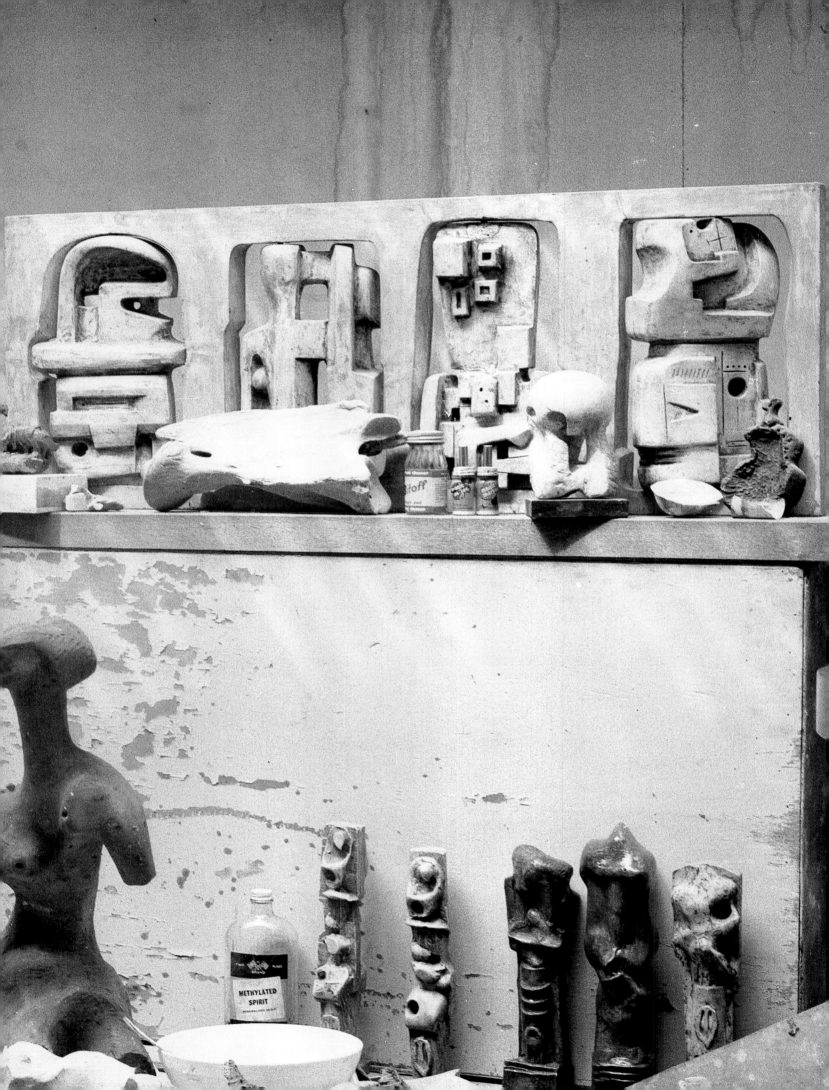

Plates

Throughout this volume the customary
abbreviations for the *catalogues raisonnés*
of Moore's work are used:

LH = *Henry Moore: Complete Sculpture*
HMF = *Henry Moore: Complete Drawings*
CGM = *Henry Moore: Catalogue of Graphic
 Work*

Plate commentaries by Clare Hillman (CH),
David Mitchinson (DM) and Julie Summers (JS)

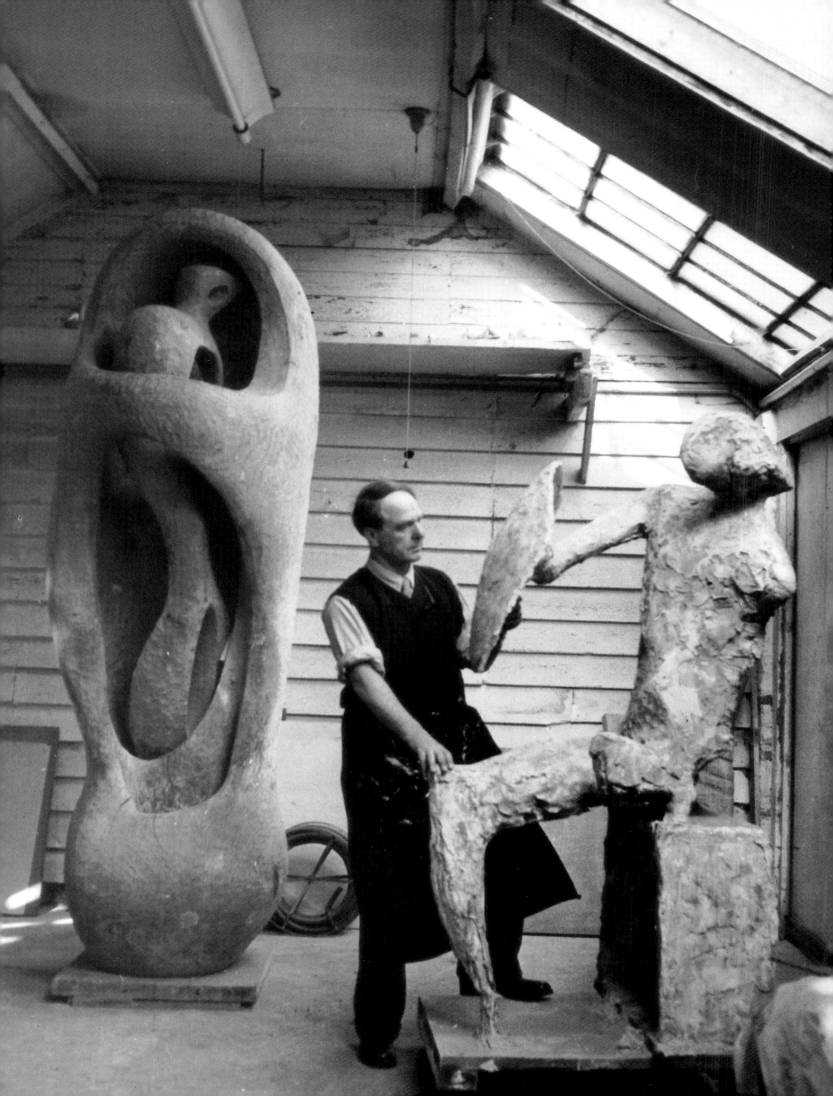

A Note on the Plasters

Henry Moore's plasters are less well known than the bronzes that were cast from them, representing as they do a stage in his working process. They have been infrequently exhibited and appear only occasionally in monographs on the artist and in catalogues of his work.

For the first twenty-five years of his working life Moore focused primarily on the direct carving of stone and wood. Indeed, modelled pieces do not occur in his oeuvre until the late 1930s. When he returned to sculpture after producing the Shelter drawings in his role as an Official War Artist (1940–42), he began modelling consistently, first in terracotta and later in plaster. Plaster has the great advantage of being able to be modelled while wet and carved when dry, and it also allowed Moore to increase the scale of his work. The early terracottas, such as plates 49, 50 and 53, were always carefully preserved – for terracotta is regarded as a sculptural medium in its own right – but to begin with Moore had no particular feeling for the plasters and many early examples were destroyed, either deliberately at the foundries or through neglect.

At the end of the 1950s, however, Moore's liking for the medium increased. He began to make versions of the same sculpture in more than one size. Typically, there would first be a maquette, up to 15 cm in size, which could be held in the hand. This had a number of advantages. Whereas a drawing could show only a single or, at most, half a dozen different views, leaving Moore with the problem of having to 'invent' the other views should he wish to realize the idea in three dimensions, the maquette was immediately three-dimensional and could be looked at from any position he chose. In addition, it meant that he could model a work without

one particular view being dominant, as was inevitable with a drawing.

Another advantage of this procedure was that, if Moore wished to make the work bigger, the three-dimensional maquette could be used as the means of enlargement. If the work was to be over life-size, an intermediate working model was often made on which changes, simplifications or modifications could first be carried out. Moore always employed young professional sculptors as assistants to help with these enlargements. Generations of artists passed through his studios. After Arthur Jackson and Bernard Meadows in the 1930s, over fifty sculptors worked at Perry Green (including Anthony Caro and Phillip King in the 1950s), some of whom, such as Brigitta Meier Denninghof, came briefly to help on specific projects.

A maquette would usually be made of solid plaster, although occasionally Moore would build on to a large armature or incorporate a found object. For larger sizes a more complex framework would be constructed, using a wood or metal structure to which chicken wire, string, hessian, cotton cloth, paper and other material would be applied along with plaster. When the assistants had the enlargement mathematically correct, Moore would make any necessary changes and carefully work the surface. This he found difficult if the plaster remained white, as its brightness obscured the modelling. He therefore coloured the surface using a mix of walnut crystals or watercolour to emphasize the forms. This surface colour would be added to, intensified or sometimes obscured by the various varnishes and shellacs used at the foundry in the course of taking moulds from the plaster.

By the middle of the 1960s the studios at Perry Green were packed with plasters that had been returned from the foundries following the completion of bronze editions. Many came back in poor

condition, with their carefully worked surfaces damaged or with an arm or a leg missing; the process of casting necessitated the cutting or slicing of the plasters into sections, which often entailed the destruction of their wood or metal armature. The plasters of several important works, such as *Family Group* (1948–49; LH 269) and *Double Oval* (1966; LH 560), have been lost without trace, only photographic evidence remaining. However, as Moore's liking for the plasters and his realization of their importance grew, he decided that those which were restorable should be preserved. An impetus to this programme of conservation was provided by the creation in 1974 of the Henry Moore Sculpture Centre within the Art Gallery of Ontario in Toronto, which offered a suitable space for the works both to be protected and to be seen by the public. Moore's assistants at that time, John Farham, Michel Muller and Malcolm Woodward, all worked on the restoration prior to the plasters' shipment to Canada, Farham concentrating on the maquettes while Muller and Woodward put together what were, in effect, three-dimensional jigsaw puzzles of the larger works. With the setting up of the Henry Moore Foundation in 1977 the restoration programme became progressively more systematic, each original plaster also being photographed and fully catalogued.

Although many of the plasters are now in Canada, and others were given to the Tate Gallery in London, the Foundation holds a fully representative selection. This collection has been drawn on extensively for the present publication and for the exhibition that it originally accompanied. For conservation reasons very few of the plasters have been exhibited. However, many of them have recently been conserved by Farham, Muller and Woodward in order to permit a detailed examination of Moore's plasters in relation to his drawings and carvings. DM

The artist in his studio at Hoglands, 1954, with *Upright Internal/External Form* (LH 297; see plate 59) and the plaster *Warrior with Shield* (plate 64)

It is a mistake for a sculptor or a painter to speak or write very often about his job. It releases tension needed for his work. By trying to express his aims with rounded-off logical exactness, he can easily become a theorist whose actual work is only a caged-in exposition of conceptions evolved in terms of logic and words....It is likely, then, that a sculptor can give, from his own conscious experience, clues which will help others in their approach to sculpture.

From 'Notes on Sculpture' (1937), reprinted in *Henry Moore: Complete Sculpture*, vol. 1, 1988, p. xxxiii

1
Small Animal Head 1921
boxwood
h. 11.4 cm
LH 1a
The Henry Moore Foundation: gift of the artist 1977

Moore was never known as a sculptor of animals, yet his oeuvre contains a large number of works depicting animals or based on their forms. The sculptures are particularly numerous in his very early work, and indeed the first two carvings shown here, both made while he was still a student, are of animals. Of *Small Animal Head*, so different from *Dog* (plate 2) and the artist's other animal sculptures, Moore said: 'This animal head was carved from a very small piece of boxwood, no bigger than my hand. Boxwood is quite common in England. The trees grow very slowly and slow growth produces a harder and closer-grained wood than fast growing trees.'[1] The work was obviously carved directly, with the shape of the block to a great extent dictating the form of the sculpture.

Wood became a favourite medium with Moore and during the 1930s he experimented with a great variety of types, partly as a result of a generous gift of woods from around the Commonwealth given to him between 1932 and 1935 by the Commonwealth Institute in London. Many years after *Small Animal Head* was created he wrote: 'The finishing of wood is a slow process because you have to cut across the grain or it splits. Also a small wood carving takes longer and is more tedious than a small stone carving. I don't mean tedious in the sense that it is not enjoyable, I mean that one has to have more patience. For example, a small wood piece like the *Animal Head* (in fact this actual sculpture) might take nearly as long as a life-size model.'[2] JS

1 HMF archive.
2 HMF archive.

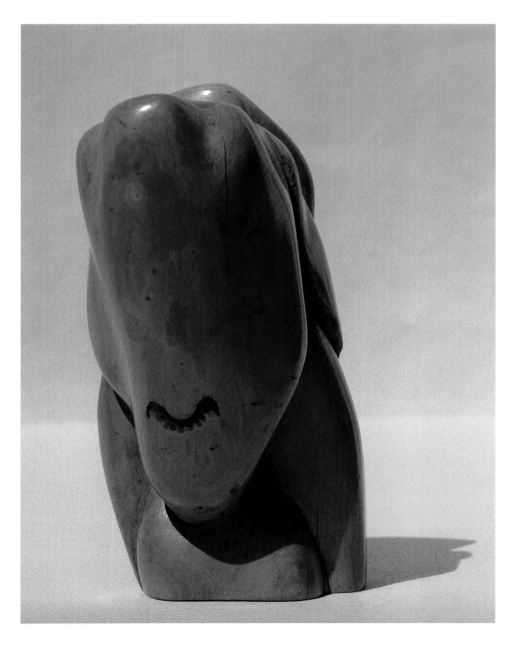

2
Dog 1922
marble
h. 17.8 cm
LH 2
The Henry Moore Foundation:
gift of the artist 1977

Moore was studying at the Royal College
of Art when he made this work and was
exploring a variety of sources and styles,
which he interpreted in his own manner.
The influence of Henri Gaudier-Brzeska
on this and Moore's other animal carvings
of the period is very clear. *Dog* is his
earliest known work in marble. It was
carved at the School House in Wighton,
where Moore spent his holidays in the
early 1920s. The family moved from their
native Castleford when his father became
ill, and his sister took up the post of
teacher at the local school in Wighton.
There are photographs of Moore in the
garden at Wighton which show *Dog*, his
first *Mother and Child*, in Portland stone,
and a piece of white marble that looks as
if he has just begun to carve it (fig. 1). In
the early 1980s the present owners of the
house found a block of marble buried in
the garden; when they showed it to Moore
he confirmed it to be this unfinished
carving. JS

Fig. 1 The artist with *Dog* and *Mother and Child*
(LH 3) in the School House garden at Wighton,
c. 1923

3
Head of the Virgin 1922
marble
h. 53.2 cm
LH 6
The Henry Moore Foundation:
purchased 1988

A mature confidence can already be
detected in this student work, carved
during Moore's time at the Royal College
of Art, London. It was made as an
academic exercise, set by Francis Derwent
Wood, Professor of Sculpture at the
College, in copying a Renaissance head.
Moore, anxious to show off his skill, had
asked whether he could carve directly, but
was told this would not produce an
accurate copy. He was instructed to make
a plaster model and use the pointing
machine to translate it into marble. He
persuaded his friend and tutor Barry Hart
to let him carve direct, and chose as his
model *Virgin and Child with Three
Cherub Heads* by Domenico Rosselli in
the Victoria and Albert Museum. While
carving exactly in the manner of the
Renaissance craftsmen, proving his care
and skill in the academic manner, Moore
chose to exaggerate the three-dimensional
quality of the head, while the rough
chiselling that surrounds it emphasizes the
smooth marble of the head itself. To aid
the deception further he peppered the
Virgin's face with tiny holes like those left
by a pointing machine. The experiment
was successful and the professor was
taken in. This work reveals the frustration
Moore was experiencing in his formal
studies. His more personal work was
developing strongly in a direction far
more closely associated with the Mexican
and tribal art that he was studying during
his visits to the British Museum. JS

4
Head of a Girl 1923
clay
h. 17.5 cm
LH 15
The Henry Moore Foundation:
gift of the artist 1977

This little head, modelled rather than
carved, exhibits formal purity of a kind
to be found in some African heads and, at
the same time, the extraordinary Classical
clarity seen in the works of an early
Renaissance painter such as Piero della
Francesca, whom Moore greatly ad-
mired.[1] For years the material of this
sculpture was recorded as terracotta,
but latterly it has been concluded that
the work was made in white clay. Moore
did not begin having bronze editions of
his sculpture cast until after the Second
World War, but there are a few excep-
tions, including this head, of which the
total number of casts is not recorded. JS

1 *Henry Moore: The Human Dimension*, exh. cat.,
1991, p. 35.

In my opinion, long and intense study of the human figure is the necessary foundation for a sculptor. The human figure is the most complex and subtle and difficult to grasp in form and construction, and so it makes the most exacting form for study and comprehension.

From *Sculpture and Drawings by Henry Moore*, exh. cat., 1951, p. 4

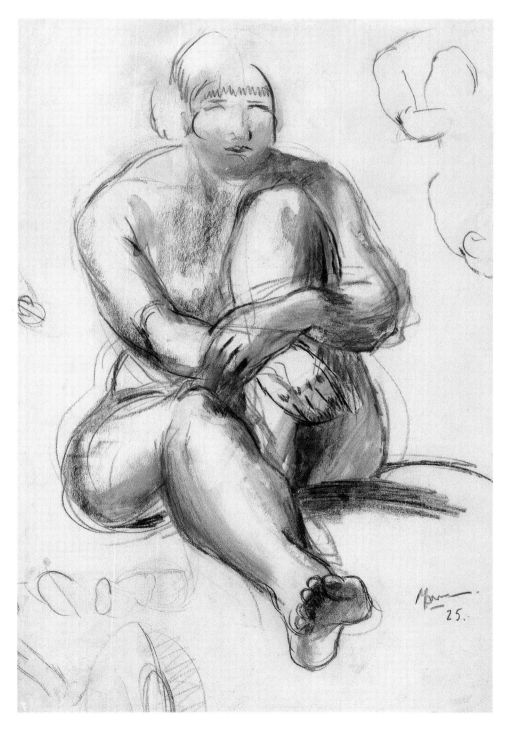

5
Nude Study of Seated Girl *c*. 1924
chalk, watercolour
425 x 350 mm
HMF 256a
The Henry Moore Foundation:
acquired by exchange 1981

The sculptural quality of Moore's drawings is often taken for granted, but it is of enormous interest and importance in his oeuvre. As already noted (see plate 3), Moore's time at the Royal College of Art was not without its problems. He felt he had little to learn from the tutors, with the notable exception of the artist Leon Underwood, who left the College in 1923 in a fit of pique. Later that summer Moore, his friend Raymond Coxon and a few other students approached Underwood in his studio and asked him to give them evening classes, for which they would pay two shillings and sixpence a week, leave him their best drawings, keep the studio tidy and look after the stove.[1] Moore benefited enormously from this instruction, and his strong drawings from this period have a freedom that he was unable to develop under the formal constraints of study at the Royal College.
JS

1 Berthoud, 1987, pp. 73–4.

6
Seated Figure 1924
Hopton Wood stone
h. 25.4 cm
LH 19
The Henry Moore Foundation:
gift of the artist 1977

'A sculpture must have its own life.
Rather than give the impression of a
smaller object carved out of a bigger
block, it should make the observer feel
that what he is seeing contains within
itself its own organic energy thrusting
outwards – if a work of sculpture has its
own life and form, it will be alive and
expansive, seeming larger than the stone
or wood from which it is carved. It should
always give the impression, whether
carved or modelled, of having grown
organically, created by pressure from
within.'[1] This work was left unfinished
for reasons that are not recorded. Tool
marks can be observed on the hands and
legs at the front of the sculpture. These
have been left rough, while the shoulders
and knees, which give the sculpture its
form and character, have been carefully
finished. Norbert Lynton points to the in-
fluence both of archaic sculpture at the
British Museum and of Henri Gaudier-
Brzeska and Jacob Epstein, artists whose
work can be seen to have had an impact
on Moore at this time.[2] JS

1 Moore, in Edouard Roditi, *Dialogues on Art*,
London, 1960, p. 196.
2 *Henry Moore: The Human Dimension*, exh. cat.,
1991, p. 38.

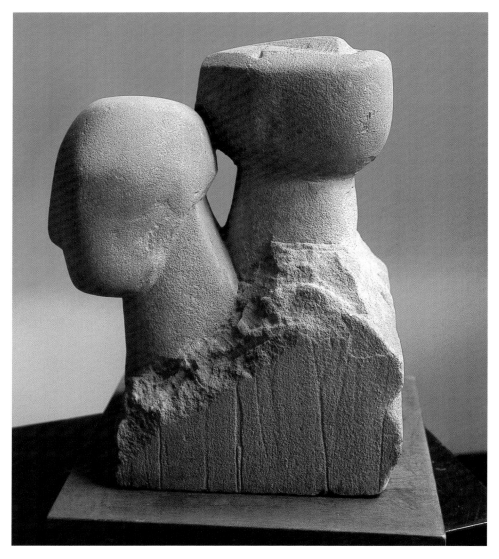

7
Two Heads 1924
Mansfield stone
h. 31.7 cm
LH 25
The Henry Moore Foundation:
gift of Irina Moore 1977

Moore won a travelling scholarship to
Italy in 1924, which he took up slightly
grudgingly, as he would have been more
interested in concentrating his research in
Paris or visiting Germany. He was trying
to reject the influence both of the Re-
naissance and of Ancient Greece, but as
John Russell has put it, the impact of
Michelangelo, Donatello and Masaccio
in Florence and of Titian and Tintoretto
in Venice 'did lasting damage to the idea

that what mattered most was non-
European art. Not that the idea was ever
dropped.... Moore knows the British
Museum and the Musée de l'Homme in
Paris as few people know them. But the
two enthusiasms had somehow to be
reconciled.'[1] *Two Heads* can best be
described as a transitional piece, in which
the Cycladic influence is undoubtedly
strong and the shape of the block still
dictates the development of the forms.
Struggling to come to terms with the
language of sculpture that he had learned
in Italy, Moore was attempting to absorb
its influences. JS

1 Russell, 1968, p. 19.

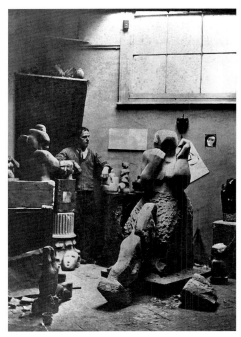

Fig. 2 3 Grove Studios, Hammersmith, *c.* 1927;
Head and Shoulders (now lost) is in the centre and
Woman with Upraised Arms in the foreground at left

66

Fig. 3 *Page 107 from Notebook No. 5 1925–26: Standing Figure*, 1925–26 (HMF 406); pencil, 222 x 178 cm; The Henry Moore Foundation: gift of the artist 1977

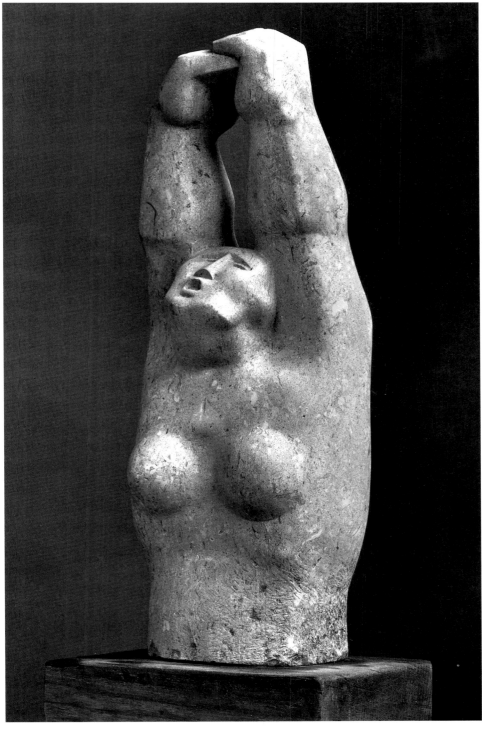

8

Woman with Upraised Arms 1924–25
Hopton Wood stone
h. 43.2 cm
LH 23
The Henry Moore Foundation:
gift of the artist 1977

This carving embodies an uncharacteristically dramatic gesture, unique in Moore's work. At this early stage in his career he was obviously experimenting with all forms of expression. Norbert Lynton finds strong art historical precedents for the work: 'This sculpture suggests Rodin in its gesture, Gaudier in the formal interaction of the raised arms, and the agonised, much simplified face of Eve in Masaccio's Brancacci Chapel frescoes. Moore visited these last repeatedly while in Florence (on his visit to Italy in 1925). They confirmed for him what

Piero's paintings had already suggested, that the sculpturally powerful forms he knew from primitive cultures could be found also within the range of Renaissance and pre-Renaissance art.'[1] Whatever its sources, the sculpture is undoubtedly an example of that energy and freedom of expression which begins to become apparent in the free carvings that Moore produced during his last year at the Royal College of Art.

A hitherto unrecorded sculpture from this period, *Head and Shoulders* (fig. 2), was recently identified in a photograph

taken in 1930 of the artist Gertrude Hermes in a garden in Suffolk. It exhibits the same energy as *Woman with Upraised Arms* and its source is found in a series of ten drawings from *Notebook No. 5* of 1925–26 (pages 89–107, HMF 397–406; fig. 3) that are also closely related in expression to *Woman with Upraised Arms*. JS

1 *Henry Moore: The Human Dimension*, exh. cat., 1991, p. 40.

I love drawing and always have done from the time I was a boy at school – it was the lesson I enjoyed most. As an art student, I realised that the great sculptors whom I admired – Michelangelo, Bernini, Rodin – had all been great draughtsmen. Ingres said 'Drawing is the probity of art', and I believe it is an essential foundation.

From *Henry Moore: Drawings 1969–79*, exh. cat., 1979, p. 5

9
Ideas for Sculpture: Standing Nudes with Clasped Hands c. 1925
brush and ink
251 x 306 mm
HMF 361
The Henry Moore Foundation:
gift of the artist 1977

Moore's drawing of this period is characterized by two different strains:

the academic life drawings, obviously produced in conjunction with his studies at the Royal College of Art, and the freer drawings, such as this one, in which he was exploring forms and shapes, poses and attitudes more strongly influenced by his independent observation of the collections of 'primitive' art at the British Museum. The faces of the figures in the present drawing foreshadow the heads in

his carvings of the late 1920s and early 1930s, such as *Girl with Clasped Hands* (plate 16). The tilt of the head and the treatment of the hair, as well as the facial expression and the hand gestures, appear again and again in the carvings of the next few years. JS

10
Two Studies of Female Nude 1928
brush and ink, chalk, wash, charcoal
washed
342 x 423 mm
HMF 649a
The Henry Moore Foundation:
purchased 1982

Many life drawings have survived from
Moore's visits to Paris at the end of the
1920s, during which he attended classes
at the Colarossi and Grande Chaumière
academies. At the end of a session of life
drawing the model would often be asked
to change position very quickly with each
pose being held for a progressively shorter
time, forcing the artist to react swiftly and
spontaneously. This particular work is
unusual as it records two poses on the
same sheet. DM

11
Reclining Figures 1928
crayon
203 x 298 mm
HMF 655
The Henry Moore Foundation:
gift of the artist 1977

Kenneth Clark wrote in 1974: 'It is im-
possible to write about Henry Moore's
drawings without also writing about his
sculpture. The best of them are studies for
sculptural ideas, and even the early draw-
ings of models seem to be part of the
process of discovering his feelings about
shape and weight that were later to be
realized in wood, metal or stone.'[1] This
is particularly true of a drawing such as
this from 1928 which, with extraordinary
economy of line, seems to be an outpour-
ing of sculptural ideas on the theme of
the reclining figure and relates directly to
Reclining Figure of 1929 (fig. 4). JS

1 Clark, 1974, p. 11.

70

There are three fundamental poses of the human figure. One is standing, another is seated, and the third is lying down. Now if you like to carve the human figure in stone, as I do, the standing pose is no good. Stone is not so strong as bone, and the figure will break off at the ankles and topple over. The early Greeks solved this problem by draping the figure and covering the ankles. Later on they supported it against a silly tree trunk.

But with either the seated or the reclining figure one doesn't have this worry. And between them are enough variations to occupy any sculptor for a lifetime. In fact if I were told that from now on I should have stone only for seated figures I should not mind at all.

But of these three poses, the reclining figure gives most freedom, compositionally and spatially. The seated figure has to have something to sit on. You can't free it from its pedestal. A reclining figure can recline on any surface. It is free and stable at the same time. It fits in with my belief that sculpture should be permanent, should last for eternity. Also it has repose.

Quoted in J. D. Morse, 'Henry Moore Comes to America', *Magazine of Art*, vol. 40, no. 3, 1947, pp. 100–1

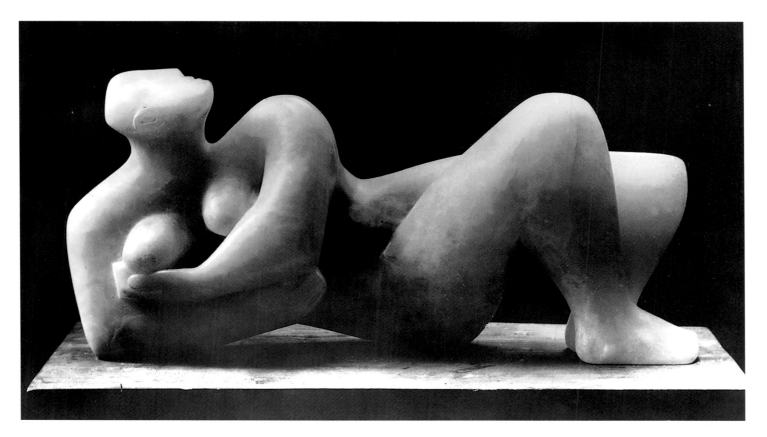

Fig. 4 *Reclining Figure*, 1929 (LH 71); alabaster, l. 47.5 cm; private collection

12
Studies for Reclining Figure with Child
1928
pen and ink
327 x 424 mm
HMF 682
The Henry Moore Foundation:
gift of the artist 1997

Although this page of studies for a
reclining figure with child was never
followed through in three dimensions, its
subject-matter, mood, expression and
even technique continued to be a power-
ful influence in Moore's work through to
the early 1980s, even though the number
of sculptures produced on this theme
remained comparatively few. Included
here, for example, is *Reclining Mother
and Child* of 1974–75 (plate 98), which

is close in form, though not in style, to
this drawing of forty years earlier. Moore
explained that he would often begin the
day with an idea and work it out on
paper: 'you would give yourself a theme
and let the variations come, and choose
from those which one seemed the best.'[1]
This time-honoured tradition of filling
the page around a drawing with sketches
based on the same idea dates back to the
Renaissance. It was a practice Moore
followed widely during this period, using
the sketches to generate ideas and find
variations on them. DM/JS

1 David Sylvester, 'Henry Moore Talking', *Listener*,
vol. 70, no. 1796, 29 August 1963, quoted in Moore,
1966, p. 150.

13
Three-Quarter Figure 1928
pen and brush, ink, chalk, watercolour
311 x 229 mm
HMF 663
The Henry Moore Foundation:
purchased 1982

Moore was excited by the possibilities
of casting and carving concrete. *Three-
Quarter Figure* would seem to be a draw-
ing of a cast sculpture emerging from its
mould with the left arm still entrapped in
a section of the mould. Although there is
no sculpture exactly comparable to the
drawing, *Half Figure* of 1929 (LH 67)
would have been made in this way. DM

14
Seated Nude 1930
charcoal, wash
426 x 340 mm
HMF 771
The Henry Moore Foundation:
gift of the artist 1977

'Early on in his life drawings Moore dis-
covered those aspects in the figure that
were to become necessary to him, and
that must have embodied deeply buried
experiences. These can be described by
the words "mass" and "weight". It was
partly the sculptor's feeling that form is
something one can put one's arms
round.'[1] Moore's woman here has a great
sense of weight, almost an awareness of
gravity, but that is not to say that she is
graceless and heavy; indeed, she is nubile
and alert, with the full breasts and
rounded thighs of a young woman. JS

1 Clark, 1974, p. 11.

15
Seated Figure 1930
charcoal, oil, pastel, wash, brush and ink
513 x 367 mm
HMF 782
The Henry Moore Foundation:
gift of the artist 1977

This carefully posed seated figure is
neither a life drawing nor an idea for
sculpture, but contains elements of both.
It probably began as a drawing from life
to which Moore has added a high degree
of modelling using oil-based paint. The
simplified features of the head, thickened
neck, and positioning of the torso all
foreshadow the carvings of the period,
while the treatment of the hands, legs and
particularly the feet remain more linear
and naturalistic. DM

...you would not put features on the back of a head to make the head as interesting as the face, because it's the difference between the back of the head and the front of the face of the human being which makes it interesting. But this doesn't mean that the back has no shape.

Extract from conversations with the artist recorded by David Mitchinson, Much Hadham, 1980, first published in Mitchinson, 1981, p. 192

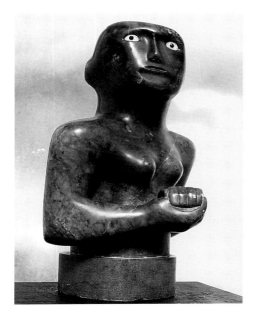

Fig. 5 Another view of *Girl with Clasped Hands* (plate 16)

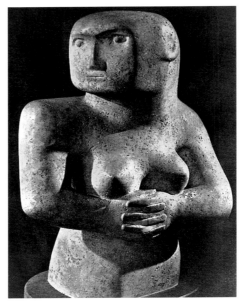

Fig. 6 *Figure with Clasped Hands*, 1929 (LH 60); travertine marble, h. 45.7 cm; Tel Aviv Museum

16
Girl with Clasped Hands 1930
Cumberland alabaster
h. 41.5 cm
LH 93
The British Council, London

This work marks a departure from the older tradition of British carving, that of Jacob Epstein and Henri Gaudier-Brzeska. Susan Compton states: 'this stone head with staring, coloured eyes like those of some antique mask, crowns a carving that denies the seductive quality usually connected with alabaster. Moore has penetrated the solid stone with beautifully worked holes between the arms and torso, anticipating his later freedom in carvings.'[1] She notes that the work has more affinity with the early carvings of Moore's contemporary Barbara Hepworth. One of a series of half figures made at this time, it is similar to *Figure with Clasped Hands* of 1929 (fig. 6), but even in the year that separates the two sculptures Moore has found greater freedom in both the form and the stone, paving the way for his abstract carvings of the 1930s. JS

1 *Henry Moore*, exh. cat., 1988, p. 175.

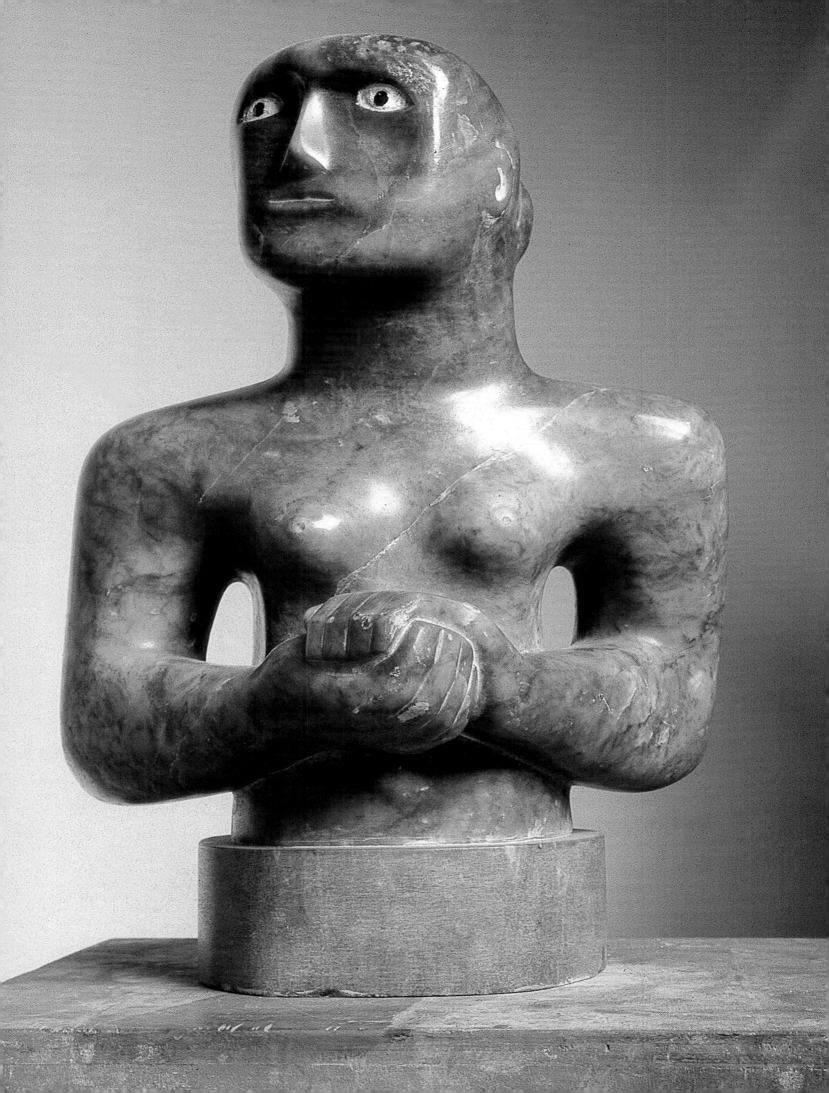

...sculpture compared with drawing is a slow means of expression, and I find drawing a useful outlet for ideas which there is not time enough to realise as sculpture. And I use drawing as a method of study and observation of natural forms (drawings from life, drawings of bones, shells, etc.).

From 'Notes on Sculpture' (1937), reprinted in *Henry Moore: Complete Sculpture*, vol. 1, 1988, p. xxxv

17
Ideas for Sculpture 1930
pencil, brush and ink
200 x 238 mm
HMF 808
Art Gallery of Ontario, Toronto:
gift of Henry Moore 1974

What started as a page of bone-like shapes and forms has been transformed by a few pencil strokes into fully recognizable three-dimensional sculptural ideas. Of special interest is the evolution from natural forms of the sculptural idea fully conceived in the top right-hand figures of the drawing: these head and shoulders sketches are studies for *Composition* of 1931 (plate 18). Hitherto the majority of Moore's drawings for sculpture had been based on the human figure, particularly the female form, either Classically European or derived from the art of a 'primitive' culture, but now he has found a new form in the organic world around him which he can imbue with a human spirit and dignity. JS

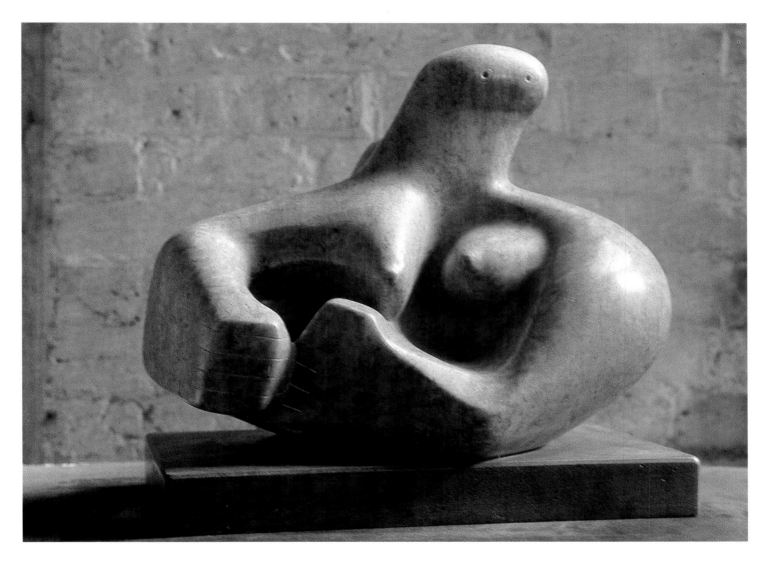

18
Composition 1931
Cumberland alabaster
l. 41.5 cm
LH 102
The Henry Moore Foundation:
gift of Irina Moore 1979

This is one of Moore's most economical expressions of the female form. With its sparse facial features, powerful arms and shoulders, and full breasts, the figure sums up one of the most important aspects of women for Moore, that of the protective and protecting female. Susan

Compton believes the inspiration for this work might be found in the Egyptian fertility goddesses, tiny figures modelled in clay with similarly snake-like heads, to be seen at the British Museum. But the final rendering of the form, the vitality and power inherent in the work, belong entirely to Moore. What has occupied him here is the presence of the woman as expressed through her body: 'Two arms making a circle and the two breasts nosing each other for company.'[1]

Moore himself wrote in 1934: 'It's no use modern sculpture being only an

imitation of ancient sculpture but it must have its life and vitality, intensity and power, sensitiveness and emotional fullness to be able to stand up to it.'[2] JS

1 John Berger, 'A Sense of Touch', *Guardian*, 21 September 1989, reprinted under the title 'Infancy' in *Keeping a Rendezvous*, London, 1992, p. 157.
2 Inscription on a drawing of 1934, *Page from Square Forms Notebook: Nineteen Ideas for Sculpture* (HMF 1120).

19
Studies of Shells and Pebbles 1932
pencil, crayon, pen and ink
248 x 171 mm
HMF 946
Arts Council of Great Britain

20
Studies and Transformation of Bones,
Shells and Mushroom 1932
pencil
248 x 171 mm
HMF 947
Arts Council of Great Britain

The 'transformation' drawings mark a
new departure in Moore's work: there is
nothing like them in the sketchbooks of
the 1920s. They begin to appear in about
1932 and contain sculptural ideas to
which the artist returned throughout his
long career. Kenneth Clark described this
phase in Moore's work as 'looking
inwards'. Certainly, these drawings
appear to exhibit a more explorative and
perhaps even intellectual approach to
form. Many observers have pointed out

21
Ideas for Sculpture:
Transformation of Bones 1932
pencil
229 x 203 mm
HMF 969
Arts Council of Great Britain

22
Ideas for Sculpture:
Transformation of Bones 1932
pencil, collage
229 x 203 mm
HMF 970
Arts Council of Great Britain

that they show Moore's first systematic study of *objets trouvés*. This may be so, but the shells, pebbles, bones and stones jumbled together with metamorphosing sculptural form suggest a thought process different from that of systematic exploration. It is difficult to tell whether the emerging sculptural ideas are emanating from the natural objects or whether the natural objects themselves have become animate. Moore notes on *Studies of Shells and Pebbles*: 'limestone pebble faceted on

curves by wind blown sand found on desert'. At this stage in his career he became fascinated by the effect of nature on objects, and later he would include natural forms, such as shells and pebbles, in his sculptures, for example *Seated Mother and Child* of 1975 (plate 104).

In the second pair of drawings (plates 21 and 22) the heads have become minimized, as was to happen so frequently in Moore's later sculpture, the emphasis being on the forms of the body. Clark was

slightly troubled by the 'transformation' drawings, describing them as spooky: 'These drawings are entirely personal; they come from a part of his imagination of which he himself seems hardly to have been aware.'[1] It is arguable, however, that the drawings represent the moment when Moore finally gained full control and command of his artistic vocabulary. JS

1 Clark, 1974, pp. 63–4.

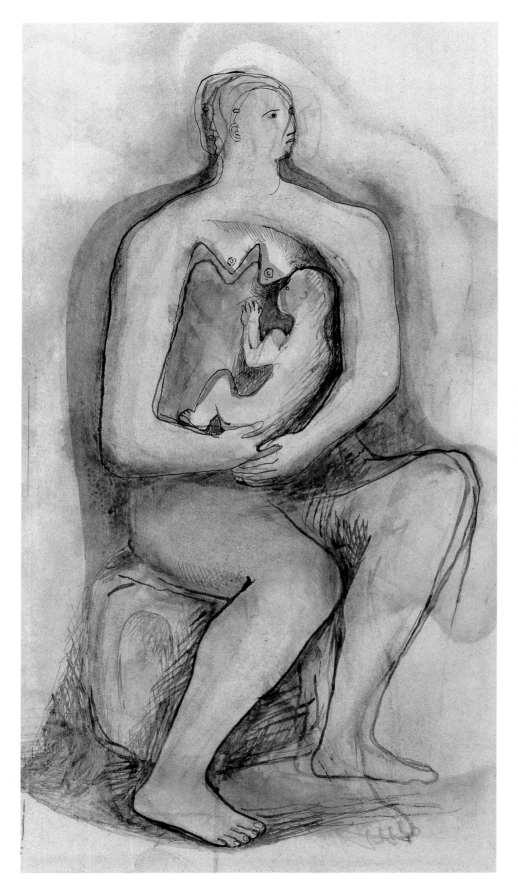

23
Seated Mother and Child 1933
charcoal, washed pastel, pen and ink,
ink wash
556 x 374 mm
HMF 1001
The Henry Moore Foundation:
gift of the artist 1977

In this work, the outline of a third foot
and a second face add to the ghostly
presences surrounding the whole figure,
which contrast so strongly with the tender
image of a suckling child. The mother's
body is the ever warm and comforting,
hiding and nourishing place, but she
herself is open and vulnerable to the
forces around her.

In the artist's hand is inscribed on the
top edge the words 'large mother and
child'. Down the right-hand side are
noted instructions for framing: '2″ cream
mount all around 2 1/4 at bottom. New
frame – thin 1/2 plain wood frame.'
Moore wrote on many of his drawings,
especially in the sketchbooks, either
comments about the subject-matter and
the treatment of certain forms or *aide-
memoires* for ideas. However, it is
relatively unusual to find a fully executed
drawing with inscriptions, especially of
such a practical kind. CH/JS

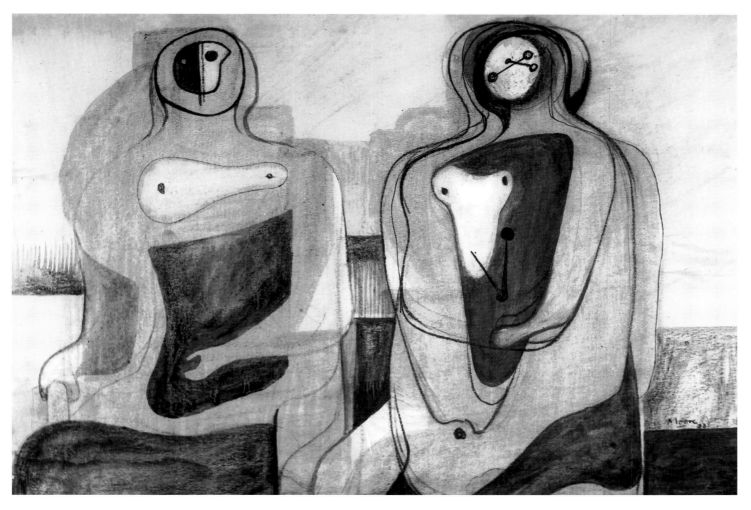

24
Two Seated Women c. 1934
(dated 1933)
charcoal, watercolour wash, pen and ink,
crayon
370 x 553 mm
HMF 1077
The Henry Moore Foundation:
purchased 1983

This work is made up of a series of flat
tonal planes and hard edges, with each
element carefully overlaid to give an
illusion of depth. The areas which Moore
wanted to bring forward, such as the
breasts and facial features, are made the
lightest, the others receding through grey
to black as the drawing builds up in
shallow relief, perhaps reminiscent of a

construction by Ben Nicholson. Drawings
of this size which Moore made during
the mid-1930s always derived from quick
pencil sketches and would often be com-
posite arrangements with the individual
elements stemming from different sources.
Compare this drawing with plate 35 for
an example of this procedure. DM

25
*Studies for Several-Piece Carvings and
Wood Carvings* 1934
chalk
213 x 271 mm
HMF 1102
The Henry Moore Foundation:
gift of the artist 1977

Moore carved three multipart sculptures
in Cumberland alabaster during 1934 –
Head and Ball (LH 151), *Bird and Egg*
(LH 152) and *Four-Piece Composition:
Reclining Figure* (LH 154) – studies for
which can be found in the sketchbook
pages of the time. In the present drawing
dismembered objects on the left are early
ideas for what was to become *Four-Piece*

Composition: Reclining Figure (fig. 7). At
least three pages of studies of the separate
elements of this carving are known: in
this sheet the 'leg end' sections and the
tiny ball appear, though no attempt has
been made either to combine them on the
page as they appear in the sculpture or to
present them arranged on a base. Some of
the sketches on the right of the sheet are
shown in position on bases and may be
sketches for wood-carvings made at this
time but later destroyed. The tiny figure
on the upper right of the left-hand side of
plate 26 is drawn on a base and clearly
relates to *Four-Piece Composition:
Reclining Figure*, this time indicating the
'head end'. DM

84

Sheet of Squarish forms.

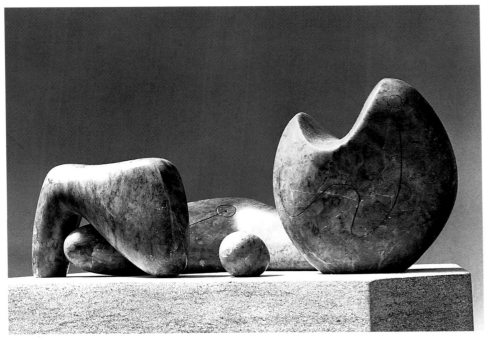

26
Studies for Square Forms 1934
chalk, pencil
200 x 274 mm
HMF 1103
The Henry Moore Foundation:
gift of the artist 1977

Fig. 7 *Four-Piece Composition: Reclining Figure,* 1934 (LH 154); Cumberland alabaster, l. 51 cm;
Trustees of the Tate Gallery, London

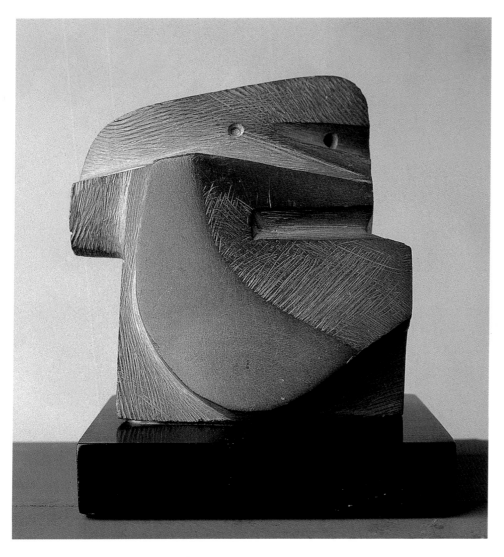

27
Carving 1934
African wonderstone
h. 9.8 cm
LH 142
The Henry Moore Foundation:
gift of Irina Moore 1977

The form of this tiny carving is clearly
dictated by the size of the stone. Bernard
Meadows, Moore's assistant during the
1930s, recalls that the artist was interested
in the rich variety of materials available
in and around London at the time. He was
particularly keen to utilize native British
stones, such as Mansfield, Hopton Wood,
Ancaster, Hornton, Corsham and
Cumberland alabaster, all of which are
represented here, but when such an un-
usual material as African wonderstone

became available he was always excited
to experiment with it. Meadows believes
that Moore had a friendly stonemason
in London who would let the artist know
if he came across any unusual stones that
he thought might be of interest. Alan
Bowness, biographer of Barbara Hep-
worth, has confirmed that she, too, was
intent on obtaining obscure stones, many
of which – including Burgundy stone
and African wonderstone – she used in
common with Moore.

This little carving seems to have been
conceived without reference to anything
outside itself. A comparison of this very
abstract piece with a rather more realistic
one (plate 39) indicates the wide range of
Moore's imagery at this time. JS

28
Hole and Lump 1934
elmwood
h. 68.6 cm
LH 154a
The Henry Moore Foundation:
gift of the artist 1979

Elm became a favourite wood with
Moore, one which he used widely for
both large and smaller sculptures from
the 1920s through to the last elmwood
reclining figure of 1978. The date ascribed
to the present sculpture probably refers
to the maquette (now lost) from which
the carving was enlarged, for Bernard
Meadows remembers working on the
piece immediately after his arrival as
Moore's assistant in 1936.

Moore wrote in 1958: 'At one time
the holes in my sculpture were made for
their own sakes. Because I was trying to
become conscious of spaces in the sculp-
ture – I made the hole have a shape in its
own right, the solid body was encroached
upon, eaten into, and sometimes the form
was only the shell holding the hole.'[1]

This sculpture was created during the
period when Moore lived and worked in
Hampstead along with many other artists,
including Ben Nicholson and Barbara
Hepworth, and it is obvious that in the
hothouse atmosphere of the time ideas
and influences would have been freely
exchanged. Hepworth, too, had carved
her first abstract hole at the beginning of
the decade – indeed, there was throughout
their lives an open rivalry as to which of
them had first pierced a block of stone.
The difference between Moore and
Hepworth came most starkly to the fore
in 1934: she was pursuing a universal,
abstract beauty, whereas Moore could
never get away from the human element
present in his work. JS

1 Quoted in Felix H. Man, *Eight European Artists*,
London, 1954, reprinted in Moore, 1966, p. 118.

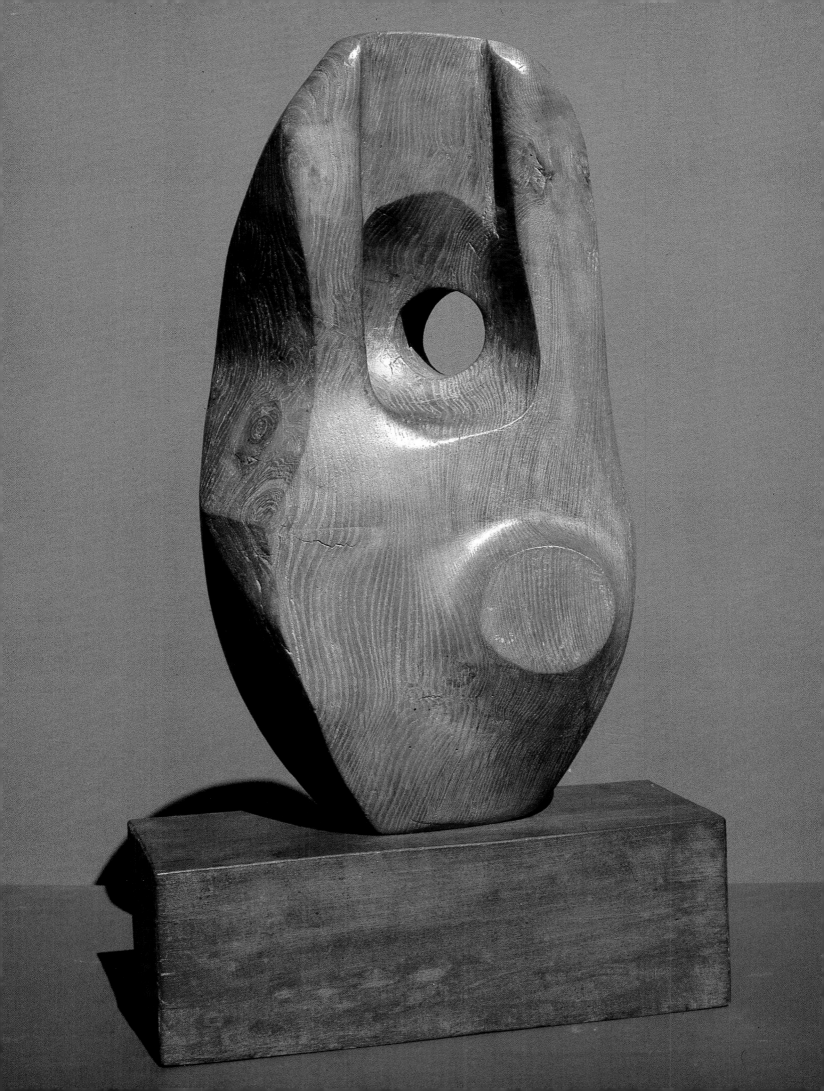

To begin with I didn't like much working in wood. You can't knock great big chunks off a piece of wood – you have to saw them. But you can only saw in a straight line. And the finishing of wood is (or was) a slower process because you have to cut across the grain instead of down it. Otherwise it splits. But later I began to like wood very much even in the big scale. Now the wood in England that you can get in big sizes is elm because the elm tree grows very thick. Unfortunately one may now find that elm disease is reducing the available large trunks.

What wood can do that stone doesn't is still give you the sense of it having grown, whereas stone doesn't grow – it's a deposit. Also for me the grain of the wood plays a part and makes it alive.

Extract from conversations with the artist recorded by David Mitchinson, Much Hadham, 1980, first published in Mitchinson, 1981, p. 98

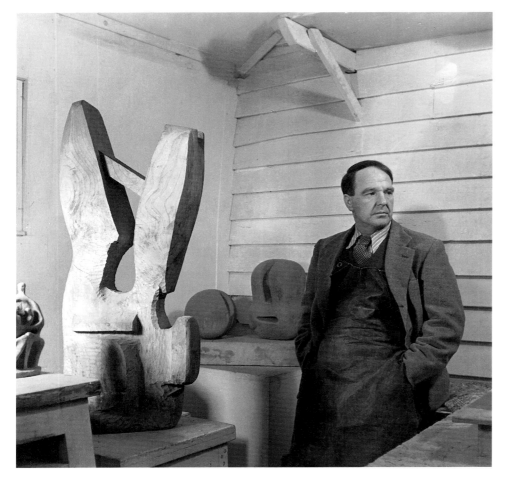

Fig. 8 Moore in his studio, c. 1941, with *Family*, showing the 'tie' between the two upper sections of the sculpture

29
Family 1935
elmwood
h. 101.6 cm
LH 157a
The Henry Moore Foundation:
gift of the artist 1977

Here Moore has carved deep into the block of elmwood with supreme confidence. The sculpture is divided almost completely in two, the higher section with its sloping face dominating the rest of the piece. It is a strange mixture of flowing forms and sharp lines. Bernard Meadows recalls that Moore was a little uncertain about the sculpture and worked on it over a period of many years, not completing it until the beginning of the Second World War. Meadows describes the sculpture as being rather like a piece of music with runs and pauses, the pauses perhaps being signified by the straight lines, the runs by the sweeping curves. It bridges the gap in Moore's work at this time between the abstracted pieces, which contain a small element of humanity, and the more realistic sculptures, which, in turn, exhibit something of the abstract. In a drawing of this sculpture (plate 41) there is far more surface detail than in the carving. The drawing shows the cross brace between the two upper sections that was removed on Moore's instruction in the 1960s (see also fig. 8). JS

Carving 1935
walnut wood
h. 96.5 cm
LH 158
The Henry Moore Foundation:
gift of Irina Moore

The deep colour and the texture of walnut add richness to this sculpture from 1935. Moore was carving in wood and stone in about equal measure during the 1930s. It was a period when he experimented with many types of wood and stone, although he used walnut only twice, in *Composition* of 1933 (LH 132) and in the present piece. The wood is very hard, with a tight grain that Moore liked, and it is difficult to carve once dried. However, it is a very attractive wood that, he told Bernard Meadows, may detract from the effect of a sculpture, since the wood takes on a disproportionately strong presence. Meadows believes this work is successful because it does not fall prey to this danger, that it 'does not show up the sweetness of the wood like some do'.[1]

The sculpture will have been carved from a maquette, although none is known to exist, nor was Meadows aware of one during the 1930s. It is possible to see the tool marks where the artist has left some areas rougher than the others, which are worked smooth and highly polished. Meadows explained that with a sculpture like this it was sometimes difficult to know at precisely which moment to stop carving, when to decide that the work was 'finished'.[2] Like *Hole and Lump* (plate 28), *Carving* has been pierced by a hole. Since the hole is in one of the limbs, rather than in the centre of the block, as in *Hole and Lump*, its impact is less dramatic, not least because it cannot be seen from a straight front view. This carving is less three-dimensional than others from the mid-1930s shown here; it has a plain back that completely obscures the detail of the front of the sculpture when seen from the rear. JS

1 Conversation with the author, October 1995.
2 Ibid.

30
Square Form 1934
Burgundy stone
h. 31.7 cm
LH 154b
The Henry Moore Foundation:
gift of Irina Moore 1979

Moore said: 'Stone for me has a blunt squareness, a squareness where you round off the corners. This seems to be a natural form for a stone, and in fact I have called some of my sculptures "Square Form". On other occasions I have deliberately worked against the square idea, trying to eliminate the squareness of the original block.'[1]

This carving has a high degree of abstraction, and the surface shapes and markings appear initially to have very little to do with the form of the sculpture. Moore possessed a copy of the book *Kulturgeschichte Afrikas* by Leo Frobenius, published in 1933, which contains a large number of illustrations of bushmen's drawings on rock. Bernard Meadows recalls Moore being fascinated by the lines and shapes in these reproductions, and it would appear that the markings on this sculpture owe their genesis to such rock drawings. JS

1 Quoted in Hedgecoe, 1968, p. 86.

To me carving direct became a religion and I have practised it during my career as a sculptor. I liked the fact that you begin with the block and have to find the sculpture that's inside it. You have to overcome the resistance of the material by sheer determination and hard work. However, although I used to think that a work carved in stone or wood, carved in solid material, was ipso facto better than a modelled work, it isn't of course. It is the quality of the idea and the mind behind it that is important whether it is something sensitive and original rather than hackneyed. I mean they are both a form, both a sculpture. You can have a terracotta that is beautiful but I didn't think so then. I thought that the difficulty of carving added some kind of strength to it which the resistance of the material gave. But now I don't. I think what matters is the mind and vision of the person that is making the sculpture. If that comes through and it's not commonplace imitation vision then it's got some value no matter how clever the carving is. If it's ordinary, uninspired vision then its third-rate no matter how clever. Nowadays, I don't mind how a thing is done, it's what it is when it's done.

From Moore, 1983, p. 17

32
Carving 1936
travertine marble
h. 45.7 cm
LH 164
The Henry Moore Foundation:
gift of Irina Moore 1977

This work displays strong connections with Pre-Columbian Mexican sculpture, as well as showing the influence of Ben Nicholson's abstract reliefs. As with so many of Moore's abstract works, there is a strong human element. Norbert Lynton likens the sculpture's upper surface to a face upturned to the heavens.[1] In this thrusting gesture the piece bears more than a passing resemblance to *Woman with Upraised Arms* (plate 8).

This is one of a group of works carved between 1934 and 1936 in the garden of Moore's cottage, Burcroft, in Kent. When not teaching in London, Moore spent much of his time there, working with his assistant, Bernard Meadows – a routine that continued up to the war. Meadows recalls that, at the time, Moore and his wife, Irina, would refer to this sculpture between themselves as 'Tombstone to a Learner'.[2] Later, such nicknames were invented in order to differentiate individual pieces in the studios and were used not only by the artist himself, but also by those who worked with him, very often taking their lead from the shape of the sculpture or from an organic form within it.

Even at this stage in his career it is obvious that Moore was enormously economical with his images and sources. This piece, though singular in character, occupies an indubitably important place in the artist's work of the time. JS

1 *Henry Moore: The Human Dimension*, exh. cat., 1991, p. 58.
2 Conversation with the author, October 1995.

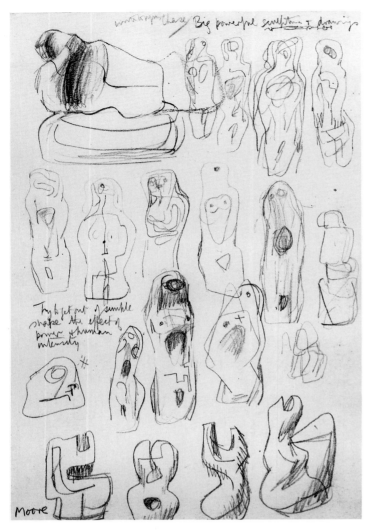

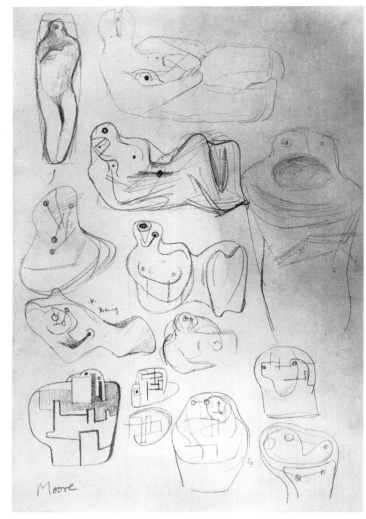

33
Page from Sketchbook 1935:
Simple Shapes 1935
pencil
273 x 181 mm
HMF 1182
The Henry Moore Foundation:
gift of the artist 1977

34
Page from Sketchbook 1935:
Ideas for Sculpture 1935
pencil
272 x 183 mm
HMF 1187
The Henry Moore Foundation:
gift of the artist 1977

During the mid-1930s Moore drew in a number of small upright notebooks. None of these has survived intact, but the dozens of existing pages show clearly the link between his drawings and his sculpture. Each individual sheet contains up to twenty tiny studies, which could serve as a memory bank to be drawn on for realization in larger size in either two or three dimensions. Virtually every sculpture of this period can be traced to these quick 'thumbnail' sketches. The mark ✳ indicated that a particular image was worthy of further consideration. In plate 34 the reclining figure singled out in

this way was to appear later the same year, drawn in reverse, in two larger works: *Eleven Ideas for Sculpture: Reclining Figures* (HMF 1150) and *Three Sculpture Ideas* (HMF 1162). The little reclining figure in the centre of the sheet appears as a pencil sketch in the latter and also became *Small Reclining Figure* of 1935 (LH 161a). The impossibility of relying on Moore's dating becomes evident from the sketch on the left of plate 35, which becomes the right-hand figure in *Two Seated Women*, dated 1933 (plate 24). DM

35
Page from Sketchbook 1935:
Ideas for Sculpture 1935
pencil
272 x 183 mm
HMF 1188
The Henry Moore Foundation:
gift of the artist 1977

94

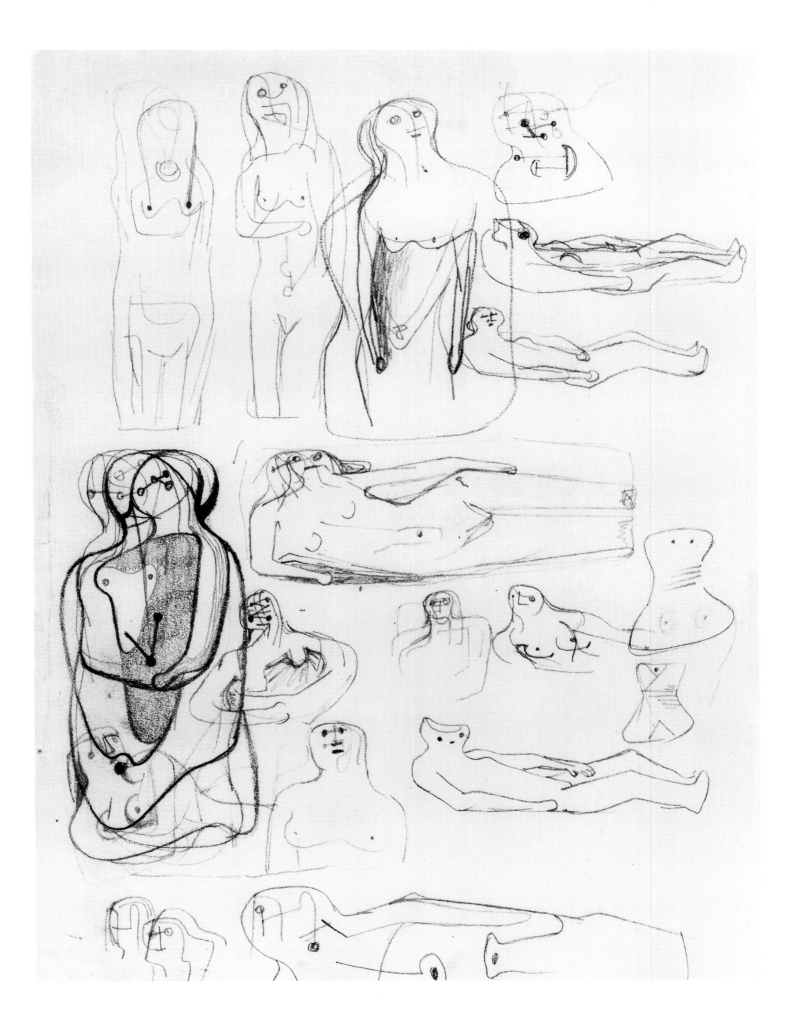

When I first began doing sculpture about 1922 or so, I often worked direct in a piece of stone or wood, which might have been not a geometric shape but just an odd random block of stone that one found cheaply in some stonemason's yard, or a log of wood which was a natural shape, and then I'd make a sculpture, trying to get as big a sculpture out of that bit of material as I could, and therefore one would wait until the material suggested an idea.

Quoted in Warren Forma, *Five British Sculptors (Work and Talk)*, New York, 1964, p. 63

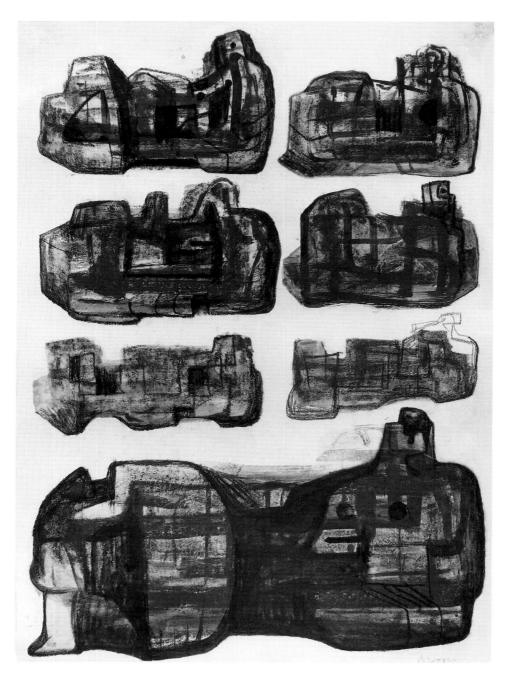

36
Square Form Reclining Figures 1936
chalk, ink wash
555 x 392 mm
HMF 1242
The Henry Moore Foundation:
gift of the artist 1977

This powerful drawing comes from a series of studies of square forms dating from 1934 and 1935, many from the *Square Forms Sketchbook* of those years. It was at this time, when Moore was most closely involved with the artists living and working in Hampstead, that he produced his most abstract work. Alan Wilkinson finds similarities in these drawings to Ben Nicholson's reliefs of the same date,[1] but the basic instinct in Moore to invest his works with a human element, however strong the abstract overtones might be, separates him from the true abstractionists. These figures show Moore's obsession with the female reclining figure made up, as here, of squares, lines and rounded shapes. JS

1 Wilkinson, 1987, p. 92.

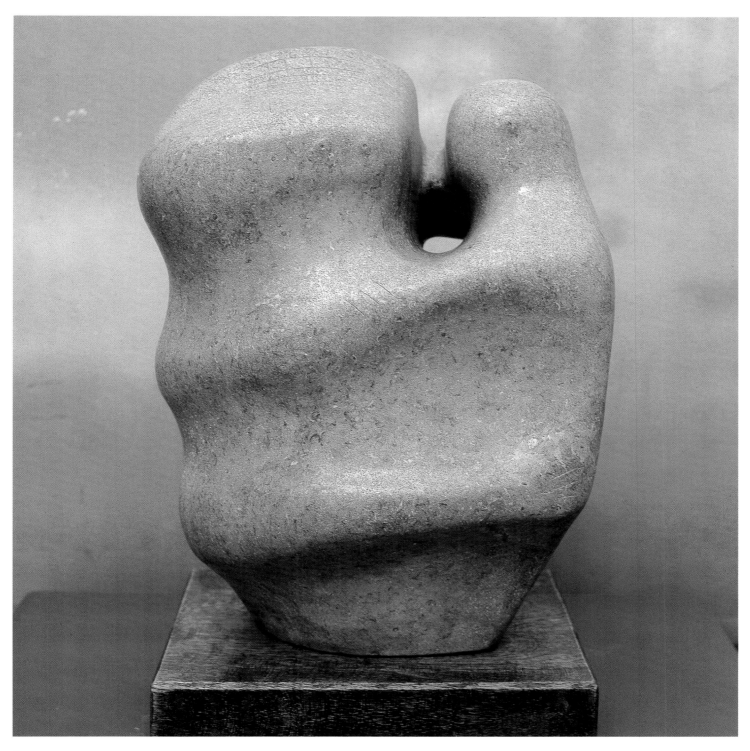

37
Mother and Child 1936
Ancaster stone
h. 45 cm
LH 165
The British Council, London

At the beginning of his career Moore bought blocks of stone from quarries and stone merchants as he found them. Later he would ask the quarry to saw the rough shape for him, as he did in the case of this sculpture. The work, although abstract, has a wonderfully strong feeling of humanity, a sense of the powerful bond between mother and child, which was to come to maturity in the *Madonna and Child* and family group sculptures of the 1940s.

The economical use of detail, such as the pin-prick eyes and the lines for hair and hands, leaves the richly curved and full forms to speak for themselves. The piece has much in common with the mother and child sculptures of the 1920s (see fig. 7, p. 20), but it is a freer, softer, more confident carving, showing consummate mastery in the handling of the stone and the releasing of the forms from the block not present in such works as *Seated Figure* (plate 6). JS

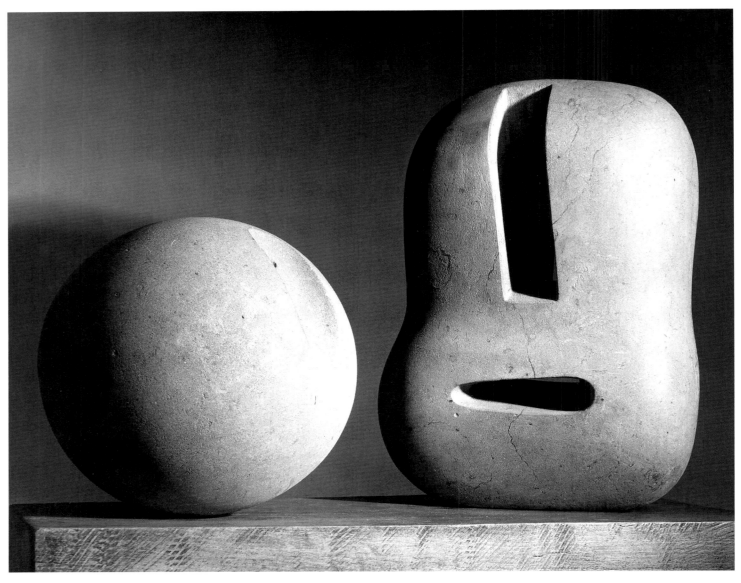

38
Two Forms 1936
brown Hornton stone
l. 64 cm
LH 166
The Henry Moore Foundation:
gift of Irina Moore 1979

Hornton stone was one of Moore's
favourite materials. It is veined in a
variety of colours including brown, blue
and green. The richness of the tones and
the variety of colours, striations and
shapes within it appealed to the artist,
who exploited these features to add
character to the surface of his sculptures.
It is also a fragile stone that cannot be
exhibited out of doors.

Moore's work never reached the pure
abstraction of Barbara Hepworth's.
Even this most abstracted of the two-
piece sculptures from the 1930s betrays
elements of a human body, with the large
upright head section and the round ball
of the body. JS

All art is abstract in one sense. Not to like abstract qualities or not to like reality is to misunderstand what sculpture and art are about. Some artists are more visual, or get more excitement from nature in front of them, and they make a work of art from that. Other people do it from their insides, a more mental approach; the actual picture-making or picture-designing can be an exercise disconnected from a relationship with the outside world.

I see no reason why realistic art and purely abstract art can't exist in the world side by side at the same time, even in one artist at the same time. One isn't right and the other wrong.

From Donald Hall, 'An Interview with Henry Moore', *Horizon*, vol. 3, no. 2, 1960, p. 104

39
Head 1936
Corsham stone
h. 9.8 cm
LH 170a
The Henry Moore Foundation:
gift of the artist 1977

The idea for this sculpture appears to date from a drawing of 1929 entitled *Ideas for Sculpture* (HMF 737). It is thought that the head is a fragment originally belonging to a seated figure with crossed arms. The head is at an unusual angle with the face staring upwards, and the bun on the back of the head is hollowed out, possibly to give the sculpture added interest when seen from behind. This rather realistic head contrasts with *Carving* (plate 27), which is so very abstract and smooth in surface. The tool lines on the head have been made by two different types of tool, those on the back by a pointing tool and the horizontal lines on the side by a claw, which acts rather like a comb and which Moore liked to use. Judging by the condition of the surface of the stone, it is probable that this little work spent some time out of doors. There is unfortunately no explanation as to what happened to the rest of the figure or why this part was preserved.

JS

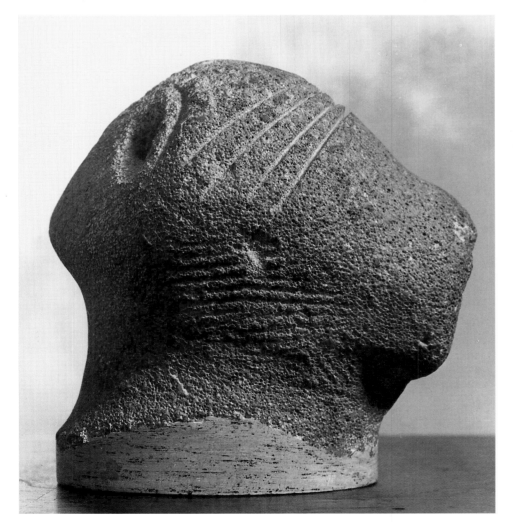

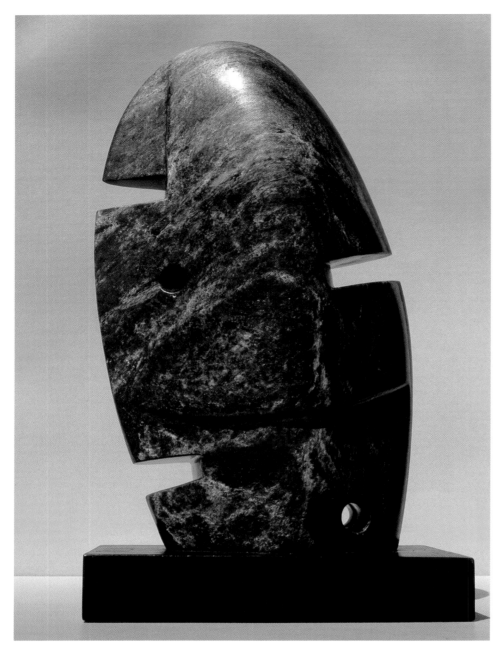

41
Sculpture in a Setting 1937
chalk
569 x 380 mm
HMF 1318
The Henry Moore Foundation:
gift of the artist 1977

Unlike the sketchbook pages of the
1930s, which were usually full of ideas
for sculpture, the larger drawings of the
period often contained studies of sculp-
ture and, increasingly, of sculpture with
some indication of pictorial space. In this
study of *Family* (plate 29) Moore has
placed the sculpture very carefully in an
architectural setting, almost certainly
inside, as would suit a carving made in
wood. We see here the beginnings of the
artist's use of architectural features in his
drawing, a background or containing
device which he was to exploit more fully
in three dimensions in the 1950s. DM

40
Head 1937 (carved 1968)
green serpentine
h. 33.7 cm
LH 182a
The Henry Moore Foundation:
gift of the artist 1977

The tiny white clay maquette for this
carving was made two years before the
outbreak of the Second World War, yet
Moore decided to make the final version
in this beautiful stone only when he
rediscovered the maquette over thirty
years later. The fashions in sculpture had
changed dramatically in the meantime,
and so had Moore's attitude to art. With
its expressionless eye and mouth, the
piece has a 'primitive' look – it is the head
of an ancient warrior, perhaps a Trojan
or a Viking – but its smooth, rich surface
and outline, reminiscent of Brancusi, give
it more general appeal. CH

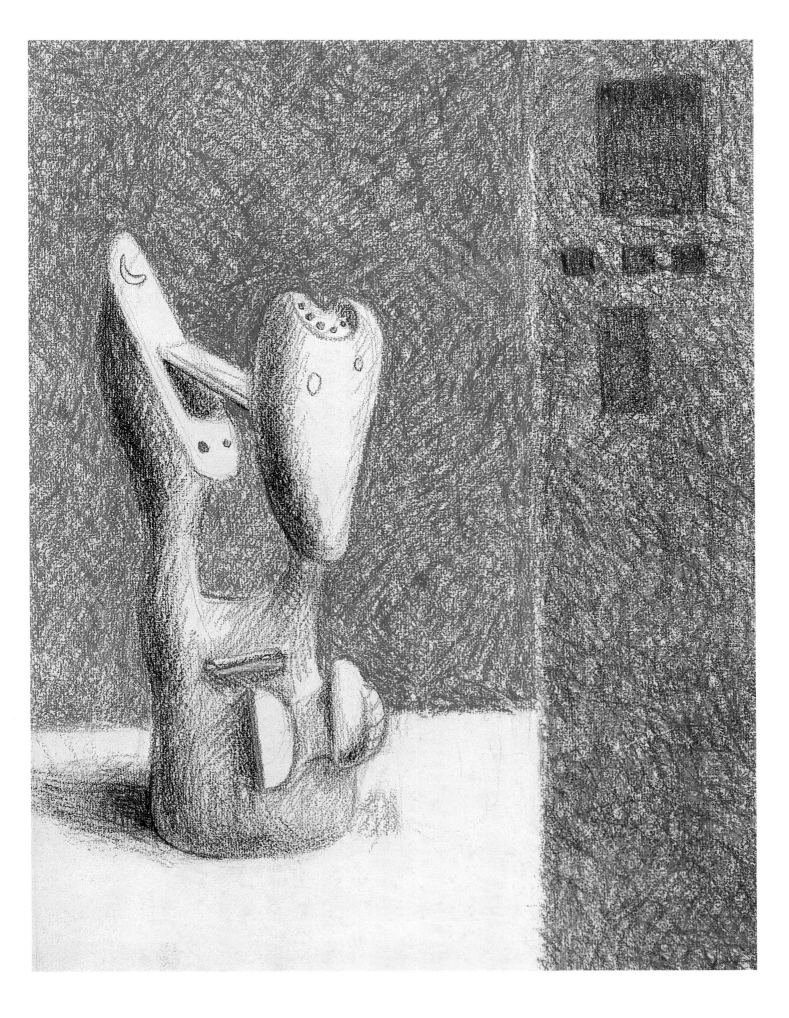

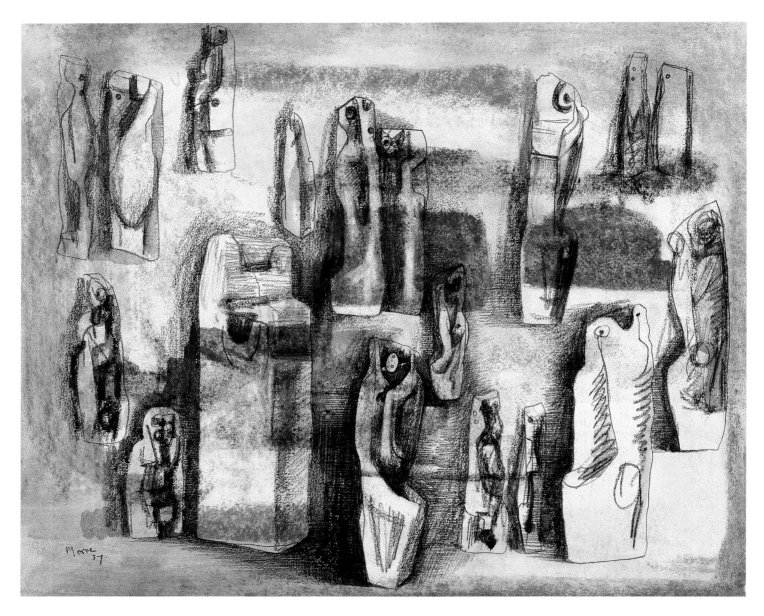

42

Drawing for Stone Sculpture 1937
watercolour, pencil, chalk, ink wash
495 x 604 mm
HMF 1320
The Henry Moore Foundation:
bequeathed by Gérald Cramer 1991

In this work the use of coloured chalk –
red, blue, green and yellow – is used to
depict an imaginary dream-like setting
that creates a pictorial horizontal land-
scape against which are seen black stand-
ing stone figures. The drawing is lit from
the front right, with the figures remaining
in light tones and given solidity by the use
of black shading on their left-hand
sides.

In 1937 Moore purchased a large
quantity of Hopton Wood stone from
the quarry in Derbyshire and, with the
assistance of Bernard Meadows, made
concrete blocks for the stones to stand on,
setting them up in a corner of the field at
Burcroft, his home in Kent.[1] Fig. 9 shows
three such blocks reminiscent of the three
stones at upper right in the drawing. DM

1 Letter from Moore to Raymond and Edna Coxon,
14 September 1937, quoted in Berthoud, 1987,
p. 155.

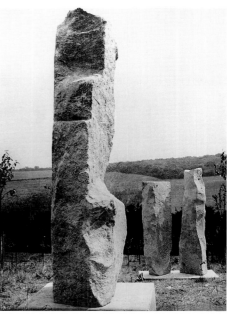

Fig. 9 Blocks of stone in the field at Burcroft, *c.* 1937

102

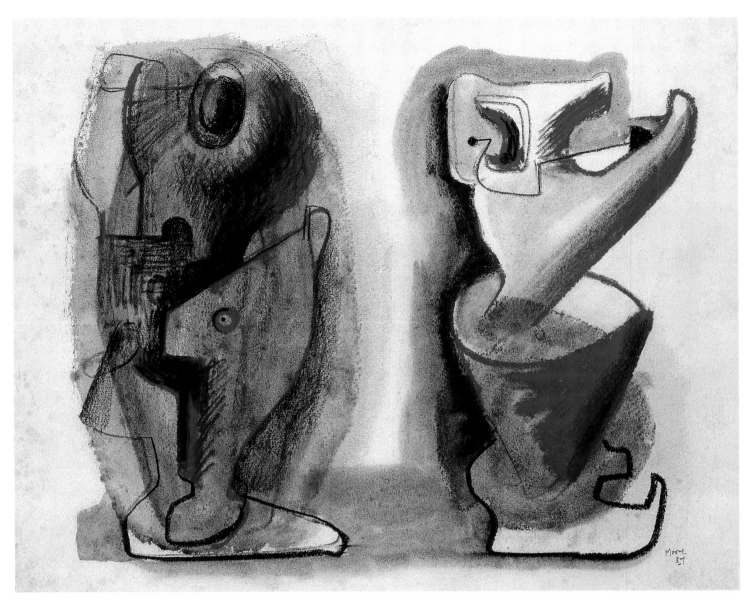

43
Drawings for Sculpture:
Two Forms 1937
chalk, watercolour
381 x 445 mm
HMF 1326
The Henry Moore Foundation:
gift of the artist 1977

In contrast to *Sculpture in a Setting* (plate
41), this drawing of the same year makes
little attempt to place the subject in space
– just the slightest indication of a ground
plane is provided by the pale watercolour
wash between the two forms. These forms
do not, and could not, exist in the real
world. They are imaginary graphic in-
ventions, not working drawings for three-
dimensional carvings. DM

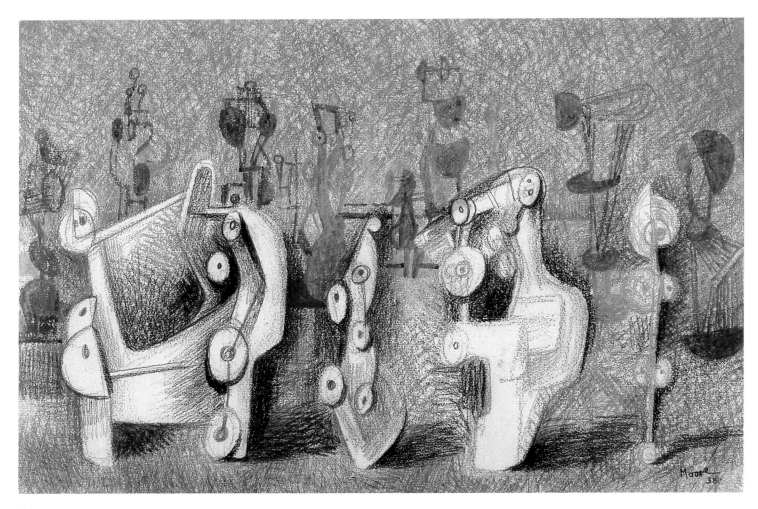

44
Mechanisms 1938
chalk, wash
397 x 572 mm
HMF 1367
The Henry Moore Foundation:
purchased 1988

In the late 1930s Moore produced a
number of drawings of sculptural
creations lined up in rows as if emerging
from a distant and imprecise horizon and
advancing, perhaps menacingly, towards
the viewer. The imagery of the present
drawing has gone beyond an idea for
sculpture and, as the figures are con-
structed of hundreds of tiny lines of
colour, the technique adds to its already
surreal nature. Hidden in the background
of the drawing are shadowy standing
figures that relate to the stringed figures
of this period (see fig. 12, p. 189) and
point the way to the more skeletal metal
sculptures of the early 1950s. DM

I had gone one day to the Science Museum at South Kensington and had
been greatly intrigued by some of the mathematical models; you know,
those hyperbolic paraboloids and groins and so on, developed by Lagrange
in Paris, that have geometric figures at the ends with coloured threads from one
to the other to show what the form between would be. I saw the sculptural
possibilities of them and did some. I could have done hundreds.

Quoted in Carlton Lake, 'Henry Moore's World', *Atlantic Monthly*, vol. 209, no. 1, January 1962,
p. 42

45

Figures with Architecture 1938
pencil, crayon, watercolour, ink wash
381 x 558 mm
HMF 1377
The Henry Moore Foundation:
gift of the artist 1977

Despite Moore's oft-repeated preference for seeing his sculpture in landscape, his drawings contain many examples of sculptural ideas in architectural settings. In this one the eye-level is fixed at a very high point so that the figures appear as if on a stage below. The figures themselves make up only a small proportion of the composition and are drawn lightly, with only a few pencil and brush strokes to indicate their presence. They show Moore moving in the direction of greater realism, as in the neck-line of the figures on the right, though elements of the sketchbook studies of the mid-1930s remain, particularly in the treatment of the head and torso of the left-hand figure. Architectural detail, seen here in the background, starts to appear in Moore's work at this time and was to remain part of his vocabulary of form. Flat planes, sometimes overlapping and punctuated by squared window-like apertures, occur in many drawings of the immediate pre- and post-war periods (see plate 41) and are introduced in the sculpture during the 1950s (see fig. 10). DM

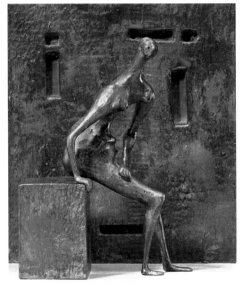

Fig. 10 *Maquette for Girl Seated against Square Wall*, 1955 (LH 424); bronze, h. 24 cm

There is a general idea that sculptors' drawing should be diagrammatic studies, without any sense of background behind the object or of any atmosphere around it. That is, the object is stuck on the flat surface of the paper with no attempt to set it in space – and often not even to connect it with the ground, with gravity. And yet the sculptor is as much concerned with space as the painter.

From *Henry Moore: Drawings, Watercolours, Gouaches*, exh. cat., 1970, unpaginated

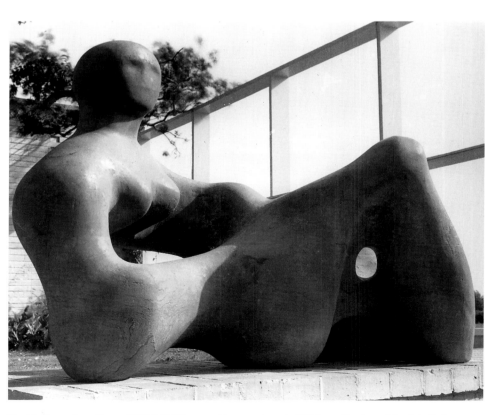

Fig. 11 *Recumbent Figure*, 1938 (LH191); green Hornton stone, h. 139.7 cm; Trustees of the Tate Gallery, London

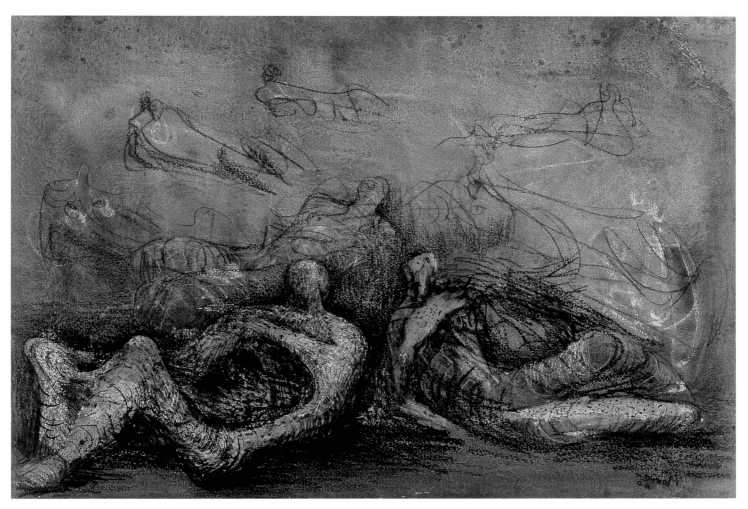

46
Studies of Reclining Figures 1940
pencil, wax crayon, pastel, watercolour
wash, gouache, pen and ink
380 x 560 mm
HMF 1478
The Henry Moore Foundation:
purchased 1984

This drawing seems to bridge the gap
between Moore's work of the late 1930s
and the early 1940s. The figures pre-date
the Shelter drawings of 1940–41, having
their origins in the reclining figures of the
late 1930s (see fig. 11). Yet there is an
almost dream-like quality to the drawing,
which in both mood and technique
anticipates the Shelter drawings. The
technique in this drawing, involving wax
crayon, watercolour wash, and pen and
ink, was first used by Moore at the very
end of the 1930s and was one he em-
ployed extensively in the war drawings.

He would draw first with white wax
directly on the white paper; then, using a
mixture of ink wash and watercolour, he
would cover the entire surface of the
drawing, allowing the waxed areas to
show through. He would then add
detailing and shading in crayon, pencil,
gouache and pen and ink. This technique
succeeds in giving an atmosphere of
darkness, mystery, almost menace to the
drawing.

The Shelter drawings have not been
selected for inclusion here as they do not
relate directly to specific sculptures, yet
Moore's wartime experiences had a
profound impact on all his subsequent
drawing and sculpture. He completed a
large elmwood *Reclining Figure* (fig. 2,
p. 49) in December 1939 and decided not
to embark on another sculpture, which
he might at any time have to give up. So
he turned to drawing. After the fall of

France the Moores had to leave their
cottage in Kent, which was in a restricted
military area. Back in London, Moore
experienced at first hand the sleeping
shelterers in the Underground stations:
'Quite against what I expected I found
myself strangely excited by the bombed
buildings, but more still by the unbeliev-
able scenes and life of the Underground
shelters.'[1] As he put it, he saw 'hundreds
of Henry Moore Reclining Figures
stretched along the platforms'[2] and, as
a result of these experiences, the human
element in his work intensified. His
figures acquired a pathos, almost a per-
sonality, that they had not previously
shown. JS

1 Quoted in *Henry Moore*, exh. cat., 1947,
introduction.
2 Quoted in Carlton Lake, 'Henry Moore's World',
Atlantic Monthly, vol. 209, no. 1, January 1962.

47
Seated Figures: Ten Studies of Mother and Child 1940
pencil, wax crayon, watercolour,
gouache, pen and ink
276 x 381 mm
HMF 1513a
The Henry Moore Foundation:
purchased 1985

Moore referred to the subject of the mother and child as one of his obsessions. He returned to it throughout his career, in a multitude of approaches that ranged from the strongly figurative to the wholly abstract. The human aspect of the theme was as important to him as the spatial relationship between a large and a small form. Initially conceived purely as mother and child studies, some of these groups became imbued with religious connotations as a result of the commission Moore received to carve a Madonna and Child for St Matthew's Church in Northampton (fig. 12). Although the present drawing predates that commission by some three years, it is likely that he had such mother and child images in his mind when he began to explore possibilities for the sculpture, finally realized in 1944. Moore never regarded an idea as exhausted or fully explored, and he went on to produce eleven mother and child maquettes, which resulted in one other life-size stone Madonna and Child carving, now in St Mary's Church, Barham.

The groups in this drawing exhibit an intimacy that is particular to this period in Moore's sculpture. Later mother and child sculptures (for example, plates 98 and 109) evince little communication between the mother figure and the child – indeed, there is almost an aloofness between the two – but here the feeling of a protective mother with a vulnerable child is pronounced. JS

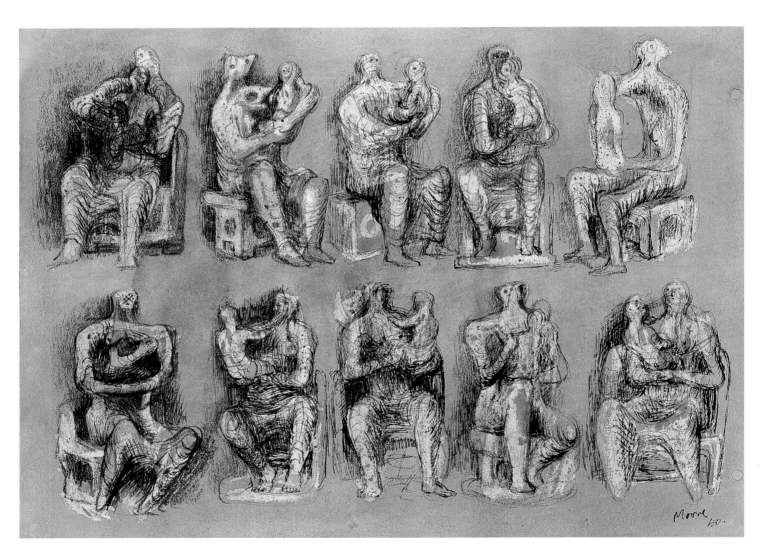

108

From very early on I have had an obsession with the mother and child theme. It has been a universal theme from the beginning of time and some of the earliest sculptures we've found from the Neolithic Age are of a mother and child. I discovered when drawing, I could turn every little scribble, blot or smudge into a mother and child. (Later, I did the same with the reclining figure theme!) So that I was conditioned, as it were, to see it in everything. I suppose it could be explained as a 'Mother' complex.

Quoted in Hedgecoe, 1968, p. 61

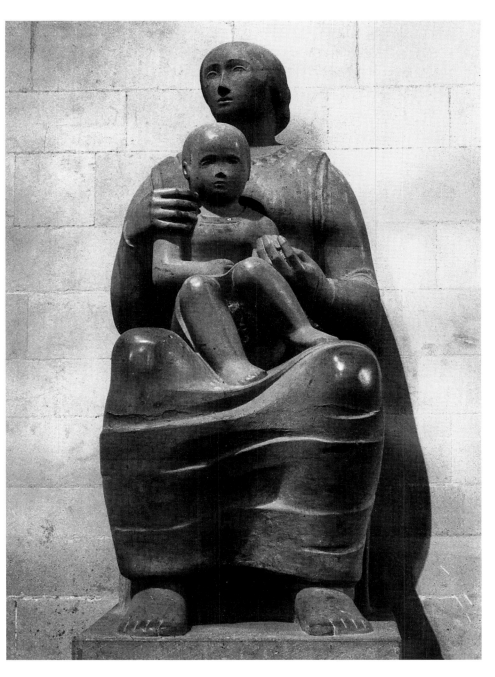

Fig. 12 *Madonna and Child*, 1943–44 (LH 226); Hornton stone, h. 150 cm; Church of St Matthew, Northampton

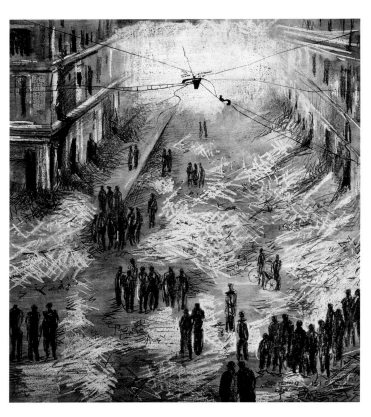

Fig. 13 *Morning after the Blitz*, 1940 (HMF 1558); pen and ink, chalk, crayon and watercolour, 635 x 559 mm; The Wadsworth Atheneum, Hartford, Connecticut

Fig. 14 The artist sketching in the London Underground, *c.* 1940. Photograph by Lee Miller

The first year of the shelter drawings was for me a very exciting and unique period. The tremendous excitement of seeing, the morning after the raid, the blitzed buildings that had been whole the day before. If the drawings of this period reflected my feelings it is because I was completely occupied in *only drawing* at this period. To me at that time it seemed that nothing had ever happened in the world like that before. Unlike anything that had ever happened in other wars.

From *Henry Moore: Drawings, Watercolours, Gouaches*, exh. cat., 1970, unpaginated

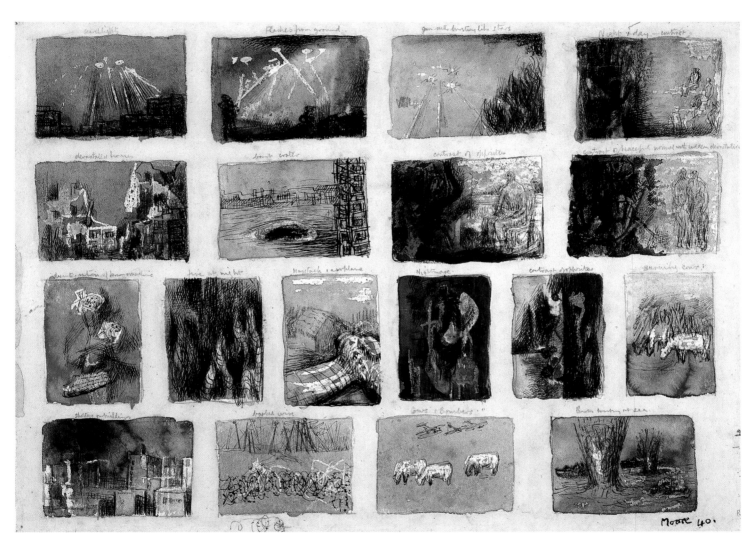

48
Eighteen Ideas for War Drawings 1940
pencil, wax crayon, watercolour wash,
ink wash,
crayon, pen and ink
277 x 382 mm
HMF 1553
The Henry Moore Foundation

This drawing combines a rather gruesome yet detached catalogue of war – bomb attacks in the night sky, burning buildings (lower left), burning cows and images of barbed wire – with vignettes of normal life continuing despite the war, for example cows grazing in a field with

bomber aircraft roaring overhead. Above each sketch Moore has written explanations: 'contrast of peaceful normal with sudden devastation', 'bombs bursting at sea', 'disintegration of person and machine', and so forth. JS

49
Family Group 1944
terracotta
h. 15.6 cm
LH 231
The Henry Moore Foundation:
gift of the artist 1977

50
Family Group 1944
terracotta
h. 16.2 cm
LH 232
The Henry Moore Foundation:
gift of the artist 1977

The family group as a theme appears to have grown out of the Shelter drawings and the Madonna and Child studies. In some groups, such as plate 50, the family is animated, the children standing or sitting, reading or watching, while others (plate 49, for example) are characterized by passivity and restfulness. Although he had married in 1929, Moore's only daughter was not born until 1946. When asked about the genesis of the family groups, he said in 1963: 'The family group ideas were all generated by drawings: and that was perhaps because the whole family group idea was so close to one as a person; we were just going to

have our first child, Mary, and it was an obsession.'[1]

The idea for the family group as a large sculpture had resulted from a discussion before the war between Moore and the German architect Walter Gropius, then living in England. Gropius had been asked to design a school at Impington, near Cambridge, and invited Moore to produce a sculpture for the school that would place strong emphasis on the involvement of the family. Moore suggested a family group as an appropriate subject, but the money was not forthcoming and the plan was dropped. The germ of the idea was sown, however, and when, in

1944, funding appeared to have been found and Moore was again approached, he embarked willingly on the project. He began by making sketches in a notebook, some of which were developed into full-sized drawings, and then went ahead with the terracotta maquettes, some for bronze sculptures, others for stone. The project fell through yet again, but Moore was sufficiently interested in his creations to enlarge three or four of the maquettes to working-model size. JS

1 David Sylvester, 'Henry Moore Talking', *Listener*, vol. 70, no. 1796, 29 August 1963, quoted in Moore, 1966, p. 225.

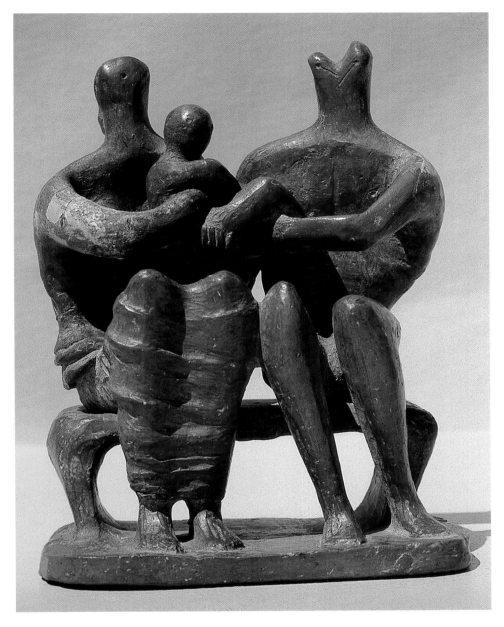

51
Family Group 1945
terracotta
h. 12.7 cm
LH 239
The Henry Moore Foundation:
gift of the artist 1977

In 1947 John Newsom, Director of
Education for Hertfordshire, approached
Moore about a project he was working
on for a school at Stevenage. The idea
excited Moore, who straight away agreed
to enlarge one of his family group terra-
cotta maquettes (plate 51). The main
difference between the maquette and the
final work (fig. 15) is in the heads, Moore
explained. 'In the small version the split
head of the man gives a vitality and
interest necessary to the composition,
particularly as all three heads have only
slight indications of features. When it
came to the life-size version, the figures
each became obviously human and re-
lated to each other and the split head of
the man became impossible, for it was so
unlike the woman and the child.'[1] JS

1 Letter to Dorothy Miller, 31 January 1931, quoted
in Moore, 1966, p. 225.

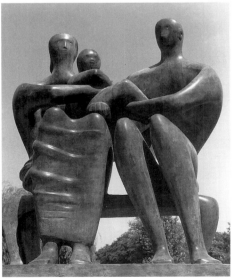

Fig. 15 *Family Group*, 1948–49 (LH 269); bronze,
h. 152 cm

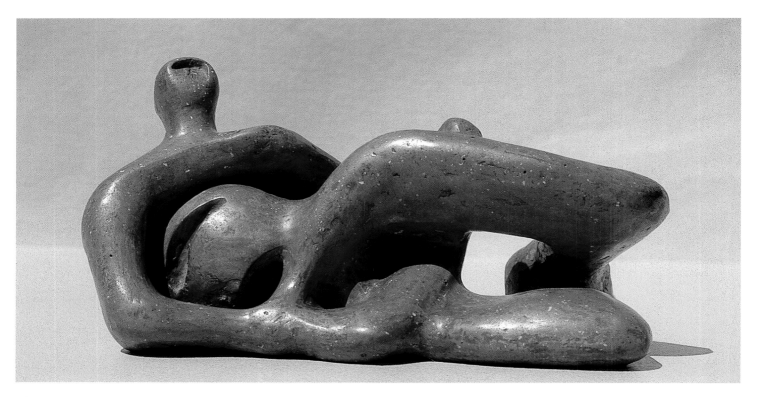

52
Reclining Figure 1945
terracotta
l. 15.2 cm
LH 247
The Henry Moore Foundation:
gift of the artist 1979

The date is crucial to understanding the messages in this work. The piece possesses a cautious optimism shrouded in the beginning of the 'post-war angst'. This little work has a beautiful, curving inter-play of shapes, the geometric relationship of the feet and the hole between the legs giving way to a large expanse of back that is so solid and strong. Yet both mother and foetus have only deep grooves for eyes. Elisabeth Frink also used this device of 'blinding' her figures. It lays open questions about the future, about the world as it will be for generations to come. The mother looks towards the sky and her body is literally knotted up with anxiety for her child.

Reclining Figure is one of several sketch models for the large elmwood *Reclining Figure* of 1945–46 (fig. 16). In the final version the shapes have been simplified, partly to adhere to Moore's still lingering 'truth to materials' ethic. In doing this the artist has deliberately made the subject-matter more obvious and more disturbing by giving the woman breasts, a reminder of both the literal subject and its implications (Moore was awaiting the arrival of his first child at this time). The wood sculpture has lost some of the wonderful complexity of curved form in the terra-cotta, which is replaced with the harsh appearance of two strong limbs forming a gaping hole rather like a cave or a shelter – perhaps a bomb shelter. CH

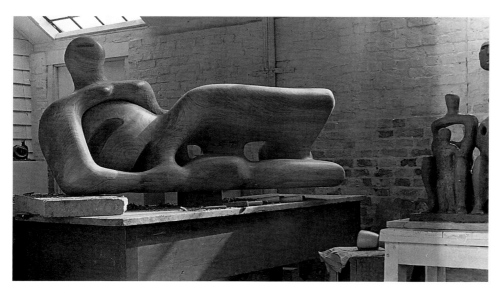

Fig. 16 *Reclining Figure*, 1945–46 (LH 263); elmwood, l. 190.5 cm; private collection (shown here during carving in the top studio at Hoglands)

In many of my reclining figures the head and neck part of the sculpture, sometimes the torso part too, is upright giving contrast to the horizontal direction of the whole sculpture. Also in my reclining figures I have often made a sort of looming leg – the top leg in the sculpture projecting over the lower leg which gives a sense of thrust and power – as a large branch of a tree might move outwards from the main limb – or as a seaside cliff might overhang from below if you are on the beach.

HMF archive

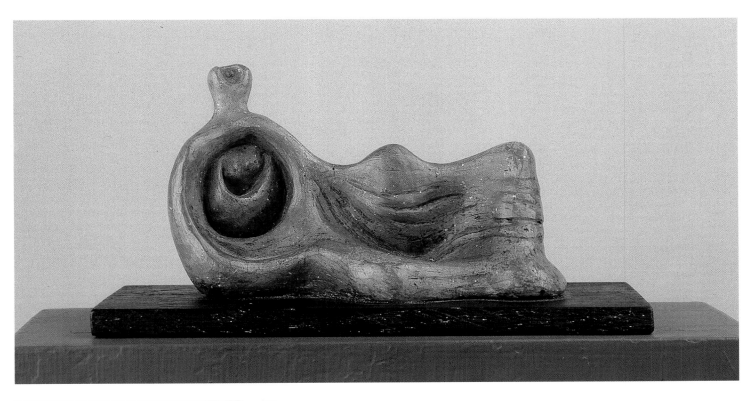

Fig. 17 *Reclining Figure*, 1945 (HMF 2327); pencil, wax crayon, charcoal, watercolour wash, crayon, pen and ink, 514 x 410 mm; private collection, USA

53
Reclining Figure 1945
terracotta
l. 13.3 cm
LH 255
The Henry Moore Foundation:
gift of Irina Moore 1977

Quite different in many ways from plate 52, this work nevertheless has an interesting form within a form in the region of the stomach – perhaps layers of clothing or an arm protecting a pregnant belly.

The figure, with its flowing modelled forms and contrasting deeply cleft head, appears in a drawing, made the same year and also entitled *Reclining Figure* (fig. 17), in which it is set against a dramatic background. It is sometimes difficult to know at this period whether such a drawing was an idea for sculpture or a drawing after it, the latter almost certainly being the case in this instance.

JS

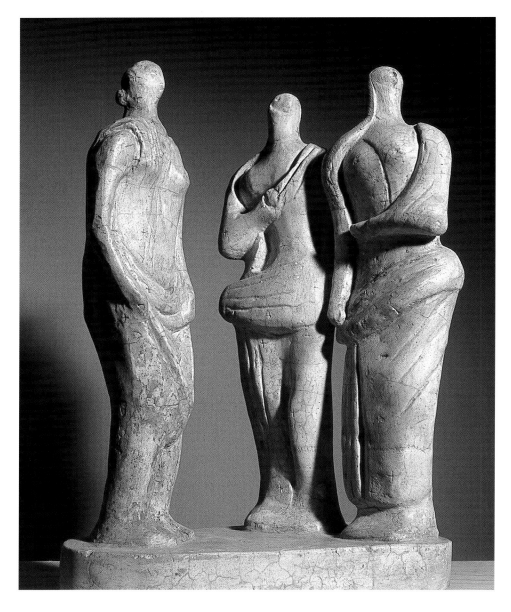

54
Three Standing Figures 1945
plaster with surface colour
h. 21.6 cm
LH 258
The Henry Moore Foundation:
gift of the artist 1977

It is almost impossible to look at this sculpture without thinking of the Three Graces, a subject to which Moore returned on several occasions. John Russell saw this group as guardians or witnesses: 'The man or woman who watches the skies has a particular emotional meaning for anyone who, from the Spanish Civil War onwards, has looked on the skies primarily as a potential source of catastrophe, and in carving this group Moore drew, whether consciously or not, on the stored memories of millions.'[1]

Moore described the figures as being profoundly influenced by the war and in particular by his war drawings. He said about the group in 1968: 'Although the figures are static, I made them look into the distance, as if they were expecting something dramatic to happen. Drama can be implied without the appearance of physical action.'[2] Moore's post-war sculptures show a considerable change from those that had occupied him before the war. He introduced a much greater degree of figuration, such as facial expressions and drapery, as well as a stronger human element – almost pathos in some cases – which is predominant in this group.

The sculpture was carved in Darley Dale sandstone during 1947–48 outside the studio at Hoglands, Perry Green, where the Moores had moved in 1940 after their London home had been damaged in the Blitz. The group now stands in Battersea Park (fig. 18), where it is seen by a very large number of people and has, over the years, elicited much comment. An admirer distressed by some graffiti on the work wrote to the Henry Moore Foundation: 'One of my pleasures is to walk through London's Battersea Park and contemplate the imagination and mental toughness of Henry Moore while standing in front of his *Three Standing Figures* of 1948.'[3] JS

1 Russell, 1968, p. 115.
2 Quoted in Hedgecoe, 1968, p. 167.
3 Letter from Nicholas Mackenzie, 23 July 1990.

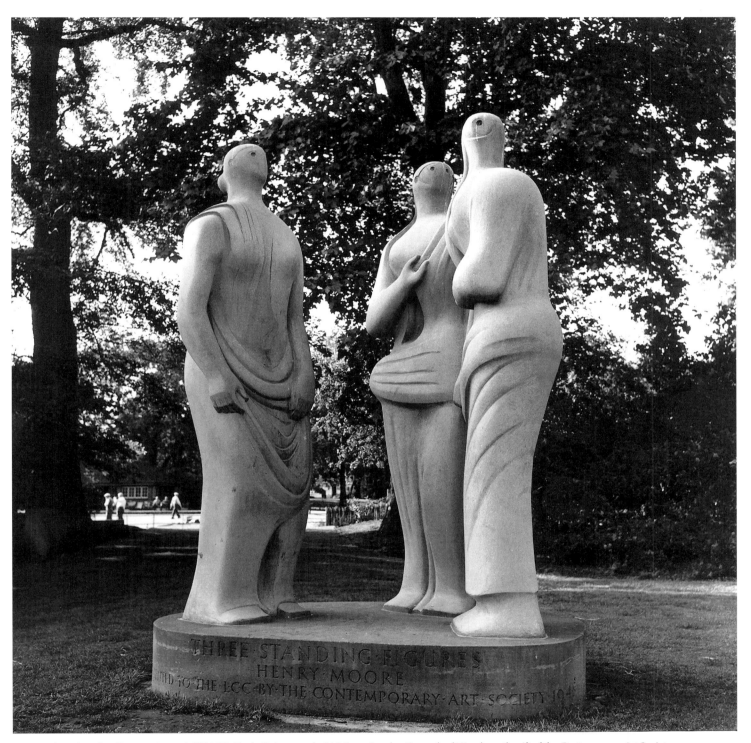

Fig. 18 *Three Standing Figures*, 1947–48 (LH 268); Darly Dale stone, h. 213.5 cm; London Borough of Wandsworth: gift of the Contemporary Art Society

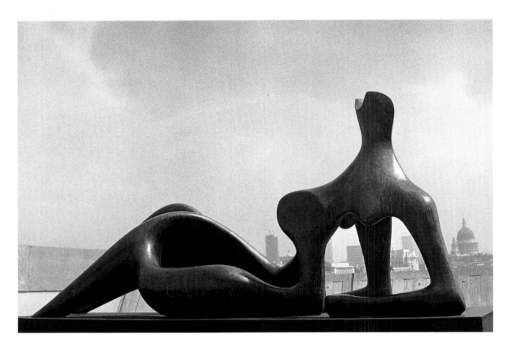

Fig. 19 *Reclining Figure: Festival,* 1951 (LH 292); bronze, l. 228.5 cm; at the Hayward Gallery, London

55
*Working Model for Reclining Figure:
Festival* 1950
plaster with surface colour
l. 43 cm
LH 292
The Henry Moore Foundation:
gift of the artist 1977

In 1949 Moore was one of a dozen or so artists approached by the Arts Council of Great Britain to produce a work for the Festival of Britain exhibition to be held in 1951. The exhibition was to mark the centenary of the 1851 Great Exhibition. The festival was enormously successful, attracting more than 8.5 million visitors throughout that summer. Originally the Arts Council had suggested Moore might make a family group carving, but when two years later he delivered a reclining figure it was one of his most powerful sculptures to date and he was himself excited and pleased by the result (fig. 19). He was always aware of the temporary nature of the exhibition and this fact was important in the conception of the work: 'I knew that the South Bank would only

be its temporary home, so I didn't worry about where it was placed. If I had studied a Festival site too carefully, the figure might never have been at home anywhere else.'[1]

Moore made two very similar maquettes and then enlarged one to working-model size in plaster. This is one of the first post-war sculptures executed in plaster, the majority of his maquettes immediately prior to this having been made in terra-cotta or clay. As with a number of his later plasters, marking points for enlarge-ment remain visible. Also visible are the lines in pencil carrying the eye around the figure like contours on a map. In the larger version these lines were accentuated by the use of thin string stuck to the sur-face of the plaster, which in turn emphas-ized the fluidity of the forms when cast in bronze. Moore adopted plaster as his preferred medium from this time on, with most of his works now cast as bronze editions and comparatively few carved. He particularly liked working in plaster because of its flexibility: it can be mod-elled while wet and carved when dry.

This became the first life-size bronze reclining figure Moore made, the material granting him the freedom to explore the relationship between mass and space more radically than he could within the confines of stone and wood. In these materials holes are opened up consciously, with the shape around the hole often being restricted by the size and shape of the block. In bronze there are no such re-strictions. Moore could now open up the sculpture in a way that would never have been possible in wood and stone. He admitted that this sculpture was his first conscious effort to make space and form absolutely inseparable, writing later: 'It would have held one back to go on carving....My desire to understand space made the change to bronze necessary. One should not be dominated by the material.'[2] JS

1 Moore, *Sculpture in the Open Air*, ed. Robert Melville, London, 1955, reprinted in Moore, 1966, p. 101.
2 *Henry Moore: Complete Sculpture*, vol. 4, 1977, p. 12.

If space is a willed, a wished-for element in the sculpture, then some distortion of the form – to ally itself to the space – is necessary.

At one time the holes in my sculpture were made for their own sakes. Because I was trying to become conscious of spaces in the sculpture – I made the hole have a shape in its own right, the solid body was encroached upon, eaten into, and sometimes the form was only the shell holding the hole. Recently, I have attempted to make the forms and the spaces (not holes) inseparable, neither being more important than the other. In the last bronze *Reclining Figure* (1951) I think I have in some measure succeeded in this aim. What I mean is perhaps most obvious if this figure is looked at lengthways from the head end through to the foot end and the arms, body, legs, elbows, etc. are seen as forms inhabiting a tunnel in recession. Seen in plan the figure has 'pools' of space.

HMF archive

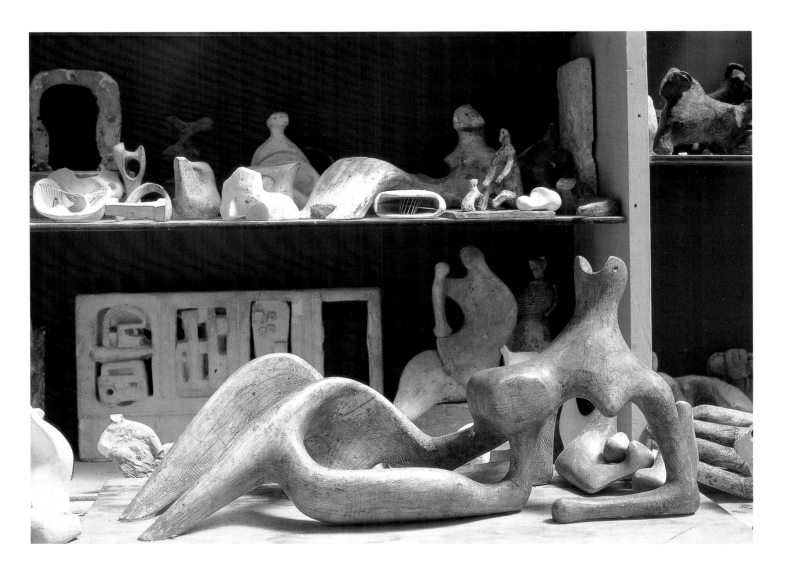

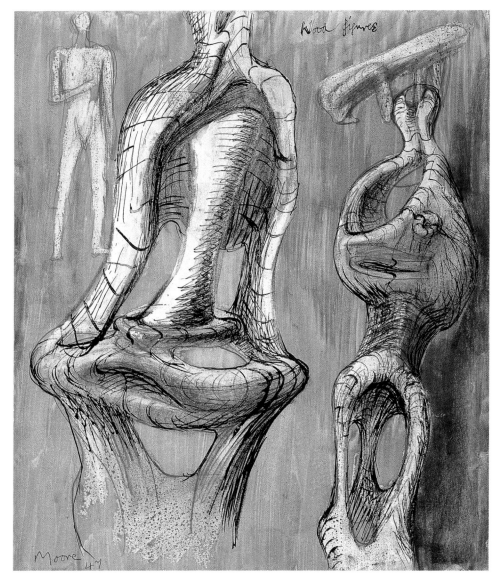

56
Page from Sketchbook 1947–49:
Drawing for Wood Sculpture 1947
pencil, wax crayon, crayon, watercolour
wash, ink, gouache
292 x 242 mm
HMF 2403
The Henry Moore Foundation:
purchased 1985

This drawing has a wonderful sense of
volume, created partly by the conjunction
of watercolour and wax, which gives the
surface of the figures an almost luminous
quality. However, Moore has also used a
technique here that he called the 'two-way
sectional line method', which reflected his
dictum that 'drawing is the expression
and the explanation of the shape of a
solid object on a flat surface'.[1] The

original idea, first used in the late 1920s,
entailed using lines drawn both down the
form and around it in order to describe
volume without the use of shading. The
technique became fully developed with
Moore's drawings for sculptures of family
groups and domestic scenes in the late
1940s. The finished appearance of these
drawings recalls the technique by which
the cast parts of a bronze sculpture are
welded together or, indeed, emphasized
(as in plate 55). Although this may not be
deliberate, it is no coincidence, as both
techniques aim for the same end: the
construction of three-dimensional mass
from something essentially two-dimen-
sional. In *Drawing for Wood Sculpture*
the technique is less rigidly applied than
elsewhere (plate 58, for example), having

been combined with a degree of modelling
that helps to give the figures dynamism.
 The organic, 'swirling' forms recall
trees, especially tree roots, of which there
were many visible in Moore's garden at
Hoglands. Yet these forms are, of course,
figures, and their structure also recalls that
of human bones. The two factors are held
in tension: wood versus bone, strength
and hardness versus flexibility and move-
ment, hollowness versus solidity. A
parallel is thus drawn between human
anatomy and the 'anatomies' of nature.
 CH

1 *The Drawings of Henry Moore*, exh. cat., 1977,
p. 12.

57
Six Studies for Family Group 1948
pencil, wax crayon, crayon, watercolour
wash, pen and ink
525 x 384 mm
HMF 2501A
The Henry Moore Foundation:
purchased 1984

This drawing was made during the period
when Moore was already beginning to
produce preliminary sketches for sculp-
ture in plaster rather than on paper. The
series of family group maquettes pre-date
this drawing by three or four years, but
the artist came back to the theme in 1948,
filling a sketchbook with ideas for family
groups after he had received the com-
mission to make a sculpture for a school
in Stevenage (see plate 51). JS

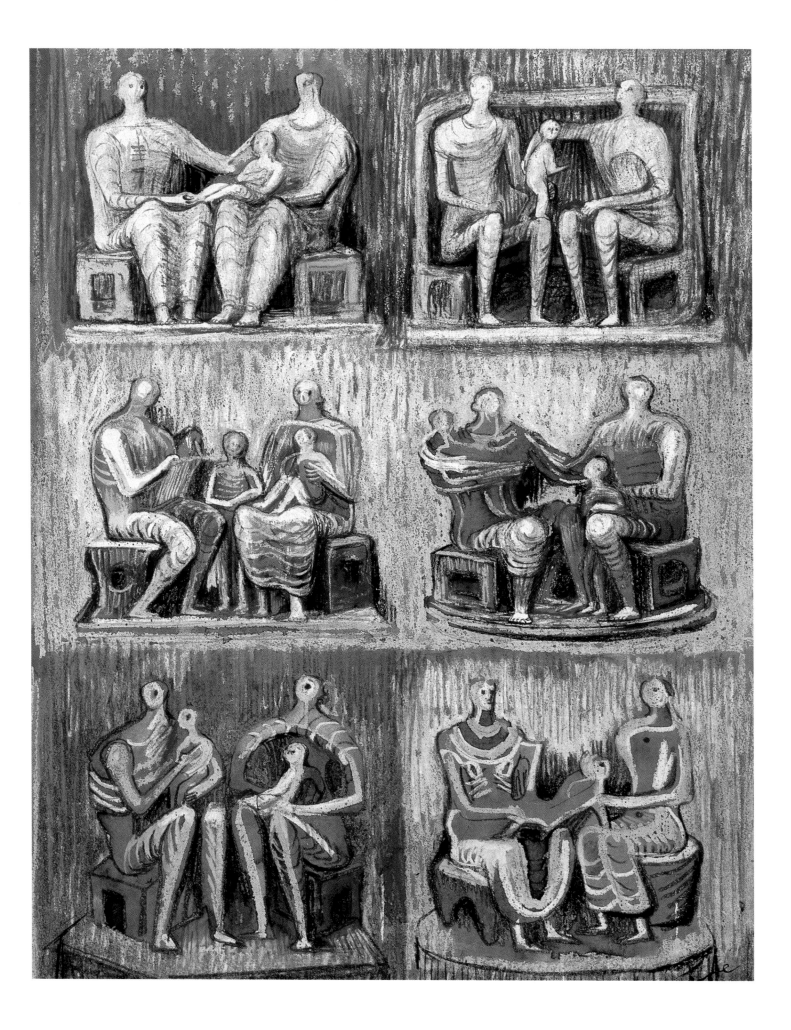

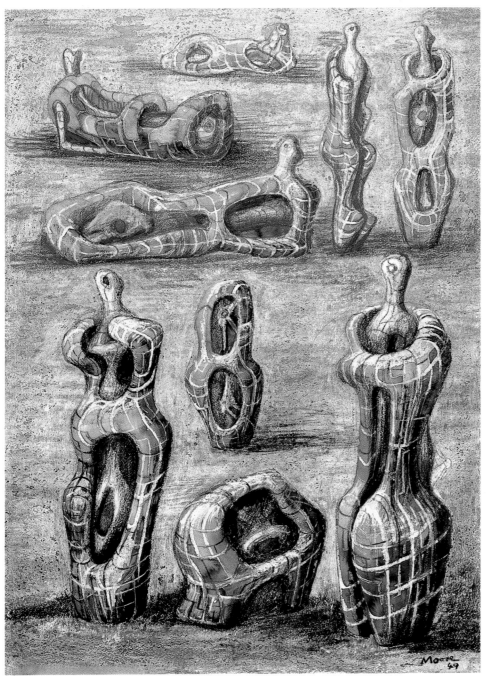

58
Studies for Sculpture: Ideas for
Internal/External Forms 1949
pencil, wax crayon, chalk, watercolour,
gouache, ink
584 x 398 mm
HMF 2540a
The Henry Moore Foundation:
purchased 1990

The concept of interior/exterior form
represents one of Moore's most successful
sculptural inventions, containing as it does
the non-figurative notion of one form
protecting another while maintaining a
strong human element. The idea had
already been explored in *The Helmet* of
1939–40 (fig. 9, p. 22). In the present
drawing, which pre-dates by two years
Working Model for Upright Internal/
External Form (plate 59), Moore examines
the upright and reclining internal/external
forms and the helmet head. The fully
worked-up nature of the drawing demon-
strates the artist's confidence in treating the
subject, which had obviously occupied him
for some time. Alan Wilkinson's research
shows that Moore's interest in the internal/
external forms dated as far back as 1935,
to a sketchbook in which he explored
the subject in detail for the first time.
Wilkinson claims that the original in-
spiration came from a 'Malanggan' fig-
ure from New Ireland, Oceania, which
Moore drew in 1935 (fig. 8, p. 21). The
artist is said to have been greatly im-
pressed by the inner and outer framework
of such works, 'by the extraordinary
craftsmanship required to create forms
within forms'.[1] JS

1 *The Drawings of Henry Moore*, exh. cat., 1977,
p. 12.

59
*Working Model for Upright
Internal/External Form* 1951
plaster with surface colour
h. 63.2 cm
LH 295
The Henry Moore Foundation:
gift of the artist 1977 (on long loan
to Leeds City Art Gallery)

Although there is little in it to suggest the human image, we accept this composition as figurative: the protecting outer form shields but at the same time restricts an inner structure that itself has human, or at least organic, connotations. It is certainly one of Moore's most impressive inventions and is susceptible to many interpretations, from the strictly physical one of a child in the womb to the more psychological, involving notions of containing and being contained. Moore spoke often about the interior/exterior forms: 'All artists have favourite subject matters or themes.…I have several (four or five) recurring themes in my work. The mother and child has been one of them from early times and this really is an interpretation of the mother and child idea. It is the larger form protecting and having enveloped within it another form, like a child being born. Also, from a sculptural point of view the putting of the form inside another forms gives to it a mystery, makes it unable to be explained immediately.…If it is obvious then one tends to look at something, recognise it and then turn away, knowing what it is. Now – my piece gives a lot of mystery.'[1]

The plaster was conceived with a view to the piece being carved, which Moore did, in elmwood, during 1953–54 (LH 297). Different sized versions exist in bronze, culminating in a monumental enlargement, over 6.75 metres high, that was completed in 1982. Moore continued to develop this theme in both his graphic and his sculptural work. *Reclining Connected Forms* (plate 91) is an example of the latter. JS

1 HMF archive.

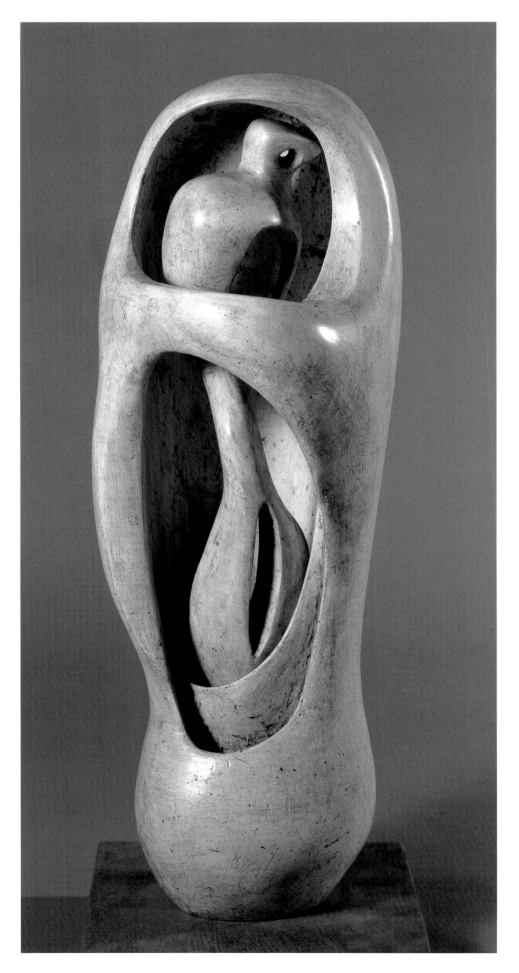

see a lot of connections between animals and human beings and I can get the same kind of feelings from an animal as from the human being. There can be a virility, a dignity or there can be a tenderness, a vulnerability. To me they are all organic life and life that can move, which is different from plant life which ordinarily is rooted. Of course the human figure is still the most interesting for me because it expresses one's feelings, but animal form is still very alive. I can see animals in anything, really.

Extract from conversations with the artist recorded by David Mitchinson, Much Hadham, 1980, first published in Mitchinson, 1981, p. 148

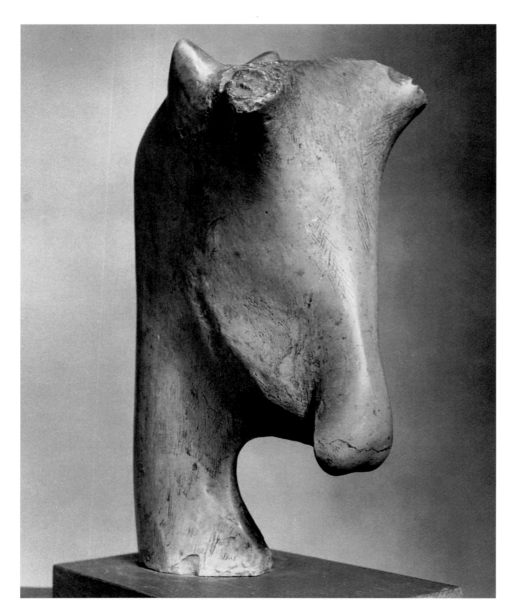

60
Goat's Head 1952
bone and plaster with surface colour
h. 20.3 cm
LH 302
The Henry Moore Foundation:
gift of the artist 1977

This piece, which belongs to the repertoire of animal themes to which Moore returned throughout his career, is one of only a very small number of works in which the artist incorporated the source object – here a piece of bone – in the maquette itself. His normal practice was to cast an *objet trouvé* and then work on the cast, carving the plaster and adding more where necessary. Many of Moore's works from the early 1950s onwards possess strong organic elements that reveal the sources of the pieces, underlining the artist's extraordinary ability to perceive sculptural ideas in even the most mundane objects. JS

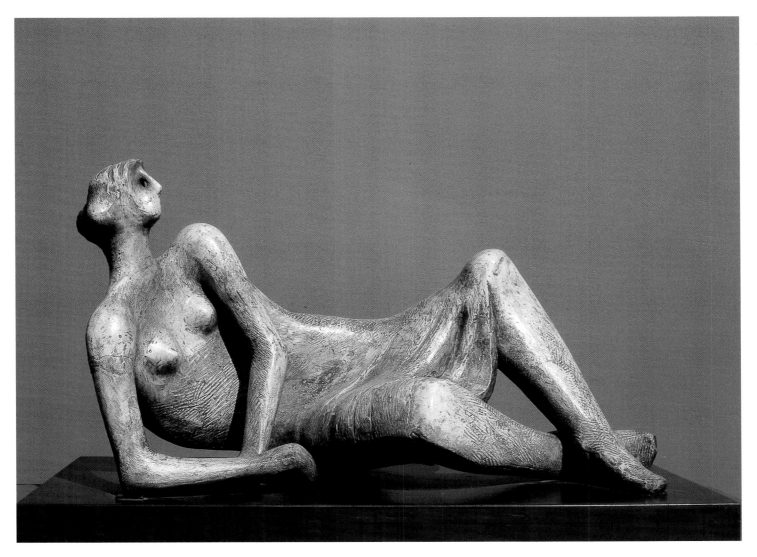

61
Reclining Figure No. 4 1954–55
plaster with surface colour
l. 58.5 cm
LH 332
The Henry Moore Foundation:
gift of the artist 1977 (on long loan
to Leeds City Art Gallery)

Moore became increasingly interested in drapery after the war, especially after his visit to Greece in 1951: it appears on many of his female figures around this time. Here he has used drapery to make the figure seem naturalistic by describing the shape of the body beneath, a device which originated in Classical Greece. This is one of the less emaciated, less contorted figures of this time. Her legs are quite sturdy – a general trait in Moore's work – and her slim arms and small, pert breasts are more suggestive of adolescence than of the sufferings of a post-war age. She has a strength about her and a sense of being relaxed, and this again makes her seem young and healthy. CH

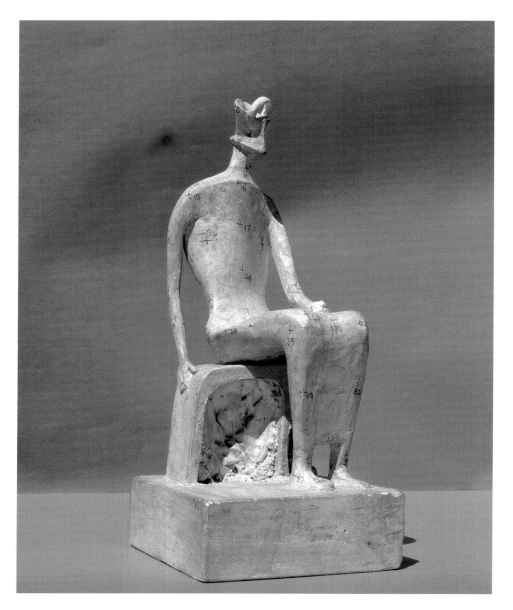

62
Fragment of Maquette for King and Queen 1952
plaster with surface colour
h. 23 cm
LH 348
The Henry Moore Foundation:
gift of the artist 1977

This fragment of the original plaster is marked up with enlarging marks ready to be interpreted by one of Moore's assistants. The enlarging of sculpture is a scientific rather than artistic process, and only once the sculpture was well on the way to being enlarged would Moore choose to make changes to proportions or other aspects of the work. An amusing example of this is recorded in the case of *Maquette for King and Queen*. There was a metal frame around the figures that was retained in the bronze edition of the maquette but jettisoned in the life-size work. When asked about this, Moore told Alan Wilkinson, in what the latter called one of the artist's 'most down-to-earth comments about his work': 'Oh, on a larger scale, they would look as if they were keeping goal in a soccer match.'[1]

Moore himself described *King and Queen* (fig. 20) as one of his favourite sculptures. He said of it in 1956: 'Perhaps the "clue" to the group is the King's head, which is a combination of a crown, beard and face symbolising a mixture of primitive kingship and a kind of animal, Pan-like quality. The King is more relaxed and assured in pose than the Queen, who is more upright and consciously queenly. When I came to do the hands and feet of the figures they gave me a chance to express my ideas further by making them more realistic – to bring out the contrast between human grace and the concept of power in primitive kingship.'[2] JS

1 Quoted in Wilkinson, 1987, p. 140.
2 Quoted in Ernest Mundt, *Art and Artist*, Berkeley and Los Angeles, 1956, reprinted in Moore, 1966, p. 246.

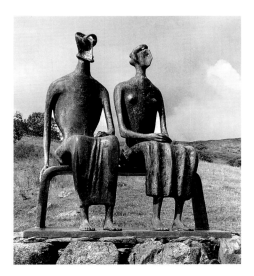

Fig. 20 *King and Queen*, 1952–53 (LH 350); bronze, h. 164 cm

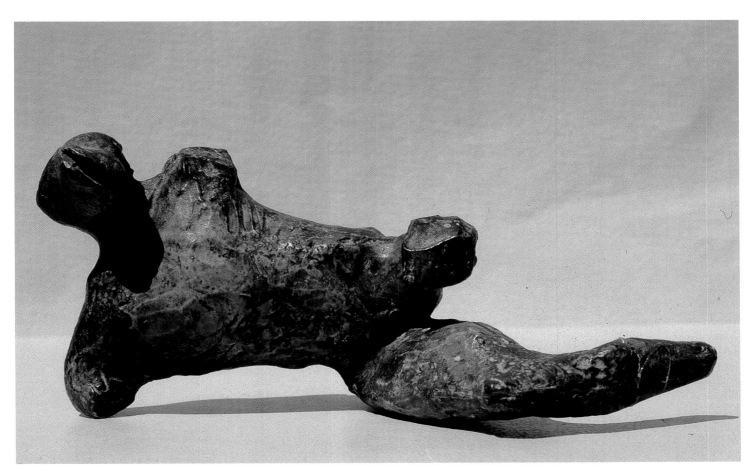

63
Reclining Warrior 1953
painted plaster
l. 19.7 cm
LH 358b
The Henry Moore Foundation:
gift of the artist 1977

This plaster is one of the studies that resulted in *Warrior with Shield* of the same year (plate 64). Until this series of warriors the artist had created no single male figures. Much has been made of this, and of the fact that Moore's warriors are not heroes of towering achievement but more often mutilated figures, broken by battle, crushed by life, though still defiant. It should be emphasized, however, that they retain a dignity that is unmistakably grounded in the art of Ancient Greece. This connection may have been subliminal in the case of the artist, but the warrior as a subject is inevitably linked in the viewer's mind to Greek sculpture. Moore had visited Greece in 1951 and had been profoundly moved by the Acropolis and by the Parthenon in particular. He knew the Parthenon frieze well from his studies at the British Museum, but it was his visit to Athens that enabled him to understand the significance of the sculpture more fully, in the context of Ancient Greece.

John Russell approaches these figures from the standpoint of the material employed, pointing out that they are 'amongst the earliest pieces in which [Moore's] loyalty is given over entirely to bronze: and not only to bronze in general but to the quintessence of the material'.[1] JS

1 Russell, 1968, p. 131.

Warrior with Shield 1953–54
painted plaster
h. 155 cm
LH 360
The Henry Moore Foundation:
gift of the artist 1977

This work is exceptional in Moore's oeuvre for several reasons. The artist himself regarded it as an important piece and, unusually for him, had much to say about its origins, its meaning and its significance in the context of his work. In a letter of 15 January 1955 he wrote: 'The idea for *The Warrior* came to me at the end of 1952 or very early in 1953. It was evolved from a pebble I found on the seashore in the summer of 1952, and which reminded me of the stump of a leg, amputated at the hip. Just as Leonardo says somewhere in his notebooks that a painter can find a battle scene in the lichen marks on a wall, so this gave me the start of *The Warrior* idea. First I added the body, leg and one arm and it became a wounded warrior, but at first the figure was reclining. A day or two later I added a shield and altered its position and arrangement into a seated figure and so it changed from an inactive pose into a figure which, though wounded, is still defiant. The head has a blunted and bull-like power but also a sort of dumb animal acceptance and forbearance of pain. The figure may be emotionally connected (as one critic has suggested) with one's feelings and thoughts about England

during the crucial and early part of the last war.... This sculpture is the first single and separate male figure that I have done in sculpture and carrying it out in its final large scale was almost like the discovery of a new subject matter; the bony, edgy, tense forms were a great excitement to make.'[1]

Christa Lichtenstern, writing in 1994, interprets the position of the shield as protecting the warrior from above, evoking memories of aerial warfare during the Second World War. 'This active moment of defence is what is essential in *Warrior with Shield*. It determines the entire course of the figure's shape as well as its content. The body seems to be enclosed within a semicircular arc, from its split crown over the rounded shield to the shank curving backwards.' She goes on to deal with the significance of the two sides of the warrior, the one active, protecting, the other vulnerable, wounded, showing the signs of suffering: 'it is through this artistic contrast that the tension between "wounding" and "challenging" is first seen. Action and suffering, alertness and mutilation express themselves as plastic sensations over the forms themselves.'[2]

Moore made one other single male figure at about this time, *Falling Warrior* of 1956–57 (fig. 11, p. 24), which excited as much comment and critical analysis as *Warrior with Shield*. It is indicative of the artistic climate in Britain at this time that examples of both these warrior sculptures

were acquired by public galleries in the late 1950s amidst considerable opposition. No such dispute greeted the purchase of a cast of *Warrior with Shield* by the Kunsthalle in Mannheim. It was to be another twenty years before Moore tackled the single male figure again, also in the form of a warrior (plate 96).

Figs. 21–3 demonstrate the technique Moore was using in the 1950s for building up a large-scale sculpture, using wire, wood and plaster. Fig. 22 clearly shows that the arm holding the shield is built up in plaster on a single piece of wire. Unfortunately, the plaster has been damaged over the last forty years, both at the foundry and subsequently in storage, and it is in a very delicate state. The shield, which still exists intact, is now too heavy to be supported by the armature within the plaster and therefore cannot be exhibited with the rest of the figure. The seat on which the plaster was balanced in the studio no longer exists and was not cast in bronze. The individual bronze casts (see fig. 24) sit on blocks of various sizes and heights, some in bronze, others in wood and quite low, offering a clear and somewhat unexpected view of the warrior's suffering. JS

1 Letter (recipient unknown), 15 January 1955, quoted in Moore, 1966, p. 250.
2 *Henry Moore: Ethos und Form*, exh. cat., 1994, p. 41.

 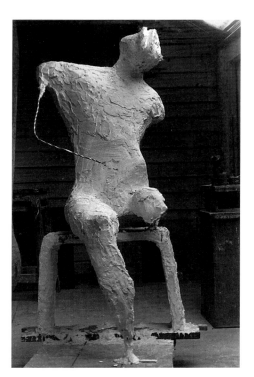 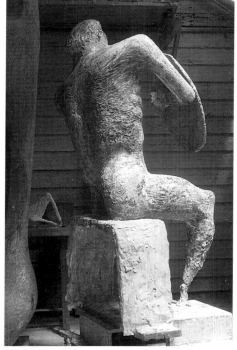

Figs. 21–3 Stages in the enlargement of *Warrior with Shield*, showing the metal armature and the enlarging process that the artist employed during the early 1950s

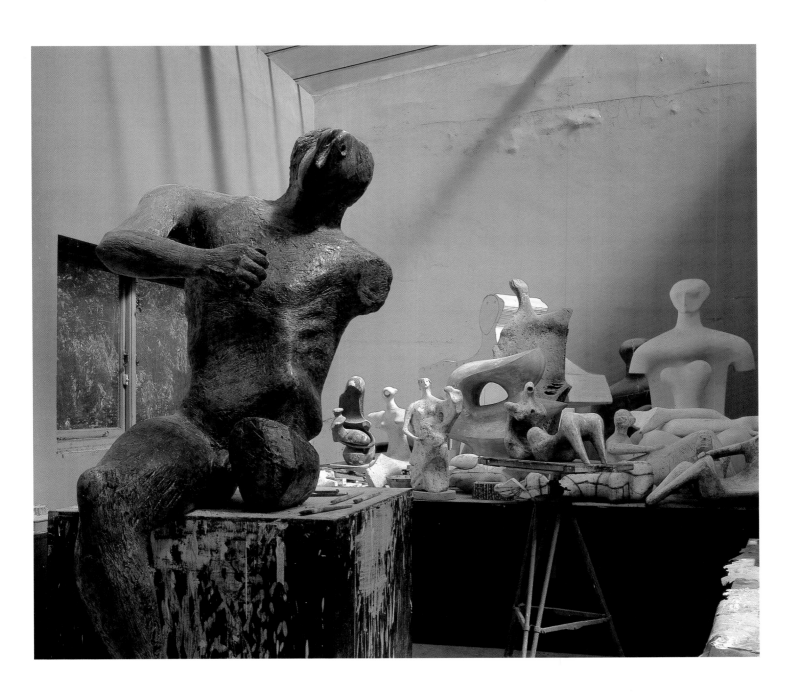

The figure may be emotionally connected (as one critic has suggested) with one's feelings and thoughts about England during the crucial and early part of the last war. The position of the shield and its angle gives protection from above. The distance of the shield from the body and the rectangular shape of the space enclosed between the inside surface of the shield and the concave front of the body is important.

Letter of 15 January 1955, quoted in Moore, 1966, p. 250

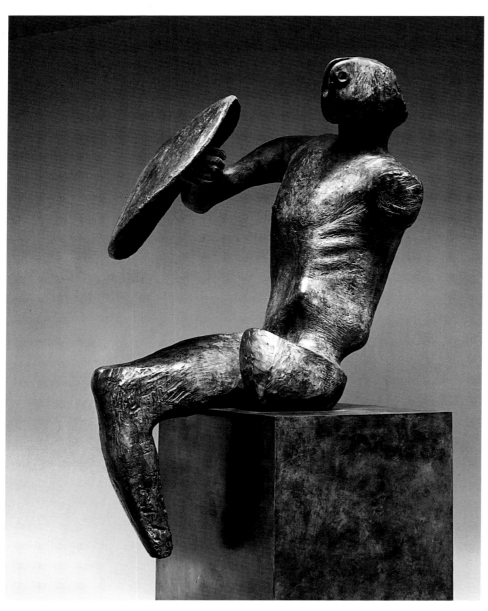

Fig. 24 *Warrior with Shield*, 1953–54 (LH 360); bronze, h. 152.5 cm

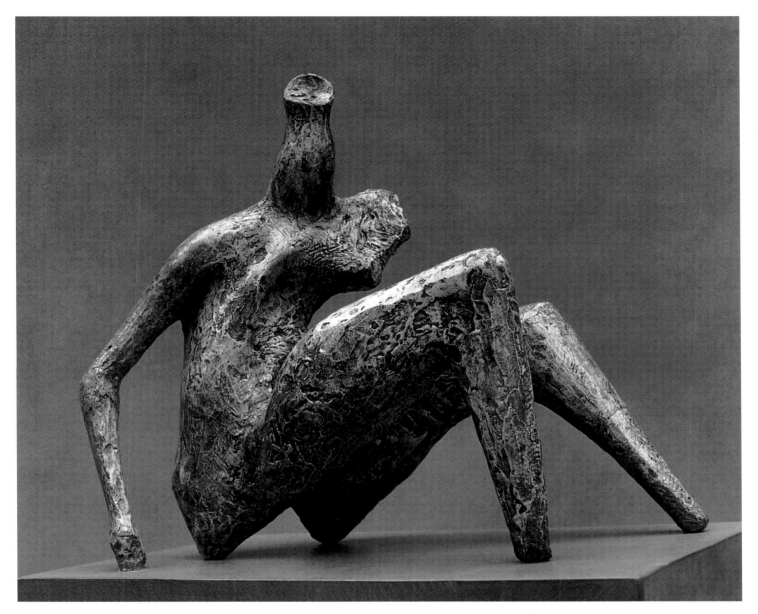

65
Seated Torso 1954
plaster with surface colour
l. 49.5 cm
LH 362
The Henry Moore Foundation:
gift of the artist 1977

This work was conceived in 1954 and
cast two years later in bronze by the Susse
Foundry in Paris, which was then casting
much of Moore's sculpture. The plaster
remained at Susse for many years before
being returned to the Henry Moore
Foundation, where it was restored by one
of the sculpture assistants, Michel Muller,
who worked for Moore from 1970 until
the artist's death in 1986. JS

The human figure is the basis of all my sculpture, and that for me means the female nude. In my work, women must outnumber men by at least fifty to one. Men get brought in when they are essential to the subject, for example in a family group. I like women and find the female figure means more to me than the male.

From *Henry Moore: Drawings 1969–79*, exh. cat., 1979, p. 35

66
Harlow Family Group 1954–55
Hadene stone
h. 164 cm
LH 364
Harlow Arts Trust, Harlow

This sculpture was carved in 1954–55, enlarged from a maquette of 1944. It was commissioned by Frederick Gibberd, the chief architect-planner of Harlow new town, one of several developments being constructed around London to house those made homeless in the Blitz. As Harlow was only about 12 km from Perry Green, Moore was a natural choice for this commission and Gibberd's idea of siting sculpture in the open air very much appealed to the artist. Sadly, though predictably perhaps, this public sculpture was received with derision by some of the inhabitants of the new town and it has been consistently subjected to vandalism ever since.

The stone block from which the sculpture was carved weighed 5,000 kg when it was delivered to Moore's studio. This was the last stone sculpture to be carved at Perry Green (see fig. 25), subsequent works all being made in Italy. Moore at that time had four assistants who worked with him on the sculpture, one of whom was very nearly sacked for carving a hole in the sculpture where no hole was intended.[1]

This is the only sculpture in Moore's oeuvre to have been carved in Hadene stone, a limestone so soft that much of the original detail of *Harlow Family Group* has been lost. After some serious vandalism in 1988 the work was brought to the Henry Moore Foundation for conservation. The damage to the surface of the stone was assessed and the recommendation made that the sculpture was now too delicate to be shown out of doors. Despite the damage, this carving epitomizes Moore's interest in the family theme and remains one of the key works of the 1950s. DM/JS

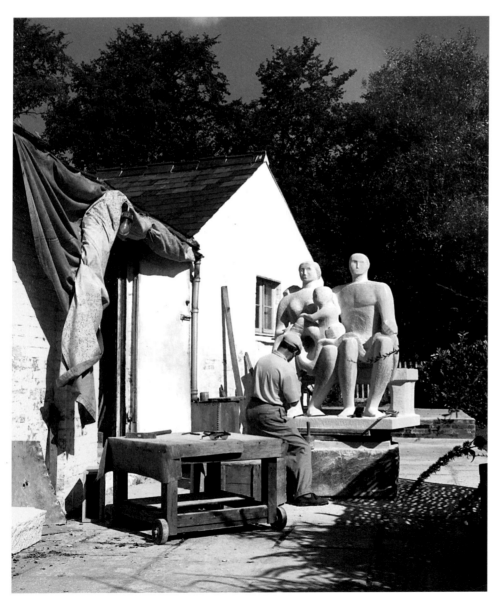

Fig. 25 The artist working on *Harlow Family Group* at Perry Green

1 Berthoud, 1987, p. 261.

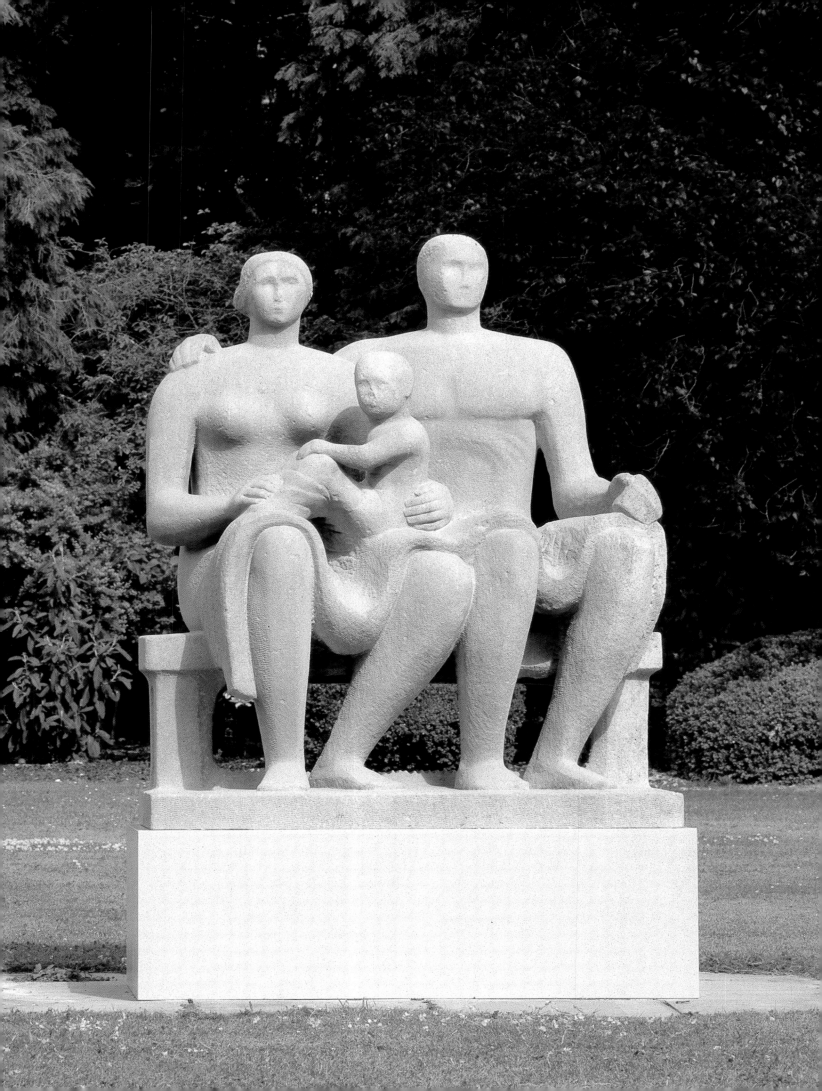

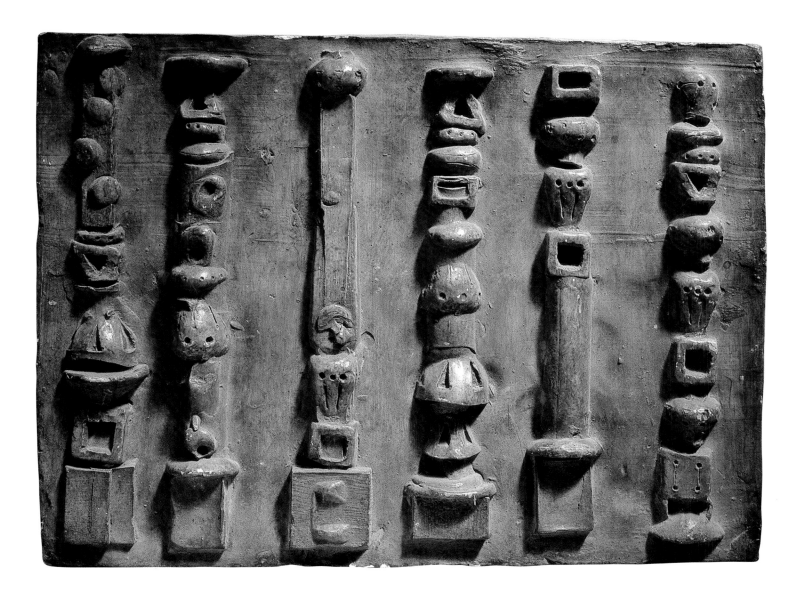

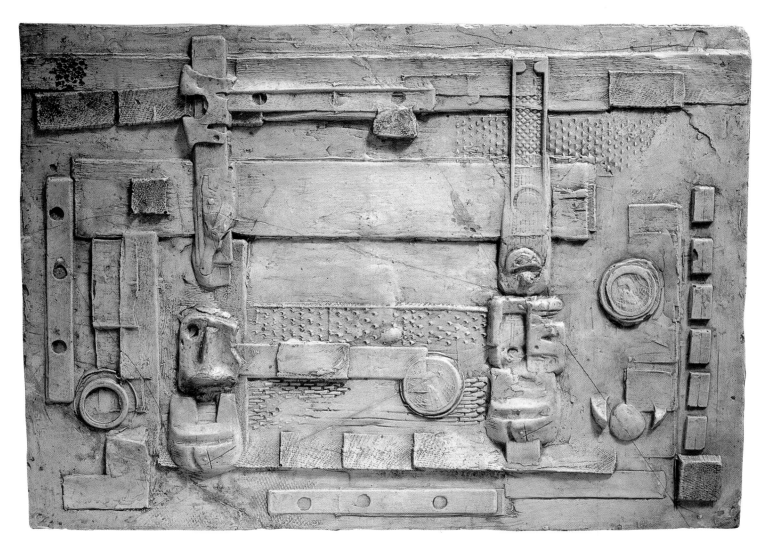

67
Wall Relief: Maquette No. 1 1955
plaster with surface colour
l. 57 cm
LH 365
The Henry Moore Foundation:
gift of the artist 1977

68
Wall Relief: Maquette No. 2 1955
painted plaster
l. 44.5 cm
LH 366
The Henry Moore Foundation:
gift of the artist 1977

69
Wall Relief: Maquette No. 8 1955
plaster
l. 46 cm
LH 372
The Henry Moore Foundation:
gift of the artist 1977

Moore made only a few reliefs during his
long career, preferring sculpture in the
round and finding the constraints of
working against the flat surface of a

building too inhibiting. Referring to his
relief *West Wind* (LH 58), commissioned
for the new headquarters of the London
Underground and completed in 1929, he
later said: 'relief sculpture symbolised for
me the humiliating subservience of the
sculptor to the architect, for in ninety-
nine cases out of a hundred, the architect
only thought of sculpture as a surface
decoration, and ordered a relief as a
matter of course. But the architect of the
Underground Building was persuasive,
and I was young and when one is young
one can be persuaded that an uncongenial
task is a problem that one doesn't want to
face up to.'[1]

What persuaded Moore to tackle a
commission for a relief twenty-seven years
later is not known, but the architect of
the Bouwcentrum in Rotterdam, J. W. C.
Boks, visited Hoglands and induced the
artist to take on the task of providing a
6.89 by 19.22-metre relief in brick for
the building (fig. 19, p. 191). The novelty
of the medium and the promise that
specialist bricklayers would be equal to
any difficulties that might arise probably

helped Moore to overcome his initial
scepticism.

The commission marks a turning point
in Moore's working methods: instead of
making preparatory drawings, he worked
entirely in three dimensions. In a burst of
creativity nine plaster maquettes were
produced, all later cast in bronze editions.
They contain a variety of forms, some
recognizably organic, others mechanical –
lobster claws, tools, objects found in the
studio, other sculpture maquettes – all
pressed directly into the plaster, as well as
more abstract lines and criss-cross
patterns.

The three shown here are very different
interpretations of the same subject. No. 2
(plate 68) comprises impressions of
formal elements directly related to the
'upright motive' maquettes on which
Moore was working at about this time
and which he subsequently enlarged as
free-standing three-dimensional sculp-
tures. The figure fourth from the left in
this maquette, for example, was enlarged
to form a 155-cm-high terracotta, *Bird
Table* of 1954 (LH 363), which stood

70
Upright Motive: Maquette No. 6 1955
plaster with surface colour
h. 30.5 cm
LH 384
The Henry Moore Foundation:
gift of the artist 1977

71
Upright Motive: Maquette No. 10 1955
plaster with surface colour
h. 30.5 cm
LH 390
The Henry Moore Foundation:
gift of the artist 1977

Neither of these two maquettes was en-
larged, although others from this group of
fourteen were, and when Moore returned
to the subject in 1968 he made five more
maquettes and enlarged one. Like the
totem poles created by the North Ameri-
can Indians, these 'upright motives' were
made by piling one form on top of an-
other. The top half of No. 6 is strangely
human, while the lower half is highly
decorative with abstract, almost mathe-
matical symbols. No. 10 is a more unified
organic compilation of bone fragments,
lumps of wood and even bits of rejected
plasters from the studio, which gives it an
altogether less complex and refined feel.

JS

outside the front door of Hoglands until
the death of the artist's wife in 1989.
No. 8 (plate 69) concentrates on the
mechanical aspect of the found objects,
incorporating impressions of blacksmiths'
files, metal plates, a sliding bevel, medals.
Finally, however, it was the combination
of the flowing curves of organic shapes
and the rigid linearity of mechanical lines,
echoing freely the windows in Boks's
building, that took precedence over the
other ideas. In its presentation of organic
forms against an architectural back-
ground the definitive maquette, No. 1
(plate 67), which incorporates ideas
distilled from the two others shown here,
may be compared to the drawing *Figures
with Architecture* (plate 45). JS

1 Moore, *Sculpture in the Open Air*, ed. Robert
Melville, London, 1955, reprinted in Moore, 1966,
p. 97.

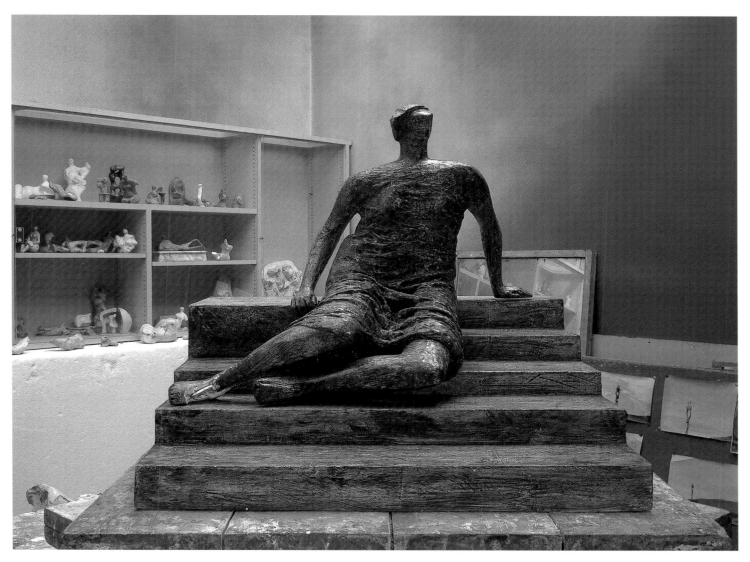

72
Working Model for Draped Seated
Woman: Figure on Steps 1956
painted plaster, paper and hessian
h. 65 cm
LH 427
The Henry Moore Foundation:
gift of the artist 1977

The problem of placing a sculpture
against a building occupied Moore from
1955 to 1957, and many of his figures
from this period are seated on or against
architectural elements. Steps and benches
feature strongly at this time, when he was
experimenting with ideas for the com-
mission to create a monumental work for
the Unesco headquarters in Paris. In an
attempt to resolve the problem he filled
a sketchbook with drawings and produced
a series of maquettes from which he devel-
oped a number of larger works, including
Draped Seated Woman (fig. 10, p. 23).

One of the most interesting aspects of
this plaster is that, owing to the damaged
leg, it is possible to see the method of
construction Moore used to make the
working model. The metal armature or
frame is covered with cloth and news-
paper, in this case an unidentified French
magazine or journal, to which layers of
plaster have been added. The cloth is
bunched up to render the folds in the
skirt and around the torso, while the
newspaper has been used to build up
such parts as the legs. The sculpture is
extremely fragile and has recently been
restored from a very damaged state. It
was decided not to repair the leg, so that
the viewer might have an opportunity to
see beneath the surface.

This figure is also significant for com-
bining the draped figures of two or three
years earlier with the figures placed
against architectural settings of the latter
half of the decade. Moore's visit to Greece
in 1951 and the people wrapped in
blankets he had seen in the Underground
shelters during the war united to bring
about the draped figures of 1953 to 1957.
Moore said: 'Drapery can emphasize
the tension in a figure, for where the
form pushes outwards, such as on the
shoulders, the thighs, the breasts, etc.,
it can be pulled tight across the form
(almost like a bandage), and by con-
trast with the crumpled slackness of the
drapery which lies between the salient
points, the pressure from inside is intensi-
fied.'[1] JS

1 Quoted in Russell, 1968, p. 132.

137

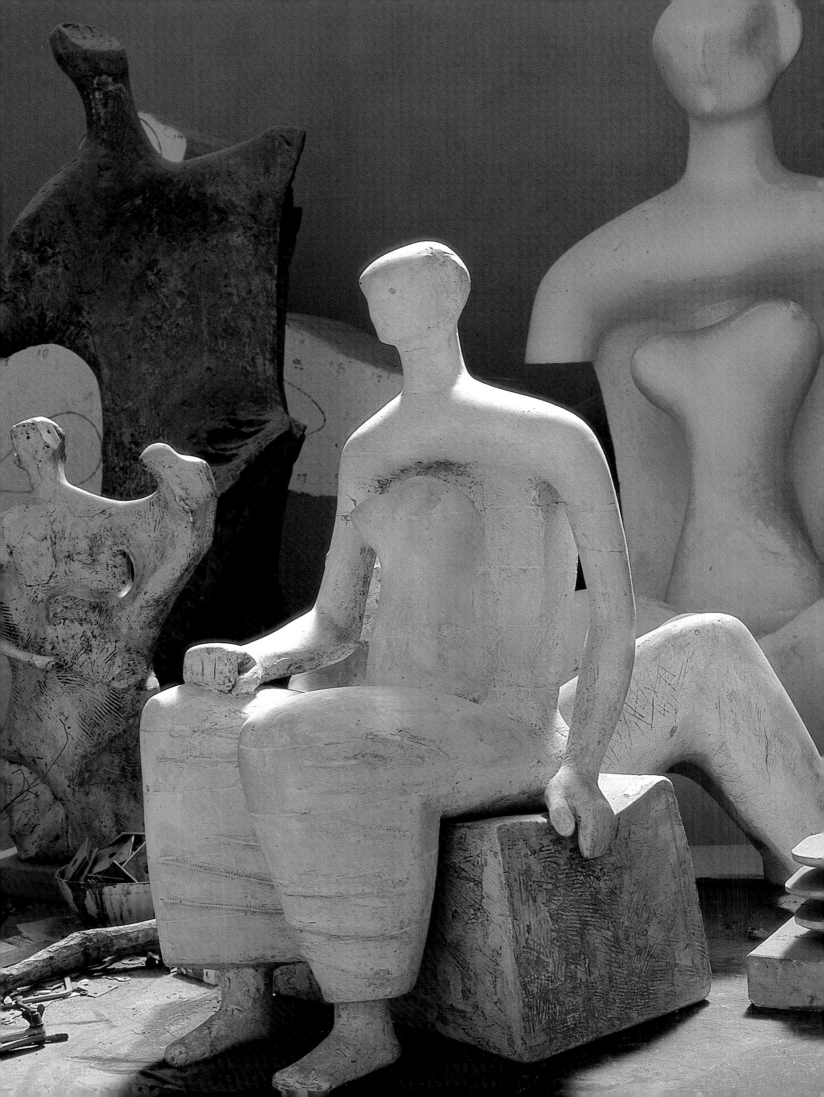

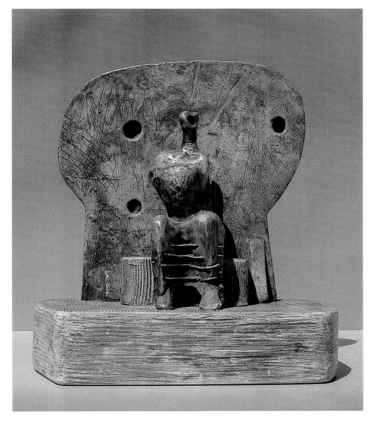

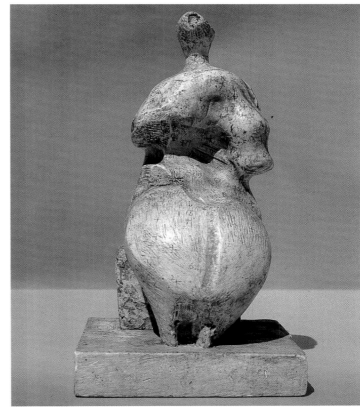

73
Working Model for Seated Woman
cast 1980
plaster with surface colour
h. 76 cm
LH 433b
The Henry Moore Foundation

Although the maquette for this *Seated Woman* dates from the mid-1950s, this working model was not made until 1980. The use of drapery in this work, unlike plate 72, is minimal and highly refined. The forms of the thighs push through the thin, almost transparent drapery with an energy and force that is quite different from that seen in the earlier draped figures. One of Moore's assistants, Michel Muller, was working on a monumental version of this work at the time of the artist's death in 1986. In accordance with Moore's wishes the large plaster remains unfinished, a testimony to his desire to be able to oversee all production of his work.
JS

74
Armless Seated Figure against Round Wall 1957
plaster with surface colour
h. 28 cm
LH 438
The Henry Moore Foundation:
gift of the artist 1977

Walls appear in Moore's drawings as backgrounds for sculpture as early as the 1930s, for example in plates 41 and 45, but he did not experiment with them sculpturally until 1955, when challenged by the Unesco commission. Moore expressed concern about the siting of his works: 'If a thing is three-dimensional and meant to have a sense of complete existence it won't do to back it up against a wall like a child that's been put in the corner.'[1] To this end he began a series of sculptures in 1956 that had their own environments, their own architecture, and it is to this series that *Armless Seated Figure against Round Wall* belongs. In some cases the environment was a set of steps, as in plate 72, in others merely a bench; in the present instance the wall provides a background that is more akin to a throne than a seat. It is most likely that the holes in this sculpture are intended to give the surface of the wall some articulated interest. JS

1 Quoted in Russell, 1968, p. 156.

75
Maquette for Seated Woman 1957
plaster with surface colour
h. 18.8 cm
LH 439b
The Henry Moore Foundation:
gift of the artist 1977

Even in a tiny size the monumentality of this work is apparent. Arms, legs, feet and facial features are minimal or entirely missing. What is of importance are the curves of the modelling and the vaginal incision across the hugely bulbous skirt, both of which lead the eye to the centre of the form. This work epitomizes female fecundity, belonging to a series of sculptures in which Moore's interest was dominated by mature womanhood rather than by youth, which is so obviously the influence in plate 61. A larger version in plaster was made shortly after the maquette, but by then the artist had lost interest in this particular aspect of woman and he did not return to the plaster and complete it until 1975, when a bronze edition was cast. DM

76
Two Reclining Figures 1957
chalk, wash
292 x 242 mm
HMF 2959
The Henry Moore Foundation:
gift of the artist 1977

At first glance these figures look more
like machine parts from the days of the
Industrial Revolution than living, breath-
ing females. Being drawn one above the
other, with no indication of background,
they have none of the imposing three-
dimensionality that Moore often em-
phasizes. Many of his reclining figure
drawings are composed of pairs of square
forms joined together by not very much
in the middle areas, and this central
portion was soon to disappear altogether
in his drawings (such as plate 78) and in
the series of two-piece reclining figure
sculptures that began in 1959 (see fig. 26).
DM/CH

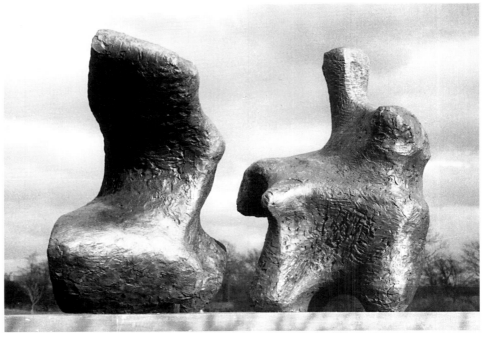

Fig. 26 *Two Piece Reclining Figure No. 1*, 1959 (LH 457); bronze, l. 193 cm

77
Page from Sketchbook 1961–62:
Two Reclining Figures 1961
pencil, wax crayon, pastel, watercolour
wash, pen, chalk
292 x 242 mm
HMF 3029
The Henry Moore Foundation:
gift of the artist 1977

In these shapes can be seen many different
figurative forms that invite free inter-
pretation, including a strong mother and
child element apparent in the upper
figure. As Moore once said, he became
obsessed with this theme, 'so that I was
conditioned, as it were, to see it in every-
thing'.[1] He seems to be passing that
obsession on to the viewer. The 'ponder-
ous, chunky forms'[2] echo each other,
especially the flowing arch shapes, giving
the whole a feeling of strength and
composure. The colouring, achieved by
use of wax and watercolour, lends the
work the atmosphere of early winter
mornings. CH

1 Quoted in *The Drawings of Henry Moore*,
exh. cat., 1977, p. 44.
2 Ibid., p. 46.

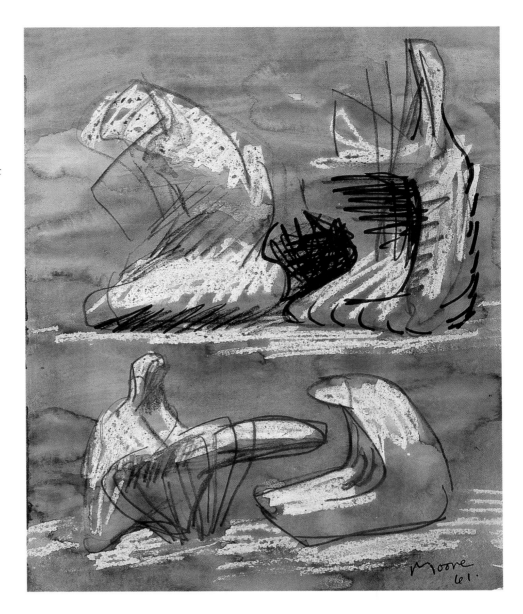

Sculpture that is made in several pieces which are arranged in relation to
each other is something which I as a sculptor am particularly conscious of.
The distances apart between the different pieces of a sculpture, if they were
wrong, is what I would notice immediately. It is like when in a museum the
art historians have found fragments of a Greek sculpture: they may have
found a head, a bit of an arm, a knee and perhaps a foot, but they don't stick
the foot on the knee and so on – they make a gap between them with a wire
connecting each piece and this distance apart between each piece is what
they must have right. My two-piece and three-piece sculptures have the space
between each part which to me is the same as spacing the knee from the foot.
This space between each piece is terribly important and is as much a form as
the actual solid, and should be looked upon as a piece of form or a shape just
as much as the actual material.

Extract from conversations with the artist recorded by David Mitchinson, Much Hadham, 1980,
first published in Mitchinson, 1981, p. 266

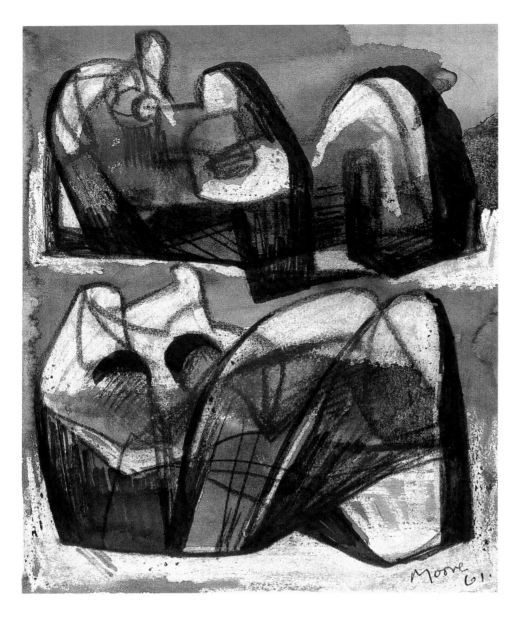

78
Page from Sketchbook 1961–62:
Two Reclining Figures 1961
crayon, wax crayon, felt-tipped pen,
watercolour wash
292 x 242 mm
HMF 3053
The Henry Moore Foundation:
gift of the artist 1977

Subject and technique have come together
in this work to create the kind of power
that can prompt deep and lyrical thought.
To use wax crayon in this way an artist
must reverse his normal working pro-
cedure, starting with the highlights and
finishing with the outlines. This helps
to create a spontaneous feel, and also
destroys the 'solidity' of many of Moore's
forms on paper. The scribbled black lines
in crayon, and more so those in felt-
tipped pen, add an agitated, spiky look
that creates the atmosphere of the work,
placed as they are in front of the heavy,
tempestuous background.

 This is one of a series of drawings of
reclining figures made from 1959 to 1962
that Kenneth Clark described as 'explo-
sions from his [Moore's] inner self, of un-
precedented potency'.[1] The sheet contains
two sketches of a reclining figure in two
pieces, in which each section is a sculp-
tural object in its own right but linked as
a reclining figure by our understanding of
the spaces between them. The top figure
was first developed in three dimensions as
Maquette for Two Piece Reclining Figure:
No. 1 of 1959 (LH 457a), in which the
two pieces were joined in the centre.
When Moore came to enlarge it later the
same year he separated the two halves.
 CH/DM

1 Clark, 1974, p. 286.

79
Reclining Figure 1959–64
elmwood
l. 261.5 cm
LH 452
The Henry Moore Foundation:
gift of Irina Moore 1977

There are six elmwood reclining figures
in Moore's oeuvre, which punctuate his
career over a period of forty-three years.
The artist said in 1968: 'I like working
with elmwood because its big grain makes
it suitable for large sculptures and because
of the cool greyness of the wood. An
interesting point about working with
wood is that it must come from a live
tree. Dead wood, by which I mean wood
from a tree that has died, has no qualities
of self-preservation and rots away.'[1] The
earliest of Moore's elmwood reclining
figures, 89 cm long, was carved in
1935–36 and is in the collection of the
Albright-Knox Art Gallery in Buffalo;
the second, 107 cm (fig. 15, p. 29), dates
from 1936 and the third, at 208 cm long
larger still (fig. 2, p. 49), from 1939.

These first three elmwood figures were
carved in Kent by Moore, assisted by
Bernard Meadows. Meadows has revealed
that the elmwood was acquired from the
local coffin maker in Canterbury.[2] Elm
is notoriously difficult to dry out and
season; it splits easily and has to be cut
into very thin sheets (ideal for coffins)
before being used. Moore, of course, was
keen to use large pieces of elm and, as a
result, the wood had to be carved wet,
before it dried out and cracked. Meadows
describes working in the studio at Burcroft
and getting soaked by the sap spurting out
of the elm as they chipped into the wood.
The three remaining elmwood reclining
figures were carved at Hoglands, the first
of them just after the Second World War,
in 1945–46 (fig. 16, p. 114).
 There was a gap of some fourteen years,
during which Moore concentrated on
bronze sculpture, before he returned to
elmwood reclining figures. 'This *Reclining
Figure* in elmwood took a long time to
finish because in the early stages there was
a crack in the lower part of it which

hadn't shown itself in the large original
tree trunk. I got somewhat disheartened
when I found that this crack was getting
bigger, and for a period I stopped work-
ing on it. However, the splitting slowed
down, and eventually I took it up again
and finished it. But from beginning to
end it took me five or six years. I think
the sculpture gained by having a slow
evolution.'[3] This is certainly one of
Moore's most powerful sculptures
and shows a mature confidence in the
handling of the wood and the forms. The
artist told Alan Wilkinson in the 1970s,
with understandable pride, that the art
critic Adrian Stokes had said that in his
opinion this carving was the Moore
sculpture best qualified to be mentioned
in the same breath as Michelangelo's
work.[4] JS

1 Quoted in Hedgecoe, 1968, p. 335.
2 Conversations with Meadows, recorded by the
author, London, 1994.
3 Quoted in Hedgecoe, 1968, p. 334.
4 Wilkinson, 1987, p. 150.

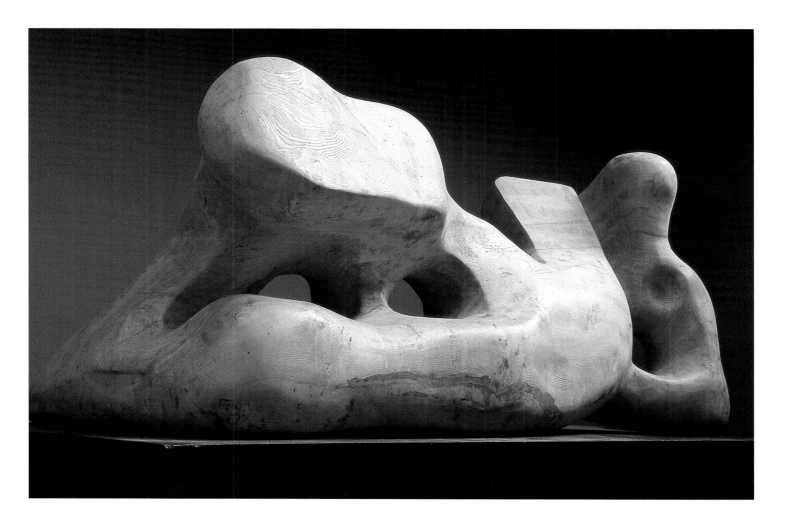

Everything I do is intended to be big, and while I'm working on the models, for me they are life-size. When I take one in my hand like this, I am seeing and feeling it as life-size. It's actually easier to visualise the small models in this way than, say, a half-size figure which would cover the top of a desk or table.

When I've got the model in my hand, I can be on all sides of it at once and see it from every point of view – as a sculptor has to do – instead of having to keep walking around it. So in my mind there's never any change of scale at all.

Quoted in Tom Hopkinson, 'How a Sculptor Works', *Books and Art*, November 1957, pp. 28–29

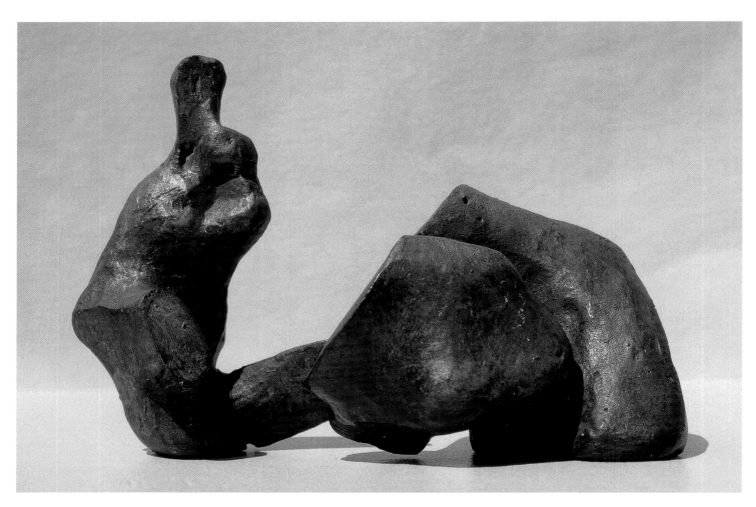

80
Maquette for Two Piece Reclining Figure No. 5 1961
sprayed and painted plaster
l. 20.5 cm
variant on LH 475
The Henry Moore Foundation:
gift of the artist 1977

Moore had experimented with divided reclining figures in two, three and four pieces in the mid-1930s. He returned to the subject in 1959, but now brought to it a rugged landscape element and a concentration on such organic forms as flints, stones and bones. He said: 'As long ago as 1934 I had done a number of smaller pieces composed of separate forms, two-

and three-piece carvings in ironstone, ebony, alabaster and other materials. They were all more abstract than these.... I did the first one in two pieces almost without intending to. But after I'd done it, then the second one became a conscious idea. I realized what an advantage a separated two-piece composition could have in relating figures to landscape. Knees and breasts are mountains. Once these two parts become separated you don't expect it to be a naturalistic figure, therefore you can justifiably make it like a landscape or a rock. If it is a single figure, you can guess what it's going to be like. If it is in two pieces, there's a bigger surprise, you have more unexpected views.'[1]

This maquette was used for enlarging into a monumental sculpture but, unusually, was itself never cast in bronze. Moore added colour to the plaster maquette, in this case black/brown, for several reasons. It was a good guide for the foundry when they were patinating a sculpture, but it also showed them where he wished to emphasize particular areas and surfaces within the work. This maquette has a fairly uniform colour because the shape and surface texture are so dominant that the final patina is inevitably less important than that on some of the smooth-surfaced pieces. JS

1 HMF archive.

144

81
Emperors' Heads 1961
sprayed and painted plaster
l. 21 cm
LH 493a
The Henry Moore Foundation:
gift of the artist 1977

Moore was – and is – often accused of
making heads on his sculpture insignifi-
cant, but he denied this, claiming that he
acknowledged them to be the most im-
portant part of a piece of sculpture.
'Heads are the most expressive part of a
human being so they have always been
treated in art as a subject on their own.
The artist can use the theme of the human
head in many different ways – for por-
traiture, for expressive purposes in an
imaginary head, or as a study for part of
a larger work.'[1]

Here the left head was originally created
as a work on its own entitled *Skull Head:
Eye Socket* (1961; LH 493), which was
never cast in bronze. The pairing shown
here was created at a time when Moore
was concentrating on the themes of heads
and two-piece figures. Although there is
no explanation as to why he decided to
add the second head, it is obvious that
the combination of the themes interested
him. There are only a few examples in
his work of pairs of heads, but in these,
as in all his two-piece sculptures, the space
between the parts is as important as the
forms themselves. JS/DM

1 Quoted in *Henry Moore: Drawings 1969–79*,
exh. cat., 1979, p. 65.

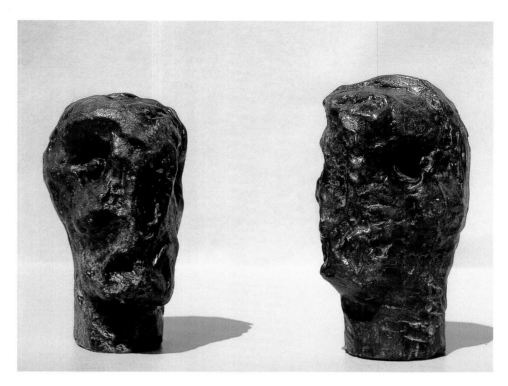

82
Maquette for Stone Memorial No. 2
1961
plaster with surface colour
h. 10 cm
LH 491
The Henry Moore Foundation:
gift of the artist 1977

The great advantage to Moore of working
directly in three dimensions was that he
could see the sculptural idea in the round,
whereas with drawing he was limited to
one view, one impression of an idea. He
explained that for some of his later work
he would have needed twenty or thirty
drawings to encompass a single sculpture.
'I need to know it from on top and from
underneath as well as from all sides. And
so I prefer to work out my ideas in the
form of small maquettes which I can hold
in my hand and look at from every point
of view.'[1]

This maquette is a perfect demonstra-
tion of the benefit Moore derived from
this working method. Based on bones
(perhaps on animal vertebrae), it is a
marvellous mixture of forms and spaces,
solids and hollows, which change and
catch the light with every slightest turn.
The sculpture was enlarged to working-
model size and cast in bronze. It was
further enlarged to a height of 180.5 cm
in travertine marble in 1969. At each
stage of enlargement slight alterations
and refinements were made to the sculp-
ture to take account of perceived changes
of proportion. JS

1 Quoted in Hedgecoe, 1968, p. 269.

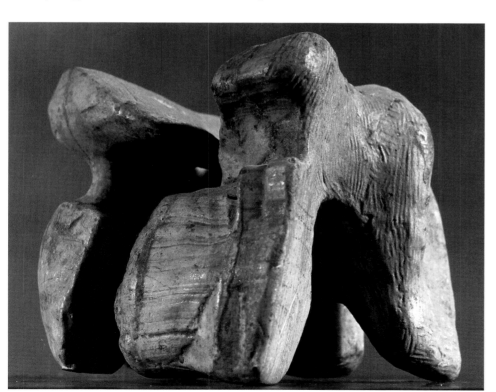

The Mother and Child idea is one of my two or three obsessions, one of my inexhaustible subjects. This may have something to do with the fact that the Madonna and Child was so important in the art of the past and that one loves the old masters and has learned so much from them. But the subject itself is eternal and unending, with so many sculptural possibilities in it – a small form in relation to a big form, the big form protecting the small one, and so on. It is such a rich subject, both humanly and compositionally, that I will always go on using it.

From *Henry Moore: Drawings 1969–79*, exh. cat., 1979, p. 29

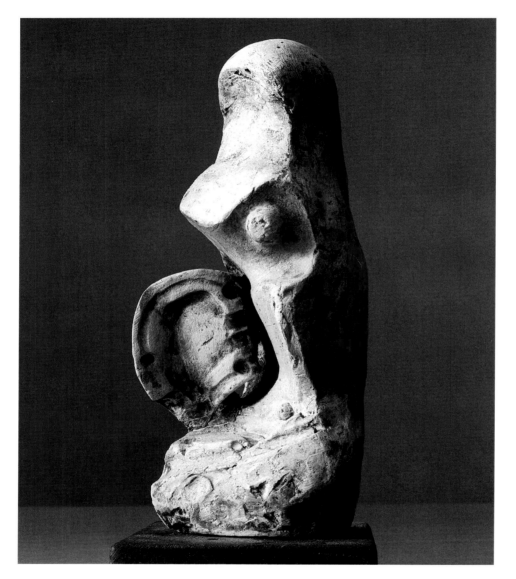

83
Mother and Child: Round Head 1963
plaster with surface colour
h. 28.5 cm
LH 512
The Henry Moore Foundation:
gift of the artist 1977

Many of the plasters, like this one, are based on organic forms, often casts of a shell, pebble, flint or bone, on which Moore then worked to produce a final maquette. His studios were littered with *objets trouvés*, on the floor, in boxes or on shelves, and some would be around for years before they caught the artist's eye and became integrated into sculptures. He would take an object, press it into clay and take a plaster cast from it. He would then work on this, adding to the forms with more plaster or carving it when dry in response to his reaction to the shape.

JS

84
Maquette for Atom Piece 1964
(cast 1970)
plaster
h. 15 cm
LH 524
The Henry Moore Foundation:
 gift of the artist 1977

'The Atom Piece symbolizes those forces
which modern man has released for ends
which cannot yet be imagined or realized,
but which for the present we inevitably
associate with universal destruction. At
the same time it negates this evil intention
and returns the contemplating mind to a
mood of stillness and serenity.'[1]

Moore was approached in 1963 by the
University of Chicago Committee to
produce a sculpture to commemorate the
25th anniversary of the first self-sustain-
ing nuclear chain reaction, achieved there
in 1942. It is important to recall that this
maquette was already conceived and did
not originate in Moore's mind as an
interpretation of atomic power, yet when
he showed it to the committee they agreed
that it would be a suitable testimonial to
one of the world's greatest events. A
working model was produced, and the
final version, over 3.5 metres high, stands
on the Campus at the University of
Chicago (fig. 27), renamed *Nuclear
Energy* because Moore was anxious not
to have the word 'Piece' misconstrued as
'Peace'. The work combines the idea of
the atomic mushroom cloud, a beautiful
shape, 'as is often the case with shapes
associated with evil or murderous
purpose',[2] as Read put it, with the far
more organic and human idea of the
skull. JS

1 Read, 1965, pp. 246–7.
2 Ibid., p. 246.

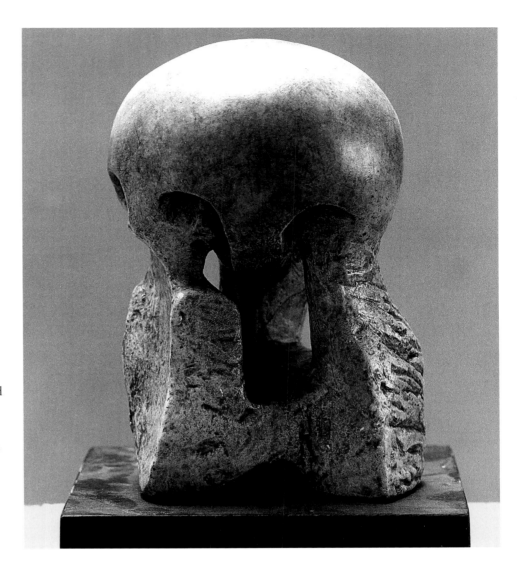

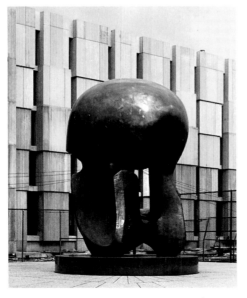

Fig. 27 *Nuclear Energy*, 1964–66 (LH 526); bronze,
h. 366 cm; on the Campus at the University of
Chicago

85

Three Way Piece No. 1: Points 1964–65
plaster with surface colour
h. 193 cm
LH 533
The Henry Moore Foundation:
gift of the artist 1977

This colossal, abstract work was conceived by Moore as a tiny maquette in the 1960s. The source was a small flint that particularly fascinated him because it could be displayed resting on its points in three different ways, hence the title. The final maquette version of this sculpture still has this potential, not being fixed to a base, and, like *The Archer* (LH 535) of the same year, shows him 'attempting to create a new kind of sculpture that was less dependent on gravity and that could be placed in at least three positions'.[1]

This, the largest version, was made in 1964–65 from a working model constructed the previous year. At this stage and date Moore was still enlarging by a method involving a wooden armature and plaster. First, his assistants would construct the armature, which would be a scaled-up enlargement of the key points of the original work. Secondly, they would build on to the armature with plaster, string and gauze, cotton, hessian or other fabric. Moore would closely oversee the process, intervening at the stage when alterations might need to be made concerning perspective, proportion or the surface of the piece. This sculpture was cast in bronze in an edition of three. JS

1 Wilkinson, 1987, p. 214.

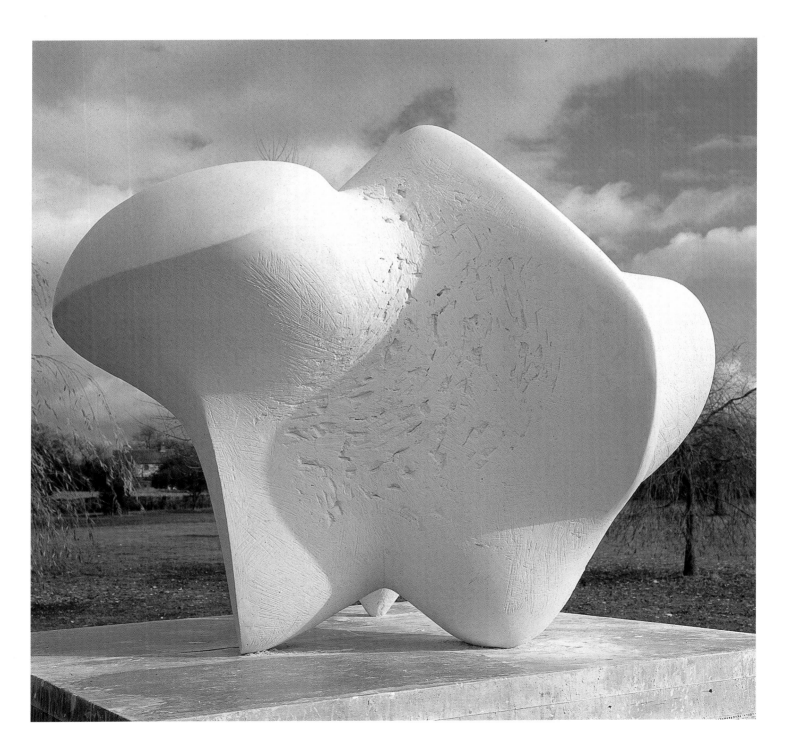

86
Two Three-Quarter Figures on Base
1984 (enlargement of a 1965 maquette)
plaster with surface colour
h. 101.6 cm
LH 539b
The Henry Moore Foundation

This is the only occasion on which cork features in Moore's work. He obviously liked the texture of the cork block into which he fixed the two little figures of the maquette so much that, when he decided to enlarge them, he kept its surface and detail in the plaster version. The tall, minimally human figures are reminiscent of standing figures that Moore was working on in the early 1950s. They owe their origins to bone forms, but their marked gesture and the turn of their heads give them a distinctly female, almost humorous character – two sisters on a podium, perhaps. JS

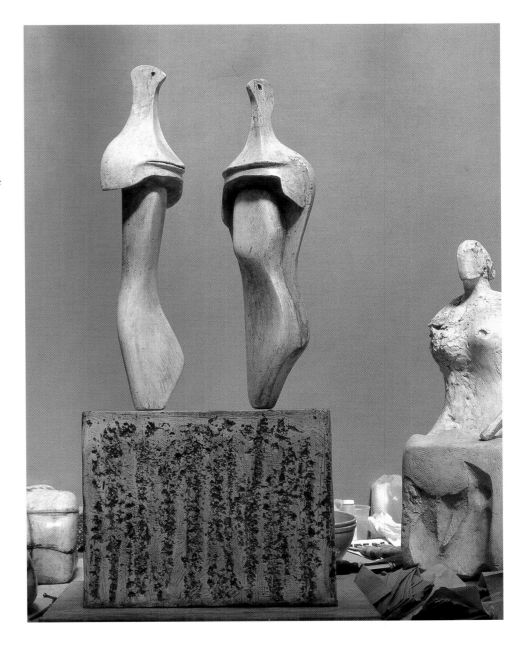

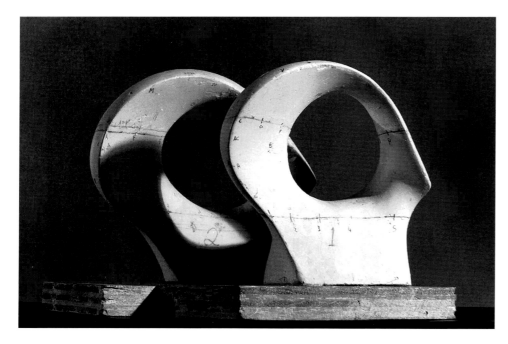

87
Maquette for Double Oval 1966
plaster
l. 24 cm
LH 558
The Henry Moore Foundation:
gift of the artist 1977

This maquette was enlarged to a length of
550 cm and cast in bronze. Unusually, the
enlargement was done directly from the
maquette, using the measurements and
lettered points visible on the surface to
build an armature that was then covered
in plaster in the method explained in the
commentary on plate 90. Moore then
checked the work and added the surface
detail with a cheese grater. Each oval is on
a separate block, which indicates that the
relationship between the two was not
fixed at this stage. The sculpture cannot
therefore be regarded in the same way as
Moore's other 'two-pieces'. The two ovals
are, in fact, quite different, and they
interact in a remarkable way. Each viewed
through the other, they become more or
less solid as the oval spaces grow and
shrink, while from head on, the two
shapes work in harmony as they lean and
seem to move forward. In their final,
immense proportions (fig. 28) they have a
contradictory bulk and grace – two great
diplodocus heads shining like pieces of
delicate jewellery. CH

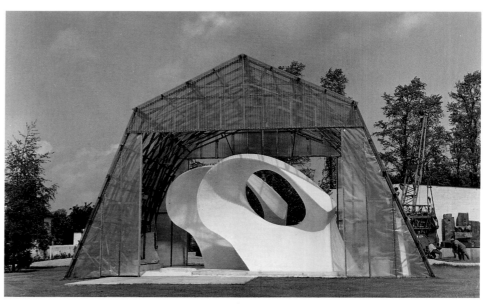

Fig. 28 Enlarged *Double Oval*, 1966 (LH 560); plaster, l. 550 cm; in the 'plastic studio' at Perry Green

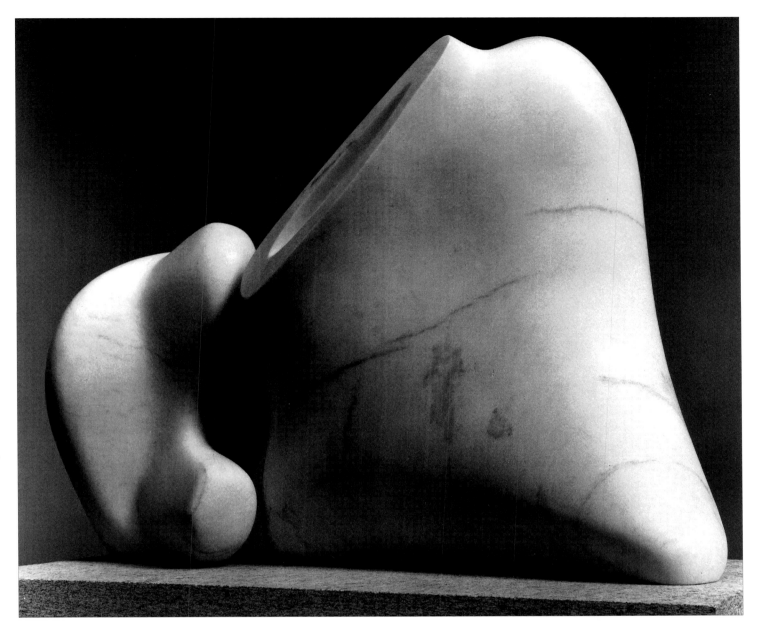

88
Mother and Child 1967
rosa aurora marble
l. 130.2 cm
LH 573
The Henry Moore Foundation:
gift of Irina Moore 1977

The Moores bought a holiday cottage
at Forte dei Marmi at the foot of the
Carrara mountains in Italy where the
family spent their summer holidays from
the mid-1960s. Moore renewed his
relationship with the Henraux stoneyard
in Querceta, where he had worked on the

Unesco Reclining Figure (fig. 8, p. 42) in
1957–58, and from 1964 produced a
small number of carvings each summer.
 The art critic David Sylvester wrote in
1968 that Moore was concerned with
'tactile sensations and motor sensations
rather than visual ones'.[1] Moore himself
wrote in a notebook at about the same
time: 'To make a shape strongly signi-
ficant, without knowing why, or why it
is so. Perhaps ability to do this comes
about because of the sculptor's interest
in all forms and shapes – through em-
pathy and human connections.'[2] This

carving is an example of the expression,
through form and shape, of maternal
affection and childlike dependence. The
soft colours of the beautiful Portuguese
marble, rosa aurora, seem further to
emphasize the tenderness of the mother,
while the firm, cold stone reminds us of
the strong protection afforded the child.

JS

1 *Henry Moore at the Serpentine*, exh. cat., 1978,
introduction.
2 Ibid.

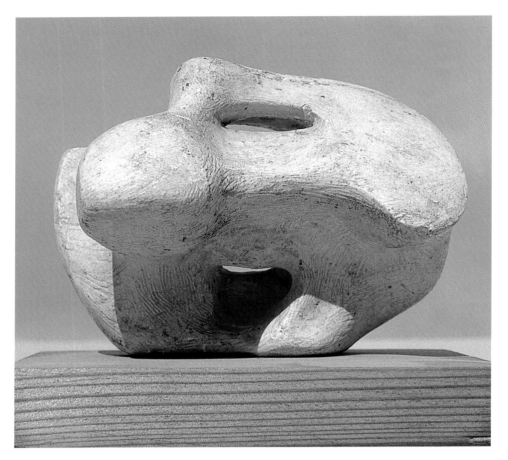

89
Maquette for Sculpture with Hole and Light 1967
plaster with surface colour
l. 10.2 cm
LH 574
The Henry Moore Foundation:
gift of the artist 1977

Moore preferred to work on maquettes of this size. He would hold the plaster in his hands, turning it round, looking at it and working at it from all sides. Seen from different angles, this sculpture presents quite different aspects, the holes being obscured from the viewer when seen from below and just the hint of a hollow being perceptible when viewed from the side. It has forms in common with both *Two Piece Reclining Figure: No. 9* (LH 576) and *Three Piece Sculpture: Vertebrae* (LH 579) and is an example of how Moore took and worked on a shape or a form until he felt he had exhausted it. The work was enlarged and carved in red travertine marble during 1967 (fig. 29) and the maquette cast in bronze in 1974.

JS

Fig. 29 Moore carving *Sculpture with Hole and Light* (LH 575) at Querceta in 1967

90
Working Model for Spindle Piece 1968
plaster with surface colour
h. 84 cm
LH 592
The Henry Moore Foundation:
gift of the artist 1977

This sculpture is based on a flint from which Moore made a casting in clay, but it owes its origins to drawings from 1938 and is closely related to *Three Points* of 1939–40 (LH 211). Here, however, the points are not straining towards each other; rather, they are bursting out of the sculpture on each side in a gesture of exploding energy. A maquette was modelled in plaster from which the present working model was enlarged. The process employed by Moore in the late 1960s was to mark the maquette with a

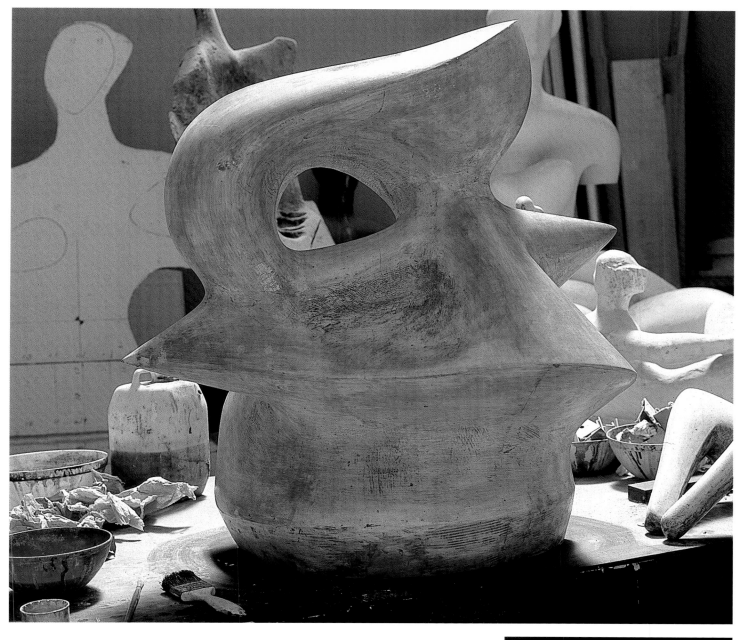

series of points. The working model was then built up in proportion with an armature of wooden stakes to give the gross outline of the sculpture, the end of each stake corresponding to the marks on the maquette (see fig. 30). At the next stage a more accurate shape was achieved through the addition of string between the stakes and to this more plaster was applied.

After the bronze edition had been taken from this plaster it was sent to Italy to be enlarged and carved in travertine marble. While at the stone quarries it was dropped and damaged. The piece was repaired and, on being returned to Moore, it was found that the cracks had merely been covered over with shellac. Considerable restoration had to be carried out before the work could be exhibited.[1] This is one of a few

sculptures by Moore that exist in four sizes as, in addition to the travertine marble carving at 4.5 metres high, an edition of large bronzes at 3.35 metres was also produced. JS/DM

1 Information supplied by the restorer, Malcolm Woodward.

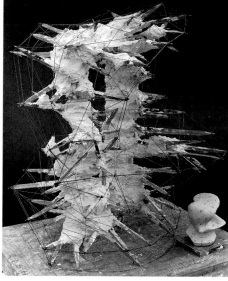

Fig. 30 *Working Model for Spindle Piece* in progress

153

For me sculpture is based on and remains close to the human figure. That works both ways. We make the kind of sculpture we make because we are the shape we are, because we have the proportions we have. All those things make us respond to form and shape in certain ways. If we had the shape of cows, and went about on four legs, the whole basis of sculpture would be entirely different. If it were only a matter of making a pleasurable relationship between forms, sculpture would lose, for me, its fundamental importance. It would become too easy.

Quoted in Carlton Lake, 'Henry Moore's World', *Atlantic Monthly*, vol. 209, no. 1, January 1962, p. 42

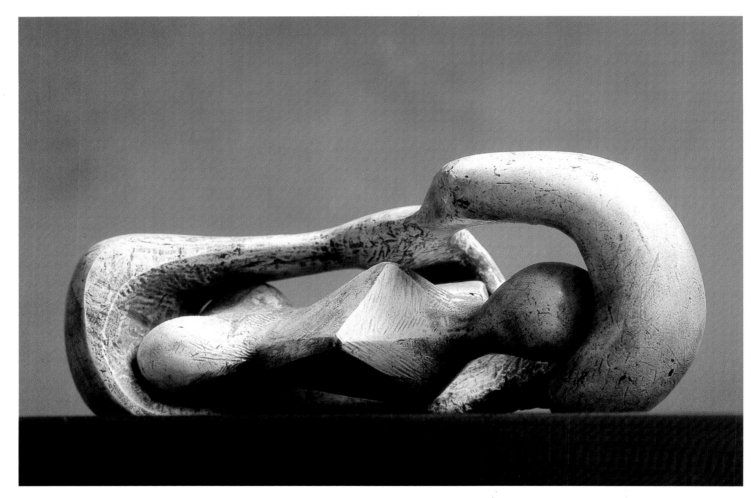

91
Maquette for Reclining Connected Forms
1969
plaster with surface colour
l. 18 cm
LH 611
The Henry Moore Foundation:
gift of the artist 1977

The ideas of Moore's to which this sculpture most obviously relates are those of the internal/external form (for example, plate 59) and the mother and child, themes which are themselves related to one another. Other versions of this work include a bronze edition of the maquette, turned upright, and two enlargements, both horizontal. The work seems most obviously to represent a baby in the womb, but can also be seen as a maternal image of protection, of the child taking shelter within something or someone strong and trusted. These analogies are complemented by the phallic shape of the whole and also by a suggestion of a lovers' embrace, introducing a masculine aspect and playing on the sexual union required to create the tiny life within the woman. The diamond shape of the foetus carries connotations of the 'precious': the work contains a precious inner energy, just as the child is both literally and psychologically an energy within the mother. CH

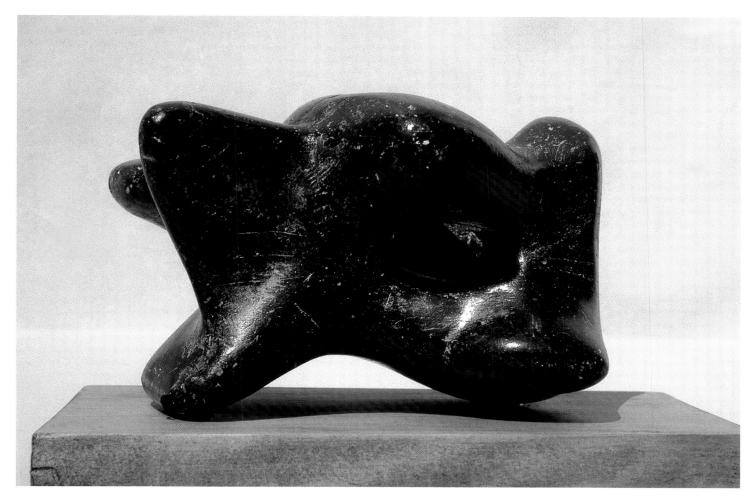

92
Maquette for Oblong Composition 1970
sprayed plaster
l. 14 cm
LH 619
The Henry Moore Foundation:
gift of the artist 1977

This is in some ways as much of a composite piece as the *Wall Reliefs* (plates 67–9) and the *Upright Motives* (plates 70–1). The open end of the sculpture is probably a cast taken from *Maquette for Large Two Forms* of 1966 (LH 554a). Moore often reused plaster casts, which he may have found on the shelves or in boxes on the floor of his studio. He was not averse to using again an idea, a shape or a form that had once proved successful. This shape reappears as the leg section of the upper figure in the drawing *Two Reclining Figures: Ideas for Sculpture* (plate 111). The black surface, maintained when the plaster was restored, is relatively unusual in Moore's work and is believed to have been applied by the foundry rather than by the artist.[1] The work was enlarged to a length of 120 cm in red travertine marble. JS

1 Information supplied by the restorer, John Farnham.

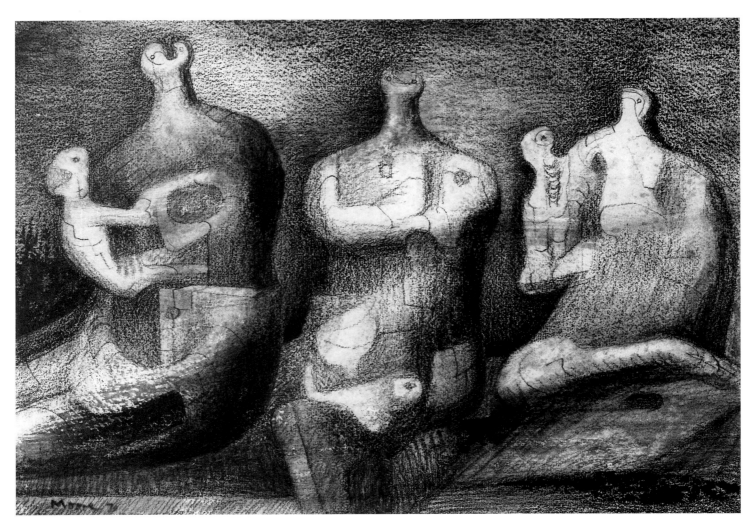

93
Three Seated Mother and Child Figures
1971
charcoal, wash, ink wash, chinagraph
298 x 432 mm
HMF 3314
The Henry Moore Foundation:
gift of the artist 1977

Writing in 1974 Moore said of his pictorial drawings and studies for sculpture that they 'illustrate my preoccupation with making shapes in space on a flat sheet of paper – pushing and destroying the surface to create the effect of solidity, depth and distance'.[1] During the early 1970s he acquired two black drawings by Seurat for his own collection and became fascinated by Seurat's ability to depict intensely dark subjects emerging into light. At the same time he produced two large albums of lithographs in which the subject-matter was almost entirely depicted in black or even picked out in white from a black surface. One was an exploration of Stonehenge (CGM 202–3, 207–23) and the other a group of imaginary landscapes and figures to accompany a selection of poems by W. H. Auden (CGM 245–73). A number of drawings, including this study of rock-like square figures, were done at the same time, and all were concerned with the tonality of the form and the textural quality that could be produced on the paper's surface by the use of black chinagraph. DM

1 *Auden Poems/Moore Lithographs*, exh. cat., 1974.

94
Bird Form I 1973
black marble
l. 36.8 cm
LH 623
The Henry Moore Foundation:
gift of the artist 1977

Birds appear irregularly in Moore's work,
sometimes depicted realistically but
usually, as here, in a rather more abstract
form. The artist said: 'Animals for me
have characters similar to many human
beings, though sometimes I feel freer when
working on an animal idea because I can
invent an imaginary animal. I would find
it less natural to try and alter a human. It
might seem more like a caricature.'[1]
 These two sculptures would seem, in
their black marble mass, to defy the image
we generally have of birds of flight, but
they nevertheless express a quintessen-
tially bird-like quality with their sharp
pointed 'beaks' and the compressed forms
of a fledgling crouching in the nest. JS

1 HMF archive.

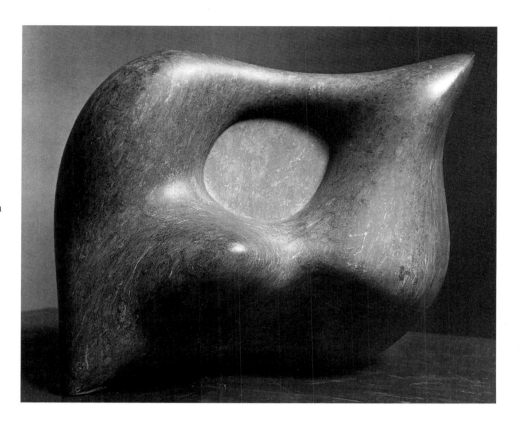

95
Bird Form II 1973
black marble
l. 34.3 cm
LH 624
The Henry Moore Foundation:
gift of the artist 1977

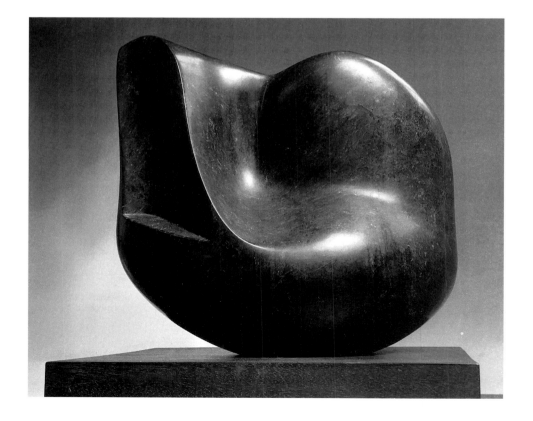

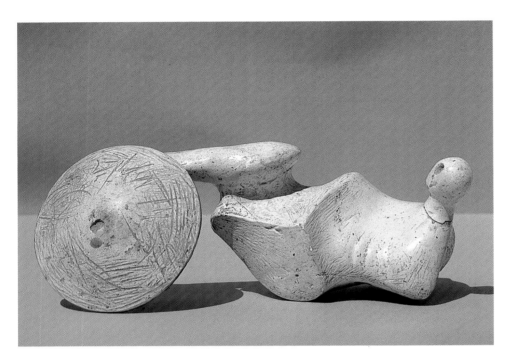

96
Maquette for Goslar Warrior 1973
plaster with surface colour
l. 24.5 cm
LH 640
The Henry Moore Foundation:
gift of the artist 1977

The large version of this sculpture,
300 cm long (fig. 31), is named after the
German city of Goslar, which acquired
the first bronze cast. It is a majestic work
which, as Susan Compton points out,
bears some relation to a few of the larger
figures of the Elgin Marbles: 'Earlier in
his career such an antecedent would have
been unthinkable, but in his maturity
Moore so transformed the underlying
source that even to mention it is almost
irrelevant, except that it links him with
the classical tradition of sculpture-making
in which the human figure is never
abandoned.'[1] The piece is beautifully
balanced, with the round shield at its feet
and the poised head acting as a counter-
balance. The back of the sculpture reveals
a surprisingly realistic rib-cage, which
adds a sense of the figure's mortality. If
the suffering of the earlier warriors (see
plates 63–4 and fig. 11, p. 24) is still
present here, it is less obvious, the pre-
dominant quality being the maintenance
of dignity in the face of pain. JS

1 *Henry Moore*, exh. cat., 1988, p. 266.

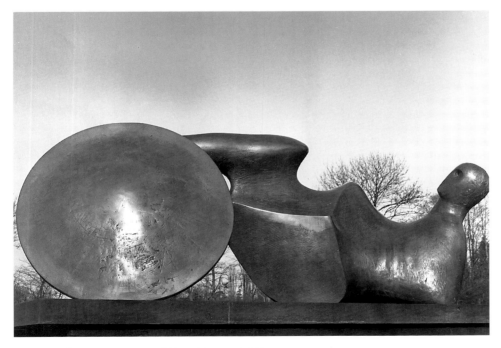

Fig. 31 *Goslar Warrior*, 1973–74 (LH 641); bronze, l. 300 cm

97
Reclining Figure: Bone 1975
travertine marble
l. 157.5 cm
LH 643
The Henry Moore Foundation

'The artist works with a concentration of his whole personality.'[1] This work is a clear example of what Moore meant by this rather romantic statement. The sculpture was the result of a lifetime of thinking about form, of studying natural shapes and perfecting the three-dimensional rendering of a narrow field of subjects that became obsessions. Moore said that 'the bone is the inner structure of all living form'.[2] To him bone embodied the strength of a living organism, with the skin stretched tightly over bone, as in a fist, giving a creature much of its power and vitality. This idea is conducive to sculpture, especially carving. To use the shape of a real bone was therefore to create exactly this feeling in art. But Moore has added layers of significance and power to the piece by combining this with the soft, fleshy, delicate form of a woman. The merest hint of buttocks and breasts and the relaxed pose are given the kind of taut power and presence not usually accorded them. The languid shape hence exudes a powerful and nervous sensuality, and although the figure lies stretched out and static, opening herself up to the onlooker's gaze, she nevertheless commands a deep respect. CH

1 'The Sculptor Speaks', *Listener*, vol. 18, no. 449, 18 August 1937, reprinted in Moore, 1966, p. 62.
2 Quoted in Warren Forma, *Five British Sculptors (Work and Talk)*, New York, 1964, reprinted in Moore, 1966, p. 60.

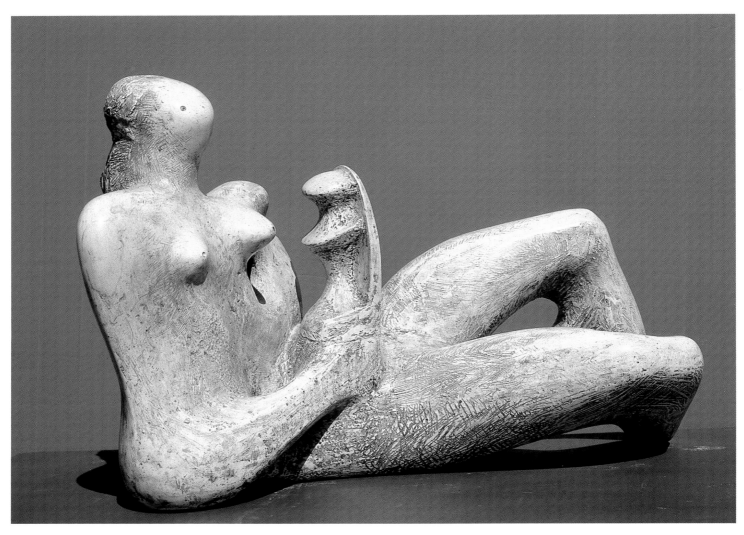

98
*Working Model for Reclining Mother
and Child* 1974–75
plaster with surface colour
l. 59 cm
LH 648
The Henry Moore Foundation:
gift of the artist 1977

Moore was, as he put it, obsessed by the
mother and child and by the reclining
figure, yet it was unusual for him to
combine the two themes in one sculpture,
although there are many depictions of
reclining mother and child groups in his
drawings. Here the mother figure is
relatively realistic, but the baby is nothing
more than a series of shapes whose juxta-
position with the mother defines its being.
Malcolm Woodward, who enlarged this
sculpture, pointed out that the baby is
derived from a shell, the 'features' of the
child being defined by the internal spiral
of the shell, which was broken. Shells
appear frequently in Moore's work at
this time, some more obviously close to
the original source than others – see, for
example, plate 104 – but few integrated
so successfully as here into the essence of
the sculpture. JS

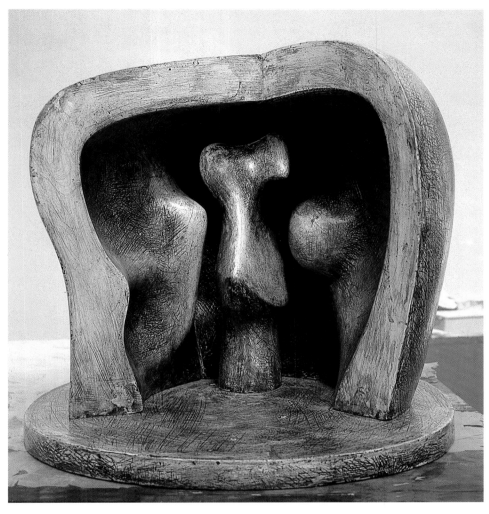

99
Helmet Head No. 6 1975
painted plaster
h. 44 cm
LH 651
The Henry Moore Foundation:
gift of the artist 1977

Moore made his first 'helmet head' in 1939–40 (fig. 9, p. 22), followed by a post-war series of such heads. In comparison to these earlier works, this version has a far less war-like feel to it, which must surely relate to the different era in which it was made. *Helmet Head No. 6* also takes up once again the idea of the interior/exterior form, which occupied Moore during the 1950s. This working model is a particularly good example of how he altered a sculpture at each enlargement. In the original maquette the figure is pushed right back inside the helmet; as the sculpture became larger, Moore brought the figure further and further forward so that in the final sculpture, 7.6 metres high, the figure stands almost completely free of the helmet structure, which itself was altered by being divided into two unequal halves. The helmet has become more like a womb or a shelter protecting its healthy inhabitant. The bulge on the right-hand wall recalls a breast, which adds the ideas of returning to nature and of nourishment for all. A monumental bronze cast of *Large Figure in a Shelter* stands in the Peace Park in Guernica (fig. 32). JS/CH

Fig. 32 *Large Figure in a Shelter*, 1975 (LH 652c); bronze, h. 762 cm

161

100
Working Model for Three Piece Reclining Figure: Draped 1975
plaster with surface colour
l. 112cm
LH 654
The Henry Moore Foundation

Moore talked a great deal from early on in his career about his belief that sculpture had to be three-dimensional, that one viewpoint was insufficient, uninteresting, and it is in his two- and three-piece sculptures that he achieves a consummate three-dimensionality, so that the sculpture can be read differently from any angle. From one side of this piece the viewer is presented with the dramatic sweep of the skirt – curved lines in a flat surface; from the front all three elements are foreshortened – an extremely dynamic view. Seen from a sideways perspective, the skirt at once protects and shields the more vulnerable, smaller leg section from the viewer and, from the foreshortened perspective of a head-on view, provides an inviting curve leading to the head. From all these views the head section dominates yet does not overpower. The skirt section of the figure is based on a piece of the mould used for casting *Helmet Head No. 6* (plate 99).

The full-size version of this work (fig. 33) constitutes the largest of Moore's three-piece reclining figures and is in a way the most complex. It embraces not only the organic forms of the divided sculptures of the 1960s, but also elements of the *Helmet Heads* of the 1950s. As Norbert Lynton points out, the torso, with its brutally cut-off bone, introduces a new note: 'it signals an inorganic intervention in nature's forming processes'.[1]

JS

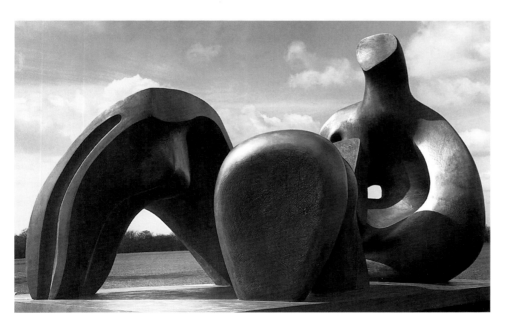

Fig. 33 *Three Piece Reclining Figure: Draped*, 1975 (LH 655); bronze, l. 447 cm

1 *Henry Moore: The Human Dimension*, exh. cat., 1991, p. 123.

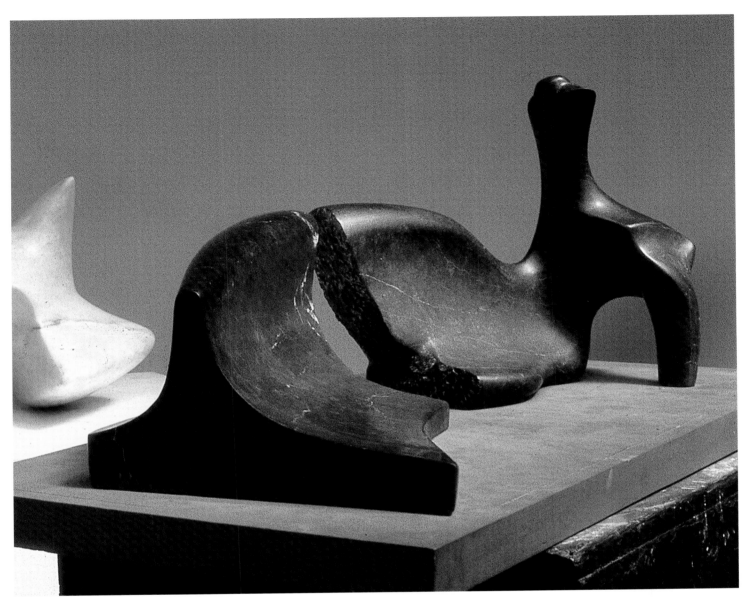

101
Broken Figure 1975
black marble
l. 108.6 cm
LH 663
The Henry Moore Foundation:
gift of the artist 1979

'This idea is connected with my two-piece
sculptures, but it came directly from a
small plaster maquette which broke
accidentally. While handling the two
pieces I found that I actually preferred a
longer figure and so I arranged them to-
gether, leaving a calculated gap between
the two parts. In making the larger
version in black marble I repeated the
gap, as a natural break.'[1]

The smooth surface of this piece is
highly polished, showing the white
striations running like arteries through
the black marble and bringing the sculp-
ture to life. Where it is broken, however,
the marble has been left rough and
unpolished, giving greater emphasis to the
break. The tension between the head and
leg sections is heightened by the rough
edges, which almost, but not quite, meet
in the middle. Moore was always inter-
ested in the relationship of space and
mass; in 1962, after completing his first
two-piece reclining figures, he said: 'If
somebody moved one of these parts one
inch, straightaway I'd know. The space
would be different, the angles through

here, there. All the relationships would
be changed.'[2] As in plate 97, the flowing
movement in the leg end seems to em-
phasize the weight and gravity of the
sculpture, while the head is typically light
and small in comparison to the rest of the
figure. JS

1 Quoted in Mitchinson, 1981, p. 257.
2 Quoted in Carlton Lake, 'Henry Moore's World',
Atlantic Monthly, vol. 209, no. 1, January 1962,
reprinted in Moore, 1966, p. 271.

A sculptor needs to be able to see form completely, and you can only understand three-dimensional form with a great deal of experience and effort and struggle. You can only do that, if you try to correct yourself on something that you feel as intensely about as the human figure. The construction of the human figure – the tremendous variety of balance, of size, of rhythm – is much more difficult to get right than an animal or a tree. You cannot understand anything wihtout also getting emotionally envolved. It isn't just academic training, it really is a deep, strong, fundamental struggle.

From *Henry Moore: Drawings, Watercolours, Gouaches*, exh. cat., 1970, unpaginated

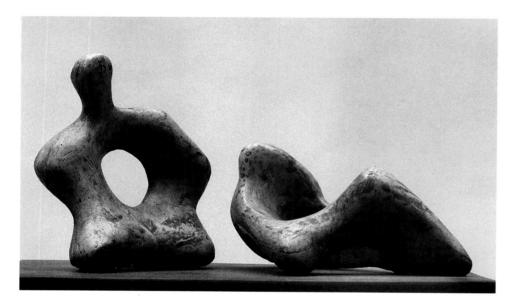

102
Two Piece Reclining Figure: Holes 1975
plaster with surface colour
l. 22 cm
LH 666
The Henry Moore Foundation:
gift of the artist 1977

Moore's works are probably best known among the general public for their holes, yet a surprisingly small number actually have them. There are eight other pierced works included here, and of these only about half can be said to be dominated by the hole (plates 87, 89, 106). At the earliest stage in Moore's career a hole was a daring feat in sculptural terms. In order to challenge the viewer to appreciate the relationship between volume and space, he was attempting to open out the mass of a block of stone or wood, thereby potentially threatening the structural quality of the medium. 'The first hole made through a piece of stone is a revelation. The hole connects one side to the other, making it immediately more three-dimensional.'[1]

A lifetime of observing nature's openings in bones, flints, wood and pebbles led Moore to an almost perfect understanding of their natural occurrence, as opposed to the forced existence of a hole created artificially in a piece of stone. Clearly influenced by an organic object such as a flint or bone, this sculpture's forms are dictated by the natural object in which the artist sought and found inspiration. The organic nature of its origin is further emphasized by Moore's choice of white marble for the larger version, which gives the work a sensuousness that leads the eye to it, through it and around it. JS/DM

1 'The Sculptor Speaks', *Listener*, vol. 18, no. 449, 18 August 1937, reprinted in Moore, 1966, p. 66.

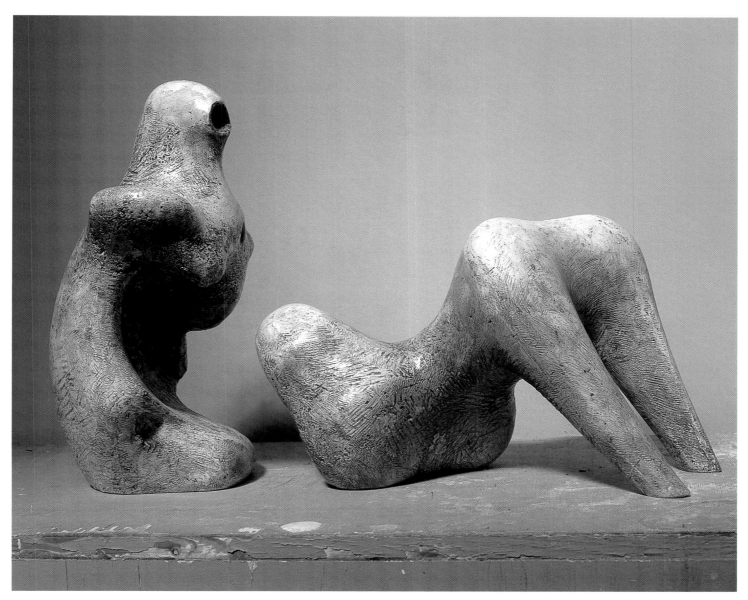

103
Two Piece Reclining Figure: Armless
1975
plaster with surface colour
l. 61 cm
LH 685
The Henry Moore Foundation:
gift of the artist 1977

Many of the plasters were given bases for
ease of handling, both for the assistants
who worked on enlargements and for the
foundries who had to prepare the works
for casting. However, to put a plaster
such as this in two parts on to a base is
to effect a judgement about the space
between those parts, an aspect about

which Moore said: 'When dividing up a
single figure, the space between the pieces
is not a blank, but a missing part to be
imaginatively filled.'[1] Here the sculpture is
not limited by the confines of the base,
although owing to its fragility and the fact
that it is not secured in any way, it has to
be displayed under a perspex cover. The
large version in black granite is com-
pletely smooth and lacks the gradations
of surface texture that are so important
in the plaster working model. JS

1 *Henry Moore: Complete Sculpture*, vol. 4, 1977,
p. 9.

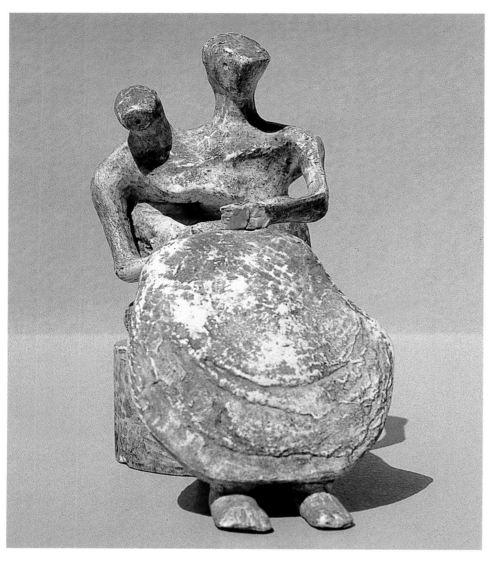

104
Seated Mother and Child 1975
plaster with surface colour
l. 16 cm
LH 679
The Henry Moore Foundation:
gift of the artist

This work is one of a small group of
sculptures incorporating shells as skirts,
in which the bivalve shells protect their
soft, vulnerable inhabitants. Moore again
presents woman as the wholesome,
strong, child-bearing, Mother Nature
type. The shell from which she emerges,
too, makes the obvious and traditional
link between woman and nature. In other
shell works, Moore has made the brittle
surface into soft, light drapery; here it is
much stiffer and less delicate, and there-
fore acts almost as a shield. It is used to
bind together the disparate bodies of the
mother and child. The mother is pulling
the child to her, although without tender-
ness, and the child itself is rather horrific
and inhuman – it seems less like a child
than another adult, and the two bodies
share the same breasts, arms and legs.
Perhaps this implies that, no matter what
happens, there is always an unbreakable
bond between a mother and her offspring.
CH

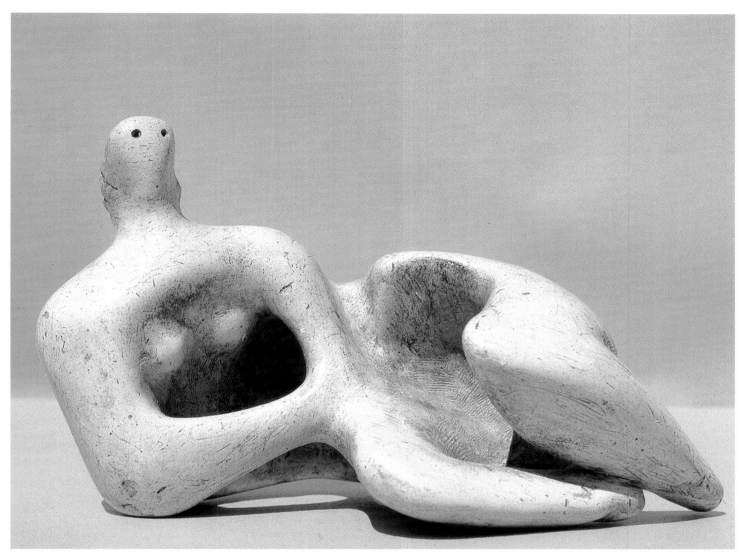

105
Reclining Figure Curved: Smooth 1976
plaster with surface colour
l. 21 cm
LH 688
The Henry Moore Foundation:
gift of the artist 1977

Moore has created a masterpiece of pure
shape unhampered by the burden of an
awkward pose or superfluous undertones.
The figure may be interpreted as a fragile
adolescent, curling up into herself
although she has all the potential for life
in her nimble body. Her arms frame her
newly forming breasts and her abdomen
is hollowed out to accentuate her youthful
fertility. Moore produced two versions of
this maquette in plaster, giving the other
a rough surface, but chose this one for
enlargement when he produced a 144-cm-
long carving in black marble. CH

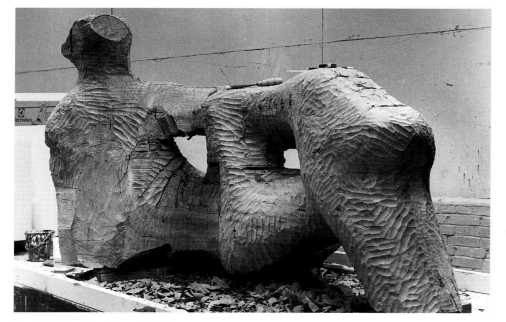

Figs. 34–6 *Reclining Figure: Holes* in progress

106
Reclining Figure: Holes 1976–78
elmwood
l. 222 cm
LH 657
The Henry Moore Foundation:
gift of the artist 1977

Moore said of this figure in 1980: 'I enjoy woodcarving, particularly if I can get a large block of wood on which on the early stages I can freely use an axe. In England, until the arrival of elm disease, the wood most easily available in large pieces was elm. I have carved five or six large over life-sized elmwood sculptures. Most of these sculptures (since I wanted to make full use of the bulk of the trunk), have one-directional rhythm, either vertical or horizontal. Elm trees are usually straight-growing, but this last large block of wood which I acquired has a slight curve in it and was big enough to allow for a bend in the sculpture's pose. This is something which in my other large elmwood carvings I wasn't able to do. For this reason I look upon this particular sculpture as having something special and different from the others.'[1]

This is the last in the series of elmwood reclining figures, the earliest dating from 1935–36. It was never quite finished, as it was required for an exhibition at the Serpentine Gallery in London in 1978 to mark Moore's 80th birthday, where it was paired with an earlier elmwood carving (plate 79). The photographs of it in progress give a very clear impression of how the block of wood was tackled during carving (see figs. 34–6). Initially, large chunks would be taken out of the block with an axe or mechanical saw, the maquette being used all the time as a point of reference. Subsequently, a mallet and chisel were employed to achieve even the finest surface detail. JS

1 Quoted in Mitchinson, 1981, p. 263.

This was the biggest piece of wood I could ever get hold of. The lower part of the root part of the tree was seven feet in diameter. It was very rare. The old Mr Fischer from Fischer Gallery obtained this tree for me. It had to be cut down. I then thought of an idea to fit the wood.

I always wanted to do in wood a figure that had a bit of a bend in it and not just a straight line of the trunk. Here I have been able to do it.

People like the grain of the wood. The grain emphasises the form. One must be careful of the sunlight in the wood, because it can split. Once it has split it can't be repaired.

From Moore, 1983, p. 139

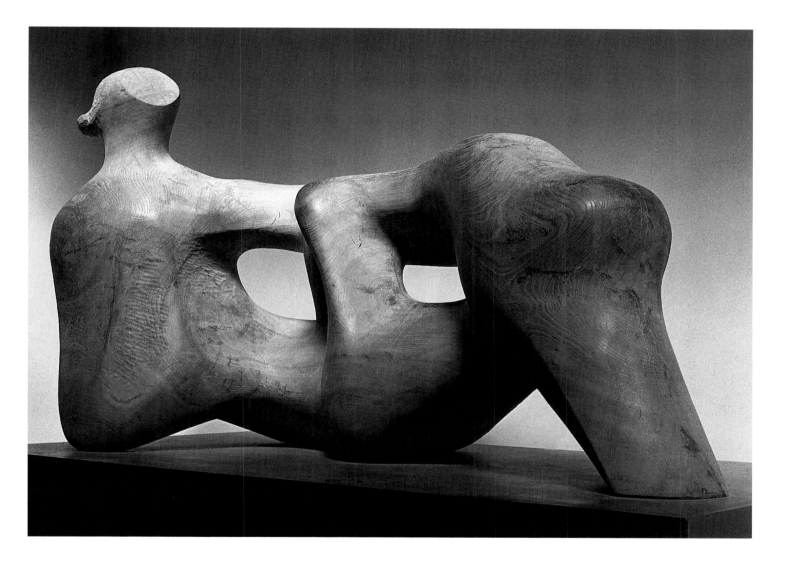

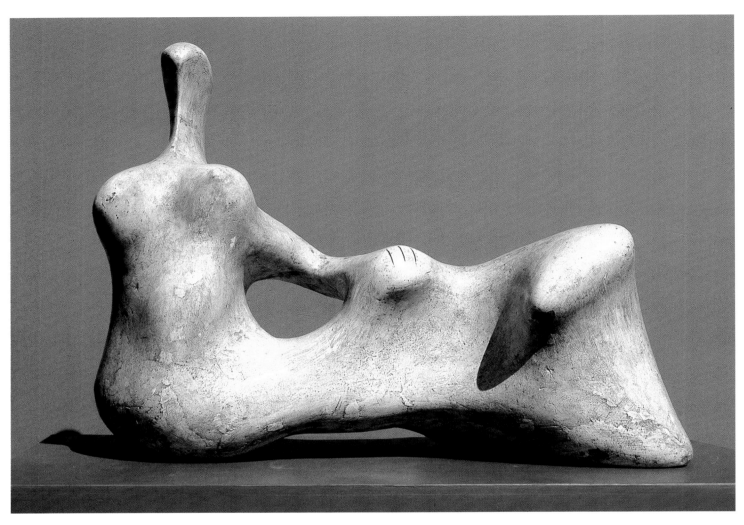

107
Working Model for Reclining Figure:
Hand 1978
plaster with surface colour
l. 86.3 cm
LH 708
The Henry Moore Foundation

One of the most abstracted of Moore's
reclining figures from the late 1970s,
Reclining Figure: Hand is closely related
to the elmwood *Reclining Figure* (plate

106), but the different medium – plaster –
gives the impression of a figure of greater
bulk. The human form is hidden under a
kind of skin through which the viewer
senses, rather than sees clearly, the forces
and stresses of the physical presence
beneath. The form in this sculpture is
expressed through the tension between
the hard form of the bones – knees,
shoulders, elbow – and the soft recesses,
such as the belly and thighs, which are

'glossed over'. The work is evidently
based on a flint, the breasts and arm
taking their shapes from the stone. The
head, however, is exceptionally minimal,
knife-edged and bone-like, giving the
figure an aura of alertness. The hand,
inscribed as a claw, was omitted from the
largest version of the sculpture. This lack
of physical detail belies the very human
feeling of the forms. JS

108
Draped Reclining Figure 1978
travertine marble
l. 182 cm
LH 706
The Henry Moore Foundation

This pose appears a number of times in Moore's work, derived originally from Mexican sculptures of the male sun god that he saw in the British Museum in the 1920s, but never was it made so sensuous, so female or so heavy as here. The figure's two arms visibly take the strain of her massive torso, one more than the other to allow her slightly to shift position, causing the buttocks to swell. This in turn gives her a wonderfully feminine shape along the left side, counteracting the bulky appearance of the rest of the body. The form is everywhere exaggerated to these ends. The stone adds to the figure's sense of mass, and the contours within it give her a firmly horizontal axis and the viewer the feeling that she is a landscape to be explored. The drapery, which goes right down to the feet, describes the shape of the thighs while maintaining its own presence to add further to the sense of volume. CH

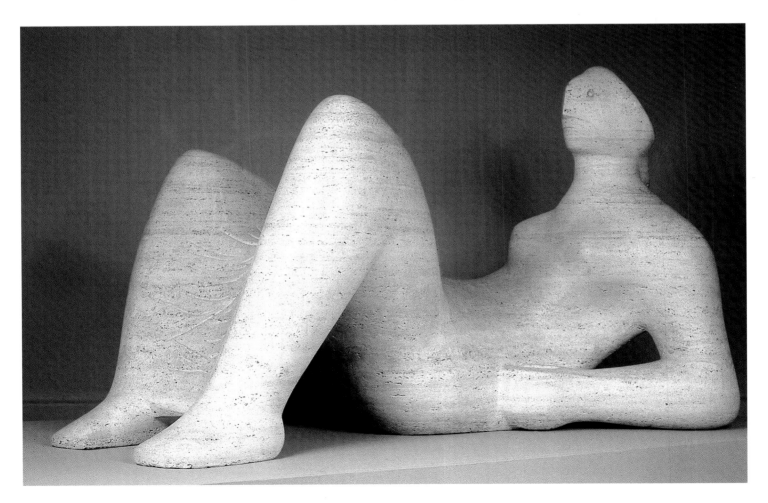

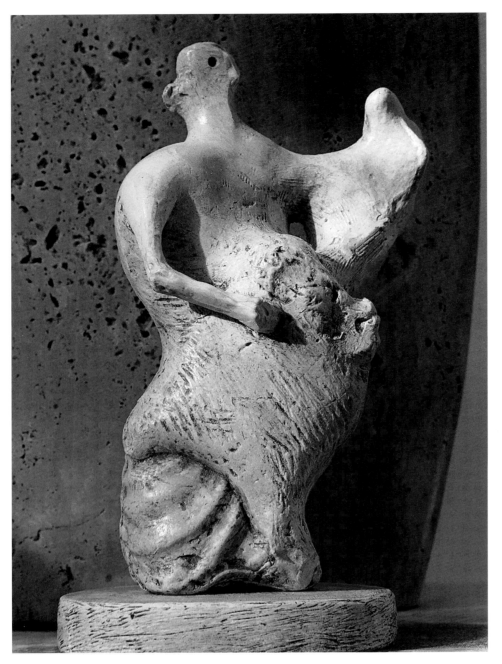

109
Maquette for Mother and Child: Upright
1978
plaster with surface colour
h. 22 cm
LH 730
The Henry Moore Foundation

As in so many of Moore's later mother and child sculptures, the mother is staring into the middle distance, away from her child, whom she holds at arm's length, the great sweep of the curve between the child and the mother seeming at once to bond yet separate them. The mother is clothed, but almost irrelevantly so, since a strong visual interest is provided only by the corrugated area at the bottom of the skirt, which has been likened to an African headdress but which is probably derived from a piece of shell cast in plaster and incorporated into the work. Moore enlarged this work in plaster to a working model size of 58 cm but never suggested that it would succeed on a monumental scale. JS

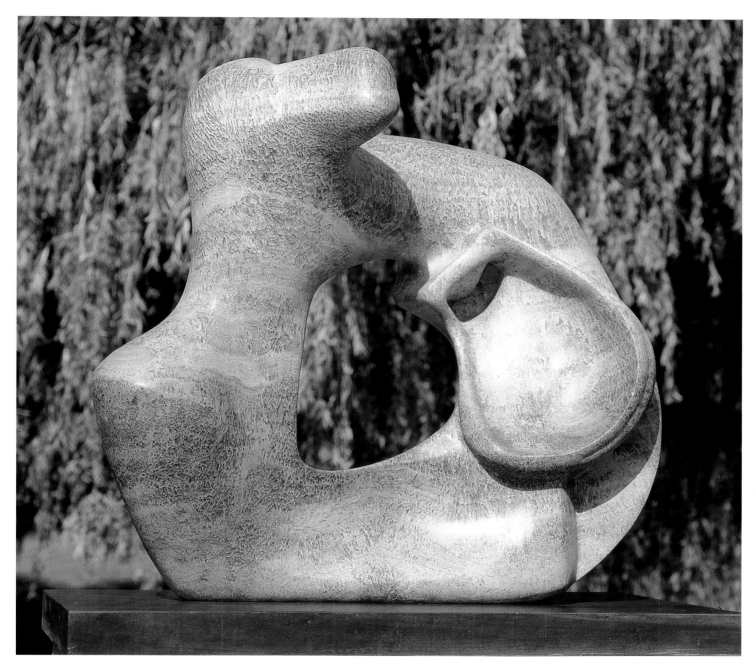

110
Mother and Child 1978
stalactite
h. 84 cm
LH 754
The Henry Moore Foundation

Stalactite is formed over millions of years from tiny droplets containing deposits of carbonate calcium that collect on the roofs of caves. The lovely crystalline structure of this exotic material lends this work a precious luminosity that is unusual in Moore's work. When he was carving in the 1930s he did not like the material to dominate the sculpture and he expressed concern over the properties of certain types of wood and stone.[1] Here, however, the stone enhances the forms of this abstract composition. JS

1 Bernard Meadows in conversation with the author, October 1995.

For me, applied colour does not help in three-dimensional sculpture, so I do not use it. But in drawing, I enjoy using colour, and now and then I use it just for its own sake, in a purely decorative way.

From *Henry Moore: Drawings 1969–79*, exh. cat., 1979, p. 60

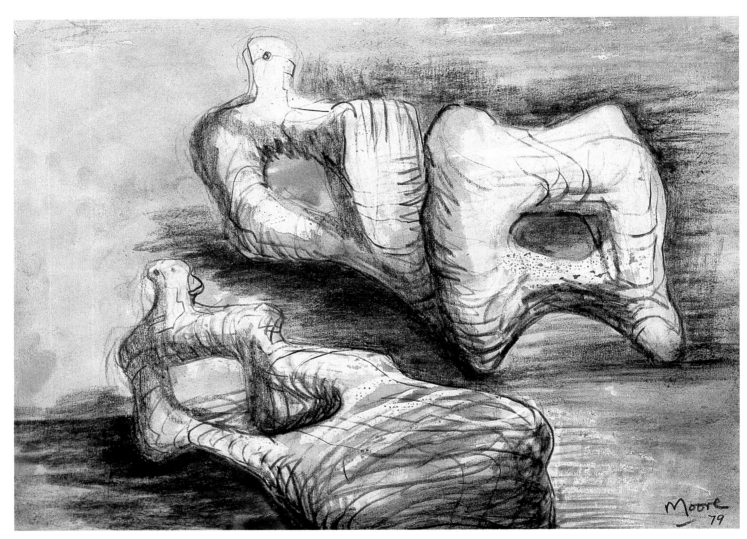

111
Two Reclining Figures: Ideas for Sculpture 1979
charcoal, chalk, wax crayon, watercolour wash
347 x 480 mm
HMF 79(60)
The Henry Moore Foundation

'In my drawings, I sometimes put a sculpture idea into a setting, to give it more appearance of reality.'[1]

From around the mid-1950s Moore ceased to use drawing as a direct preparation for sculpture because he felt it led to one view of the resulting sculpture taking precedence over others. However, since he was essentially a sculptor his drawings rarely broke from those considerations – of volume, relationship of masses and so on – that are at the core of sculpture. The appearance of reality to which Moore refers in the statement quoted above is not, therefore, a form of naturalism, but rather the idea of a three-dimensional mass in space.

To this end Moore often used backgrounds of some kind in his drawings. In the present example the background is nondescript, as unnaturalistic as the figures within it. The shadows from some unknown and unplaced source of light add a feeling of weight and volume in space, as does the two-way sectional line technique (see the commentary on plate 56) and the angled placing of the figures on the paper. CH

1 Quoted in *Henry Moore: Drawings 1969–79*, exh. cat., 1979, p. 28.

174

112
Thin Reclining Figure 1979–80
white marble
l. 196 cm
LH 734
The Henry Moore Foundation

This skeletal figure, reclining on its side, has a tense vitality emanating from within. The combination of the smooth white marble with the gentle curves of the female form creates a sculpture that is compulsively tactile. The front of the figure pivots around a central abstract form that is balanced by the two extended legs on one side and the neck/head and single truncated arm on the other. The external surface of the figure is stretched over the skeleton, which actually pierces through the skin at the base of the chest.

CH/DM

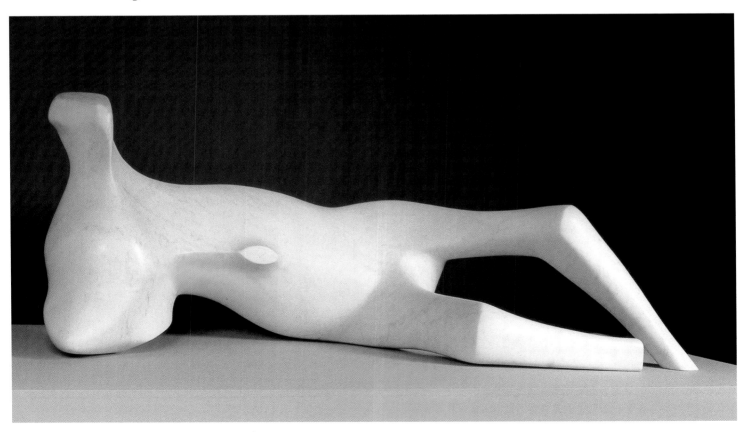

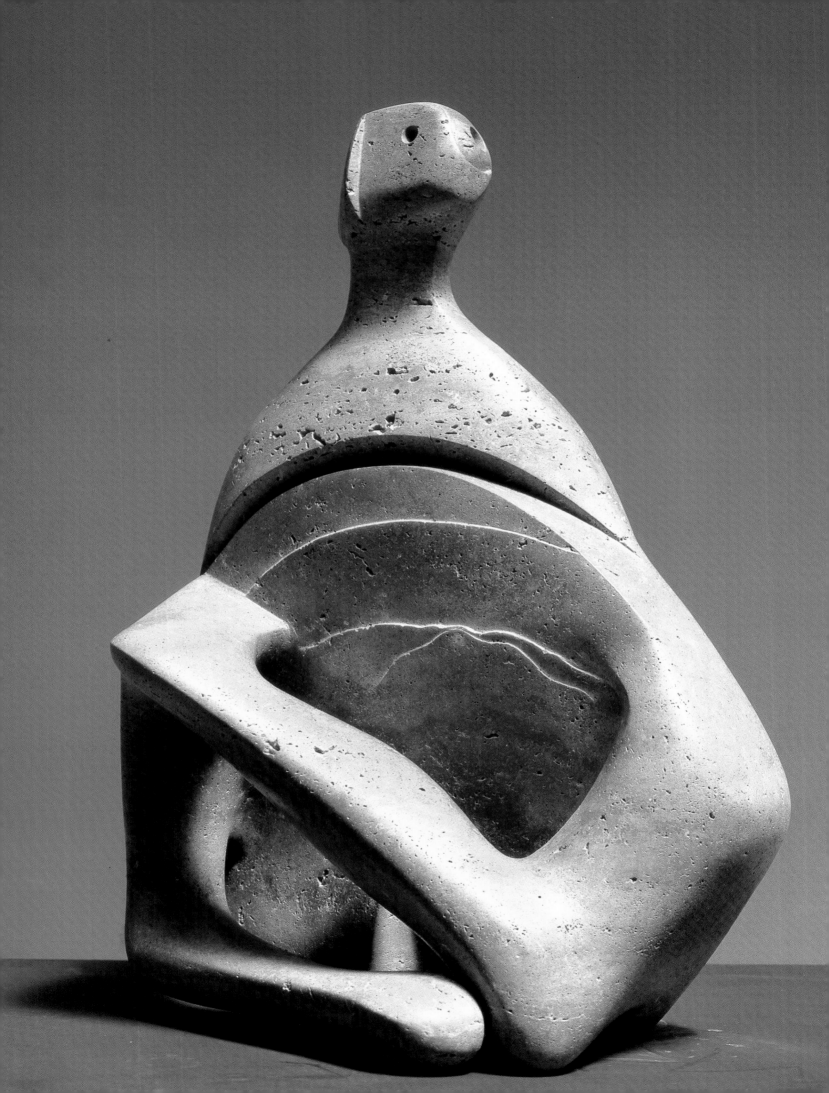

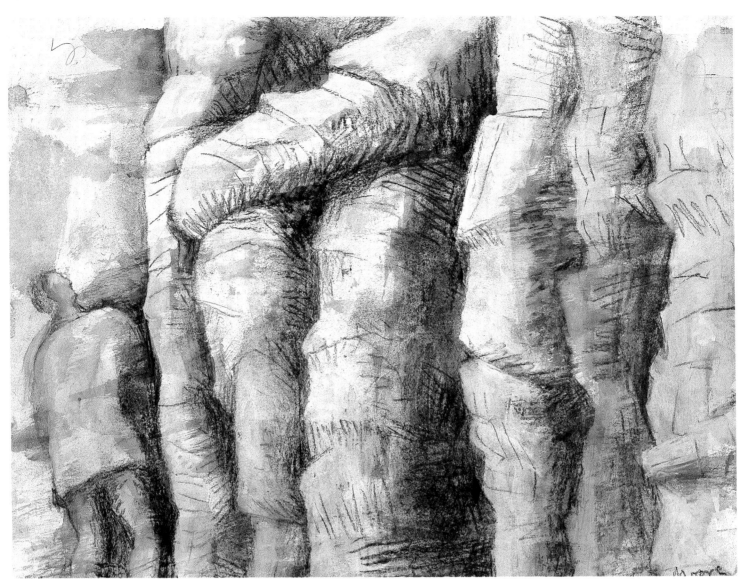

113
Girl with Crossed Arms 1980
travertine marble
h. 72.4 cm
LH 776
The Henry Moore Foundation

Travertine, which Moore first used in the
1930s, later became one of his favourite
stones. He liked its porous surface as well
as its rich variety of colour, from greyish
pink (see plate 32) through cream (plate
108) to the amber of this work. This
figure has a distinctly mechanical feel in
the piston-like movement of the arms.
The circular movement thus created con-
trasts with the serenity of the curve of
the shoulders and the composure of the
diagonally set head, perhaps reflecting the
contrast between mechanical and human
activities. CH/DM

114
Sculptor Looking at Rock Formation
1980
charcoal, gouache, watercolour
335 x 400 mm
HMF 80(217)
The Henry Moore Foundation

This drawing and the similar one, plate
118, are unusual in Moore's oeuvre for
being close-up views of a background
that towers above the subject. In both
instances the enormity of the rock forma-
tion appears to dominate; the possible
autobiographical implications of this are
strengthened by the fact that the artist
depicted is in both cases male. Here the
rock formation is powerful and dramatic,
with both the sculptor and the viewer
being overwhelmed by the proximity of
the rocks. DM

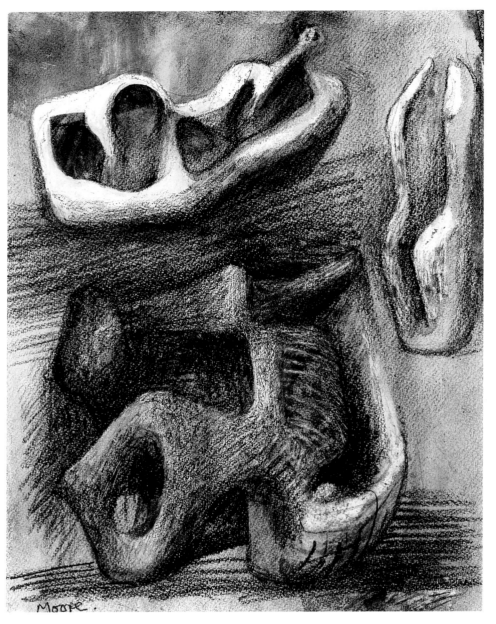

115
*Reclining and Upright Figures with
Square Form* 1981
pencil, wax crayon, watercolour wash,
chinagraph, gouache
327 x 252 mm
HMF 81(184)
The Henry Moore Foundation

Moore used such forms as bones not only
for their perfection of shape, but also for
their associations with nature and with
the human form, and the psychological
element embodied by these. In this
drawing the reclining figure top left is
almost certainly based on a bone that
Moore metamorphosed into one of his
most persistent motifs. The lower form,
which seems to relate to such sculptures
as *Maquette for Stone Memorial* (plate
82), has a more insubstantial, shadowy
feel, as though it is emerging from the
surface of the paper. This contrasts with
the structural strength and hard tenseness
of the bone from which it was created.
The paper is rough in texture, and Moore
has used chinagraph on it to create
atmosphere in much the same way as
Seurat did in his drawings. CH

116
Reclining Figure No. 7 1980
plaster with surface colour
l. 91.4 cm
LH 752
The Henry Moore Foundation

The maquette for this sculpture, dated 1975, was based on a flint that Moore incorporated directly into the figure rather than first casting it in plaster. The flint gives the direction of the breasts, arm and pelvis, producing a strangely animat-ed female reclining figure. Moore was so fascinated by the sculpture that he made a drawing of it in the same year, an etching in 1979 and this final, enlarged version in 1980. The sculpture was originally to be entitled *Reclining Figure: Distorted*, but he changed the name because, according to Ann Garrould, he preferred 'to omit any reference to distortion'.[1] JS

1 *Henry Moore: Complete Drawings*, vol. 5, 1994, p. 138.

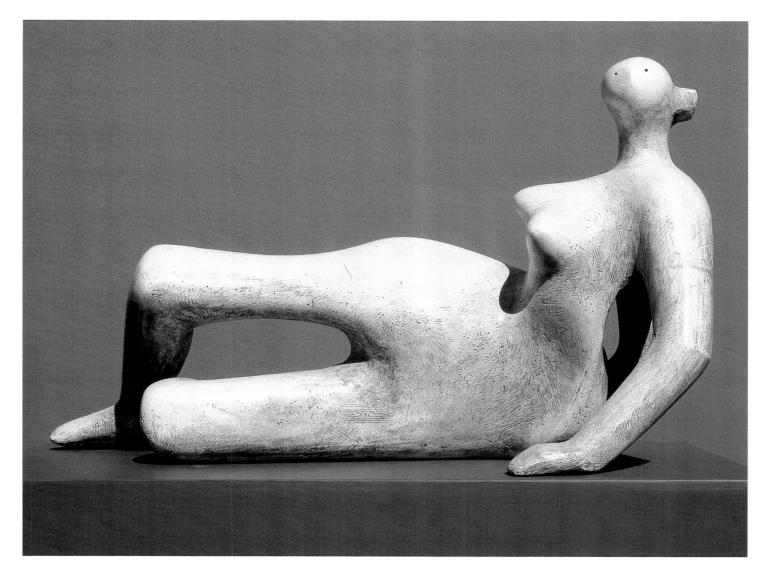

Sculpture should always at first sight have some obscurities, and further meanings. People should want to go on looking and thinking; it should never tell all about itself immediately. Initially both sculpture and painting must need effort to be fully appreciated, or else it is just an empty immediacy like a poster, which is designed to be read by people on top of a bus in half a second. In fact all art should have some more mystery and meaning to it than is apparent to a quick observer.

Quoted in Hedgecoe, 1968, p. 83

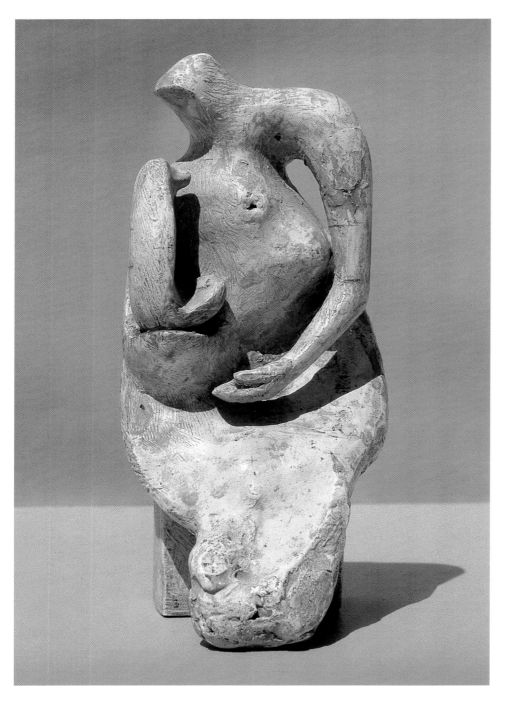

117
Maquette for Mother and Child: Block Seat 1981
plaster with surface colour
h. 17.8 cm
LH 836
The Henry Moore Foundation

Of all the mother and child sculptures, this late work is one of the most maternal. The mother is protecting the child in an affectionate manner uncharacteristic of Moore's imagery. The realistic hand falls limply on her lap in a gesture of great tenderness. The child is an abstracted being seemingly oblivious to the mother's gentle gaze, staring only at her hollow nipple, points of emphasis that became more obvious as the work increased in scale to a 244-cm-high bronze (p. 184).

John Berger, writing in 1989, valued this work most highly among Moore's late sculptures. He saw it as the culmination of a life's pursuit of the quintessence of mother and child: 'I don't like puns, but if I try to approach the emotions generated by this last or almost last sculpture by Henry Moore, I can't get round the word "mummy".'[1]

This sculpture encapsulates that aspect of Moore's work which is most difficult to define, his obsession with the female form as a life-giving animate body, a protector to the child and almost a Madonna to the rest of humanity. JS

1 John Berger, 'A Sense of Touch', *Guardian*, 21 September 1989, reprinted under the title 'Infancy' in *Keeping a Rendezvous*, London, 1992, p. 157.

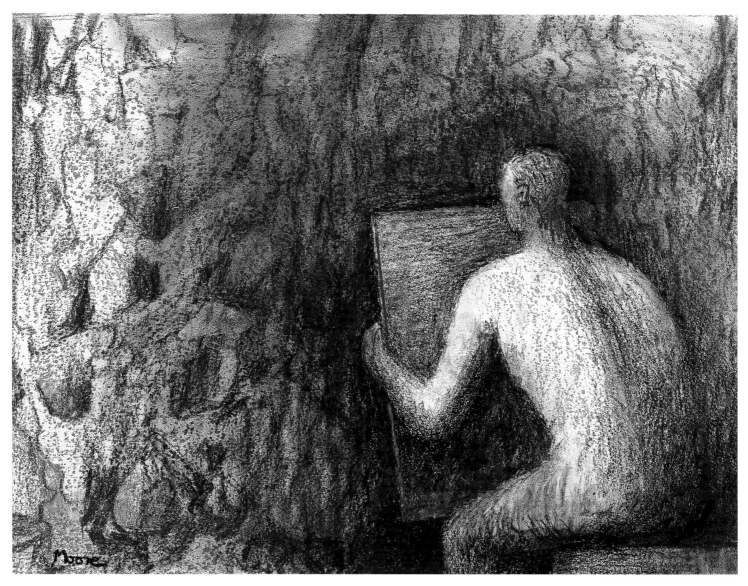

118
Man Drawing Rock Formation 1982
charcoal, chinagraph, chalk, pencil over
lithograph
321 x 402 mm
HMF 82(437)
The Henry Moore Foundation

This drawing was made over a litho-
graphic proof of a frottage, a rubbing
taken from the wall of the Curwen studio
in London. Moore frequently reworked
lithographic and etching proofs, some-
times quite extensively, so that the print-
ing would be disguised by the drawing.
During 1982 he produced two other draw-
ings using similar proofs. The irregular
patterns produced by the frottage on the
surface of the paper interested him greatly:
'Many of the landscape drawings I make
now are not done through direct observa-
tion but are evidence of my general liking
for landscape. In fact I can find a land-
scape in blots or random marks on
paper.'[1] Here the textured surface of
the paper gives a rugged quality to this
powerful observation of an artist drawing
inspiration from nature. It was unusual
for Moore to take a step back from his art
and this is certainly not intended as a self-
portrait. DM/JS

1 *Henry Moore: Drawings 1969–79*, exh. cat.,
1979, p. 22.

119
Reclining Figure: Pointed Head 1982
plaster with surface colour
l. 86.5 cm
LH 827
The Henry Moore Foundation

The change in the treatment of surface in Moore's sculpture during the 1970s and early 1980s is striking. This reclining figure epitomizes the smooth, even surfaces that dominate the late period (plates 103, 112, 116). Whereas in the 1960s Moore sought to enhance the idea of the human figure and landscape as one by using rough, rock-like surfaces, he gradually turned away from that during the last decade of his working life and produced a series of sleek reclining figures. This change was perhaps in part due to his return in the 1970s to carving in stone and particularly marble, whose smooth surface reflected the beauty of the material as much as the forms of the figure.

JS

120
Three Figures 1982
plaster with surface colour
l. 36.2 cm
LH 853
The Henry Moore Foundation

In the tiny maquette of this sculpture the influence of the bones of a small animal is clearly visible. The three forms are based on the same bone, each worked up in a slightly different way and then joined together at the belly like Siamese triplets. They have been likened to penguins, fledglings and other young animals. They show, once again, Moore's extraordinary ability to animate organic objects: from a dead bone is born new life. JS

You see, I think a sculptor is a person who is interested in the shape of things. A poet is somebody who is interested in words; a musician is someone who is interested in or obsessed by sounds. But a sculptor is a person obsessed with the form and the shape of things, and it's not just the shape of any one thing, but the shape of anything and everything.

Quoted in Warren Forma, *Five British Sculptors (Work and Talk)*, New York, 1964, p. 59

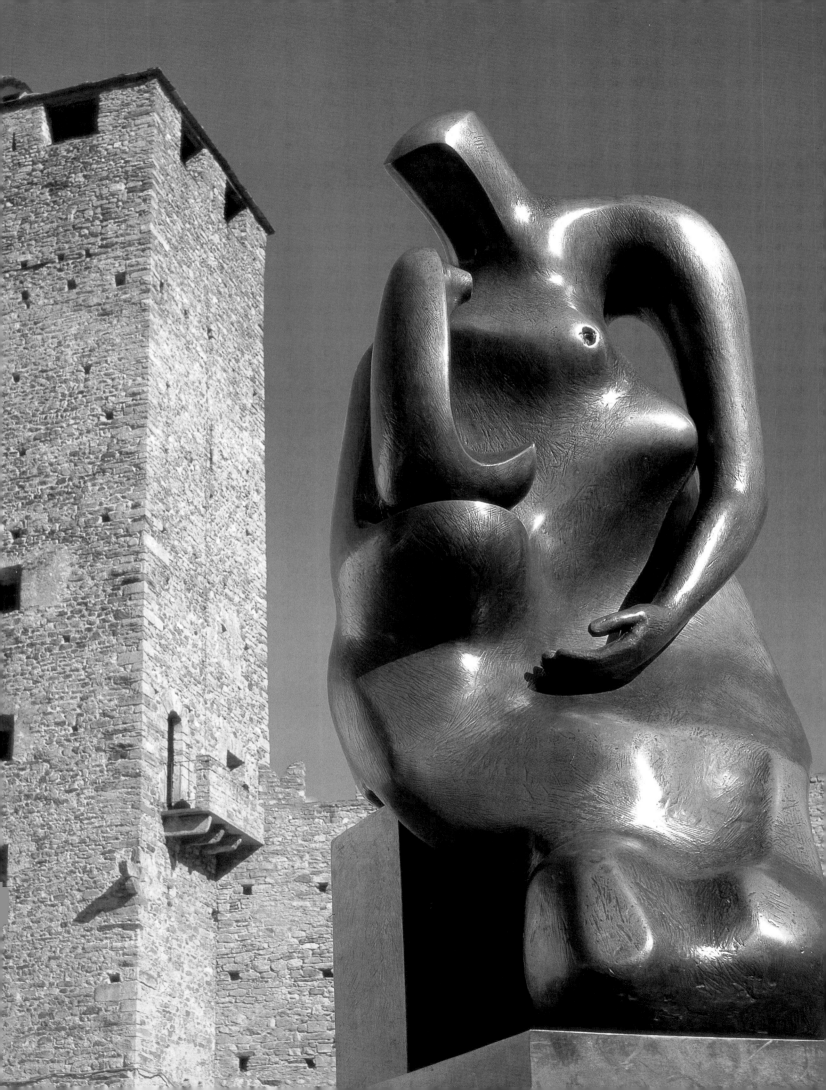

Chronology

Célia Houdart

1898

Henry Spencer Moore, the seventh of eight children, is born in Castleford, in the coal mining area of Yorkshire (fig. 1): 'The slag heaps ... for me as a boy, as a young child, were like mountains.'[1] His father, Raymond Spencer Moore, initially a miner working at the coal-face, though later promoted to work above ground, is a committed Socialist and union member, and an autodidact with wide-ranging interests. He is concerned that his children should succeed in life and his one hope is that none of them should have to work, as he has done, in a mine.

Fig. 1 Castleford, the artist's birthplace, in about 1900

1902

Attends Temple Street School in Castleford (until 1910).

1904–09

Each summer he escapes from the world of depots and blast furnaces and from the din of foundries to the wildness of the Yorkshire moors, where he stays with farmers who are friends of the family. Here he discovers the magical country described in the novels of the Brontë sisters.

Mother and Child: Block Seat, 1983–84 (LH 838); bronze, h. 244 cm

1910–14

In summer 1910 he gains a scholarship to Castleford Secondary (later Grammar) School, where his art teacher, Miss Alice Gostick, fosters his artistic talents. During school trips to Yorkshire churches, she introduces him to Gothic sculpture; she also encourages him to read *The Studio,* one of the few English journals to pay attention to contemporary developments in European art. Moore thus learns of Post-Impressionism, the Vienna Secession and Art Nouveau.

'I think I was probably about eleven when I first decided I wanted to be a sculptor.'[2] Moore first hears of Michelangelo, described as a 'great sculptor', in a Sunday School class. He often goes to the local abattoir to watch the slaughter and dismembering of oxen and their brains being scraped out of their skulls. He retains a disturbingly vivid memory of such scenes and will later link his vision of these hollowed forms with his discovery, at this time, of a gaping rock, at which he often goes to stare and which he finds captivating: 'a huge natural outcrop of stone at a place [Adel] near Leeds which as a young boy impressed me tremendously ... it had a powerful stone, something like Stonehenge has' (fig. 2).[3] 'It was there, it seems to me, in front of this mighty piece of nature, that I acquired a sense of scale, of the monumental, of the open-air, and it was there, above all, that I grasped the primitive presence of stone, the sort of energy that is to be found condensed within the rock and which seems to push outwards, with an incredible force, towards the exterior.'[4] Throughout his life Moore is to feel that the powerful megaliths punctuating the English countryside are signalling to attract his attention.

1915

At his father's urging, Moore gives up his plan to attend the local art school and

enrols instead at a teachers' training college. He reads Thomas Hardy, D. H. Lawrence and Dostoevsky.

Fig. 2 Adel Cragg, outside Leeds

1916

Takes up a teaching post at Temple Street School in Castleford. Volunteers for war service and is attached to the Civil Service Rifles, 15th London Regiment. In London he visits the British Museum and the National Gallery for the first time.

1917

In September leaves England for the French Front. In November is gassed at the Battle of Cambrai. Is sent back to Britain for medical care.

1918

After convalescing, goes to Aldershot for instruction in physical training. Becomes an instructor in bayonet practice; rises to the rank of lance corporal. Volunteers to return to the Front. Reaches France shortly before the Armistice.

Fig. 3 Pottery evening class at Castleford Grammar School, December 1919; Alice Gostick far right, Moore at her knees

1919
Is demobbed in February. In March returns to his teaching post in Castleford, which bores him. Attends evening classes in pottery (fig. 3). In September enrols at Leeds School of Art. Is the only student to sign up for a course in sculpture: an additional teaching post is created to provide instruction for him.

1920
Writes a play, *Narayana and Bhataryan* (dedicated to the memory of the poet Rupert Brooke), for the amateur theatrical company of Castleford Grammar School (fig. 4). He himself plays the part of Bhataryan, his sister Mary that of Narayana. In Leeds reference library

Fig. 4 Cover of Moore's play *Narayana and Bhataryan*, 1920

reads *L'Art*, a collection of interviews with Rodin edited by Paul Gsell (1912), and *Vision and Design* (1920) by Roger Fry. Moore later says: 'Once you'd read Roger Fry the whole thing was there.'[5] Makes frequent visits to the British Museum to draw from works in the collections of Etruscan and Egyptian art,

though his imagination is captured above all by the Aztec sculptures. 'My decision was made there, in front of those stern, often cruel figures. That's where I decided that in my work there would be no "beauty" as this was understood in the Hellenistic world or during the Renaissance.'[6]

First encounters African art and modern art – the work of Cézanne, Gauguin, Rouault, Matisse, Kandinsky – when he goes to see the collection of Sir Michael Sadler, Vice-Chancellor of the University of Leeds.

1921
Wins a scholarship to the Royal College of Art in London (where he remains as a student until 1924), in those days a very academic institution, where his work comes in for fierce criticism. 'This pupil has been feeding on garbage', says one of his teachers.[7] Moore, however, invariably receives moral support from the Director of the Royal College, Sir William Rothenstein. Is decisively influenced by Ezra Pound's book of 1916 on the sculptor Henri Gaudier-Brzeska, whose work delights him. At the same time he finds in the work of another sculptor, Jacob Epstein, an echo of Roger Fry's ideas (in particular the new regard for the value of direct stone carving), these in turn corresponding to the approach adopted by Gaudier-Brzeska. Moore visits Stonehenge for the first time. Between 1920 and 1926 he fills six sketchbooks with drawings after 'primitive' sculptures in the British Museum.

Perfects a drawing technique that is both convenient and original: the 'two-way sectional line'. This allows him to achieve an immediately perceptible effect of volume without recourse to light and

shade: with his pencil he follows an imaginary horizontal section of the object he is drawing, then suddenly changes direction, forming a right angle in order to return to the vertical section. This subtle 'shorthand' notation has the virtue of respecting the quality of three-dimensional forms.

1922
Moore's family leaves Yorkshire and moves to Norfolk. Moore makes many drawings from life and starts sculpting in wood and stone with Barry Hart, assistant to Professor Derwent Wood at the Royal College. Moore makes his first Madonna and Child carvings, clearly influenced by Pre-Columbian sculpture, and his *Head of the Virgin* (plate 3), after a work by the Florentine Renaissance sculptor Domenico Rosselli in the Victoria and Albert Museum, London.

1923
With Raymond Coxon, a painter friend from Leeds, Moore travels to Paris for the first time. Rothenstein provides letters of recommendation to a number of French artists and collectors. Moore plans to visit the sculptor Aristide Maillol, but at the last moment decides against this. He later explains this change of mind as simply the result of discretion and a 'fear of disturbing' the artist. Moore is deeply impressed by the paintings of Cézanne in the private collection of Auguste Pellerin. The *Large Bathers* (1906) overwhelms him: 'For me this was like seeing Chartres Cathedral.'[8] He prefers to explore the ethnographic collections of the Musée de l'Homme rather than visit the Musée Rodin. Is unable to follow Rodin in his conception of sculpture as the expression of movement. For Moore, sculpture is a synonym for immobility, because it is so closely associated with a material (stone) that is by definition static. He nevertheless acknowledges that he has derived from Rodin a distinct taste for sculptures made up of individual pieces initially conceived as works in their own right and only

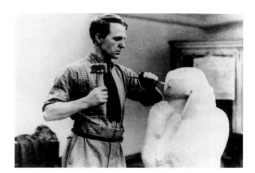

Fig. 5 The artist carving in Grove Studios, Hammersmith, c. 1926

subsequently brought together (as with Rodin's *The Burghers of Calais*), and a concern for the internal structure of forms in which the interior determines the exterior: 'What makes Rodin the great sculptor he is', Moore notes, 'is his complete understanding of the body's internal structure, his ability to feel inside, into the sculpture.'[9]

Moore goes frequently to the Louvre and discovers the oriental collections of the Musée Guimet. Henceforth he will visit Paris as often as possible.

1924–25
His first group exhibition, at the Redfern Gallery in London. Takes up a part-time teaching post as an assistant in the Sculpture Department of the Royal College. Wins a travelling scholarship for a six-month stay in France and Italy. In

Fig. 6 Irina and Henry Moore on their honeymoon in Cornwall, 1929

Florence, where he spends a month, he goes every day to the Brancacci Chapel to see Masaccio's frescos. Also visits Rome, Ravenna, Padua, Pisa, Assisi and Venice. Sees for the first time the work of Michelangelo, Giotto and Giovanni Pisano. He greatly admires this last, preferring him to Donatello, whom he regards as a genius who, none the less, was unable to understand the superiority of direct carving over modelling: 'Donatello was a modeller, and it seems to me that it is modelling that has sapped the manhood out of Western sculpture.'[10]

1926–27
On his return from Italy, Moore is appointed assistant to Professor Ernest Cole at the Royal College for a seven-year term. He meets T. S. Eliot and E. M. Forster. Takes part in a group show at St George's Gallery, London. Rents a work space at 3 Grove Studios, Hammersmith (fig. 5). Makes his first reclining figures. Draws a great deal

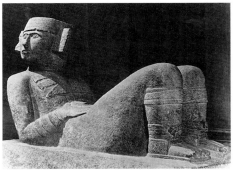

Fig. 7 Mayan statue of Chac-Mool, 11th or 12th century AD

from life – 'a continual struggle to understand the complete three-dimensional form of the model and to express it on the flat surface of the paper'.[11] Starts work on a series of masks.

1928
Meets Irina Radetsky, a student of painting at the Royal College who is to become his wife.

First one-man show, at the Warren Gallery, London. Augustus John and Jacob Epstein pledge their support for Moore's work and buy several drawings.

1929–30
Completes his first important public commission: *West Wind* (LH 58), one of a number of large reliefs for the façades of the headquarters of the London Underground at St James's Park station. Marries Irina Radetsky (fig. 6). They move to Hampstead, which is to remain their London home until 1941. At this time Hampstead is home to many writers, architects and artists from all over Europe, including Marcel Breuer, Wells Coates, Walter Gropius, Ivon Hitchens, E. L. T. Mesens, Piet Mondrian, Paul Nash, Roland Penrose, Adrian

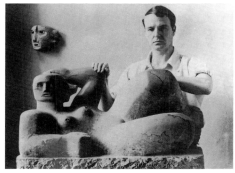

Fig. 8 *Reclining Figure*, 1929 (LH 59); brown Hornton stone, l. 84 cm; Leeds City Art Galleries

Stokes, Ben Nicholson, Barbara Hepworth and John Skeaping. Moore is elected to membership of the Seven and Five Society, a group of seven painters and five sculptors belonging to the avant-garde. He exhibits with the Young Painters' Society and the London Group in the British Pavilion at the Venice Biennale of 1930.

Interested in finding new materials, and in particular in working with new types of stone, he makes a careful study of the geological collections of the Natural History Museum in London, thus discovering Hopton Wood stone from Derbyshire, green and brown Hornton stone from Oxfordshire, and finally Cumberland alabaster. His London studio is soon so cluttered with work that there is no longer room for Moore to carve.

Makes *Reclining Figure*, a work directly inspired by a photograph of the Mayan statue of Chac-Mool (the Rain Spirit) (figs. 7, 8). He renders his own figure more feminine, giving it more rounded curves. During a visit to Paris, Moore and his wife take classes in sketching at the Académie Colarossi and the Académie de la Grande Chaumière.

Fig. 9 On holiday at Happisburgh, Norfolk, 1931; from left: Ivon Hitchens, Irina Moore, Henry Moore, Barbara Hepworth, Ben Nicholson and Mary Jenkins

Fig. 10 View of the artist's maquette studio at Perry Green, showing the shells and pebbles that he collected throughout his life

1931
Exhibition of sculptures and drawings at the Leicester Galleries in London. Jacob Epstein, now convinced of Moore's talent, writes in his introduction to the catalogue: 'Before these works I ponder in silence.... What is so clearly expressed is a vision rich in sculptural invention, avoiding the banalities of abstraction, and concentrating upon those enduring elements that constitute great sculpture.... Sculpture in England is without imagination or direction. Here in Henry Moore's works are both qualities. Bound by the severest aesthetic considerations, this sculpture is yet filled with the spirit of research and experiment.' The Museum für Kunst und Gewerbe in Hamburg buys a sculpture and several drawings by Moore – his first sale outside England.

A very favourable review of the exhibition, by Herbert Read, appears in the *Listener*; but the rest of the press, for the most part hostile to Moore's work, takes issue with its perceived immorality and openly denounces the artist's 'cult of ugliness', his 'scorn for the beauty of women and children' and even 'the atrophy of spirit and vision' evident in his works. A critic writing in the *Morning Post* (with the backing of the extremely conservative association of Former Students of the Royal College) goes so far as to demand that Moore be dismissed from his teaching post. Rothenstein resolves to ignore this outcry and supports Moore in the face of such a ferocious campaign of disparagement. Moore nevertheless decides to exchange his post at the Royal College for one at the Chelsea School of Art, where he establishes a new sculpture department.

Takes part in the exhibition 'Plastik' (Sculpture) held at the Kunsthaus and other sites in Zurich.

Using money inherited by Irina, the couple buy Jasmine Cottage at Barfrestone in Kent.

Moore produces several variations on the themes of Mother and Child and Reclining Figure. Biomorphic abstraction makes its first appearance in his work. During these years Moore abandons

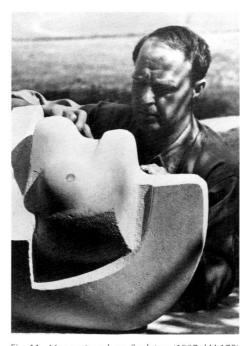

Fig. 11 Moore at work on *Sculpture* (1937; LH 175) in the garden at Burcroft, Kent

drawing as a process of rigorous *observation* in favour of drawing as a process of *transformation*. Starting with items picked up during his walks, almost always along the beach, he amasses a collection of *objets trouvés* – bones, pebbles, bits of shingle, twigs, driftwood, lobster claws (fig. 10) – which he then draws from various points of view, transforming them into elongated figures or simple bodily fragments without entirely losing the formal qualities of the originals. He makes casts of such objects, and occasionally adds to them a piece of plasticine or clay to create a head, an arm or a leg. In his drawings of the 1930s Moore increasingly eschews the 'two-way sectional line' in favour of modelling with chiaroscuro or the addition of colour. Makes his only wood engravings.

1933
Becomes a member of Unit One, a group founded by Paul Nash that includes architects, painters and sculptors, among them Colin Lucas, Wells Coates, Barbara Hepworth and Ben Nicholson. Contributes to the journal *The Group*, edited by Herbert Read. On a visit to Paris meets Osip Zadkine, Alberto Giacometti and Jacques Lipchitz for the first time.

1934
Herbert Read, who becomes a friend of Moore, publishes the first monograph on the artist. While on holiday in France and Spain, Moore visits the prehistoric wall paintings at es Eyzies and Altamira; also goes to Madrid and Barcelona. Begins the *Square Forms Sketchbook*, drawings in red and black chalk and pastel.

1935
Moore leaves Barfrestone and buys Burcroft, a cottage with its own land at Kingston, near Canterbury. He is thus able to work out-of-doors. One-man show at the Zwemmer Gallery in London.

The German journal *Konkretion* devotes an issue to English art, reproducing a sculpture by Moore on the cover.

1929–36
Produces an increasing number of hollowed forms, including *Half-Figure* (1929; LH 67), *Head* (1929; LH 73), *Composition* (1933; LH 132), *Hole and Lump* (1934; plate 28), sculptures in which the hole provides a 'formal contrast to the solid part'. Moore is later to say of these works: 'I wanted to destroy the tyranny of the surface, to go beyond the skin of the stone, I wanted to penetrate it. My mind was made up in 1933. I started to cut into it. I was moved.... When one loves stone, and when one has

been happy for such a long time simply scratching marks on its surface, there's something deeply disturbing in daring to pierce it.'[12]

In 1934 Moore also starts to divide the single sculptural mass into two or more pieces, which sometimes interlock: *Reclining Figure* (1934; LH 155) and *Two Forms* (1936; plate 38), for example. During these years he is not only preoccupied with carving stone; he also explores the possibilities offered by the essential qualities of various woods – beech, elm, cherry, sycamore, walnut, ebony and lignum vitae. While he retains the technique of direct carving, Moore increasingly prefers to use reduced, three-dimensional models (of plaster or of clay): this allows him far more easily to grasp, to 'handle' in every sense, and so to modify a work eventually intended for execution on a large scale. Assisted by Bernard Meadows, Moore installs a small foundry for leadcasting at Burcroft; he turns increasingly to professional founders. In essence, it is for reasons of scale that Moore gradually abandons the practice of direct carving in favour of casting in bronze.

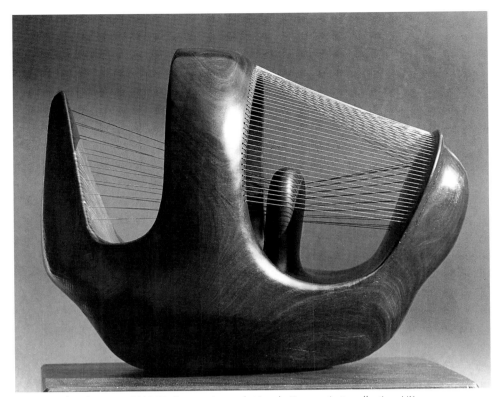

Fig. 12 *Bird Basket*, 1939 (LH 205); lignum vitae and string, l. 42 cm; private collection, UK

1936

Alongside Dalí, Arp, Magritte, Miró and Tanguy, Moore takes part in the International Surrealist Exhibition at the New Burlington Galleries in London (fig. 6, p. 40); he is a member of the exhibition committee. Max Ernst visits Moore in his studio.

Moore adds his signature to the manifesto issued by the English Surrealist Group to protest against the British policy of 'non-intervention' in the Spanish Civil War. Following visits to the Science Museum in London, and no doubt also influenced by the contemporary work of Naum Gabo and Antoine Pevsner, Moore makes his first stringed figures.

1937

Moore's 'Notes on Sculpture' published in the *Listener*. These reflections are reprinted the same year in *The Painter's Object*, a volume of texts by artists associated with the journal *Axis*, among whom are Léger, Kandinsky and Moholy-Nagy.

Moore also contributes to the journal *Circle*, edited by Leslie Martin, Ben Nicholson and Naum Gabo.

During a stay in Paris, Moore visits Picasso's studio with Breton, Eluard, Ernst and Giacometti.

1938

Takes part in the International Exhibition of Abstract Art at the Stedelijk Museum in Amsterdam, even though he simultaneously appears to reconsider his experience of abstraction gained through his contact with the Surrealists. *Reclining Figure* of 1938 (LH 193) marks, in fact, a clear return to a naturalistic style, which is to be a characteristic of his work after 1945.

1939–40

On the outbreak of the Second World War, Moore and his wife have to leave their cottage at Kingston, which is in a restricted area and thus not easily accessible. They return to London and move into the studio of Barbara Hepworth, who has recently married Ben Nicholson and gone to live at St Ives in Cornwall. In a situation of general austerity, sculptural materials are also scarce; nor is it possible to hire transportation. Moore virtually stops creating sculpture and turns to drawing. Chelsea School of Art is evacuated from London and moves to Northampton. Forced to call a temporary halt to his classes, Moore signs up for a course in precision-tool making at Chelsea Polytechnic, but this proves to be over-subscribed.

Makes his first lithograph, *Spanish Prisoner* (CGM 3), which he intends to sell in aid of Spanish prisoners-of-war currently detained in France. However, war starts before the lithograph can be editioned. Moore attempts to go to Spain along with W. H. Auden, Stephen Spender and other members of a delegation of English artists and writers, but the British Government refuses them permission to make the journey.

Fig. 13 *Two Sleepers in the Underground*, 1942 (HMF 1848); crayon, wax crayon, watercolour wash, pen and ink, brush and ink, 380 x 561 mm; private collection

1940

Appointed an Official War Artist. In this capacity makes his first drawings of people sheltering in the London Underground during the Blitz (the Shelter drawings; fig. 13). He makes only sketches on the spot, subsequently enlarging these into more complex images; he thus feels that he is not intruding on the intimacy of the scenes he observes, while preserving their inherent drama. This is the first time that Moore draws the clothed human figure. The motif of drapery –

Fig. 14 The artist sketching a miner in Wheldale Colliery, Castleford, in 1942

Fig. 15 *Coalminer with Pick*, 1942 (HMF 1987); crayon, watercolour, wash, pen and ink, 493 x 495 mm; Imperial War Museum, London

which recurs in his post-war work – is soon to make its first appearance in his terracotta maquettes.

Moore's Hampstead studio is bombed. He leaves London for the village of Perry Green near Much Hadham in Hertford-shire, where he rents a house, Hoglands, which he is later to buy. The gardens at Hoglands will serve as a sort of testing bench for a good many works that, characteristically for Moore, are to be erected, as isolated pieces, in the open air.

From now until the end of the war drawing will be Moore's principal artistic activity.

1941

First retrospective exhibition of Moore's work is held in Leeds. Continues to pro-duce his Shelter drawings. Appointed to the Board of Trustees of the Tate Gallery in London.

1942

A series of drawings of the miners of Wheldale Colliery, near his native Castle-ford, is Moore's last work as a War Artist (figs. 14, 15).

1943

First one-man show outside England, at the Buchholz Gallery in New York, at the instigation of Curt Valentin, who now becomes Moore's dealer for sales to America.

1943–44

Makes an extensive series of sketches and maquettes for the sculptures *Madonna and Child* (fig. 12, p. 109), for the church of St Matthew in Northampton, and *Family Group* (plate 66), to be executed in 1954–55 for Harlow new town, Essex. The first volume of *Henry Moore: Complete Sculpture* is published by Lund Humphries.

1945

Madonna and Child is installed in the church of St Matthew. One-man show at the Berkeley Galleries, London. Moore is appointed (until 1951) to the Arts Panel of the British Council, an institution that is soon to prove a crucial ally and to play a vital role in his career. Takes part in the exhibition 'Quelques artistes anglais contemporains' in Paris. While in Paris, visits Brancusi in his studio in the Impasse Ronsin (fig. 16).

Completes the sculpture *Memorial Figure* (LH 262) at Dartington Hall, Devon. Makes studies for *Three Standing Figures* (plate 54). Receives an honorary doctorate from the University of Leeds.

1946

Birth of his daughter, Mary. First visit to New York, on the occasion of his first touring retrospective, which opens at the Museum of Modern Art. One-man shows at the Leicester Galleries in London and at the Phillips Memorial Gallery in Washington, D.C. Goes to see the Barnes Collection in Merion, near Phila-delphia. J. J. Sweeney publishes a mono-graph on Moore.

1947

The New York retrospective moves on to the Art Institute of Chicago and later to the Museum of Modern Art in San Francisco. The British Council organizes a touring exhibition of Moore's sculp-tures and drawings for the state galleries of Australia; this is shown in Sydney, Melbourne, Adelaide, Hobart and Perth. A *Madonna and Child* (LH 270) is com-missioned by the church at Claydon in Suffolk. Completes *Three Standing Figures* for Battersea Park, London (fig. 18, p. 117).

Moore is appointed to the Royal Art Commission (until 1971). He seems set to become the official representative of British sculpture.

1948

One-man show in the British Pavilion at the 24th Venice Biennale, where he wins the International Prize for Sculpture. The Venice exhibition is subsequently shown at the Galleria d'Arte Moderna in Milan. Travels in Italy and becomes a friend of the Italian sculptor Marino Marini. A monograph on Moore by Giulio Carlo Argan is published in Turin.

Braque visits Moore at Much Hadham.

Moore's connection with the Surrealists does not survive the war, and his pro-motion throughout Europe under the auspices of the British Council evidently annoys the Surrealist artists, who see Moore's acquiescence as an act of treason.

1949–51

A touring exhibition of Moore's work, organized by the British Council, visits the Musée d'Art Moderne in Paris, the Palais des Beaux-Arts in Brussels, the City Art Gallery in Wakefield, the Stedelijk Museum in Amsterdam, and galleries in Hamburg, Düsseldorf, Berne and Athens.

Completes the large-scale *Family Group* (LH 269) for Stevenage in Hert-fordshire. *Standing Figure* is installed at Shawhead, Scotland (fig. 17). For a few months Anthony Caro works as Moore's assistant.

Produces lithographs for an edition of André Gide's translation of Goethe's *Prometheus* (CGM 18–32).

Fig. 16 Moore and Brancusi in Paris, 1945

1951

First Moore retrospective in London, at the Tate Gallery. One-man shows at the Leicester Galleries in London, the Buchholz Gallery in New York and the Albertina in Vienna. Takes part in the second international exhibition of open-air sculpture in London and in the first such exhibition at the Parc du Middel-heim in Antwerp. Starts work on a series of *Helmets*, sculptures he defines as 'internal/external' and that have emerged

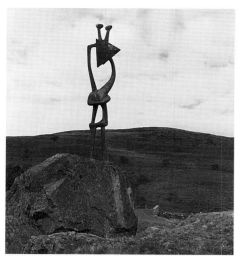

Fig. 17 *Standing Figure* (1950; LH 290) at Shaw-head, Dumfries

from his study of the armour in the Wallace Collection in London. Each of these works is made up of two distinct forms, one enveloping the other.

Travels in Greece, visiting Mycenae, Corinth, Delphi, Olympia and Athens: 'The Greek light is, as everyone says, something you can't imagine till you've experienced it. In England half the light is, as it were, absorbed into the object, but in Greece the object seems to give off light as if it were lit up from within itself.'[13]

1952–53

A stone screen measuring 3 by 8 metres and a bronze *Draped Reclining Figure*, 158 cm in length (LH 336), are commissioned for the terrace of the *Time/Life* building in Bond Street, London (fig. 18). Moore wins sculpture prize at the second São Paulo Bienal; travels in Brazil and in Mexico. An exhibition of his drawings, 'Figures in Space', is organized by the

Fig. 18 Moore and his assistant Alan Ingham in 1952 with the plaster *Working Model for Time/Life Screen* (LH 343)

Institute of Contemporary Arts in London.

Period of very intensive sculptural activity, during the course of which Moore produces several works that are to become among his most famous: large versions of *Upright Internal/External Forms* (LH 297), *King and Queen* (fig. 20, p. 126) and *Warrior with Shield* (plate 64).

1954

Travelling exhibition in Germany. An enormous low relief in brick is commissioned for the new Bouwcentrum in Rotterdam (installed in 1956; fig. 19). Works on the family group in stone for Harlow new town.

Small exhibitions of his sculpture and drawings in London and in New York. Travels in Italy and in Germany.

Fig. 19 *Wall Relief*, 1955 (LH 375); brick, l. 1992 cm; Bouwcentrum, Rotterdam

1955

Appointed member of the Order of the Companions of Honour.

Takes part in the exhibition 'documenta I – Kunst des 20. Jahrhunderts' in Kassel. An exhibition of his sculptures and drawings, organized by the British Council, is shown in Basle, Zagreb, Belgrade, Skopje and Ljubljana. Appointed member of the Board of Trustees of the National Gallery (a position he retains until 1974). Makes a series of totemic sculptures (plates 70, 71).

The second volume of *Henry Moore: Complete Sculpture* (covering the years 1949 to 1954) is published.

1955–58

A retrospective exhibition of Moore's sculptures and drawings, organized by

Fig. 20 Moore in 1955

the British Council, tours Canada, New Zealand and South Africa.

1956

Receives a commission for a sculpture for the entrance of the Unesco headquarters in Paris. Visits the Netherlands for celebrations marking the 350th anniversary of the birth of Rembrandt. Makes the *Glenkiln Cross* (LH 377).

1957

Makes a bronze version of *Falling Warrior* (fig. 11, p. 24).

Exhibitions held at the Galerie Berggruen in Paris and at Roland Browse Delbanco in London.

1958

Reclining Figure is unveiled at the Unesco headquarters in Paris (fig. 8, p. 42). This large-scale sculpture in Roman travertine marble was carved in Italy, in the Henraux workshops at Querceta (fig. 21), and then transported by sea to be finished in Paris.

Moore takes part in many group exhibitions in Europe and America. Appointed Chairman of the Auschwitz Memorial Committee.

Makes large bronzes of draped figures (see fig. 10, p. 23).

1959

Takes part in the exhibition 'documenta II' in Kassel and in the exhibition 'Jeunesse des Maîtres de la Sculpture du XXième Siècle' at the Musée Rodin in Paris. Increasingly eschews naturalistic motifs. Wins Foreign Minister's Prize at the Fifth Tokyo Biennale. Exhibitions of his work tour Japan, Portugal and Spain. Receives honorary doctorates from the universities of Cambridge and Reading.

Fig. 21 The artist carving *Unesco Reclining Figure* (1957–58; LH 416) at Querceta

Makes small bronze animals and the sculpture *Two Piece Reclining Figure No. 1* (LH 457).

1960

Exhibition at the Whitechapel Gallery, London. Retrospective exhibition of sculptures and drawings dating from 1927 to 1960 opens at the Kunsthalle in Hamburg and subsequently travels to the Folkwang Museum, Essen, the Haus der Kunst in Munich, the Kunsthaus, Zurich, and other venues.

1961

Receives an honorary doctorate from the University of Oxford. Elected a member of the American Academy and the Institute of Arts and Letters and of the Akademie der Künste in Berlin. Exhibits at Marlborough Fine Art in London and at the Scottish National Gallery of Modern Art in Edinburgh. Completes *Three Piece Reclining Figure No. 1* (LH 500) and *Standing Figure: Knife Edge* (fig. 22).

1962

Exhibitions at Marlborough Fine Art, London, the Knoedler Gallery in New York, the Ashmolean Museum in Oxford and the Galerie Cramer in Geneva. Receives a commission for a sculpture to be sited on water at the Lincoln Center for the Performing Arts in New York.

The Geneva publisher and gallery owner Gérald Cramer invites Moore to explore new print-making techniques.

1963

Invested with the insignia of a Member of the Order of Merit (Civil Division). Wins the Premio Feltrinelli for sculpture, conferred by the Accademia Nazionale dei Lincei in Rome.

Works on *Locking Piece* (LH 515) and *Large Torso: Arch* (LH 503).

During the winter, when prevented by the cold from working on his large-scale sculptures, Moore learns a number of new print-making techniques. He entrusts to Gérald Cramer several of the prints made at this period. Cramer is eventually to specialize in the publication of the etchings on which Moore is to embark in 1966 with the help of the French master printer Jacques Frélaut.

1964

Appointed to the Arts Council of Great Britain; wins the Fine Arts Medal of the Institute of Architects in America. Exhibitions of Moore's work tour Argentina, Brazil, Mexico and Venezuela.

Returns to carving.

Makes *Nuclear Energy* (LH 526) for the University of Chicago.

1965

Becomes an Honorary Fellow of Churchill College, Cambridge. Receives an honorary doctorate from the University of Sussex. Exhibitions at Marlborough Fine Art, London, in Rio de Janeiro and in New Orleans. Visits New York for the installation of *Reclining Figure* (LH 518) at the Lincoln Center.

Publication of the third volume of *Henry Moore: Complete Sculpture* (covering the years 1955 to 1964) and of Herbert Read's *Henry Moore: A Study*

Fig. 22 Moore with *Standing Figure: Knife Edge* (1961; LH 481) in his studio in 1961

of his Life and Work. Three of the *Upright Motives* (LH 377, 379, 386) are erected on a stretch of raised ground in the park surrounding the Kröller-Müller Museum at Otterlo.

During this and the following year Moore completes *Sundial* (LH 528) for the *Times* building in London.

Gérald Cramer has Fequet et Baudier in Paris print two woodblocks engraved in 1931 that Moore had rediscovered by chance at the back of a drawer at Much Hadham. Moore buys a summer house at Forte dei Marmi, on the north-west Italian coast, not far from Carrara, so that he can spend his holidays there and carve in marble.

Fig. 23 The artist in Carrara, 1967

1966

Receives honorary doctorates from the universities of York, Sheffield and Yale. Becomes a Fellow of the British Academy. Exhibitions at Marlborough Fine Art, London, and at the Philadelphia College of Art. Touring exhibitions in Eastern Europe. Moore travels to Canada for the installation of *Three Way Piece No. 2: Archer* (LH 535) in Nathan Phillips Square, Toronto. Publication in London of Donald Hall's *The Life and Work of a Great Sculptor: Henry Moore* and of *Henry Moore on Sculpture*, a collection of articles and interviews compiled and edited by Philip James. Moore carves *Two Forms* (LH 555) in red travertine marble, *Three Rings* (LH 548) in rose aurora marble and a large version of this work (LH 549) in red travertine marble.

1967

Elected Honorary Professor at the Accademia delle Belle Arti, Carrara. Exhibitions at the Marlborough New London Gallery and at the museum in Lincoln,

Massachusetts. Works by Moore are included in Expo 67 in Montreal and in the International Exhibition at the Solomon R. Guggenheim Museum in New York. Takes part in the homage to Rodin organized by the Galerie Lucie Weil in Paris. An album of facsimiles of Moore's Shelter drawings is published in Berlin. Supervises the installation of *Nuclear Energy* for the University of Chicago (fig. 27, p. 147). Makes *Three Way Piece No. 1: Points*, a cast of which is later installed at Columbia University, New York.

1968
Awarded the Order of Merit by the Federal Republic of Germany.

Adopts a new technique for enlarging his sculptural models: he abandons the use of plaster with wood armatures in favour of polystyrene, which he has delivered to Perry Green in large square blocks. A vast hangar covered in plastic sheeting is constructed to provide shelter for the largest pieces while these are being worked. Originally erected for the Lincoln Center *Reclining Figure*, this is, in effect, a new studio (fig. 24), in addition to the four already in existence – one for creating models, a second for making enlargements, a third for photographic work and polishing, the fourth, with a view across the surrounding countryside, for making drawings.

Moore wins the Albert Einstein Award for the Arts, conferred by the Yeshiva University of New York.

Important retrospectives, marking Moore's 70th birthday, at the Tate Gallery, London, and at the Kröller-Möller Museum, Otterlo (where he is awarded the Erasmus Prize; fig. 25); the latter travels to the Museum Boymans-van Beunigen, Rotterdam, the Städtische Kunsthalle in Düsseldorf and the Städtische Kunsthalle in Baden-Baden.

Among new publications on Moore appearing at this time are a study of his life and work by John Russell and a selection of photographs by John Hedgecoe with a text by Moore himself.

1969
Writes a general introduction to the work of Giovanni Pisano for a volume on this artist edited by Michael Ayrton.

Begins *Three Piece Reclining Figure: Vertebrae* (fig. 34) and the large bronze version of *The Arch* (p. 32). Works on *Large Two Forms* (LH 556).

Collaborates with Gérald Cramer and Jacques Frélaut on a project involving an unusual object that the artist has kept in his studio for more than a year: an elephant skull given to him by his friends Julian and Juliette Huxley. Moore makes

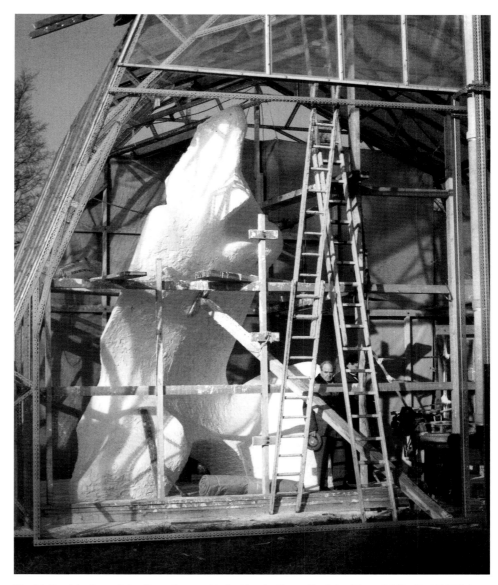

Fig. 24 The 'plastic studio' at Perry Green, with the Lincoln Center *Reclining Figure* (1963–65; LH 509) in progress

forty-three etchings, which are published in an album (fig. 26), and this prompts the exhibition 'Elephant Skull' the next year at the Galerie Cramer in Geneva. The exhibition subsequently travels to the Musée Rodin and the Maison de la Chasse, Hôtel Guénégaut, in Paris.

1970
An important exhibition of Moore's recent work is held in New York, marbles at the Knoedler Galleries and bronzes at the Marlborough-Gerson Gallery.

1971
Moore makes a large bronze version of *Oval with Points* (1968–70; LH 596), which is installed at the University of Princeton.

Travels to Toronto to launch plans for the Henry Moore Sculpture Centre at the Art Gallery of Ontario. Elected an

Honorary Fellow of the Royal Institute of British Architects.

Experiments with aquatint and makes a series of two-colour etchings.

1972
Large retrospective at the Forte di Belvedere in Florence. Moore presents a cast of *Warrior with Shield* (plate 64) to the city of Florence; it is subsequently installed next to the church of Santa Croce. Stays in Italy after the opening of the exhibition. Wins the Florentine international prize 'Le muse'.

Forced to leave his sculpture studios at Perry Green (where he feels overwhelmed by the preparations for his Florentine retrospective), Moore moves into a small studio with a view of a field of sheep. He begins the *Sheep Sketchbook* (HMF 3317–66), using ball-point pen with occasional touches of gouache (fig. 27).

Fig. 25 The artist with Queen Juliana and Princess Beatrix on receipt of the Erasmus Prize in Otterlo, The Netherlands, in 1968

The following November these drawings are to provide the starting point for the first etchings of his album *Sheep* (CGM 196–201, 225–35).

1973

Wins the Premio Umberto Biancamano in Milan; is made a Commandeur de l'Ordre Français des Arts et des Lettres.

Exhibition at the Los Angeles County Museum of Art. To mark the publication of the first volume of the *catalogue raisonné* of Moore's work as a print-maker, a retrospective exhibition is held at the Galerie Cramer.

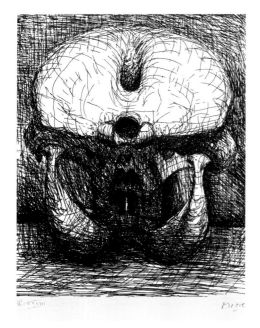

Fig. 26 *Elephant Skull Plate XXVIII*, 1969 (CGM 141); etching, 254 x 200 mm

1974

Despite his advanced age, Moore continues to work every day. Helped by John Farham, he still makes his own maquettes, but leaves their enlargement to his assistants Malcolm Woodward and Michel Muller, the latter from Alsace. Moore is invariably pleased with the enlargements, thinking increasingly in terms of large-scale sculptures for outdoor sites.

Publishes a series of lithographs, executed in 1972–73, on the theme of Stonehenge (CGM 207–23). Takes up etching again, working together with Jacques Frélaut. Moore's work as a print-maker is now decisively influenced by the etchings of Hercules Seghers and those of Rembrandt, as also by the late, extremely dark drawings of Georges Seurat. As a form of homage to Rembrandt, Moore makes forty variations after the etching *The Hundred Gilder Print*, a work he admires enormously.

Fig. 27 *Page 36 from Sheep Sketchbook 1972: Sheep with Lamb VII* (HMF 3352); ballpoint pen, 210 x 251 mm; private collection, UK

Travels to Canada for the inauguration of the Henry Moore Sculpture Centre at the Art Gallery of Ontario, in Toronto, to which he has donated 101 sculptures, 57 drawings and examples of most of his work as a print-maker (fig. 28).

1975

Elected Membre de l'Institut, Académie des Beaux-Arts, Paris.

At the request of Franco Russoli, Director of the Brera in Milan, a number of artists, including Moore, are invited to interpret in their own terms a work of their choice from the museum's collection. Moore chooses to draw the *Pietà* of 1460 by Giovanni Bellini.

One-man show of prints at the Tate Gallery, London.

1976

Exhibition of Shelter drawings at the Imperial War Museum, London. Exhibition in Zurich organized by the Zürcher Forum.

Fig. 28 The artist in Toronto in 1974, preparing for the inauguration of the Henry Moore Sculpture Centre at the Art Gallery of Ontario

1977

The Henry Moore Foundation is inaugurated at Much Hadham. Moore donates to it much property, including studios, cottages and the works still in his possession, which the Trustees of the Foundation are to administer in perpetuity. The aim of the Foundation is 'to advance the education of the public by the promotion of their appreciation of the fine arts and in particular the works of Henry Moore'. This is to be accomplished by a series of grants, bursaries and fellowships awarded by a committee.

Makes charcoal drawings after Georges de la Tour.

Exhibitions in Paris, at the Orangerie des Tuilleries (fig. 29) and a retrospective of Moore's entire oeuvre of prints at the Bibliothèque Nationale. An exhibition at the Art Gallery of Ontario in Toronto travels to four Japanese cities and then to the Tate Gallery in London.

1978

Presents 36 sculptures to the Tate Gallery and exhibits drawings there. Moore's 80th birthday is celebrated by exhibitions at the Serpentine Gallery in London and at the City Art Gallery in Bradford. The sculpture *Mirror, Knife Edge* (LH 714) is installed in the National Gallery of Art in Washington, D.C.

1979–80

For almost two years arthritis has restricted Moore's sculptural activity to the production of maquettes; he turns increasingly to drawing, taking as his subjects the trees at Much Hadham or his own hands, now knotted and deformed by a lifetime of work and by rheumatism (fig. 30).

Exhibition of tapestries made after drawings by Moore at the Victoria and Albert Museum in London.

Large Two Forms is installed outside the Bundeskanzleramt in Bonn (fig. 31).

Donates a large marble version of *The Arch* (LH 503c) to the Department of the Environment for installation in Kensington Gardens, London.

1981

Moore makes a series of drawings after David Finn's photographs of the Baptistery in Florence. These are essentially studies of the work of Andrea Pisano and Lorenzo Ghiberti.

Fig. 29 Moore with Kenneth Clark in front of *The Nympheas* in the Orangerie, Paris, in 1977

Elected Full Member of the Académie Européenne des Sciences, des Arts et des Lettres in Paris. A large retrospective of his work is held at the Palacio Velázquez, the Palacio Cristal and the Parc del Buen Retiro in Madrid, and is subsequently shown at the Fundação Calouste Gulbenkian in Lisbon and the Fundación Joan Miró in Barcelona.

1982

Formal inauguration of the Henry Moore Sculpture Gallery and the Centre for the Study of Sculpture at Leeds City Art Gallery. Touring exhibition opens at the Museo de Arte Moderno in Mexico City. Another exhibition is shown at the Hoam Art Museum in Seoul.

Fig. 30 *The Artist's Hands*, 1977 (HMF 77 [10]); carbon line, charcoal, ballpoint pen, felt-tipped pen, 329 x 241 mm; The Henry Moore Foundation

1983

His health deteriorates to the extent that he has to stop working.

Major exhibition at the Metropolitan Museum of Art, New York.

1984

Is made a Commandeur de l'Ordre National de la Légion d'Honneur when the French President, François Mitterrand, visits him at Perry Green (fig. 32). A touring exhibition opens at the Nationalgalerie in East Berlin.

1986

Touring exhibition shown in Hong Kong, Tokyo and Fukuoka.

Fig. 31 Moore with Chancellor Helmut Schmidt in 1979 at the Bundeskanzleramt in Bonn for the inauguration of *Large Two Forms* (1966–69; LH 556)

Dies at Much Hadham on 31 August. A Service of Thanksgiving for the Life and Work of Henry Moore is held on 18 November at Westminster Abbey.

1987

Exhibitions at the Yorkshire Sculpture Park at Bretton Hall, near Wakefield, and at the National Gallery of Modern Art in New Delhi.

1988

Inauguration of the Henry Moore Sculpture Trust in Leeds. Exhibitions in London at the Royal Academy of Arts and at the British Museum.

1989

Exhibitions at the Fondation Pierre Gianadda in Martigny and at the Castello Sforzesco in Milan.

Fig. 32 The artist receiving the Légion d'Honneur from President François Mitterrand at Perry Green in 1984

1990

Several works by Moore are included in the exhibition celebrating Glasgow as this year's European Capital of Culture. Exhibition at the Museo de las Bellas Artes in Bilbao.

1991

An exhibition tours Russia and Finland, opening at the Benois Museum in Leningrad, moving on to the Pushkin Museum in Moscow and, subsequently, to the Helsingin Kaupungin Taidemuseo in Helsinki.

1992

27 large-scale bronzes are exhibited in the Parc de Bagatelle, Paris (fig. 34).

An exhibition of Moore's work tours Germany (Cologne, Kreis Unna, Norden

Fig. 33 Hoglands, Moore's house at Perry Green

and Ratzeburg) and is then shown at Huddersfield.

1993
Touring exhibition of Moore's work shown in Budapest, Bratislava and Prague. The Henry Moore Sculpture Trust moves into a new building in Leeds.

1994
Exhibition of works in bronze at Pforzheim and Bad Homburg, and of Shelter drawings at Ittingen and in Salzburg.

1995
Two touring exhibitions, a retrospective shown in Cracow, Warsaw and Venice, and one devoted to sculptures and drawings from the final decade of Moore's life, shown in Bellinzona (Switzerland), Naples and Bologna.

NOTES

This Chronology is based on original source material in the possession of the Henry Moore Foundation. In cases of factual discrepancy the author has adhered to information published in Berthoud, 1987.

1 Moore, 1966, p. 51.
2 Ibid.
3 Ibid.
4 *Visages de l'Art moderne*, ed. Jean Clay, Paris, 1969, p. 125 (interview with Henry Moore).
5 Moore, 1966, p. 33.
6 *Visages de l'Art moderne* (note 4), p. 127.
7 Moore, 1966, p. 36.
8 Ibid., p. 190.
9 Moore, 1992, p. 203.
10 Moore, 1966, p. 37.
11 HMF Archive.
12 *Visages de l'Art moderne* (note 4), p. 133.
13 Moore, 1966, p. 47.

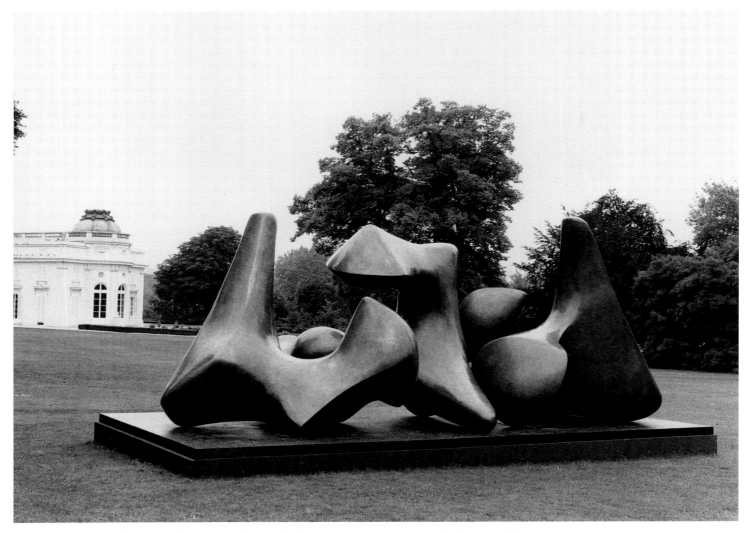

Fig. 34 *Three Piece Reclining Figure: Vertebrae* (1969–70; LH 580) on show in the Parc de Bagatelle, Paris, in 1992

Selected Bibliography

Bibliography

Henry Moore Bibliography, 5 vols, ed. Alexander Davis, London and Much Hadham, The Henry Moore Foundation, 1992–94.

Catalogues Raisonnés

Henry Moore: Complete Sculpture, vol. 1 *1921–48* (originally entitled *Sculpture and Drawings*) ed. Herbert Read, 1944, 5th edn ed. David Sylvester, 1988; vol. 2 *1949–54* (originally entitled *Sculpture and Drawings*), ed. Herbert Read, 1955, 3rd rev. edn, ed. Alan Bowness, 1986; vol. 3 *1955–64* (originally entitled *Sculpture and Drawings*), ed. Alan Bowness, 1965, 2nd rev. edn, 1986; vol. 4 *1964–73*, ed. Alan Bowness, 1977; vol. 5 *1974–80*, ed. Alan Bowness, 1983, 2nd rev. edn, 1994; vol. 6 *1980–86*, ed. Alan Bowness, 1988; London, Lund Humphries.

Henry Moore: Catalogue of Graphic Work, [vol. 1] *1931–72*, ed. Gérald Cramer, Alistair Grant and David Mitchinson, 1973; vol. 2 *1973–75*, ed. Gérald Cramer, Alistair Grant and David Mitchinson, 1976; vol. 3 *1976–79*, ed. Patrick Cramer, Alistair Grant and David Mitchinson, 1980; vol. 4 *1980–84*, ed. Patrick Cramer, Alistair Grant and David Mitchinson, 1988; Geneva, Cramer.

Henry Moore: Complete Drawings, vol. 5 *1977–81*, vol. 6 *1982–83*, ed. Ann Garrould, 1994; (vols. 1–4 forthcoming); London, The Henry Moore Foundation in association with Lund Humphries.

Monographs

Argan, Giulio Carlo, *Henry Moore*, Milan, Fabbri, 1971; Paris, Hachette-Fabbri, 1972; New York, Abrams, 1973; Munich, Praeger, 1974; rev. edn Milan, Fabbri, 1987; Alphen aan den Rijn, Atrium, 1988; Stuttgart, Klett-Cotta, 1989.

Berthoud, Roger, *The Life of Henry Moore*, London, Faber; New York, E. P. Dutton, 1987.

Clark, Kenneth, *Henry Moore Drawings*, London, Thames and Hudson; New York, Harper and Row, 1974.

Cohen, David, *Moore in the Bagatelle Gardens*, Paris, photographs by Michel Muller, London, Lund Humphries; Woodstock, NY, The Overlook Press, 1993.

Fezzi, Elda, *Henry Moore*, London, Hamlyn; Florence, Sansoni, 1971; New York, Crown Publishers; Lucerne, Kunstkreis, 1972.

Finn, David, *Henry Moore: Sculpture and Environment*, New York, Abrams, 1976; London, Thames and Hudson, 1977.

Garrould, Ann, *Henry Moore Drawings*, London, Thames and Hudson; New York, Rizzoli; Paris, Cercle d'Art; Milan, Rizzoli, 1988; Barcelona, Polígrafa, 1989.

Garrould, Ann, and Valerie Power, *Henry Moore: Tapestries*, London, Diptych, 1988.

Gelburd, Gail, *Henry Moore: Mother and Child Etchings*, Much Hadham, Raymond Spencer Company, 1988.

Grigson, Geoffrey, *Henry Moore*, London, Penguin Books, 1943.

Grohmann, Will, *The Art of Henry Moore*, Berlin, Rembrandt Verlag; Milan, Il Saggiatore; London, Thames and Hudson; New York, Abrams, 1960.

Hall, Donald, *Henry Moore: The Life and Work of a Great Sculptor*, London, Gollancz; New York, Harper and Row, 1966.

Hedgecoe, John, *Henry Spencer Moore*, London, Nelson; New York, Simon and Schuster, 1968.

Hodin, J.P., *Henry Moore*, Amsterdam, De Lange, 1956; London, Zwemmer, 1958.

Jianou, Ionel, *Henry Moore*, Paris, Arted; New York, Tudor, 1968.

Lichtenstern, Christa, *Henry Moore: Zweiteilig Liegende 1*, Frankfurt am Main and Leipzig, Insel Verlag, 1994.

Melville, Robert, *Henry Moore: Sculpture and Drawings 1921–1969*, London, Thames and Hudson; New York, Abrams, 1970; Munich, Bruckmann, 1971.

Mitchinson, David, *Henry Moore: Unpublished Drawings*, Turin, Fratelli Pozzo; New York, Abrams, 1971.

——, *Henry Moore: Sculpture*, introduction by Franco Russoli, Barcelona, Polígrafa; Lisbon, Gulbenkian; London, Macmillan; New York, Rizzoli, 1981; Milan, Rizzoli, 1982.

Mitchinson, David, and Julian Stallabrass, *Henry Moore*, Barcelona, Polígrafa; London, Academy Editions; New York, Rizzoli; Groningen, B & P; Paris, Éditions Albin Michel, 1992.

Moore, Henry, *Heads, Figures and Ideas*, with a comment by Geoffrey Grigson, London, Rainbird; Greenwich, Conn., New York Graphic Society, 1958.

——, *Schriften und Skulpturen*, introduction by Werner Hofmann, Frankfurt am Main, S. Fischer, 1959.

——, *Henry Moore on Sculpture*, ed. Philip James, London, Macdonald, 1966; New York, Viking, 1967, rev. 1971; Munich, Pier, 1972; New York, Da Capo, 1992.

——, *Hauptthemen*, ed. Heinz Spielmann, Herrsching, Pawlak Verlag, 1976.

——, *With Henry Moore: The Artist at Work*, photographs by Gemma Levine, London, Sidgwick and Jackson; New York, Times Books, 1978.

——, *Henry Moore's Sheep Sketchbook*, London and New York, Thames and Hudson, 1980.

——, *Henry Moore at the British Museum*, photographs by David Finn, London, British Museum Publications, 1981; New York, Abrams, 1982.

——, *Henry Moore: Wood Sculpture*, photographs by Gemma Levine, London, Sidgwick and Jackson; New York, Universe Books, 1983.

——, *A Szobrászatól*, Budapest, Helikon Kiadó, 1985.

——, Henry Moore: *My Ideas, Inspiration and Life as an Artist*, photographs by John Hedgecoe, London, Ebury Press; San Francisco, Chronicle Books, 1986.

——, *A Shelter Sketchbook*, London, British Museum; Munich, Prestel, 1988.

Neumann, Erich, *The Archetypal World of Henry Moore*, London, Routledge; New York, Pantheon Books, 1959; Zurich and Stuttgart, Rascher, 1961; Turin, Boringhieri, 1962; New York, Harper and Row, 1965; Princeton, NJ, Princeton University Press, 1985.

Packer, William, *Henry Moore: An Illustrated Biography*, photographs by Gemma Levine, London, Weidenfeld and Nicolson; New York, Grove Press, 1985.

Polacci, Marcello, and Silvana Arata, *Henry Moore a Forte dei Marmi e in Versilia: l'uomo, l'artista*, Pisa, Giardina, 1988.

Read, Herbert, *Henry Moore, Sculptor: An Appreciation*, London, Zwemmer, 1934.

——, *Henry Moore: A Study of his Life and Work*, London, Thames and Hudson, 1965; New York, Praeger, 1966.

——, *Henry Moore: Mother and Child*, London, Unesco/Collins; New York, New American Library; Milan, Silvana, 1966.

Read, John, *Henry Moore: Portrait of an Artist*, London, Whizzard Press/André Deutsch; New York, Hacker, 1979.

Russell, John, *Henry Moore*, London, Allen Lane; New York, Putnam, 1968; rev. edn London, Penguin Books, 1973; The Hague, Gaade, 1968; Tokyo, Hosei University Press, 1985.

Sanesi, Roberto, *Sul Linguaggio Organico di Henry Moore: Annotazioni e diari*, Pollenza-Macerate, Nuova Foglio, 1977.

San Lazzaro, G. di, *Homage to Henry Moore*, Paris, XXe Siècle; London, Zwemmer; New York, Tudor, 1972.

Spender, Stephen, *Henry Moore: Sculptures in Landscape*, introduction by Henry Moore, photographs by Geoffrey Shakerley, Oslo, J.M. Stenersens; London, Studio Vista; New York, Clarkson Potter, 1978.

Steingräber, Erich, *Henry Moore: Maquetten*, Munich, Pantheon Edition, Studio Bruckmann, 1978.

Strachan, Walter, *Henry Moore: Animals*, London, Aurum Press/Bernard Jacobson, 1983.

Wilkinson, Alan G., *The Moore Collection in the Art Gallery of Ontario*, Toronto, Art Gallery of Ontario, 1979; rev. edn entitled *Henry Moore Remembered*, Toronto, Art Gallery of Ontario/Key Porter, 1987.

——, *The Drawings of Henry Moore*, London and New York, Garland, 1984.

Exhibition Catalogues

New York, Museum of Modern Art: *Henry Moore*, text by James Johnson Sweeney, New York, Museum of Modern Art, distributed by Simon and Schuster, 1947.

London, The Tate Gallery: *Sculpture and Drawings by Henry Moore*, text by David Sylvester, London, Arts Council of Great Britain, 1951.

London, Whitechapel Art Gallery: *Henry Moore: Sculpture 1950–1960*, text by Bryan Robertson, London, Whitechapel Art Gallery, 1960.

London, Marlborough Fine Art: *Henry Moore: Stone and Wood Carvings*, London, Marlborough Fine Art, 1961.

Otterlo, Rijksmuseum Kröller-Müller; Rotterman, Boymans-van Beuningen Museum: *Henry Moore*, ed. David Mitchinson, Otterlo, Rijksmuseum Kröller-Müller, 1968.

London, The Tate Gallery: *Henry Moore*, text by David Sylvester, London, Arts Council of Great Britain; New York, Praeger, 1968.

New York, M. Knoedler/Marlborough Gallery: *Henry Moore: Carvings 1961–1970, Bronzes 1961–1970*, New York, M. Knoedler/Marlborough Gallery, 1970.

Basle, Galerie Beyeler: *Henry Moore: Drawings, Watercolours, Gouaches*, text by Alan G. Wilkinson, Basle, Beyeler, 1970.

Geneva, Galerie Cramer: *Elephant Skull: Original Etchings by Henry Moore*, Geneva, Galerie Cramer, 1970.

Munich, Staatsgalerie moderner Kunst: *Henry Moore 1961–1971*, Munich, Staatsgalerie moderner Kunst, 1971.

Florence, Forte di Belvedere: *Mostra di Henry Moore*, ed. Giovanni Carandente, Florence, Il Bisonte/Vallecchi, 1972; rev. edn entitled *Moore e Firenze*, 1979.

Los Angeles County Museum of Art: *Henry Moore in America*, text by Henry J. Seldis, Los Angeles County Museum of Art and New York, Praeger; London, Phaidon, 1973.

London, British Museum: *Auden Poems/Moore Lithographs*, text by Henry Moore, London, British Museum Publications, 1974.

London, The Tate Gallery: *Henry Moore: Graphics in the Making*, text by Pat Gilmour, London, The Tate Gallery/Idea Books, 1975.

Høvikodden, Henie-Onstad Kunstsenter; Stockholm, Kulturhuset; Alborg, Nordjyllands Kunstmuseum: *Henry Moore: Skulptur, Teckning, Grafik 1923–1975*, text by Anne Seymour, Høvikodden, Henie-Onstad Kunstsenter, 1975.

Zurich, Zürcher Forum: *Expo Henry Moore*, ed. Georg Muller, Zurich, Zürcher Forum, 1976.

Toronto, Art Gallery of Ontario; Iwaki, Shimin Art Gallery Museum; Kanazawa, Prefectural Museum; Kumamoto, Kumamoto Municipal Museum; Tokyo, Seibu Gallery; London, The Tate Gallery: *The Drawings of Henry Moore*, text by Alan G. Wilkinson, London, The Tate Gallery, and Toronto, Art Gallery of Ontario, 1977.

Paris, Orangerie des Tuileries: *Henry Moore: Sculptures et Dessins*, text by Dominique Bozo, Paris, Editions des musées nationaux, 1977.

Bradford, Bradford Art Gallery: *Henry Moore: 80th Birthday Exhibition*, Bradford, Bradford Art Galleries and Museums, 1978.

London, Serpentine Gallery: *Henry Moore at the Serpentine*, text by David Sylvester, London, Arts Council of Great Britain, 1978.

London, The Tate Gallery: *The Henry Moore Gift*, text by John Russell, London, The Tate Gallery, 1978.

New York, Wildenstein: *Henry Moore: Drawings 1969–79*, text by Henry Moore, New York, Wildenstein, and Much Hadham, Raymond Spencer Company, 1979.

Bonn, Bundeskanzleramt: *Henry Moore: Maquetten, Bronzen, Handzeichnungen*, text by Gerhard Bott, Darmstadt, Eduard Roether Verlag, 1979.

London, Victoria and Albert Museum: *Tapestry: Henry Moore & West Dean*, London, Victoria and Albert Museum, 1980.

Seoul, Hoam Art Museum: *Henry Moore*, Seoul, Samsung Foundation of Art and Culture, 1982.

Leeds City Art Gallery: *Henry Moore: Early Carvings 1920–1940*, texts by Ann Garrould, Terry Friedman and David Mitchinson, Leeds, City Art Galleries, 1982.

Mexico City, Museo de Arte Moderno: *Henry Moore en Mexico: Escultura, Dibujo, Grafica de 1921 a 1987*, Mexico City, Instituto Nacional de Bellas Artes-Cultura, 1982.

Caracas, Museo de Arte Contemporaneo: *Henry Moore*, text by José María Salvador, Caracas, Museo de Arte Contemporaneo, 1983.

New York, The Metropolitan Museum of Art: *Henry Moore: 60 Years of His Art*, text by William S. Lieberman, New York, The Metropolitan Museum of Art, and London, Thames and Hudson, 1983.

Vienna, Palais Auersperg, Orangerie; Munich, Residenz: *Henry Moore: Skulpturen, Zeichnungen, Grafiken*, introduction by Gerhard Habarta, Vienna, Habarta Kunsthandel & Verlag, 1983.

Berlin, Nationalgalerie der Staatlichen Museen; Leipzig, Museum der bildenden Künste; Halle, Staatliche Galerie Moritzburg; Dresden, Staatliche Kunstsammlungen: *Henry Moore: Shelter and Coal Mining Drawings*, text by Julian Andrews, Berlin, Ministerium für Kultur der Deutschen Demokratischen Republik, 1984.

Columbus, Ohio, Columbus Museum of Art; Austin, Texas, Archer M. Huntington Art Gallery; Salt Lake City, Utah, Utah Museum of Fine Arts; Portland, Oregon, Portland Art Museum; San Francisco Museum of Modern Art: *Henry Moore: The Reclining Figure*, texts by Steven W. Rosen, David Mitchinson and Ann Garrould, Columbus, Ohio, Columbus Museum of Art, 1984.

Marl, Skulpturenmuseum Glaskasten: *Henry Moore: Mutter und Kind*, texts by Ann Garrould and Uwe Ruth, Marl, Skulpturenmuseum Glaskasten, 1984.

Hong Kong Museum of Art/Hong Kong Arts Centre/Tsim Sha Tsui Promenade: *The Art of Henry Moore*, text by David Mitchinson, Hong Kong, Urban Council, 1986.

Tokyo, Metropolitan Art Museum; Fukuoka, Fukuoka Art Museum: *The Art of Henry Moore*, texts by David Mitchinson and William Packer, Tokyo, Metropolitan Art Museum, and Fukuoka, Fukuoka Art Museum, 1986.

New Delhi, National Gallery of Modern Art: *Henry Moore: New Delhi 1987*, ed. Ann Elliott and David Mitchinson, text by Norbert Lynton, New Delhi, National Gallery of Modern Art, and London, British Council, 1987.

Hempstead, NY, Hofstra Museum: *Mother and Child: The Art of Henry Moore*, ed. Gail Gelburd, Hempstead, NY, Hofstra Museum and University, 1987.

London, Royal Academy of Arts: *Henry Moore*, ed. Susan Compton, London, Royal Academy of Arts and Weidenfeld and Nicolson; New York, Scribner's, 1988.

Martigny, Fondation Pierre Gianadda: *Henry Moore*, ed. David Mitchinson, Martigny, Fondation Pierre Gianadda, and Milan, Electa, 1989.

Milan, Castello Sforzesco: *Henry Moore al Castello Sforzesco*, text by Roberto Sanesi, Milan, Edizioni L'Agrifoglio, 1989.

Petrodvorets, Benois Museum; Moscow, Pushkin Museum of Fine Art; Helsinki, Taidemuseo: *Henry Moore: The Human Dimension*, ed. Ann Elliott and David Mitchinson, text by Norbert Lynton, London, The British Council; Much Hadham, HMF Enterprises; and Helsinki, Helsingin Kaupungin Taidemuseo, 1991.

Cologne, Käthe Kollwitz Museum; Kreis Unna, Schloss Cappenberg; Norden, Kunstkreis; Ratzeburg, Ernst Barlach Museum; Huddersfield, City Art Gallery: *Henry Moore: Mutter und Kind/Mother and Child*, text by David Mitchinson and Julian Stallabrass, Much Hadham, The Henry Moore Foundation, 1992.

Sydney, Art Gallery of New South Wales: *Henry Moore 1898–1986*, text by Nick Waterlow and Susan Compton, Sydney, Art Gallery of New South Wales, 1992.

Paris, Didier Imbert Fine Arts; Tokyo, Sezon Museum of Art; Kitakyushu, Kitakyushu Municipal Museum of Art; Hiroshima, Hiroshima City Museum of Contemporary Art; Oita, The Oita Prefectural Museum of Art: *Henry Moore Intime*, text by Timothée Trimm, Paris, Editions du Regard, and Tokyo, Sezon Museum of Art, 1992.

Pforzheim, Reuchlinhaus; Bad Homburg, Sinclair-Haus: *Henry Moore: Ethos und Form*, text by Christa Lichtenstern, Stadt Pforzheim and Bad Homburg, Altana AG, 1994.

Cracow, BWA Gallery; Warsaw, Ujazdowski Castle, Centre for Contemporary Art: *Henry Moore Retrospektywa*, texts by David Mitchinson, Susan Compton and Piotr Krakowski, Cracow, Galeria BWA, 1995.

Bellinzona, Castelgrande: *Henry Moore: gli ultimi 10 anni*, text by Augusta Monferini, Milan, Skira Editore, 1995.

Photographic Acknowledgements

Geneviève Allemand-Lacambre fig. 9, p. 43
Archives Artstudio, Paris fig. 1, p. 48; fig. 3, p. 49; figs. 5 and 6, p. 51
Maria Austria, Amsterdam fig. 25, p. 194
Courtauld Institute of Art, London fig. 6, p. 40
Brian Coxall plates 28, 40, 49, 52, 61–3, 67–71, 73–5, 80, 86, 89, 90, 92, 96, 98–100, 104, 105, 107, 116, 117
Prudence Cuming Associates plate 47
Kurt Garthe, Düsseldorf fig. 31, p. 195
Dennis Gilbert cover; plates 64, 72
John Hedgecoe fig. 8, p. 42; fig. 29, p. 152; fig. 2, p. 185

Errol Jackson plate 106; fig. 7, p. 20; fig. 20, p. 126; fig. 17, p. 191; fig. 24, p. 193
Lidbrooke, London fig. 20, p. 191
© Lee Miller Archives, Chiddingly, East Sussex fig. 14, p. 110
Michel Muller plates 4, 10, 12, 14, 15, 23, 25, 27, 30, 33, 34, 37, 41–4, 48, 53, 56–8, 66, 76–8, 93, 97, 110, 111, 114, 115, 118; fig. 5, p. 76; fig. 24, p. 130; fig. 26, p. 194; fig. 34, 196
Julian Stallabrass plates 2, 6, 29, 31, 55, 103; pp. 8, 32, 46, 184
Tate Gallery, London fig. 3, p. 14; fig. 5, p. 17